A DICTIONARY OF
WATERCOLOUR PAINTERS
1750–1900

A DICTIONARY OF
WATERCOLOUR PAINTERS
1750-1900

by Stanley W Fisher FRSA

LONDON
W FOULSHAM & CO LTD
NEW YORK TORONTO CAPE TOWN SYDNEY

W FOULSHAM & CO LTD
Yeovil Road Slough Bucks

By the same author
English Watercolours
English Blue and White Porcelain of the 18th Century
The Decoration of English Porcelain
The China Collector's Guide
Collector's Progress
Worcester Porcelain
English Ceramics
British Pottery and Porcelain
English Pottery and Porcelain Marks

ISBN 0–572–00794–9

Designed by Peter Constable
Printed and bound in Great Britain by
C. Tinling & Co. Ltd, London and Prescot

ACKNOWLEDGEMENTS

I am grateful to the private owners who have allowed me to illustrate watercolours from their collections, but who have preferred to be anonymous. Some of the illustrations are of watercolours which were once in my possession, but which have passed into other ownership. I can only trust that I may be forgiven for using them.

I am glad to be able to thank my friend Albert Hollis for his invaluable advice in the preparation of this book, and for his practical help in providing the names and particulars of many artists who I had inadvertently omitted. My particular thanks are also due to Malcolm Fry for several further additions made and to my publishers, especially B. A. R. Belasco, for many valuable suggestions and inexhaustible forbearance.

Stanley W Fisher
Bewdley
1972

DEDICATED
to the memory of
George Hamilton Ashe, M.A.

CONTENTS

INTRODUCTION

It is perhaps not out of place to preface this dictionary of bare facts with a short survey of the development of watercolour painting in Britain into an art which serves as a lasting reminder of former ways of life and of a countryside which is rapidly becoming a thing of the past.

The use of pigment mixed with water, together with some kind of fixing medium, such as gum arabic, egg-yolk and white, or flour or rice paste, was known to 14th-century monks who illustrated manuscripts. They also knew that if they mixed their colours with Chinese white the result was an opaque, more solid and more lasting 'body colour', or 'gouache', as we now call it. As for outline, which is virtually but a conventional method of separating one colour or mass from another, this has always been effected by the use of pencil, chalk or pen, applied either before or after the application of colour, as a guide, or as a means of emphasising shape.

Miniature-painters, working first on vellum and later, after about 1685, on ivory, found watercolour superior to oil painting for their delicate work. Occasionally they tried their hand at landscape background. As early as the end of the 15th century Albrecht Dürer (1471–1528), working in the Alps, in Nüremberg and in Holland, carried a stage further the rough, preliminary watercolour sketches of such masters in oil painting as Van Dyck and Rubens. He drew landscapes with a pen and washed in his outlines with pure watercolour and, sometimes, with touches of body-colour. It was in Holland, too, that there grew up what was perhaps the first 'school' of watercolour

painting proper, practised by Adriaen van Ostade (1610–85), Albert Cuyp (1620–91), Hans Bol (1534–93) and others, who colour-washed drawings sketched in ink or chalk. In those early days the outline was all-important, and the colour was added merely to give liveliness, depth and warmth, with little attention to faithfulness of tone or accurate application.

Considering first how continental ideas of painting in watercolour reached England, we know that Rubens attended the Court of Charles I in 1629, being then an accomplished watercolourist of twenty years' experience, and working in the style of the artists already mentioned. He was followed by Van Dyck in 1632, who introduced a new emphasis on the massing of coloured shapes, paying less attention to detailed outline. Wenceslaus Hollar (1607–77) was taken to England in 1637 as the protégé of the Earl of Arundel and left his accurate drawings of 17th-century London. A follower of his was Francis Place (1647–1728) who travelled widely throughout Britain, drawing his 'picturesque' views with a pen, washing in his shadows in sepia or Indian ink, and adding touches of colour. Francis Barlow (1626–1702) was a portrait-painter who also painted animals, birds and fish, often with landscape backgrounds. Another Barlow, Edward, born in 1642, was a seaman who illustrated his travels with drawings of the sea and shipping done in fine penwork with washes of bright viridian, blue, yellow, brown, vermilion and rose madder.

Apart from foreign influences, the practice of 16th- and 17th-century English miniaturists (or 'portrait-limners' as they were called) of setting their subjects against landscape or architectural backgrounds set a pattern for the later important English school of *topography*. By this is meant the rendering of views accurately enough to form a true record of the features of a particular place. One of the earliest English topographers was John White (1577–90), who went to Virginia with Raleigh in 1585. Some of his drawings were used to illustrate Theodore de Bry's 'America', published in 1590. Parallel with the development of topography came the growth of romantic imaginative landscape drawing, which seems to have had its birth in Italy. Inigo Jones (1573–1652), for instance, went there at Lord Pembroke's expense. Though he is better known as an architect and a designer of stage scenery and costume, much of his work in the latter regard was purely imaginative. So was much of the work of Anthony Van Dyck (1599–1641), some of it done while he was in England. Indeed, a considerable number of early English artists visited the vicinity of Rome, among them Henry Cook (1642–1700), Thomas Manby (fl. 1670–95), Hugh Howard (1675–1737), and Henry Trench (d. 1726), who set the style of

18th-century English landscape drawing of the imaginative style as distinct from topography.

The Dutch marine painter William van de Velde the Elder (1611?–93) took his son William (1633–1707) to England before 1677. Both drew in pencil or pen, washed in with Indian ink or sepia. The son in particular drew ships and shipping scenes of great beauty, freedom and accuracy which did much to inspire English 18th-century marine painters. Marcellus Laroon (or Lauton) the Elder, (1653–1702) left Holland to live first in Yorkshire and later in London, working on figure subjects. In about 1688 some of his designs were used to illustrate P. Tempest's 'The Cries of the City of London'. His son, Marcellus the Younger (1679–1772), drew conversation pieces. In other spheres of the watercolour art Isaac Fuller (1606–72) drew portraits, house decorations and mythological subjects; draped figures were the speciality of Isaac Oliver (1556?–1617?); and Alexander Marshall (fl. 1660–90) painted flowers, as did Richard Waller (c. 1650–1715), who became secretary of the Royal Society in 1687.

Before moving on to 18th-century English watercolour, which was founded upon the work of such pioneers as those just mentioned, a little must be said about an art which was virtually inseparable from it—the art of the engraver. This, in turn, was greatly encouraged by the increasing popularity of foreign travel. Tourism as we now understand it did not begin until after about 1815, when the middle-class—the business, professional and literary men—began to travel abroad for pleasure, often with their families. This was a very different thing from the 'grand tour' of an earlier generation, undertaken by learned aristocrats almost as a duty. From the beginning, the wealthy took with them their own draughtsmen, as the Earl of Warwick took John 'Warwick' Smith to Italy, and every government or other publicly sponsored expedition of note did the same. The draughtsmen's duty was to make watercolour sketches of places visited and things seen. As time went by the artists, if not engravers themselves, as many were, supplied drawings to the publishers of illustrated travel books, thus bringing cheap art within the reach of all. Unless a painter had a rich patron, he found it difficult to scrape a living, and a thousand prints made from a single drawing did much to enhance his fame. Thus, even J. M. W. Turner did not scorn to make drawings for the 'Southern Coast' series of engravings at £7 10s: each, and Samuel Prout found that his engravings of the crumbling continental architecture he loved so much were eagerly welcomed by a public enraptured with the 'picturesque' and blind to the squalor which lay beneath.

It might be said that the engravers replaced the wealthy nobility as

patrons of the arts, though at the same time it is significant that many of the great men of watercolour, such as Paul Sandby, Thomas Girtin and Turner, were on friendly terms with the nobility. It was inevitable that among the artists who worked for engravers, many of whom are now quite forgotten and unrecorded, there should emerge some whose work was valued then, as now, for its own sake. These artists played a leading part in the quick growth during the 18th century of painting in watercolour as an art in its own right. We can mention here but a few. John Robert Cozens (1752–97) was among the first of many to be inspired by Italian scenery—he visited that country first in 1776. Cozens's example was followed by Francis Towne (1740–1816) and by his friend and teacher William Pars (1742–82), who was also chosen to accompany a party of architects to Greece in 1764. The work of William Marlow (1740–1813), a pupil of Samuel Scott (1702?–72), already a fine painter of country mansions, was widened and strengthened by a visit to France and Italy in 1765. He returned to England in 1768 to paint views in the Thames Valley and his documentary views of Old London.

These two factors—travel which opened the eyes of the wealthy to the beauties of foreign landscapes, and the art of the engraver which publicised them—gave a new status to the painter in watercolour. But there were other contributory factors to the growth of his art. Country gentlemen often found it cheaper and much less bothersome to employ a watercolourist rather than an oil painter to make pictures of their mansions and estates, and even portraits of their families. And the same gentlemen, with the wealthy dilettanti, found a new way of passing their time pleasantly when taking the waters at Bath or some other fashionable resort. Every resort soon had its drawing teachers— Gainsborough, for example, lived at Bath—and each attracted his own circle of amateurs.

The drawing master, as can be seen by glancing through the dictionary, had his place not only at fashionable resorts but also in practically every town of any size, and he had enormous influence on the development of watercolour. The earliest recorded drawing master was a Mr Ffaithorne, who worked at Christ's Hospital. Indeed the post was later a recognised necessity at every military or naval college and public school, while both in England and elsewhere it became customary for royalty and the nobility to employ their own private tutors. There was no lack of applicants for positions, which supplemented at best a precarious and meagre income. When once a man was recognised as a craftsman, he found no difficulty in obtaining pupils, even though a lesson from a fashionable teacher might consist

of little more than the opportunity to watch him working. Among those who supplemented their income in this way were Richard Sasse, Alexander Cozens, John Glover, Peter la Cave, Paul Sandby, John Varley, John Hassell, William Payne, David Cox, and Francis Nicholson. It is significant that with few exceptions, such as James Sowerby (1757–1822) and Patrick Syme (1774–1845), both of whom taught flower painting, drawing masters taught landscape painting. It was therefore natural that it was this branch of the art which flourished above all and which, with marine painting, occupied the attention of the great men. Many teachers published books of instruction. David Cox's 'Treatise on Landscape Painting in Water Colours' is well-known; as are Francis Nicholson's 'Practice of Drawing and Painting Landscapes from Nature'; James Roberts's 'Painting in Water Colours'; and John Hassell's 'Art of Drawing in Water Colours'.

It was inevitable that painting in watercolour could never attain the height of respectability or popularity enjoyed by oil painting so long as the two were obliged to exhibit publicly together. Artists had presented their works at the Foundling Hospital in Russell Square for the first time in 1760 at an exhibition of oil paintings, sculpture and drawings. Two years later they had formed themselves into two exhibiting sections, the Free Society of Artists, and the Society of Artists, which became the Incorporated Society of Artists of Great Britain in 1765. Each held annual exhibitions, but their members gradually drifted away to exhibit at the Royal Academy after its foundation in 1768. By 1799 both societies had ceased to exist. Unfortunately for water-colourists, they could now exhibit only at the Academy, where, as related by W. H. Pyne, their work was usually shown side by side with inferior oil paintings in badly lit rooms. Watercolours were not considered worthy enough to be shown in the Grand Exhibition Room. Furthermore, it appears that watercolour drawings had to be mounted, one supposes for the sake of conformity, in the style of oils, with heavy frames and wide gilt mounts, which effectively 'killed' their delicate nature.

To established watercolourists such a position was intolerable, and in 1804 sixteen of them banded together to found what is now called the Old Water Colour Society. This is now known as The Royal Society of Painters in Water Colours—the R.W.S., but was then officially named the Society of Painters in Water Colours. Owing to waning support, oil paintings were admitted for exhibition between 1813 and 1820, but since then they have been excluded. The initial success of the Old Society was such that in 1808 a rival society, Associated Artists in Water Colours, held its first exhibition. This

B

was what we now refer to as the 'New Society', which broke up in 1812 but which was virtually revived in 1831 as what is now known as the Royal Institute of Painters in Water Colours. The actual details of policy and changes of name of the societies are complicated, but those are the bare facts of decisions which had an enormous effect on the history and development of watercolour painting. It was enabled thereby to receive recognition as an art in its own right, and no longer be regarded as a poor relation of oil painting. Moreover, while on the one hand the public was able to see fine drawings properly to the best advantage, on the other hundreds of struggling but brilliant young painters were brought from obscurity to fame.

The members of the Old Society when the first exhibition was held were W. F. Wells, George Barret Jr, William Havell, S. F. Rigaud, John and Cornelius Varley, W. S. Gilpin, J. Holworthy, S. Shelley, John Glover, J. C. Nattes, Nicholas Pocock, Robert Hills, W. H. Pyne, F. Nicholson, and Joshua Cristall. It is not to be supposed that any effort was made to enlist an initial representative membership, but in effect this was achieved. John Varley (1778–1842), often regarded as the 'grand old man' of watercolour, contributed 739 works to the Society's exhibitions, representing all that is best both in topography and in imaginative landscape. In the former regard his placid drawings of the Thames Valley, notably around Chiswick, and his accurately drawn, sparingly tinted drawings of Shrewsbury, Hereford, Bridgnorth and other Welsh border towns are well known. As he grew older he drew upon a vocabulary of distant mountains, placid water, perhaps a castle on a hill, and a foreground with one or two figures and a tree or two leaning inwards to one side. The many results of this concept were purely imaginative, often romantic, and in style often similar to landscapes painted by one of his many pupils, Anthony Vandyke Copley Fielding (1787–1855). John Varley's brother Cornelius (1781–1873) worked much in the same style of John's earlier work, especially when he painted buildings, though his colours are usually brighter and of a wider range.

George Barret Jr (1767–1842) was above all an imaginative landscape-painter, who usually worked in a palette of browns, purple-brown and orange, sometimes with delicate evening or morning effects carried out in pale yellow and red. He was partial to Greek temples, judiciously placed on a hill or in a glade. His compositions commonly feature water in the middle-distance, sometimes with a bridge, and a goatherd or shepherd, with clumps of burdock, in the foreground. One often sees much the same brownish colour scheme in the landscapes, many of them topographical, of John Glover (1767–1849). But here

the colouring is usually due to fading because, in common with many of his contemporaries, Glover made considerable use of a mixture of indigo and Indian red, which in skies in particular has faded to a reddish-brown. Two outstanding features of Glover's work are his use of a split brush (with the hairs tied together to form several separate spikes) for his foliage, and the use of tiny flecks of white on trees and bushes to give the effect of slanting evening light. An artist, not one of the original members, who worked much in Barret's romantic style was F. O. Finch (1802–62). One of Barret's collaborators was J. Frederick Tayler (1802–89), a pupil of Richard Sass (1774–1849) and a painter of sporting and historical subjects and of genre in a style not unlike that of David Cox, apparently careless and slapdash, but actually making every brush-stroke vital and indispensable.

William Havell (1782–1857) was a painstaking artist, known best perhaps for his Thames views, but widely travelled and prolific. He was able to depict large masses of trees in full foliage, in dark browns, greens and purple-greys without being monotonous. Francis Nicholson (1753–1844) was also a master of foliage, though inclined to be a little woolly. His yellow-greens and faded browns, usually faded skies, and love of mountain torrents make his work distinctive and easily recognisable. William Henry Pyne (1769–1843) was one of those artists who had the knack of placing small figures to the best advantage in his landscapes. Joshua Cristall (1767?–1847), who began his career as a painter on porcelain, was a worthy representative of genre. His works usually featured plump country children, with their rather voluminous clothing tinted in mauve-pink, yellow-green and grey-blue, and foliage washed in with yellow-grey with hardly any pencil work.

The treasurer of the Old Society, Samuel Shelley (1750?–1808), painted miniatures, and he was also an illustrator of poetic themes. His work is not well known, and neither is that of the president, William Sawrey Gilpin (1762–1843), or of Stephen Francis Rigaud (1777–1861), or John Claude Nattes (1765–1822), though all were prominent in the watercolour world. Robert Hills (1769–1844) the secretary, however, is known to every collector, and not only because his work is often seen (he exhibited 600 works at the Society alone). It is also because no one excelled him as an animal-painter, whether in his earlier style—low-toned, full of soft light and exquisitely stippled— or in his later work—rather woolly, more crudely drawn and painted in hotter, reddish tones. Hill's animals are sometimes found in the landscapes of G. F. Robson (1788–1833), usually his earlier kind

of animals, which seem to blend to perfection with Robson's subdued, almost misty colours. William Frederick Wells (1762–1836) was the prime-mover in the formation of the Society. He was a landscapist whose rustic scenes are carefully drawn and washed in with bright and cheerful colours. Some of his topographical, slightly tinted drawings, though, show a distinctive use of line shading and cross-hatching in soft pencil. The sea-painting representative of the Old Society was Nicholas Pocock (1740–1821), whose sea and shipping is most accurately drawn because he had himself been a sea captain. He also painted landscapes.

During the late 18th century there were so many great water-colourists, apart from those already mentioned, that it is impossible to mention more than a few, depending on individual preference. It is impossible, however, to omit the name of Thomas Girtin, born in 1775 and destined to rise to what heights, had he not died at the age of 27. His was the complete mastery of landscape, the rare ability to depict the grandeur and spaciousness of acres in a few square inches, and the power to express the sympathy of colour in sky and earth with that of the sunlight. In a purely technical vein he was probably the finest painter of trees in watercolour. Joseph Mallord William Turner was born in the same year as Girtin, and died in 1851. 'If Girtin had lived', said Turner, 'I should have starved.' Nevertheless, Turner was a master with his pencil and of every relevant detail in his early land-scape painting. His fame, though, rests more upon his later work, when his great powers of suggestion were allied to magnificent skies, grandeur of conception, still the same early attention to detail, and brilliant colour. Girtin and Turner possessed in common the rare ability to represent light on paper.

Among the great names of the 18th century the name of Paul Sandby (1730–1809) and to a lesser extent that of his brother Thomas (1721–98) are known to all. Whereas Paul's work was essentially pictorial, Thomas had a bent for the architectural. Contemporary with them, and belonging to the same topographical school, were Michael Angelo Rooker (1743–1801), Thomas Hearne (1744–1817), Anthony Thomas Devis (1729–1817) and Samuel Hieronymous Grimm (1733–94). Lovers of painting in monochrome are familiar with the work of Joseph Farington (1747–1821). The pen-outlined wash drawings of gipsies and rustics, with cattle and horses, done by Peter la Cave (1799–1806) and Julius Caesar Ibbetson (1759–1817) are outstanding.

It is surprising how many of the finest early 19th-century water-colour painters were taught by John Varley. David Cox (1783–1859)

and Peter de Wint (1784–1849) are to be classed with Turner—though their work is very different in style—in their ability to represent Nature in all her moods. Cox on the one hand loved her wilder aspects, and found in North Wales his inspiration for magnificent tempestuous skies and windswept mountains and moors. De Wint on the other preferred rich valleys and slow-moving rivers, paying little attention to skies, but laying on his deep, glowing colours with a dripping brush. Anthony Vandyke Copley Fielding often painted very much in the Varley style, as we have already mentioned, but this was in his earlier years. Later his landscape style became looser, with mysterious mists across water-meadows and valleys. He was also a fine marine painter, always achieving a perfect colour balance between sea and sky, and second-to-none in painting coastal and harbour scenes with the sea like a mill-pond. William Turner 'of Oxford' (1789–1862) might well have rivalled all his contemporaries had he not decided to settle in Oxford as a drawing master. John Linnell (1792–1882), brother-in-law of Samuel Palmer, painted at times much in Palmer's style, although he is not well known. William Henry Hunt (1790–1864) painted in two entirely different styles. To earn his living he painted studies of fruit and flowers, often with a bird's nest in one corner, for which reason he is known as 'Bird's Nest Hunt'. But his finest and rarer work took the form of stippled genre subjects, some of considerable size.

Of the many 'schools' of painting which flourished where a great watercolourist lived, that of Norwich is best known, though in fact its founder, John Crome, painted little in watercolour. He should rather be classed with artists like Dürer, Ostade and Van Dyck, who used watercolour incidentally. In fact the figure best known to collectors did not exhibit until the 1807 exhibition. He is John Sell Cotman (1782–1842), who studied with Dr Munro, the patron of so many young watercolour painters. Cotman's status was such that after Girtin's death, the exclusive Girtin's Drawing Society became known as Cotman's Drawing Society. The outstanding feature of Cotman's work was his use of flat washes to build up his picture, rather like a stage setting of flat against flat, a method which has a resemblance to that used by the rather earlier Francis Towne. Working with Cotman were his brother-in-law, John Thirtle (1777–1839), and the godson of Paul Sandby, Paul Sandby Munn (1773–1845), who painted rather slight, delicate landscapes featuring ruined mills, cottages and farmyards, sometimes in colour but more usually in monochrome. Another less important school grew up in Bath around the Barker brothers 'of Bath', Benjamin (1776–1838) and Thomas (1769–1847),

both of whom painted landscapes featuring 'wiped-out' foliage and misty distances.

The 19th century was so rich in watercolour drawings of every kind that it is difficult to choose which outstanding names ought not to be omitted in an introduction of this kind. Again, there must be a personal bias. One collector of the author's acquaintance, for example, a lover of the work of George Barret Jr, places William Payne (fl. 1776–1830) a close second, simply because his work has usually faded to a pleasing brown. Actually, of course, his earlier work, most of it done in Cornwall and Devon, can often be found in quite brilliant state, though with much use of the 'Payne's grey', which he invented. During this period and sometimes after 1809 when he painted in Wales, his topographical drawings show a Sandby influence, with careful drawing and good figures. Later, when he worked in the Lake District, from about 1811, his work tended to become more imaginative, with shadowy figures washed in without any pencil outline.

The Prout family naturally stand high in favour with those who like architectural drawing. The work of Samuel (1783–1852) in particular has been much copied, while at the same time the engravings which he made from his own drawings have been known to deceive the unwary, especially when under glass. At first Prout painted coastal scenes and rustic views and buildings, but later, when a visit to the Continent had filled him with a love of Gothic architecture, he confined himself to painting it in browns and greys, outlining the crumbling stonework in pen with his familiar 'broken line'. His nephew John Skinner Prout (1806–76) painted in a similar style and is best known for his drawings of old Bristol, and so did his son Samuel Gilhespie Prout (1822–1911). Other architectural topographers include William Callow (1812–1908), Charles Wild (1781–1835), Henry Edridge (1769–1821), Samuel Read (1815?–83), J. D. Harding (1797–1863), T. C. Dibdin (1797–1863) and J. Scarlett Davis (1804–45).

The name of Richard Parkes Bonington (1802–28) stands high in any company. Like Girtin he died before he had reached his full stature. Among those who sometimes approached his delicate drawing of detail and of figures, and his ability to lay a perfect 'broken wash' of colour, were his friend and pupil Thomas Shotter Boys (1803–74), James Holland (1800–70), and William Callow. David Roberts (1796–1864) is best known for his firm pencil drawing of continental scenes, lightly tinted. Edward Lear (1812–88) is noted for his accurately seen, economical Mediterranean landscapes, drawn on the spot and scribbled over with pencil notes which enabled him to finish them in his studio. John Frederick Lewis (1805–76) has no rival for

his Eastern figure drawings. At the other far extreme of style, mood and climate, the David Cox tradition was carried on by Thomas Collier (1840–91), Edwin Hayes (1820–1904), Edmund M. Wimperis (1835–1900) and J. W. Whittaker (fl. from 1862, d. 1876).

NOTES ON THE ENTRIES

It is extremely difficult to decide how the date limits should be set in a dictionary of this kind, and criticism may have been invited by the omission of living painters. Though some of the painters included worked well into the 1900's, the great majority of entries fall into the period 1750 to 1900, with a few exceptions who, born after 1900, could not be omitted due to the importance of their work. The reason for so doing is that the collector's interest lies mainly in the water-colourists of the 18th and 19th centuries, and it is primarily for him that information which has hitherto had to be sought in literally hundreds of reference books and gallery catalogues has been brought together into one volume. The work of modern painters will in any case be seen in better perspective at some future date.

Considerable use has been made of the 1901 Third Edition of Algernon Graves's 'Dictionary of Artists', first published in 1884 and recently reprinted. The information taken from it of course concerns only those who painted at one time or another in watercolour, though the great majority of painters listed therein worked both in that medium and in oils. Graves's upper date limit of 1893 for exhibited works has been adopted in this dictionary, although very many painters must obviously have worked at a later date. By and large it is always surprising to find that information about dates of birth and death and of periods of working life is often lacking or unreliable, perhaps because many painters were not held in such esteem during their lifetime as they are by posterity. When dates of birth and death are unknown, the usual practice of giving the approximate dates between which a painter was exhibiting at the London galleries has

been adopted. It must be remembered, though, that exhibition at local or provincial galleries was often unrecorded. Thus, details of the number of works exhibited refer to the known London totals. These totals, of course, unless particular note is made by use for instance of the abbreviations N.W.C.S. or O.W.C.S., include works in oils and drawings in watercolour, body-colour, ink and wash, chalk or pastel.

As the title of this book indicates, the entries are not confined to British-born water-colour painters, but include many of foreign birth who worked for some time in Britain. Other foreign painters who never lived in Britain, but who may have exhibited at British galleries, have been omitted.

Each entry follows a set pattern, the details being given in the following order:

Name

Dates of birth and death if known, or the approximate period of
 working life

Birthplace if known

Details of career, memberships of societies, and so on

Types of subjects usually painted

Number of exhibited works

Names of galleries in which typical examples may be found

ABBREVIATIONS USED IN THE TEXT

A.R.A.
Associate of the Royal Academy
B.I.
British Institution, 1806–67
B.M.
The British Museum
F.R.S.
Fellow of the Royal Society
F.R.S.A.
Fellow of the Royal Society of
Arts
F.S.A.
Fellow of the Society of
Antiquaries
H.R.A.
Honorary Retired Academician
N.W.C.S.
New Society of Painters in
Miniature and Water Colours.
The title changed in 1808 to
Associated Artists in Water
Colours and in 1810 to Associated
Painters in Water Colours. The
Society closed in 1812, but
virtually revived in 1831 as the
Royal Institute of Painters in
Water Colours. There is likely to
be confusion between the several
abbreviations used for the New
Society, the Institute and the Royal
Institute, but the reference will
always serve to distinguish
between membership of the 'New'
and the 'Old' Societies. In the
latter regard, O.W.C.S. and
R.W.S. are similarly synonymous
O.W.C.S.
Society of Painters in Water
Colours 1804–81, after which date,
the Royal Society of Painters in
Water Colours, the Royal Water
Colour Society, the Old Water
Colour Society
R.A.
Royal Academy or Royal
Academician
R.B.A.
Royal Society of British Artists,
Suffolk Street which until 1887 was
the Society of British Artists
(S.B.A.), founded 1823
R.B.C.
Member of the British Colonial
Society of Artists
R.B.S.A.
Royal Birmingham Society of
Artists, formerly the Birmingham
Society of Artists 1842–68, the
Birmingham Society of Arts

1821–42, and the Birmingham
Academy of Arts 1814–21

R.C.A.
Royal Cambrian Academy

R.H.A.
Royal Hibernian Academy

R.I.
Royal Institute of Painters in
Water Colours, 1831. *See*
N.W.C.S. and note under

R.I.B.A.
Royal Institute of British
Architects

R.O.I.
Royal Institute of Oilpainters

R.P.
Member of the Royal Society of
Portrait Painters

R.S.A.
Royal Scottish Academy (until
1838 the Scottish Academy)

R.S.B.A.
See R.B.A.

R.S.W.
Royal Scottish Water Colour
Society or the Royal Scottish
Society of Painters in Water
Colours, which until 1888 was the
Scottish Society of Painters in
Water Colours, founded 1878

R.W.A.
Royal West of England
Academy

R.W.S.
Royal Water Colour Society or
the Royal Society of Painters in
Water Colours. *See* O.W.C.S.

S.A.
The Free Society of Artists,
founded 1762, which became the
Incorporated Society of Artists
of Great Britain (Incorp. S.A.)
in 1765

S.B.A.
See R.B.A.

The Institute
The Institute of Painters in Water
Colours. *See* N.W.C.S.

V. & A.
Victoria and Albert Museum

W.C.S.
The Water Colour Society.
See O.W.C.S.

A DICTIONARY OF WATERCOLOUR PAINTERS

ABBEY, Edwin Austin (1852–1911)
Born Philadelphia. Came to
London. A.R.A. 1901; R.A. 1902;
R.W.S. 1895. Exhibited 9 works,
2 at R.A., 5 at N.W.C.S. 1879–90.

ABBOT, John (1751–1839?)
Pupil of J. Benneau; to America
1773. Entomological drawings.
(B.M., *Natural History Museum,
South Kensington*)

ABBOTT, John White (1763–1851)
Born Exeter; a surgeon,
encouraged by Sir Joshua
Reynolds and Benjamin West;
pupil of Francis Towne. Land-
scapes with finely drawn figures.
Exhibited 16 works at R.A.
1793–1822. (*V. & A.*)

ABBOTT, Lemuel Francis (d. 1803)
Born Leicestershire. Pupil of
Francis Hayman. Portraits and
figure subjects. Exhibited 15 works
at R.A.

ABSOLON, John (1815–95)
Born Lambeth; pupil of Ferrigi;

a scene-painter; member and
treasurer N.W.C.S. 1838.
Illustrator and genre painter.
Exhibited 660 works at N.W.C.S.
1832–89.

ACKERMANN, Arthur Gerald
(born 1876)
Member R.I. 1914. Landscapes
and seascapes. Exhibited 10
works at R.A.

ADAM, James (1730–94)
Brother of Robert; an architect.
Escapist drawings.
(*Edinburgh*)

ADAM, J. Denovan (1842–96)
Fruit and animal subjects, and
landscapes. Exhibited 53 works,
1 at N.W.C.S. and 6 at B.I. 1859
onward.

ADAM, Robert (1728–92)
Born Kirkcaldy; architect and
landscape-painter, working with
his brother James. Fellow of the
Royal Society. Landscapes in
romantic and topographical style,

25

somewhat in the Sandby style.
(*V. & A., Sloane*)

ADAMS, John Clayton (1840–1906)
Landscapes. Exhibited at R.A. and
R.B.A. 1863–1906. (*V. & A.*)

AGLIO, Agostino (1777–1857)
Born Cremona, Italy; studied at
the Brera, Milan; to England with
W. Wilkins 1803. Landscapes and
theatrical scenery; wash drawings
on grey-blue paper in the manner
of Constable. Exhibited 13 works
at R.A., 22 at B.I. and 8 at R.S.B.A.
(*V. & A.*)

AIRY, Anna (1882–1918)
Born Greenwich; member R.I.,
member Royal Institute of Oil
Painters. Fellow of the Royal
Society of Painter-Etchers and
Engravers. Flowers and still life.
(*Leeds*)

AITKEN, William Costen
(1817–76)
Born Dumfries; to Birmingham
c. 1837 to teach art. (*Birmingham,
one work in sepia*)

ALABASTER, Mary Ann
See Criddle, Mrs Harry.

ALBERT
See Marks, Albert Ernest.

ALEFOUNDER, John (d. 1795)
Studied R.A. India 1784, where he
died. Silver medallist R.A. 1782.
Miniatures and portraits.

ALEXANDER, Edwin (1870–1926)
Born Edinburgh; studied at
Edinburgh and Paris; to Egypt
c. 1894; assoc. R.W.S. 1899,
member 1910. Animals and birds.
(*Edinburgh, B.M.*).

ALEXANDER, Herbert
(1874–1946)
Born Cranbrook, Kent; studied
under Merkomer, and at
Slade; assoc. R.W.S. 1905,
member 1927. Kentish rural
scenery.

ALEXANDER, Robert
(1833–1913)
Born Leeds; pupil of Joseph
Rhodes. Landscapes and figures.
Exhibited 3 works at R.A.

ALEXANDER, William
(1767–1816)
Born Maidstone; studied under
Henry Pars and J. C. Ibbetson, and
at R.A.; to China with Lord
Macartney 1792; professor of
drawing Great Marlow Military
College 1802; keeper of prints and
drawings B.M. 1808. Chinese
subjects, and studies of archi-
tectural or antiquarian interest in
the style of Girtin. Exhibited 16
works at R.A. (*B.M., Newcastle,
Whitworth*)

ALKEN, Henry Thomas
(1785–1851)
Sporting scenes, especially
hunting, carefully drawn and
palely washed. (*V. & A., B.M.,
Liverpool, Whitworth*)

ALKEN, Henry, Jr (1810–94)
Hunting scenes and sporting
subjects.

ALKEN, John Macdonald
b. 1880
Member R.I. 1944; Member R.S.A.
and Royal Society of Painter-
Etchers and Engravers.

ALKEN, Samuel (1784–1825)
Hunting scenes and sporting
subjects.

ALLAN, David (1744–96)
Born Alloa; studied in Rome
1764–77; in London 1777–79;
director Edinburgh Academy of
Arts 1786. Figures, portraits and
genre. Exhibited at R.A. and S.A.
1771–81. (*B.M.*, *Glasgow*,
Edinburgh)

ALLAN, Robert Weir (1851–1942)
Born Glasgow; to London c. 1880;
member R.W.S. 1896. Continental
buildings, and scenery in Japan,
India and on the Scottish coast.
Exhibited 189 works, 94 at R.W.S.,
26 at R.A., 1874 onwards.
(*Birmingham*)

ALLAN, Sir William (1782–1850)
Born Edinburgh; A.R.A. 1825, R.A.
1835, member Scottish Academy
1830, President R.S.A. 1837–50.
Figures, travel sketches, sea-
pieces, landscapes and historical
genre. Exhibited 48 works at R.A.
1803–49.

ALLASON, Thomas (1790–1852)
An amateur, whose sketches of
Olympia were redrawn by De
Wint. Architectural drawings,
among them one of Milan
Cathedral engraved by J. Coney.
Exhibited 16 works at R.A.

ALLEN, James Baylis (1802–76)
Born Birmingham. Pupil of
Vincent Barber. Exhibited 5 works
1833–59, 3 at R.A.

ALLEN, James C. (fl. 1824–30)
Pupil of E. W. Cooke. Book
illustrations.

ALLEN, Joseph William (1803–52)
Born Lambeth; painted theatrical
scenery with Clarkson Stanfield;
founder member S.B.A.; drawing
master at City of London School.
Exhibited 329 works at R.S.B.A.

and 11 at R.A. (*V. & A.*,
Newcastle)

ALLEN, Thomas John (1821–1846)
Architectural subjects.

ALLESANDRI, Angelo
Worked in Britain during the 19th
century as a watercolour copyist
of Venetian architectural subjects
for his teacher John Ruskin.
(*Birmingham*)

ALLINGHAM, Helen
(née Paterson) (1848–1926)
Born near Burton-on-Trent;
studied at Birmingham School of
Design and at R.A.; assoc. R.W.S.
1875, member 1890. Rustic
subjects and scenery in the style of
Birket Foster. (*V. & A.*,
Birmingham)

ALLOM, Thomas (1804–72)
Born London; an architect;
founder of R.I.B.A. A prolific water-
colourist, producing exquisitely
detailed, picturesque views for
book illustration. Exhibited 43
works at R.A.

ALLPORT, Henry Curzon
(1789–1854)
Lived near Litchfield, Staffs.;
pupil of John Glover; member
o.w.c.s.; drawing teacher in
Birmingham; to Australia 1834
where he died. Landscapes.
Exhibited at R.A. 1811–12, and
o.w.c.s. 1813 onwards. (*B.M.*)

ALMA-TADEMA, Sir Lawrence
(1836–1912)
Born Holland; to Brussels 1865,
London c. 1869; assoc. o.w.c.s.
1873, member 1875; A.R.A. 1876,
R.A. 1879. Greek and Roman life.
Exhibited 1869 onwards, mostly at
R.A. and o.w.c.s. (*Birmingham*)

A Dictionary of Watercolour Painters

ALMOND, William Douglas
(1868–1916)
Born London. Worked for the
Illustrated London News. R.I.
1897. Exhibited 21 works, 8 at
R.A. from 1886.

ALVES, James (1737–1808)
Worked in London. Miniatures
and portraits in watercolour and
crayon. Exhibited 14 works, 7 at
R.A. 1775–9.

AMHERST, William Pitt
(1773–1857)
Earl of Amherst. Pupil of
Malchair; led Embassy to China
1816.

AMHERST, Sarah (fl. 1827–35)
Daughter of above; possibly
taught by De Wint. Landscapes.
(*Clayden House*)

ANDERSON, Robert (1842–85)
A.R.S.A.; R.W.S. Figure subjects,
landscapes and marines. Exhibited
4 works, 3 at N.W.C.S.

ANDERSON, William (1757–1837)
Born Scotland; early to London.
River and sea views in the Van de
Velde tradition, using the stained
drawing technique. Exhibited at
R.A. 1787–1834, and at B.I. and
S.B.A. (*B.M., V. & A.*)

ANDREWS, George Henry
(1816–98)
Born Lambeth; member and
treasurer O.W.C.S. Marine painter
and illustrator to *Illustrated
London News, Graphic* and
'English Landscape' (1883).
Exhibited 368 works, 5 at R.A.,
368 at O.W.C.S. (*V. & A.,
Newcastle, Cardiff*)

ANDREWS, H. (d. 1868)
Genre, and copied Watteau.

Exhibited 39 works 1827–63,
8 at R.A.

ANGEL, Mrs Thomas William
(née Helen Cordelia Coleman)
(1847–84)
Born Horsham. Pupil of her
brother W. S. Coleman: Assoc.
O.W.C.S. 1879, N.W.C.S. 1875.
Birds, flowers, and fruit.

ANNESLEY, Rev. Charles
(fl. 1809–50)
Nephew of Lord Valentia; Fellow
of Christ Church, Oxford. Swiss
scenes and landscapes. (*B.M.,
Cardiff*)

ANROOY, Anton Van
(b. 1870)
Member R.I. 1918.

ANSDELL, Richard (1816–85)
Born Liverpool. R.A. Exhibited
181 works, 149 at R.A. 1840–85.

APPERLEY, George Owen Wynne
(b. 1884)
Member R.I. 1912. Landscape
and figure studies.

ARBUTHNOT, Malcolm
(b. 1874)
Member R.I. 1942. Landscapes,
seascapes.

ARCHER, John Wykeham
(1808–64)
Born Newcastle-upon-Tyne;
pupil of engraver John Scott;
assoc. N.W.C.S. 1842. Old London
buildings. Exhibited at N.W.C.S.
(*B.M., V. & A., Newcastle*)

ARDEN, Lady Margaret
(1762?–1851)
An amateur; early patron and
perhaps pupil of David Cox.
Landscapes.

A Gateway at Winchester

Joseph Charles Barrow
(fl. 1790–1800)
Signed, and dated 1800
14" x 20"

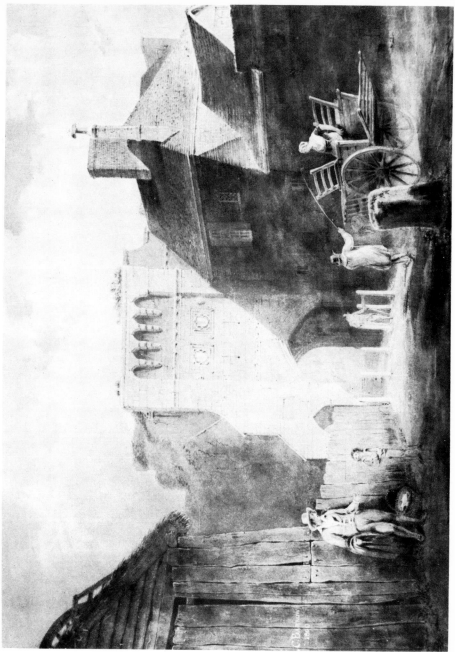

J. C. Barrow was an eminently successful drawing master. His own work is seldom seen today, although there are examples in the British and the Victoria and Albert museums. There are also illustrations in his 'Picturesque Views of Churches and other Buildings', which was published in 1790. Barrow began his career as a drawing master in 1791 as assistant to Henry Pars. Later he opened his own schools in Lincoln's Inn Fields and at his home in Holborn, where John Varley and Francois Louis Thomas Francia were among his pupils. Although he worked often in monochrome, this example is in faded yellows and browns. It is in the Sandby tradition, rather stiff and formal, but it shows the good perspective and almost geometrical precision which characterise Barrow's best work. As is so often the case with the works of lesser-known watercolourists, attribution would have been difficult were it not clearly signed.

Beaumaris, Anglesey

David Cox
(1783–1859)

Signed, and dated 1847

8½" x 12"

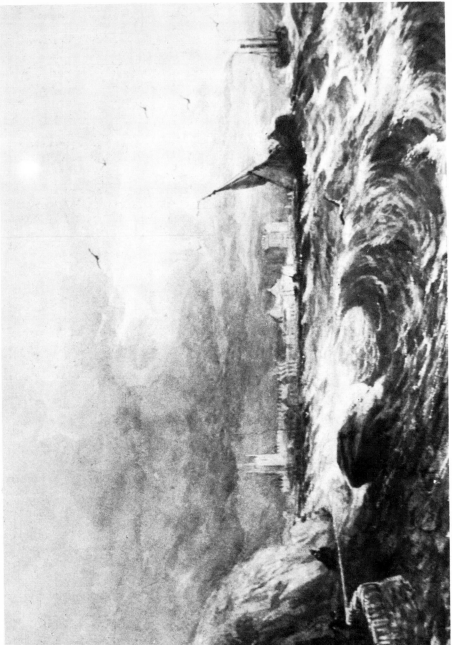

This drawing belongs to Cox's last period, when he had finally returned to Harborne. By then he had developed the looser, broader touch and the full understanding of Nature's every mood which mark his finest work. At that time he was even more closely associated with North Wales. It is interesting to speculate whether he may have visited Anglesey during his 1847 stay at the Royal Oak Inn in Bettws-y-Coed, when he painted the well-known inn sign showing Charles II hiding in an oak tree. 'Beaumaris, Anglesey' is engraved in Thomas Roscoe's 'Wanderings and Excursions in North Wales.' It has a power and beauty which is often lacking in Cox's larger drawings. It exemplifies the artist's wonderful powers of detailed observation and his complete familiarity with the ways of the wind and the sea.

ARLAUD, Benoit (or Bernard?)
(d. 1801)
Brother of J. A.; died in Geneva.
Miniatures. Exhibited 41 works at
R.A. 1793–1800.

ARMSTRONG, Elizabeth Adela
See Forbes, Mrs Stanhope.

ARMSTRONG, Francis Abel
William Taylor (1849–1920)
Born Malmesbury; member R.B.A.
and R.W.A. Illustrations for
periodicals, landscapes and
architectural subjects. (*V. & A.*)

ARMSTRONG, Thomas
(1832–1911)
Born Manchester; director of Art
at V. & A. 1881–98. Exhibited
45 works, 15 at R.A., 30 at B.I.
1860–82.

ARNALD, George (1768–1841)
Pupil of W. Pether; toured with
John Varley. Landscapes in a
rather gloomy Turneresque style.
(*V. & A.*)

ARNOLD, Harriet
(née Gouldsmith)
(1787–1863)
Member O.W.C.S. 1813. Exhibited
204 works, 34 at O.W.C.S., 4 at
N.W.C.S. 1809–55.

ASHFIELD, Edmund (d. 1700?)
Pupil of Michael Wright.
Portraits.

ASHPITEL, Arthur (1807–69)
With David Roberts in Italy
1853–54; fellow Institute of
British Architects; F.S.A.
Romantic landscapes. Exhibited
18 works at R.A.

ASSHETON, William (fl. 1783–84)
An amateur, who probably
accompanied Anthony Devis to
Rome. Landscapes.

ASTLEY, John (1736–?)
Born Wem, Salop; married Lady
Daniell.

ASTON, Charles Reginald
(1832–1908)
Born Birmingham; studied
architecture in London before
becoming a landscape painter;
member R.S.B.A. and R.I. 1882.
Exhibited 247, 18 at R.A., 4 at
B.I., 13 at S.B.A., 85 at N.W.C.S.
1855–93. (*Birmingham*)

ATKINS, Samuel (fl. 1787–1808)
In East Indies c. 1796–1804,
during which time he painted
shipping, at first in simple washes
and later in full colour. Exhibited
18 works at R. A. 1787–1808.
(*V. & A., B.M., Whitworth*)

ATKINSON, John Augustus
(1775–1833?)
Born London; in Russia 1784–
1801; member O.W.C.S. 1808.
Russian subjects, battle scenes
and camp incidents. Exhibited
197 works, 60 at R.A., 45 at B.I.,
24 at S.B.A., 68 at O.W.C.S.
1803–33. (*V. & A., B.M.,
Newcastle, Whitworth*)

ATKINSON, Robert (1863–96)
Born Leeds; pupil of Richard
Waller, portrait painter, 1878;
also studied in Antwerp. Book
illustrator. (*Leeds*)

ATKINSON, Thomas William
(1799–1861)
Son of John Augustus and an
architectural draughtsman; after
1840 toured Siberia and Tartary,
resulting in books illustrated with
his sketches, mostly architectural.
Exhibited 8 works at R.A.
(*V. & A.*)

AUMONIER, James (1832–1911)

Born Camberwell, assoc. N.W.C.S. 1876, member 1879. Landscapes, mostly in Sussex. Exhibited 249 works, 100 at N.W.C.S., 36 at R.A., 5 at B.I., 52 at S.B.A.

AUSTIN, Samuel (1796–1834)
Born Liverpool, pupil of De Wint; toured extensively on the Continent; member Liverpool Academy 1824, founder member S.B.A. 1824, O.W.C.S. Coast scenes, landscapes and architectural subjects which rank in quality with those of Bonington. Exhibited 9 works at R.S.B.A. (*B.M., V. & A., Liverpool*)

AYLESFORD, Heneage Finch, 4th Earl of (1751–1812)
Pupil of Malchair. Landscapes and architectural subjects, usually in brown and grey pen and sepia wash. Exhibited 7 works at R.A. 1786–90. (*Leeds, B.M., V. & A.*)

AYLING, Albert William (d. 1905)
Member R.C.A., and associated with Liverpool art circles. (*Walker Gallery*)

BACH, Guido R. (1829–1935)
Born Annaberg, Germany; to England 1862; member R.I., assoc. N.W.C.S. 1865, member 1868. Portraits and genre. Exhibited 155 works, mostly at N.W.C.S. 1866–91.

BACH, W. H. (fl. 1829–59)
N.W.C.S. member 1833. Landscapes. Exhibited 24 works at R.A. and 7 at R.B.A.

BACON, Frederick (1803–87)
Born London; died in America.

Illustrated Finden's travel books.

BACON, John Henry Frederick (1865–1914)
Illustrations, and historical and domestic subjects. Exhibited 10 works, 9 at R.A.

BADESLADE, Thomas
Little known, but his water-colours, mostly of country houses, were published in books of views by Johannes Kip 1655–72.

BADHAM, Edward Leslie (d. 1944)
Member R.I. 1937, member R.B.A. and R.O.I. Landscapes. Exhibited 2 works at R.A., 1898 onwards.

BAKER, Alfred (1850–72)
Landscapes and rustic genre. Exhibited 5 works at S.B.A.

BAKER, Henry (1849–75)
Born Birmingham. Landscapes in North Wales, Devon and Cornwall. Exhibited 17 works, 9 at S.B.A. 1868–74 (*Birmingham*)

BAKER, Samuel Henry (1824–1909)
Studied at Birmingham School of Design and Birmingham Society of Artists, and under J. P. Pettit. Midland and North Wales landscapes. Exhibited 59 works at R.A. 1856–92. (*Birmingham*)

BAKER, Thomas (1809–69)
Known as 'Baker of Leamington'; friend of David Cox. Landscapes and cattle in the style of William Callow. Exhibited mainly in Birmingham, but showed 4 works at R.A., 19 at B.I. (*V. & A., B.M., Leicester*)

BALDREY, John (or Joshua) Kirby

(1750?–1821?)
Engraver and draughtsman;
worked in London and Cambridge.
Portraits and landscapes in the
stained drawing technique.
Exhibited at R.A. 1793–94.
(*V. & A.*)

BALE, Edwin (1838–1923)
Assoc. member R.I. 1876,
member 1879. Figure subjects
and landscapes. Exhibited 138
works, 80 at N.W.C.S., 6 at R.A.

BALL, Wilfred Williams
(1853–1917)
Born London; an etcher. Fellow
Royal Society Painter-Etchers
and Engravers 1881. Exhibited
101 works, 12 at N.W.C.S., 34 at
R.A., 22 at S.B.A.

BALMER, George (1806?–46)
Born North Shields; friend of
J. W. Carmichael and one of the
best of the North Country School;
studied at the Louvre. Marine
subjects in the manner of
C. Bentley and topographical land-
scapes. Exhibited over 40 works at
B.I. and S.B.A. 1830–41. (*Newcastle,
V. & A., B.M.*)

BAMPFYLDE, Coplestone Warre
(1720–91)
An amateur. Caricatures and
landscapes in the manner of Paul
Sandby. Exhibited 6 works at R.A.
1763–83. (*V. & A.*)

BARBER, Charles Vincent
(1784–1854)
Born Birmingham; friend of David
Cox, his father's pupil; lived at
Liverpool, becoming instructor at
the Institute; member Liverpool
Academy c. 1822 and president
1847–53; member Associated
Artists in Water colours and
assoc. O.W.C.S. 1812. Landscapes

very much in the style of John
Glover. (*V. & A., Liverpool*)

BARBER, Christopher (1737–1810)
Member Incorp. S.A. Miniatures
and landscapes. Exhibited 22
portraits at R.A. 1770–1808.

BARBER, Joseph (1750–1811)
Born Newcastle-upon-Tyne;
father of Charles Vincent and
Joseph Vincent; went to
Birmingham to become drawing
master, David Cox being one of
his pupils. Works somewhat old-
fashioned. (*Birmingham*)

BARBER, Joseph Vincent
(1788–1838)
Son of Joseph. Landscapes, often
with figures. Exhibited 11 works
at R.A. 1810–30.

BARKER, Benjamin (1776–1838)
With Thomas given the name of
'Barker of Bath'; member
Associated Artists in Water
Colours. Landscapes, mostly of the
Bath area. Exhibited 246 works,
18 at R.A., 145 at B.I., 40 at
S.B.A., 38 at O.W.C.S. 1800–38.
(*Bath, V. & A., Newport,
Newcastle, Whitworth*)

BARKER, John Joseph (fl. 1835–63)
Related to Benjamin and Thomas;
worked at Bath. Pen and wash
drawings of animal and figure
subjects. Exhibited 5 works, 4 at
R.A. and 1 at B.I. 1835 onwards.
(*Bath*)

BARKER, Thomas (1769–1847)
Born Pontypool; after a short stay
in Italy c. 1790, lived in Bath
where his best work was done.
Landscapes, genre and rustic
subjects in the manner of
F. Wheatley. Exhibited 118
works, 18 at R.A., 97 at B.I., 3 at
S.B.A.

BARLOW, Francis (1626?–1702)
Born Lincolnshire; pupil of
W. Sheppard. Famed for tinted
drawings of birds and animals in
landscapes. Made 110 etchings for
'Aesop's Fables.' (*V. & A.*)

**BARNARD, Rev. William Henry
(1769–1818)**
Pupil of Malchair. Painted
subjects in Ireland, Oxford, Wales,
Madeira and Italy, mostly in
Indian ink monochrome, at first
with pen outline.

BARNES, Robert (1840–95)
A.R.S.A.; assoc. R.W.S. 1876.
Exhibited 14 works at R.A.,
1873 onwards.

BARNEY, Joseph (1751–1827)
Born Wolverhampton; pupil of
Zucchi and A. Kauffman; drawing
master of Addiscombe
c. 1793–1815. Illustrations,
portraits and still life. Exhibited
143 works, mostly at R.A. and
B.I. 1777 onwards.

**BARRALET, John James
(1747–1815?)**
Born Ireland; studied and taught
at Dublin Academy; in 1773
opened a drawing school in
London; emigrated to America in
1795, where he died; member
Incorp. S.A. Landscapes, figures
and architectural subjects in a
subdued palette of greyish-blues
with brown trees in the manner of
A. Cozens. Exhibited 19 land-
scapes at S.A. 1773–80.
(*V. & A., B.M.*)

**BARRATT, Reginald R.
(1861–1917)**
Born London; studied in Paris;
worked for *Graphic* and *Daily
Graphic* before becoming a
watercolourist; painted in Italy

(particularly in Venice), India,
Persia, Algeria, Spain and
Holland; assoc. R.W.S. 1901,
member 1912. Exhibited 9
landscapes at R.A. 1885–93.
(*Birmingham*)

BARRAUD, Henry (1812–74)
Sporting scenes with horses and
dogs, and genre subjects.
Exhibited 33 works at R.A., 48 at
B.I. and 19 at R.S.B.A.

BARRAUD, William (1810–50)
Brother of Henry, and worked
with him on sporting subjects;
pupil of Abraham Cooper, R.A.
Exhibited 175 works, 58 at R.A.,
36 at B.I., 38 at S.B.A. 1829–50.
(*V. & A.*)

BARRET, George, Sr (1732–84)
Born Dublin; to London 1762;
worked with Sawrey Gilpin, R.A.
Member Incorp. S.A., and founder
member R.A. 1768. Landscapes
with horses and figures. Exhibited
32 works at R.A. (*V. & A., B.M.*)

BARRET, George, Jr (1767–1842)
Younger son of George Sr, a
founder member O.W.C.S.;
published 'Theory and Practice of
Water Colour Painting' in 1840.
Romantic landscapes and effects of
evening and morning light,
executed in yellows and browns.
Exhibited 600 watercolours at
O.W.C.S. (*V. & A., Manchester,
Liverpool, Newcastle, Whitworth*)

BARRET, James (fl. 1785–1819)
Son of George Sr. Landscapes in
watercolour and body-colour.
Exhibited 38 works at R.A.
1785–1819.

BARRET, Mary (fl. 1797–1836)
Daughter of G. Barret Sr.
Member O.W.C.S. 1823.

Miniatures, landscapes, birds, and still life.

BARROW, Joseph Charles
(fl. 1790–1800)
A successful art teacher who taught John Varley and F. L. T. Francia; fellow s.a. at which he exhibited 14 works. His own topographical works are rare. (*B.M.*, *V. & A.*)

BARTHOLOMEW, Valentine
(1799–1879)
Born Clerkenwell. Flower painter to Queen Victoria; member N.W.C.S. 1834–35 and assoc. O.W.C.S. His views of Windsor are examples of his landscape painting. Exhibited 1826 onwards. (*V. & A.*)

BARTLETT, William Henry
(1809–54)
Born Kentish Town; visited Europe, the Middle East and America, painting as he travelled, accurately and clearly; published illustrated books such as 'Walks about Jerusalem' (1845). Exhibited 4 at R.A. and 2 at N.W.C.S. 1831–33. (*B.M.*, *V. &. A.*, *Newport*)

BARTON, Rose (1856–1929)
A.R.W.S. 1893; R.W.S. 1911. London Scenes. Exhibited 9 works at R.A. 1889 onwards.

BATES, David (1840–1921)
Lived at Worcester from 1872. Local and Welsh landscapes. Exhibited 26 works at R.A. 1868–93. (*Worcester*)

BAUMER, Lewis Christopher
Edward (1870–1960)
Member R.I. 1921. Landscape and domestic scenes. Exhibited 2 works at R.A. 1885 onwards.

BAXTER, Thomas (1782–1821)
Born Worcester; china-painter at Worcester and Swansea; drew for J. Britton's 'Salisbury Cathedral'. Exhibited 16 works at R.A. 1802–21. (*V. & A.*, *B.M.*)

BAYES, Walter (1869–1956)
Born London. A.R.W.S. 1930, R.W.S. 1931.

BAYLISS, Sir Wyke (1835–1906)
Studied at R.A.; member S.B.A. 1864; president R.B.A. 1888. Church interiors. Exhibited 198 works, 3 at R.A., 193 at S.B.A. 1855–93.

BAYNES, James (1766–1837)
Born Kirkby Lonsdale, Westmorland; pupil of G. Romney, and studied at R.A.; taught John Varley; member Associated Artists in Water Colours. Topographical artist, working mostly in the Welsh valleys, usually featuring cattle and figures. Exhibited 52 works at R.A., 14 at R.S.B.A. and many at O.W.C.S. 1796–1837. (*B.M.*, *V. & A.*, *Whitworth*, *Newcastle*)

BAYNES, Thomas Mann (b. 1794)
Brother of James, and painted in a similar style. Exhibited 41 works at R.A. 1811–52.

BEAUCLERK, Lady Diana
(1734–1808)
Stained drawings of sentimental rustic groups, children and cherubs, for engraving and book illustration. (*B.M.*, *V. & A.*)

BEAUMONT, Sir George Howland
(1753–1827)
A skilled amateur, following no distinct style; pupil of A. Cozens at Eton, and worked with T. Hearne and J. Farington.

Exhibited 36 landscapes at R.A.
(*Leeds*)

BEAUVAIS, Simon
Practised in Bath and London as a
miniature-painter and portrait
artist in pencil and Indian ink.
Exhibited at Incorp. S.A. and
Free S.A. 1761–68.

BEAVIS, Richard (1824–96)
Born Exmouth; employed as a
decorator. Assoc. R.W.S. 1882,
member 1892; member B.I.
Animals, military subjects and
landscapes. Exhibited 331
works, 43 at R.A., 21 at B.I.,
16 at S.B.A., 100 at O.W.C.S.,
83 at N.W.C.S. Between 1851–96.

BECKER, Edmund (fl. 1780–1810)
Probably taught by A. Cozens.
Drawings of Rome, later of Lake
District, and lastly of Thames
Valley, mostly in grey mono-
chrome. Exhibited 2 drawings at
R.A. and 2 at B.I. (*B.M.*)

BEECHEY, Sir William
(1753–1839)
Born Burford, Oxon; studied at
R.A. 1772; A.R.A. 1793, R.A. 1798;
portrait-painter to Queen
Charlotte, and a capable landscape-
painter. Exhibited 417 works,
32 at B.I., 13 at S.B.A., 372 at
R.A. 1776–1839. (*B.M.*,
Birmingham)

BELL, Jonathan Anderson
(1809–65)
Born Glasgow; in Rome 1829–30;
later practised as an architect in
Birmingham and Edinburgh.
Landscapes. (*Edinburgh*)

BELL, Robert Anning
(1863–1933)
A.R.W.S. 1901, R.W.S. 1904;
A.R.A. 1914, R.A. 1922. Studied

in Paris (studio moret).
Illustrator, portraits, landscapes.
Master Art Workers Guild 1921.
Exhibited 8 works at R.A. (Tate)

BENNETT, William (1811–71)
Possibly taught by David Cox;
member N.W.C.S. 1894. Painted in
Somerset, Northumberland and
Wales. Exhibited 407 works,
18 at R.A., 3 at B.I., 8 at S.B.A.,
378 at N.W.C.S. (*V. & A.*)

BENNETT, William James
(fl. 1787–1844)
Member and secretary Associated
Artists in Water Colours, assoc.
O.W.C.S., and later president New
York Academy. Exhibited 7
works at O.W.C.S. 1808–25.
(*B.M.*)

BENTLEY, Charles (1806–54)
Born London; articled to Theodore
and Thales Fielding and trained as
an engraver; member O.W.C.S.
Painted coastal scenes, many of
European origin, and was also an
illustrator. Exhibited 233 works,
11 at B.I., 3 at S.B.A., 209 at
O.W.C.S. 1832–54. (*B.M.*, *V. & A.*,
Newcastle, Whitworth, Blackburn)

BENTLEY, Joseph Clayton
(1809–51)
Born Bradford; pupil of
C. Brandard. Coastal scenes in the
style of C. Bentley. Exhibited 62
works, 10 at R.A., 11 at B.I.,
21 at S.B.A. 1833–53. (*V. & A.*)

BENWELL, John Hodges
(1764–85)
Born Blenheim, Oxon; illustrator
of poems and stories. Exhibited
1 work at R.A. 1784. (*B.M.*,
V. & A.)

BENWELL, Mary (Mrs Code)
(d. 1800?)

Portraits and miniatures.
Exhibited 83 works, 20 at R.A.
1762–82.

BESTLAND, Charles
(fl. 1783–1837)
Historical and domestic subjects.
Exhibited 115 works, mostly at
R.A. and B.I.

BEVAN, Robert Polhill
(1865–1925)
Born Hove; studied in Paris;
worked principally in Devon.
Studies of cab ranks and the show
ring.

BEVERLEY, William Roxby
(1824–89)
Fine beach scenes in the
Bonington manner. Exhibited 28
works at R.A. after 1864.
(*Whitworth, Newport, B.M.,
V. & A.*)

BEWICK, Robert Elliot
(1788–1849)
Son of Thomas, whom he assisted
in his illustrations for 'Aesop's
Fables' in 1818.

BEWICK, Thomas (1753–1829)
Born Cherryburn, Northumber-
land; apprenticed to the engraver
R. Beilby, and himself a well-
known wood engraver. Rare
watercolours of animals and birds.
(*B.M. 230 works*)

BIFFIN, Sarah (1784–1850)
Born Quantox Head; pupil of
W. M. Craig; having neither
hands nor feet, she painted with
her mouth; worked at Brighton
and Liverpool. Miniatures.
Exhibited 1 work at R.A. 1850.

BILLINGS, Robert William
(1813–74)
An architect. Painted architectural

topography in pen and wash.
Exhibited 22 works at R.A.
(*Edinburgh, Bath*)

BINGLEY, James George
(1841–1920)
Landscapes. Exhibited 57 works,
3 at N.W.C.S., 27 at R.A.

BIRCH, Samuel John Lamorna
(1869–1955)
Born Egremont, Cumberland;
settled in Cornwall; A.R.A. 1926,
R.A. 1934; member O.W.C.S.
Landscapes, especially featuring
running water. Exhibited at R.A.
1893 onwards. (*V. & A., B.M.*)

BLAKE, William (1757–1827)
Born London; studied at Pars's
drawing school at age of 10;
apprenticed to the engraver
J. Basire; member Associated
Artists in Water Colours.
Original and imaginative
illustrator of his own poems, of the
works of Milton and of the Bible.
Exhibited 12 works at R.A.
1780–1808. (*B.M., V. & A.*)

BLORE, Edward (1789–1879)
Born Derby; friend of Sir Walter
Scott; F.R.S. Topographical and
architectural subjects, some for
Britton and Clutterbuck.
Exhibited 9 works at R.A.
1814–36.

BODICHON, Madame Eugene
See Smith, Barbara Leigh.

BOGLE, John (fl. 1769–94)
Worked in Glasgow and
Edinburgh, and after 1772 in
London. Miniatures. Exhibited
46 works, 44 at R.A.

BOND, Richard Sebastian
(1805–86)
Welsh views, notably around

Bettws-y-Coed. Exhibited 25 works, 7 at R.A., 13 at B.I., 5 at S.B.A.

BONE, Henry (1755–1834)
Born Truro; pupil of Richard Champion; A.R.A. 1801; R.A. 1811. Exhibited 255 works, 242 at R.A., 7 at B.I., 4 at S.B.A. 1781–1834.

BONE, Henry Pierce (1779–1855)
Born Islington; member Associated Artists in Water Colours. Exhibited chiefly at R.A., mostly enamels, over 250 in number.

BONE, Sir Muirhead (1876–1953)
Hon. R.W.S. 1943. War Drawings. Exhibited 4 works at R.A. 1900 onwards. (*V. & A., B.M. Imp. War Museum*)

BONINGTON, Richard Parkes (1802–28)
Born Arnold, near Nottingham; lived in France 1817–18 and studied under F. L. T. Francia, Baron Gros and Eugène Delacroix; in England 1824; in Italy 1826. Landscapes, seascapes and river views in a style very like that of William Callow and T. Shotter Boys. Exhibited at R.A. 1827–28 and at B.I. 1826–29. (*V. & A., B.M., Whitworth, Liverpool, Newcastle, Cambridge*)

BONNAR, William (1800–53)
Born Edinburgh; collaborator of David Roberts. Romantic pastoral subjects. (*Edinburgh*)

BOOT, William Henry James (1848–1918)
Born Nottingham; studied at Derby School of Art; art editor the *Strand Magazine*; vice-president R.B.A.; member R.I.

1909. Black and white illustrations. Exhibited 73 works, 4 at N.W.C.S., 15 at R.A.

BOSTOCK, John (fl. 1826–69)
Assoc. O.W.C.S. 1851. Genre and portraits. Exhibited 66 works, 48 at R.A., 4 at O.W.C.S.

BOUGH, Samuel (1822–73)
Born Carlisle; self-taught 'Cox of the North'; a scene-painter who became a landscapist of considerable ability; assoc. R.S.A. 1856, member 1875. Exhibited 15 works at R.A. 1856–76. (*Edinburgh, V. & A., Glasgow, Whitworth, Carlisle*)

BOUGHTON, George Henry (1833–1905)
Born Norwich; went to America with family, then left to study in Paris; to England 1862; A.R.A. 1879, R.A. 1896; R.I. 1879–85. Landscapes, portraits and genre. Exhibited 117 works 1862–93, 59 at R.A., 4 at B.I., 1 at S.B.A., 7 at N.W.C.S. (*V. & A.*)

BOURNE, James (1773–1854)
Born Dalby, Lincs.; pupil of A. Cozens. Topographical works, well drawn and often poetic, but sometimes 'woolly'. Exhibited 13 works at R.A. 1800–09. (*Birmingham, York, Swansea, B.M., V. & A.*)

BOUVIER, Agnes Rose
See Nicholl, Mrs Samuel Joseph.

BOUVIER, Augustus Jules (1827?–81)
Born London; studied at R.A. 1841, and also in France and Italy; assoc. N.W.C.S. 1852, member N.W.C.S. 1856. 1852–65. Portraits and genre. Exhibited 241 works at N.W.C.S.,

9 at R.A., 8 at B.I., 6 at S.B.A. 1845–81.

BOWLER, Henry Alexander (1824–1903)
Born Kensington; headmaster of Stourbridge School of Art 1861; teacher of perspective at R.A. 1861–99. 10 landscapes exhibited at R.A. 1847–81 and 6 at B.I. 1847–60.

BOWYER, Robert (1758–1834)
Pupil of John Smart (of Norfolk); painter in watercolours to George III, and miniature-painter to the Queen. Exhibited 35 works, 32 at R.A.

BOYCE, George Price (1826–97)
Began watercolour painting after meeting David Cox about 1849; member O.W.C.S. Landscapes and architectural subjects. Exhibited 218 works at O.W.C.S., 12 at R.A. 1853–61. (*V. & A., B.M., Newcastle, Oxford*)

BOYLE, Hon. Mrs Richard (1825–1916)
Known as E.V.B. Illustrations for children's books. Exhibited 4 works, 3 at New Gallery 1878–81.

BOYNE, John (1750?–1810)
Born Co. Down; apprenticed to the engraver Byrne; opened a drawing school in London. Genre and scenes from books. Exhibited 18 works at R.A. (*B.M., V. & A.*)

BOYS, Thomas Shotter (1803–74)
Born Pentonville; articled to the engraver G. Cooke; studied in Paris under Bonington; worked with William Callow. A fine draughtsman and painter of clean, sparkling city scenes, particularly in Paris, Antwerp, Rouen, Ghent and London. Assoc. N.W.C.S.

1840, member 1841. Exhibited 174 works, 2 at R.A., 14 at S.B.A., 158 at N.W.C.S. 1824–73. (*B.M., V. & A., Whitworth, Bedford, Newcastle*)

BRABAZON, Hercules Brabazon (née Sharpe) (1821–1906)
Born Paris; friend of John Ruskin; studied in Rome under J. H. d'Egville and A. D. Fripp; travelled extensively around the Mediterranean and in India; member of the New English Art Club. Impressionist landscapes. (*V. & A., B.M., Newcastle, Cambridge, Whitworth*)

BRADLEY, Basil (1842–1904)
Born Hampstead; studied at Manchester School of Art; member O.W.C.S. Animal subjects. Exhibited 141 works at O.W.C.S., 7 at R.A. 1866–93.

BRADLEY, Gordon (fl. 1831–58)
Member N.W.C.S. 1834. Landscapes. Exhibited 21 works, 12 at N.W.C.S., 6 at R.A.

BRADSHAW, John (1782–1809)
Born Lancs.; gifted amateur. Architectural topographical studies in the Ibbetson manner.

BRANDARD, Edward Paxman (fl. 1849–68)
Landscapes. Exhibited 9 works at R.A., 5 at B.I. and 21 at R.S.B.A.

BRANDARD, Robert (1805–62)
Born Birmingham; to London 1824; studied landscape painting under Edward Goodall. Topographical landscapes and coastal scenes. Exhibited 66 works, 3 at R.A., 21 at B.I. 1831–58. (*B.M., V. & A., Whitworth*)

BRANDLING, Henry (fl. 1847–56)

Assoc. o.w.c.s. Views of buildings
and portraits. Exhibited 11 works,
9 at o.w.c.s.

BRANGWYN, Sir Frank
(1867–1956)
Born Bruges; to London 1875;
to Spain with A. Melville 1892;
r.a.; assoc. r.w.s. 1921. Figure
draughtsman with an exotic
colour sense. Exhibited 16
works at r.a. 1885–93.
(*B.M., Hull, Liverpool*)

BRANWHITE, Charles (1818–80)
Born Bristol; first a sculptor before
becoming a landscape painter,
excelling in summer foliage;
assoc. o.w.c.s. Exhibited 9 works
at r.a., 25 at b.i. and 2 at r.s.b.a.
1843–79. (*B.M., V. & A.*)

BREE, Rev. William (1753?–1822)
Rector of Allesly, near Lord
Aylesford's home, whose low-
toned work his resembles.
Exhibited 2 landscapes r.a.
(*Coventry, B.M.*)

BRETT, John (1830–1902)
A Pre-Raphaelite who studied at
r.a. 1853; a.r.a. 1881. Land-
scapes and sea-pieces praised by
John Ruskin. Exhibited 78 works
at r.a. 1856–93. (*Maidstone*)

BREWER, Henry Charles
(b. 1866)
Member r.i. 1911. Landscapes.
Exhibited 4 works at r.a. 1888
onward.

BREWTNALL, Edward Frederick
(1846–1902)
Member s.b.a.; assoc. o.w.c.s.
1875, member 1883. Landscapes.
Exhibited 156 works at o.w.c.s.
(*Warrington, V. & A.*)

BRICKDALE, Eleanor Fortescue

(fl. 1900–1945)
a.r.w.s. 1901, r.w.s. 1919.
Landscapes.

BRIERLEY, Sir Oswald Walter
(1817–94)
Born Chester; studied at Sass's
Academy; marine painter to the
Queen 1874; travelled widely
with the Duke of Edinburgh and
the Prince of Wales; curator of
the Painted Hall, Greenwich
1881; assoc. o.w.c.s. 1872;
member 1880. Sea-pieces.
Exhibited 192 works at o.w.c.s.,
11 at r.a.

BRIGGS, Ernest Edward
(1865–1913)
Studied at the Slade under Legros;
member r.i. 1906. Landscapes.
Exhibited 21 works, 4 at n.w.c.s.,
9 at r.a., 8 at s.b.a.

BRIGHT, Henry (1814–73)
Born Saxmundham, Suffolk; to
London 1836; member n.w.c.s.
1839. A brilliant draughtsman
and a master of atmospheric
effects in bright colour. Exhibited
82 works, 12 at r.a. and 20 at
b.i. 1836–76. (*Newport,
Whitworth, B.M., V. & A.*)

BRISCOE, Arthur John Trevor
(1873–1943)
Member r.i. 1934; member
Royal Society of Painter-Etchers
and Engravers. Seascapes.

BRITTON, John (1771–1857)
Born Kingston St Michael, Wilts.;
to London 1787; published many
works on architecture. Archi-
tectural subjects and landscapes.
Exhibited 25 works at r.a.

BROCAS, Henry (1766–1838)
Born Dublin; taught landscape
painting in Dublin Society schools

from 1801. Illustrator; birds and landscapes in chalk and water-colour.

BROCAS, Samuel Frederick (fl. 1801–47)
Son of Henry. Landscapes, animals and views of Dublin. (*Dublin, B.M., V. & A.*)

BROCK, Charles Edmund (1870–1938)
Lived at Cambridge. Member R.I. 1909. Domestic subjects. Exhibited 5 works at R.A.

BROCK, Henry Matthews (b. 1875)
Member R.I. 1906. Illustrations. Exhibited 2 works at R.A.

BROCKEDON, William (1787–1854)
Born Totnes; studied at R.A.; travelled in Italy 1821–22; member Rome and Florence Academies; founder Graphic Society; F.R.S. Illustrated travel books and painted landscapes, portraits and genre. Exhibited 65 works, 36 at R.A., 29 at B.I. 1812–37. (*V. & A., Newcastle, B.M.*)

BROCKY, Charles (1807–55)
Born Hungary; studied in Vienna and Paris; to London c. 1838; assoc. N.W.C.S. 1854. Portraits and figures, landscapes, sea-pieces and genre. Exhibited 43 works at R.A. and 16 at B.I. (*V. & A., B.M.*)

BROMLEY, Valentine Walter (1848–77)
Born London; travelled in America; drew for the *Illustrated London News*; assoc. B.I., member S.B.A. 1870. Historical, poetical and figure subjects. Exhibited 84

works, 5 at R.A., 42 at N.W.C.S. 1865–77.

BROMLEY, William (fl. 1835–88)
Domestic and figure subjects. Exhibited 228 works, 187 at S.B.A.

BROOKBANK, Mrs
See Scott, Miss Maria.

BROOKE, William Henry (1772–1860)
Figure subjects in the manner of Stothard, clean and bright landscapes with bluish-green foliage, sometimes signed SP. Exhibited 33 works, 9 at R.A., 6 at B.I., 9 at S.B.A. 1808–33. (*B.M.*)

BROOKES, Warwick (1808–82)
Born Salford; known as 'Brookes of Manchester'; designer for calico printing; studied under J. Z. Bell at the Government School of Design, Manchester; member Manchester Academy of Fine Arts. Genre, particularly of children, and Welsh landscapes. (*B.M., V. & A.*)

BROOKING, Charles (1723–59)
A ship painter at Deptford dockyard, who became a master of the Dutch style of marine painting; many of his works were engraved. (*V. & A., B.M.*)

BROWN, Alexander Kellock (1849–1922)
A.R.S.A.; member R.I. 1916. Landscapes. Exhibited 34 works at R.A.

BROWN, Ford Madox (1821–93)
Born Calais; studied at Bruges, Ghent, Antwerp, Paris and Rome; taught D. G. Rossetti. His watercolours are rare. Exhibited 16

figure subjects, 5 at R.A., 5 at
B.I. 1841–67. (*Birmingham,
Manchester, Whitworth, V. & A.*)

BROWN, John (1752–1787)
Born Edinburgh; taught by
A. Runciman; in Italy 1771–81.
Monochrome figure studies in the
Fuseli manner. Exhibited 8
miniatures at R.A. in 1786.
(*B.M., Nottingham*)

BROWN, Thomas Austen
(1857–1924)
Born Edinburgh. A.R.S.A.;
member R.I. 1888–99. Exhibited
18 works at R.A. 1885 onwards.

BROWNE, Gordon Frederick
(1858–1932)
Member R.I. 1896, also member
R.B.A. Landscapes. Exhibited 14
works at R.A. from 1886.

BROWNE, Hablot Knight
(1815–82)
Born Kennington; known as
'Phiz'; apprenticed as an
engraver; studied at St Martin's
Lane School. Book illustrator and
famed caricaturist. Exhibited 40
works, 3 at R.A., 14 at B.I. 10 at
S.B.A. 1834–75.

BROWNE, Thomas Arthur
(1870–1910)
Born Nottingham; member R.I.
1901 and R.B.A. A black and white
artist, working in Holland,
Spain, China and Japan.

BROWNE, Vandyke (fl. 1820–40)
Sepia landscapes in the style of
James Robertson, and sketches
with David Cox.

BUCK, Adam (1759–1833)
Born Cork; portraits and
miniatures, and figures in the

neo-classic style. Exhibited 172
portraits at R.A. 1795–1833.

BUCK, Samuel (1696–1799)
Views of towns and old buildings
in pen and wash. Exhibited 9
wroks, 2 at R.A. 1761–95. (*B.M.,
Cardiff*)

BUCKLER, John (1770–1851)
Born Colbourne, I.O.W.; an
architect until c. 1826; F.S.A.
Noted for capable stained
drawings of cathedrals and
churches. His son, John Chesel,
drew in exactly the same style.
Exhibited 143 works at R.A.
1796–1849. (*B.M., V. & A.,
Newport, Newcastle*)

BUCKMAN, Edwin (1841–1930)
Assoc. O.W.C.S. 1877. On the
original staff of The Graphic.
Directed art studies of Queen
Alexandra. Street scenes of
London. Exhibited R.A. 1870–81.

BUNBURY, Henry William
(1750–1811)
A soldier, and equerry to the
Duke of York. Caricatures,
humorous drawings, and
occasional pure landscapes.
Exhibited 20 caricatures at R.A.
1780–1808 (*V. & A., B.M.,
Whitworth*)

BUNDY, Edgar (1862–1922)
Member R.I. 1891; vice-president
R.I., A.R.A. 1915; member R.I.O.
and R.B.A. Exhibited 42 works,
8 at N.W.C.S., 1881 onwards.

BURBANK, J. (fl. 1821–49)
English and Italian landscapes.
Exhibited 28 works at R.A.,
11 at R.S.B.A.

BURBANK, J. M. (d. 1873)
Member N.W.C.S. Animal

subjects. Exhibited 58 works, 11 at R.A. and 6 at B.I. 1825–72.

BURCHELL, W. J. (fl. 1805–20)
Landscapes, including some South African drawings. Exhibited 3 works at R.A.

BURDEN, J. (fl. 1796–1814)
Views in Hereford and Wales. Exhibited 16 works at R.A., 14 at B.I.

BURGESS, Arthur James Wetherall (1879–1956)
Member R.I. 1916; member R.O.I. and R.B.A. Seascapes and fishing scenes. Exhibited 1 work at R.A. 1904.

BURGESS, H. W. (fl. 1809–44)
Brother of John Cart B. Landscape painter to William IV. (*B.M., V. & A.*)

BURGESS, John (1814–74)
Son of J. C.,; studied in Italy 1834–37; assoc. O.W.C.S. Landscapes and architectural views. Exhibited 263 landscapes at O.W.C.S., 4 at R.A. (*V. & A.*)

BURGESS, John (fl. 1816–40)
Member N.W.C.S. Miniatures and portraits. Exhibited 47 works, 25 at R.A., 3 at B.I., 8 at S.B.A., 2 at O.W.C.S., 9 at N.W.C.S.

BURGESS, John Bagnold (1830–97)
Son of H. W.; R.A. Tinted pen drawings. Exhibited 118 works, 15 at B.I., 4 at S.B.A., 66 at R.A.

BURGESS, John Cart (1798–1863)
A drawing master. Landscapes and flowers. Exhibited 57 landscapes, 31 at R.A. (*B.M., Newport*)

BURGESS, William (1749?–1812)

Stained drawing topography and chalk drawings. Exhibited 49 works at R.A. (*B.M., V. & A.*)

BURGESS, William 'of Dover' (fl. 1827–56)
In Brussels with T. S. Cooper 1827. Exhibited 9 landscapes at O.W.C.S. (*B.M., Newport*)

BURNE-JONES, Sir Edward Coley, Bart. (1833–98)
Born Birmingham; worked with William Morris 1855; visited Italy 1859. Assoc. O.W.C.S. 1864, member 1868; A.R.A. 1885, resigned 1893. Mythical, religious and historical subjects, much copied. Exhibited 346 works, 112 at O.W.C.S., 1 at R.A. 1872–93. (*Birmingham, Cambridge, Cardiff, B.M., V. & A.*)

BURNET, James M. (1788–1816)
Born Edinburgh; brother of John; studied at Graham's Evening Academy. Rural scenery and cattle. Exhibited 34 works, 5 at R.A. and 24 at B.I. 1812 onward.

BURNET, John (1784–1868)
Born Edinburgh; studied under the engraver R. Scott; in London 1806. Genre subjects. Exhibited 30 works at R.A. (*B.M.*)

BURNETT, Cecil Ross (1872–1933)
Member R.I. 1909. Landscapes.

BURNEY, Edward Francis (1760–1848)
Born Worcester; in London 1776, studying at R.A.; friend of Reynolds. Illustrator in the manner of Stothard. Exhibited 19 portraits at R.A. (*B.M., V. & A., Nottingham, Guildhall*)

BURR, John R. (1836–1894)
Assoc. R.W.S. and R.B.A. Genre
subjects. Exhibited 102 works
at R.A.

BURRELL, Joseph Francis
(fl. 1801–54)
Probably a landscape painter.
Exhibited 13 works at R.A.
(*V. & A.*)

BURRINGTON, Arthur Alfred
(1856–1924)
Member R.I. 1896. Exhibited
R.A. (9) and elsewhere between
1880–93.

BURTON, Sir Frederick William
(1816–1900)
Born Co. Clare; pupil of H. Brocas
in Dublin 1828; assoc. R.H.A. 1837,
member 1839; member O.W.C.S.,
F.S.A.; director National Gallery
1874–94. Genre, miniature
portraits and landscapes.
Exhibited 68 watercolours at
O.W.C.S. (*V. & A., B.M.*)

BURTON, William Paton
(1828–83)
Born Madras; educated in
Edinburgh. Landscapes in Surrey
and Sussex, on the Continent and
in Egypt. Exhibited 95 works at
R.A. 1862–83. (*V. & A., B.M.*)

BURTON, William Shakespeare
(1824–1916)
Born London; studied at the
Government School of Design,
Somerset House; gold medallist
R.A. 1851; influenced by the Pre-
Raphaelites. Exhibited 19 works,
7 at R.A.

BURY, Rev. Edward (d. 1832)
Landscapes, some engraved by
T. Lupton.

BUSS, Robert William (1804–75)

Born London; pupil of G. Clint;
member N.W.C.S. 1833. An
illustrator and theatrical portrait-
painter. Exhibited 112 works,
25 at R.A., 20 at B.I., 45 at S.B.A.,
7 at N.W.C.S. 1826–59. (*B.M.,
Newcastle-under-Lyme*)

BUTLER, James
Exhibited 3 landscapes at the R.A.
in 1763, which were probably
copies of the work of his teacher,
J. D. Bond of Birmingham.

BUTLER, Mildred A. (1858–1941)
A.R.W.S. 1896, R.W.S. 1937.
Picture entitled Morning Bath,
R.A. 1895. Purchased Chantry
Bequest and presented to Tate.
Exhibited 16 works at R.A. 1889
onward.

BUTLER, Samuel (1835–1902)
Author of 'Erewhon'; an amateur
specialising in figure studies and
Alpine views. Exhibited 6 works
at R.A. 1869–75. (*B.M.*)

BUTTERSWORTH, Thomas
(fl. 1797–1827)
Exhibited 3 marine studies of
Napoleonic naval battles during
this period. (*B.M., Greenwich*)

BYRNE, Anne Frances (1775–1837)
Born London; daughter of
landscape-painter William Byrne;
member O.W.C.S. 1809. Landscapes
and flowers. Exhibited 77 works
60 at O.W.C.S., 6 at R.A.
1796–1833. (*V. & A.*)

BYRNE, John (1786–1847)
Brother of Anne; studied in Italy
1833–37. Assoc O.W.C.S. 1827.
English and French landscapes.
Exhibited 143 works, 100 at
O.W.C.S., 15 at R.A., 5 at B.I., 23
at S.B.A. (*V. & A., Newcastle*)

BYRNE, Letitia (1779–1849)
Sister of Anne and John; married
portrait-painter James Green;
member Associated Artists in
Water Colours. Miniature
portraits and copies of Old
Masters. Exhibited 21 works at
R.A. (*B.M.*)

CABALIERE, John (d. 1780)
A wine merchant by trade.
Miniatures.

CADENHEAD, James (1858–1927)
Born Aberdeen; studied at Royal
Scottish Academy Schools under
Carolus Duran; assoc. R.S.A. 1902,
member 1921, member R.S.W.;
also an etcher.

CAFE, Thomas 'the Younger'
(fl. 1844–68)
Landscapes in Scotland, Jersey,
Cumberland and on the South
Coast. Exhibited 9 works at R.A.,
22 at R.S.B.A.

CAFE, Thomas Smith (1793–1840)
Father of Thomas 'the Younger'.
Landscapes. Exhibited 21 works,
7 at R.S.B.A. (*B.M.*)

CAFFIERI, Hector (1847–1932)
Member R.I. 1885–1920; member
R.B.A. Landscapes. Exhibited 31
works at R.A., 84 works at R.B.A.,
45 at N.W.C.S. between 1869–93.

CAHUSAC, J. A. (fl. 1827–1853)
Member N.W.C.S. 1834. Fruit and
flowers. Exhibited 35 works at
R.I., 36 at N.W.C.S.

CALDECOTT, Randolph
1846–86)
Born Chester; drew for periodicals

from 1868; in London 1872.
Member R.I. 1882. Illustrator of
children's books. Exhibited 35
works, 4 at R.A., 10 at N.W.C.S.
1872–85. (*V. & A., Manchester,
Whitworth*)

CALDERON, Philip Hermogenese
(1833–98)
Born Poitiers; educated in London;
studied at Leigh's School, London,
and under Picot in Paris; A.R.A.
1864, R.A. 1867; Keeper of R.A.
1887. Figure subjects. Exhibited
134 works, 100 at R.A., 6 at B.I.,
9 at S.B.A. 1853–93.

CALDWELL, Edmund
(fl. 1880–93)
Animals. Exhibited 11 works at
N.W.C.S.

CALDWELL, James (1739–89)
Born London; pupil of Sherwin;
designer and engraver, and
painted some portraits. (His
brother John was a miniature-
painter working in Scotland, who
died 1819.) Exhibited 30 works
1768–80, 29 at Free Society.

CALLCOT, Sir Augustus Wall
(1779–1844)
Born Kensington; studied at R.A.
1797, and under Hoffner; A.R.A.
1806, R.A. 1810; knighted 1837.
Portraits and landscapes.
Exhibited 129 works at R.A., 13 at
B.I. 1799–1844. (*B.M., V. & A.,
Newcastle, Whitworth*)

CALLENDER (or
CALLENDAR), H. R.
(fl. 1780–1800)
Friend of Francis Nicholson.
Landscapes, some of Thames
Valley. (*Note.* Another artist of the
same name, Adam, painted
Scottish scenes, exhibiting
1780–1811.)

CALLOW, John (1822–70)
Brother and pupil of William;
professor at Addiscombe Military
Academy 1855–61 and Royal
Military Academy, Woolwich
1861–65; professor at Queen's
College, London, 1875–78;
member N.W.C.S. 1848, assoc.
O.W.C.S. 1845. Marine subjects
and landscapes. Exhibited 352
works at O.W.C.S., 7 at R.A., 9 at
B.I., 2 at S.B.A., 38 at N.W.C.S.
1844–78. (*B.M., V. & A.,
Newcastle*)

CALLOW, William (1812–1908)
Born Greenwich; articled to
Theodore and Thales Fielding; in
Paris 1829; Professor of drawing
to family of Louis Philippe;
friend of T. Shotter Boys; in
London 1841; in Great Missenden
1855. Assoc. O.W.C.S. 1834,
member 1848, Sec. 1865–70.
Landscapes and continental street
scenes. Exhibited 1,152 works
at O.W.C.S., 29 at R.A., 36 at B.I.
1838–93. (*V. & A., B.M.,
Hereford, Warrington, Newcastle*)

CALVERT, Charles (1785–1852)
Born Glossop Hall, Derbyshire;
a founder of Royal Manchester
Institution. Landscapes. (*V. & A.*)

CALVERT, Edward (1799–1883)
Born Devon; studied under J. Ball
and A. B. Johns at Plymouth;
friend of William Blake and
Samuel Palmer. An illustrator, and
painter of landscapes with nymphs
and dryads. Exhibited 5 works at
R.A. 1825–36. (*B.M.*)

CALVERT, Edwin Sherwood
(1844–98)
Member R.S.W. Exhibited 21
works, 14 at R.A., 1 at N.W.C.S.
1878–93.

CALVERT, Frederick (fl. 1815–45)
Landscapes, mostly small views,
and marine subjects in the David
Cox manner. Exhibited 6 works
2 at B.I., 1827–44 (*B.M.,
V. & A.*)

CAMERON, Sir David Young
(1865–1945)
Born Glasgow; R.A., R.S.W., R.W.S.
Seascapes. (*Edinburgh, B.M.,
V. & A.*)

CAMERON, Hugh (1835–1918)
Born Edinburgh; pupil of R. S.
Lauder; member R.S.A. and R.S.W.
Children and domestic subjects.
Exhibited over 40 works, 25 at
R.A.

CAMPBELL, Alexander
(1764–1824)
A Scottish topographer.
(*Edinburgh*)

CAMPBELL, Charles William
(1855–87)
Born Tottenham; a mezzotint
engraver. Painted in the Pre-
Raphaelite style.

CAMPBELL, John Henry
(1757–1828)
An Irish artist. Landscapes in
Wicklow, Down and around
Dublin. (*B.M., V. & A.*)

CAMPBELL, J. Hodgson
(1855–1927)
Studied art in Edinburgh; a
founder of the Bewick and Pen &
Palette Clubs of Newcastle-upon-
Tyne. Landscapes.

CAMPION, George Bryan
(1796–1870)
Drawing master at Woolwich
Military Academy; member
N.W.C.S. 1834. Topographical
scenes and genre. Exhibited 473

**The Eagle's Nest,
Killarney**

*John Varley
(1778–1842)*

Signed
11½" x 14"

In his use of the typical
formula of foreground with a
figure or two, lake, and distant
mountains, Varley was a
master of the dramatic. The sky
here is for Varley unusually
unfaded and interesting, and
we can see his characteristic
use of broad, horizontal
brush-strokes to depict still
water. It is not known that
Varley ever visited Killarney, and
it seems highly probable that,
as he so often did, he drew
upon the work of others for
the salient features of the
landscape. It is instructive
to see that the artist has
created a wholly satisfying
effect by the use of massed
forms of varying density. In
much of his later work he
achieved a similar effect
rather by 'prettiness' and
detailed drawing.

**The Farm at Egton
Bridge, near Whitby**

*William Frederick Wells
(1762–1836)*

Dated 1829 on the reverse

12" x 19"

This drawing should be
compared with that illustrated
in Plate CLXIV, No. 338, of
Iolo Williams's 'Early English
Watercolours' (1970). It seems
almost certain that the two
were painted on the same
occasion. Wells is not
nowadays a well-known
watercolourist. But it must be
remembered that he was the
originator of the Old Water-
colour Society, a close friend of
Turner, and an early traveller
abroad. For the last twenty
years of his life he was
professor of drawing at
Addiscombe Military College.
This accomplished drawing,
which is quite unfaded, is
carefully pencilled. The
characteristically bright yet
soft washes of colour are
beautifully translucent.

works at N.W.C.S. 1829–69.
(*V. & A., B.M.*)

CANE, Herbert Collins
(fl. 1883–93)
Animal subjects. Exhibited 5
works at N.W.C.S.

CAPON, William (1757–1827)
Born Norwich; scene-painter, and
architectural views in London,
Bath and elsewhere. Exhibited 56
works at R.A. 1788–1827.
(*B.M., Bath*)

CAPPER, J. J. (fl. 1849–59)
Exhibited 5 works at R.A.

CARLINE, George (fl. 1886–93)
Worked in Lincoln. Exhibited 10
works at N.W.C.S.

CARLINE, George F. (1855–1920)
Born Lincoln. Studied
Heatherleys, Antwerp and Paris.
Member S.B.A. Portraits and
landscapes. (*V. & A.*)

CARLISLE, George James Howard,
9th Earl of (1843–1911)
Studied under Alphonse Legros
and Giovanni Costa; friend of
Frederick Lord Leighton and
G. F. Watts. Landscapes.
Exhibited 92 works 1866–93,
38 at R.I., 9 at N.W.C.S.

CARLISLE, John (fl. 1866–93)
Landscapes. Exhibited 38 works at
R.I., 9 at N.W.C.S.

CARMICHAEL, James Wilson
(1800–68)
Born Newcastle; at first a sailor,
then apprenticed to a ship-
builder; to London c. 1845;
visited the Baltic; painted first in
oils, and then mostly in
watercolour. Marine subjects and
occasionally architectural interiors.

Exhibited 56 sea-pieces, 21 at
R.A., 21 at B.I., 6 at S.B.A.
1835–62. (*Newcastle, Newport,
Carlisle*)

CARPENTER, Mrs William
Hookham (née Margaret Sarah
Geddes) (1793–1872)
Born Salisbury; to London 1814.
Portraits, landscapes and flowers.
Exhibited 217 works, 147 at R.A.,
50 at B.I., 19 at S.B.A., 1 at
O.W.C.S. 1816–66.

CARPENTER, William (d. 1899)
Lived for many years in India; fl.
1840 until his death. Over 30
drawings of scenes in Hindustan
in V. & A.

CARR, David (fl. 1875–93)
Figure subjects. Exhibited 69
works, 7 at N.W.C.S., 6 at R.A.

CARRICK, Robert (d. 1904)
Born Scotland; assoc. N.W.C.S.
1848, member 1850; member
Institute of Painters in Oil
Colours. Genre in the Pre-
Raphaelite manner. Exhibited 66
works at N.W.C.S.

CARRICK, Thomas Heathfield
(1802–75)
Born Carlisle; self-taught.
Miniatures. Exhibited 140 works
at R.A. 1841–66.

CARRINGTON, Louis
(fl. 1874–88)
Worked in Forest Hill.
Exhibited 6 works at R.I., 4 at
N.W.C.S.

CARSE, Alexander (fl. 1780?–1820)
Topographical and genre.
Exhibited 29 works 1812–20, 11
at R.A., 18 at B.I. (*Edinburgh*)

CARTER, Ellen (née Vavashur)
(d. 1815)

D

Illustrated for the *Gentleman's Magazine* and other periodicals.

CARTER, Henry Barlow (d. 1867)
Born Scarborough; always worked around Scarborough and Whitby. Seascapes with rocks, wrecks and buoys. (*B.M., V. & A.*)

CARTER, Hugh B. (1837–1904)
Born Birmingham; member Institute of Oil Painters. Portraits; R.I. 1875. Genre and topographical views. Exhibited 133 works at N.W.C.S., 14 at R.A. (*V. & A.*)

CARTER, James (1798–1855)
Born Shoreditch; a line engraver, who worked for S. Prout, and engraved after E. M. Ward; drew for the *Art Journal.*

CARTER, John (1748–1817)
Draughtsman to Society of Antiquaries; F.S.A. Accurate architectural drawings. Exhibited 39 works, 21 at R.A. 1765–94. (*V. & A., B.M., Bath, Whitworth*)

CARTER, Joseph Newington (1835–71)
Born Scarborough; son of Hugh B.

CARTER, Richard Harry (fl. 1864–93)
Worked in Truro. Landscapes. Exhibited 18 works at N.W.C.S.

CARTWRIGHT, Joseph (1789–1829)
Paymaster-General to the army in Corfu; marine painter to Duke of Clarence 1828; member S.B.A. Landscapes and marine subjects. Exhibited 16 works, 10 at B.I. 1823–29. (*B.M., V. & A.*)

CARVER, Robert (d. 1791)
Born Ireland; a scene-painter at

Covent Garden; member Incorp. S.A.; died London. Landscapes and coastal scenes. Exhibited 29 works at S.A. 1765–90.

CASSIE, James (1819–79)
Born Iverurie, Aberdeen; assoc. R.S.A. 1869, member 1879, member R.S.W. Landscapes, portraits, genre and coastal scenes. Exhibited 188 works at N.W.C.S. (*Edinburgh*)

CATTERMOLE, Charles (1832–1900)
Nephew of George; assoc. N.W.C.S. 1862, member 1870; member Institute of Oil Painters, R.B.A. and R.I. Illustrator, romantic historical figure subjects. Exhibited 188 works at N.W.C.S. (*B.M., V. & A.*)

CATTERMOLE, George (1800–68)
Born Dickleburgh, near Diss, Norfolk; pupil of John Britton; member O.W.C.S., Amsterdam Academy, and Belgian Water Colour Society. Dramatic romantic and historical subjects and fine landscapes. Exhibited 97 works at O.W.C.S. (*V. & A., Bath, Whitworth, Newport, Newcastle*)

CATTERMOLE, Rev. Richard (fl. 1814–18)
Painted palace interiors before entering the Church. Exhibited 6 works at O.W.C.S.

CATTON, Charles, Sr (1728–98)
Born Norwich; worked as a coach-painter; R.A. Animals and landscapes. Exhibited 59 works, 16 at Soc. of Artists, 43 at R.A. 1760–98.

CATTON, Charles, Jr (1756–1819)
Born London; studied under his

R.A. father, court painter to
George III, and at R.A.; in 1804
emigrated to America, where he
died. Theatre scenery, animals, and
topography. Exhibited 37 works
at R.A. (*Ashmolean*)

CAVE, Henry (1780?–1836)
A drawing master at York;
instructor of the Cholmondeley
family, later replaced by Cotman.
Yorkshire topography. (*B.M.*)

CAVE, James (fl. 1801–17)
Worked in Winchester. Local
topography. Exhibited 7
examples at R.A. (*York, B.M.*)

CHADWICK, Ernest Albert
(born 1876)
Member R.I. 1939. Detailed
landscapes.

CHALON, Alfred Edward
(1780–1860)
Born Geneva; brother of J. J.;
studied at R.A. 1797; member
Associated Artists in Water
Colours, A.R.A. 1812, R.A. 1816;
painter in watercolours to Queen
Victoria. Miniatures and portraits.
Exhibited 396 works at R.A.,
21 at B.I. (*B.M., V. & A.,
Whitworth*)

CHALON, Henry Bernard
(1770–1849)
Born London; animal-painter to
the Duchess of York 1795, to the
Prince Regent, and to William IV.
(His daughter M. A. Chalon was
miniature-painter to the Duke of
York, and became Mrs Moseley.)
Animals, especially horses.
Exhibited 250 works, 198 at R.A.,
28 at B.I. 1792–1849.

CHALON, John James (1778–1854)
Born Geneva; brother of A. E.;
studied at R.A. 1796; Founded

the Sketching Society with A.E.
in 1808. Member O.W.C.S., A.R.A.
1827, R.A. 1841. Landscapes,
marine views, animals and figure
subjects. Exhibited 55 works at
O.W.C.S., 86 at R.A., 48 at B.I.
(*Newcastle, B.M., V. & A.*)

CHALMERS, George Paul
(1836–78)
Born Montrose; studied under
R. S. Lauder at Edinburgh School
of Design; assoc. R.S.A. 1867,
member 1871. Genre, portraits
and landscapes. Exhibited 6 works
at R.A. 1863–76.

CHALMERS, W. A.
Late 18th century, and believed to
have died young. Interiors of
churches, and so on, and figure
subjects.

CHAMBERS, George (1803–40)
Born Whitby; went to sea at an
early age, and later became a
house-painter; subsequently went
to London. Assoc. O.W.C.S. 1834,
member 1835. Theatre scenery,
fine marine and river and coastal
scenes. Exhibited 41 works at
O.W.C.S., 3 at R.A., 15 at B.I.,
28 at S.B.A. (*V. & A., B.M.,
Whitby, Newport, Newcastle,
Whitworth*)

CHAMBERS, Thomas (1724–89)
Born London; engraver for
Boydell's collections.

CHARLTON, John (1849–1917)
Born Bamburgh, Northumberland;
taught by his father; attended
Newcastle School of Art and
South Kensington Museum; in
London worked in the studio of
J. D. Watson; member R.I. and
R.B.A. Exhibited 98 works, 21 at
R.I. 1870–93, and at R.A. every
year from 1870.

CHARLTON, William Henry
(1846–91)
Born Newcastle; studied under
C. Richardson, and in Paris. Local
topography and continental land-
scapes. Exhibited 2 works at R.A.
(*B.M.*, *Newcastle*)

CHARRETIE, Mrs John (née Anna
Maria Kenwell) (1819–75)
Miniatures and flowers. Exhibited
50 works at R.B.A., 40 at R.A.

CHASE, John (1810–79)
Born London; taught by
Constable; also studied archi-
tecture. Member N.W.C.S. 1834,
R.I. 1834. Landscapes and views
of churches. Exhibited 465 works
at N.W.C.S., 11 at R.A. (*V. & A.*)

CHASE, Mrs John (née Mary Ann
Rix) (1819–1875)
Member N.W.C.S. 1835.
Landscapes. Exhibited 10 works
at N.W.C.S. 1836–39.

CHASE, Miss Marion Emma
(1844–1905)
Daughter of John; assoc. N.W.C.S.
1875, member 1879; member R.I.
Flower pieces. Exhibited 205
works at N.W.C.S.

CHATELAIN, Jean Baptist Claude
(1710–71)
Born London of French parents;
served in Flanders in the French
army; teacher of F. Vivares.
Landscapes, mostly imaginary, and
some London views. Exhibited
only engravings. (*V. & A.*, *B.M.*)

CHENEY, Harriet
Little known, but lived at Badger,
Shropshire, and was an amateur
pupil of De Wint.

CHESTON, Charles Sidney
(1882–1960)

Assoc. R.W.S. 1929; R.W.S. 1933.
Ass. Royal Society of Painter-
Etchers. Landscapes.

CHILD, James Warren
(1778–1862)
Miniatures of actors and
actresses. Exhibited 83 works,
67 at R.A. 1815–53.

CHILDE, Elias (fl. 1798–1848)
Member S.B.A. 1825. Exhibited
495 works, 114 at R.A. and 314 at
R.S.B.A.

CHILDS, George (fl. 1826–73)
An authority on trees. Landscapes
in Yorkshire, Wales, the New
Forest and Hampstead. Exhibited
22 works at R.S.B.A.

CHINNERY, George (1774–1852)
Born London; an amateur, son of
an East Indian merchant; in
Ireland 1797 as portrait painter;
Madras 1802; China 1827;
England 1834; died at Macao.
Landscapes, portraits, miniatures,
and scenes of native life in China
and India. Exhibited 39 works at
R.A. 1791–1846. (*B.M.*, *V. & A.*,
Birmingham)

CHISHOLM, Alexander
(1792–1848)
Born Elgin; apprenticed to a
weaver and patronised in
Edinburgh by the Earl of Buchan;
art teacher at Edinburgh; in
London 1818; assoc. O.W.C.S.
1829; F.S.A. Portraits, genre, and
historical subjects. Exhibited 40
works at O.W.C.S., 15 at R.A., 15
at B.I., 11 at S.B.A. (*Edinburgh*,
V. & A.)

CHRISTMAS, Thomas C.
(fl. 1819–25)
Sporting subjects. Exhibited 5

works at o.w.c.s., 2 at r.a., 11 at
b.i., 6 at s.b.a.

CHUBBARD, Thomas (1738–1809)
Born Liverpool. Portraits and
Northern topographical views.
Exhibited 6 works, 4 at Soc. of
Artists, 1771–73. (*Liverpool*)

CHURCHMAN, John (d. 1780)
An ex-curate. Miniatures.

CHURCHYARD, Thomas
(1798–1865)
Born Woodbridge, Suffolk; a
solicitor, influenced by Chrome
and Constable. Landscapes.
Exhibited 8 works at r.s.b.a.,
2 at r.a. (*Liverpool*)

CIPRIANI, Giovanni Baptista
(1727–85)
Born Florence; pupil of Hugford at
Florence; to Rome 1750; to
England 1755; a founder member
r.a. Classical figure subjects.
Exhibited 14 works at r.a.
(*V. & A., B.M.*)

CLARK, Christopher (1875–1942)
Member r.i. 1905. Landscapes.

CLARK, John (1771–1865)
Known as 'Waterloo Clark' from
his impressions of the battlefield.
Landscapes and book illustrations.

CLARK, John Cosmo (1897–1967)
Assoc. r.w.s. 1950; r.w.s. 1952;
r.a. 1959. Director of Rural
Industries Bureau Figure
Compositions, Landscapes,
Scenes of London.

CLARK, John Heaviside
(fl. 1812–32)
Author of a book on watercolour
painting. Marine and coastal
views. Exhibited 4 works at r.a.

CLARK, Thomas (fl. 1827–70)
Assoc. r.s.a. Landscapes at home,
and in France, Egypt and Italy.
Exhibited 47 works, 15 at b.i.,
12 at r.a., 6 at s.b.a.

CLARK, W. F. C. (fl. 1884–90)
Landscapes. Exhibited 7 works at
n.w.c.s., 2 at s.b.a.

CLAY, G. (fl. 1846–60)
Landscapes with sunrise and sunset
effects, in Kent and Wales.
Exhibited 20 works, 9 at b.i.,
8 at r.a., 3 at s.b.a.

CLAUSEN, Sir George
(1852–1944)
Studied at South Kensington
Schools and in Paris; assoc.
n.w.c.s. 1876, member 1879–88;
r.a.; assoc. r.w.s. 1889, member
1898. Pastoral landscapes.
Exhibited 120 works, 39 at
n.w.c.s., 18 at o.w.c.s., 16 at r.a.,
1874–93. (*Whitworth, Newcastle
Bedford, B.M., V. & A.*)

CLAYTON, John (1727?–1800)
Trained as a surgeon; member
Incorp. s.a. Fruit and still life.
Exhibited 2 works at r.a. 1763.

CLEAVESMITH, Edmund
(fl. 1880–84)
Worked in Sheffield. Exhibited 8
works at r.i., 5 at n.w.c.s.

CLENNELL, Luke (1781–1840)
Born Ulgham, near Morpeth,
Northumberland; apprenticed to
T. Bewick; to London 1804 as an
engraver before becoming a
painter; member Associated
Artists in Water Colours and
o.w.c.s. Genre subjects. Exhibited
70 works, 18 at o.w.c.s., 6 at
r.a., 15 at b.i. 1810–18.
(*Whitworth, Newcastle, Newport,
B.M., V. & A.*)

CLERISSEAU, Charles Louis
(1722–1820)
Born Paris; encouraged to go to
England by Robert Adam, and
worked there 1772–90. Archi-
tectural antiquities in a style
copied by Girtin. Exhibited 14
works at s.a., 4 at r.a. (*V. & A.*)

CLERK, John 'of Eldin'
(1728–1812)
Amateur Scottish topographer and
friend of Paul Sandby.

CLEVELEY, John (1747–86)
Born Deptford; twin brother of
Robert; pupil of Paul Sandby;
employed at Deptford dockyard;
with Banks to Iceland 1772;
draughtsman to northern regions
expedition with Captain Phipps
(later Lord Mulgrove) 1774.
Marine subjects. Exhibited 86
works, 55 at Free Society, 31 at
r.a., 1764–86 (*Greenwich, B.M.,*
V. & A.)

CLEVELEY, Robert (1747–1809)
Born Deptford; twin brother of
John; marine painter to Prince of
Wales and Duke of Clarence.
Marine subjects. Exhibited 73
works, 15 at Free Society, 57 at
r.a., 1767–1806. (*Greenwich,*
Newcastle, Whitworth, B.M.,
V. & A.)

CLEYN, Charles, John and Penelope
Children of Francis Cleyn, a
German tapestry painter. Mid-
17th century miniature painters.

CLIFFORD, Edward Charles
(1858–1910)
Illustrations for the *Art Journal*,
and so on; r.i. 1899; secretary
Langham Sketching Club.
Exhibited 9 works, 2 at r.a.,
1 at n.w.c.s. 1891–93.

CLIFTON, W. (fl. 1870–87)
Drawing master at Royal Marine
Academy, Woolwich. Landscapes.
Exhibited 9 works, 2 at r.a.,
3 at b.i., 2 at n.w.c.s. (*Woolwich*)

CLINT, Alfred (1807–83)
Member n.w.c.s. 1833 and s.b.a.
1843; president s.b.a. 1870.
Portraits, landscapes and coastal
scenes. Exhibited 468 works,
24 at r.a., 35 at b.i., 406 at
s.b.a., 3 at n.w.c.s. (*V. & A.,*
B.M.)

CLINT, George (1770–1854)
Born London, the son of a barber;
a very successful painter; a.r.a.
Dramatic subjects and miniatures.
Exhibited 125 works, 9 at r.a.,
9 at b.i., 2 at o.w.c.s. 1802–47.

COCKBURN, Madeline Francis
See Marrable, Mrs Madeline
Frances.

COCKBURN, Maj.-Gen. James
Pattison (1778–1849)
Possibly a pupil of Paul Sandby;
influenced by R. Dixon and J.
Crome; travelled in Canada and
Italy. Landscapes in the style of
W. L. Leitch. (*B.M., Norwich*)

COCKRAM, George (b. 1861)
Member r.i. 1913; member r.c.a.
Exhibited 19 works at r.a., 13
works at r.i. 1883–93.

CODE, Mrs
See Benwell, Mary.

COLBY, Joseph (fl. 1851–86)
Domestic subjects. Exhibited 6
works at r.a.

COLE, George (1808–83)
Self-taught. Landscapes. Exhibited
277 works, 19 at r.a., 35 at b.i.,
1838–83.

COLE, George Vicat (1833–93)
Born Portsmouth; son of George;
member s.b.a. 1859–64, a.r.a.
1869, r.a. 1880. Landscapes and
Thames Valley scenes. Exhibited
139 works, 76 at r.a., 10 at b.i.,
48 at s.b.a., 1852–92. (*V. & A.,
B.M.*)

COLEMAN, Edward
Of Birmingham. Game. Exhibited
16 works at r.a. 1813–48.

COLEMAN, Helen Cordelia
See Angel, Mrs Thomas William.

COLEMAN, William Stephen
(1829–1904)
A naturalist; drew for books on
natural history. Designs for
pottery, figures, and landscapes
with figures. Exhibited 31 works
1865–79.

COLKETT, Samuel David
(1800–63)
Born Norwich; pupil of J. Crome
and J. Stark. Landscapes. Exhibited
65 works, 2 at r.a., 30 at b.i.,
33 at s.b.a. 1825–62.

COLLET, John, 'of Chelsea'
(1725?–80)
Born London; studied under
J. Lambert Sr, and at St Martin's
Lane Academy. Landscapes and
humorous figure subjects.
Exhibited 47 works at Free Soc.
1761–80. (*V. & A., B.M.*)

COLLIER, Thomas (1840–91)
Born Glossop, Derbys.; studied at
Manchester School of Art;
Chevalier de la Légion d'Honneur
1878; Silver medallist Paris
Exhibition 1889; assoc. n.w.c.s.
1870, member 1872; member r.i.
Landscapes with fine cloudy skies.
Exhibited 80 works at n.w.c.s.,
4 at r.a. (*Whitworth, Newcastle,*

*Leeds, Nottingham, V. & A.,
B.M.*)

COLLINGWOOD, William
(1819–1903)
Born Greenwich, the son of an
architect; pupil of J. D. Harding
and Samuel Prout; influenced by
William Henry Hunt; member
n.w.c.s. 1846–52 and o.w.c.s.
Interiors and Alpine scenery.
Exhibited 732 works at o.w.c.s.,
108 at n.w.c.s., 26 at r.a.
(*V. & A.*)

COLLINS, Charles (d. 1744)
(fl. 1700 onwards)
Game (chiefly birds) sometimes in
landscape settings; used much
body-colour. (*B.M.*)

COLLINS, John
Several of this name.
(1) fl. c. 1763; an example of his
work illustrated in 'Collecting
English Watercolours' by Clifford,
Plate 40.
(2) fl. c. 1740–50; 6 etchings of
his work done by P. Sandby and
E. Rooker, from Tasso's
'Jerusalem Delivered'.
(3) fl. 1811.

COLLINS, Richard (1755–1831)
Born Hampshire; pupil of
Jeremiah Meyer. Miniatures.
Exhibited 33 works at r.a. 1777–
1818.

COLLINS, Samuel
Born in Bristol, the son of a
clergyman; educated as a lawyer;
practised in Bath; in Bristol
c. 1762. Miniatures.

COLLINS, William (1788–1847)
Studied at r.a. 1807; patronised by
Sir George Beaumont, and friend
of J. Stark; travelled in Italy.
Coastal scenes and genre,

especially of children. Exhibited 124 works at R.A. and 45 at B.I. 1807–46. (*V. & A., B.M., Newcastle*)

COLLINS, William Wiehe
(b. 1862)
(fl. 1886–93)
Member R.I. 1897. Domestic subjects. Exhibited 10 works at N.W.C.S., 1 at R.A., 14 at S.B.A.

COLLYER, Joseph (1748–1827)
Born London; book illustrator and engraver; portrait-engraver to Queen Charlotte; A.R.A. Exhibited 31 works, 11 at Society of Artists, 18 at R.A. 1770–1822.

COLSON, J. (fl. 1844–66)
Architectural draughtsman. Exhibited 2 works at R.A. 1844.

COLTMAN, Thomas (or John?)
(fl. 1780)
Probably of Lancashire, and may have been the T.C. (1746–1826) who was a friend of Wright of Derby. Simple Lake District scenes in ink and wash in the manner of F. Towne.

COMERFORD, John (1762?–1831?)
Born Kilkenny; studied at Dublin Society's School. Miniatures and portrait sketches. Exhibited 3 works at R.A. 1804–9.

COMPTON, T. (fl. 1806–14)
Drawing master at Royal Marine College, Woolwich; probably responsible for 24 drawings used as illustrations to 'The Cambrian Mountains'. (*Woolwich*)

CONDER, Charles Edward
(1868–1909)
Descended from Roubiliac; as a child in India; thence to Australia as a surveyor; studied at Sydney

and Melbourne; to Europe 1890; studied in Paris 1893; to England 1897. Landscapes and figure subjects on silk. (*B.M., V. & A., Whitworth*)

CONDY, Nicholas Matthew
(1799–1857)
Born Plymouth. Landscapes and marines. Exhibited 3 works at R.A. 1842–45.

CONEY, John (1786–1833)
Born Ratcliff Highway; trained as an architect. Very accurate architectural drawings, landscapes and continental buildings reminiscent of the work of J. S. Cotman. Exhibited 6 works at O.W.C.S. and 10 at R.A. 1805–24. (*Bath, Whitworth, B.M., V. & A.*)

CONNARD, Philip (1875–1958)
Born Southport; studied at South Kensington and later in Paris; member New English Art Club 1909; taught at Lambeth School of Art; friend of P. W. Steer; A.R.A. 1918, R.A. 1925; assoc. R.W.S. 1932, member 1934; Keeper R.A. 1945–49. Landscapes.

CONRADE, Alfred Charles
(1863–1955)
Born England, but exhibited in France; travelled in Japan. Architectural topography.

CONSTABLE, John (1776–1837)
Born East Bergholt, Suffolk the, son of a miller; encouraged by Sir George Beaumont; to London 1795, then back to Suffolk; returned to London 1799 to study at R.A.; A.R.A. 1819, R.A. 1829. Landscapes. Exhibited 137 works, 104 at R.A., 32 at B.I., 1802–37. (*V. & A., B.M., Cambridge, Norwich, Whitworth*)

COOK, Ebenezer Wake (b. 1848)
Born Malden. Landscapes.
(*Gateshead*)

COOK, H. Moxon (fl. 1868–93)
Landscapes. Exhibited 10 works at
R.I. and 6 at N.W.C.S.

COOK, Samuel (1806–59)
Born Camelford; apprenticed to a
woollens manufacturer; then
worked at Plymouth as a painter
and glazier; member N.W.C.S.;
assoc. N.W.C.S. 1849, member
1854. Coastal scenes, mostly
around Plymouth. Exhibited 70
works at N.W.C.S. (*V. & A.,
B.M.*)

COOKE, Edward William
(1811–80)
Born London; associated with
M. E. and J. J. Cotman, and
sketched ship details for Clarkson
Stanfield; visited France,
Scandinavia, Holland, Egypt and
Italy 1845–46; A.R.A. 1851, R.A.
1863. Illustrations for the
'Botanical Cabinet', river scenes
and marines. Exhibited 256 works,
115 at B.I., 129 at R.A. 1835–79.
(*V. & A., B.M.*)

COOKE, Isaac (fl. 1877–93)
Worked at Liskeard, Cornwall.
Exhibited 13 works at N.W.C.S.,
6 at R.A., 4 at B.A.

COOPER, Abraham (1787–1868)
R.A. Battle scenes with horses
against fine landscapes, in oils and
in watercolour. Exhibited 419
works, 332 at R.A., 74 at B.I.,
13 at O.W.C.S. 1812–69.

COOPER, Alexander Abraham
(1605?–60)
Brother of Samuel; pupil of John
Hoskins; in the Hague 1632–33,
and portrait-painter to Queen

Christina in Stockholm; worked
for Christian IV in Denmark 1656.
Miniatures and portraits.

COOPER, Edwin (1785–1833)
Born Beccles, the son of Daniel,
drawing master at Bury School.
Horses and other animals, and
genre. Exhibited 2 works at R.A.
(*B.M., Norwich*).

COOPER, Emma (fl. 1872–1893)
Worked at New Barnet. Exhibited
12 works at N.W.C.S., 1 at R.A.

COOPER, Richard Jr (1740?–1814?)
Born Edinburgh; son of engraver
R. Cooper and studied under him,
also in Paris; travelled in Italy;
drawing master at Eton. Land-
scapes and views. Exhibited 24
works at R.A. 1787–1809.
(*Whitworth, V. & A., B.M.*)

COOPER, Samuel (1609–72)
Born London; pupil of John
Hoskins. Miniatures.

COOPER, Thomas George
(fl. 1861–93)
Rustic subjects with figures.
Exhibited 13 works at N.W.C.S.,
30 at R.A., 3 at B.I.

COOPER, Thomas Sidney
(1803–1902)
Born Canterbury; a coach-painter,
helped by Sir T. Lawrence to study
at R.A.; to Brussels 1827 to study
under Verboeckhoven; to England
1831; member N.W.C.S. 1833,
A.R.A. 1845, R.A. 1867. Cattle
and pastoral scenes, and occasional
marine views. Exhibited 312
works, 230 at R.A., 48 at B.I.,
14 at S.B.A., 1833–93. (*Newport,
V. & A., B.M.*)

COOPER, W. Sidney (fl. 1871–91)
Son of Thomas Sidney. Animal

subjects. Exhibited 63 works, 36 at R.I., 2 at N.W.C.S.

COPE, Charles West, 'the elder' (fl. c. 1800)
Father of Charles West Jr; worked in Leeds.

COPE, Charles West, Jr (1811–90)
Born Leeds; studied at Sass's Academy 1827; R.A. schools 1828, and later in Paris, Naples and Florence; R.A. Domestic scenes. Exhibited 134 works at R.A. (*B.M.*)

CORBAUX, Fanny (1812–83)
Self-taught; member N.W.C.S. 1839, hon. member S.B.A. 1830; Society of Arts gold medal 1830. Portraits. Exhibited 38 works at N.W.C.S., 86 at R.A., 15 at B.I., 48 at S.B.A. 1828–54.

CORBAUX, Louisa (1804–88)
Member N.W.C.S. 1837. Animal subjects. Exhibited 86 works at N.W.C.S., 3 at R.A., 17 at S.B.A. 1828–81.

CORBET, Matthew Ridley (1850–1902)
Born South Willingham, Lincolnshire; studied at the Slade and at R.A.; A.R.A. 1902. Portraits and landscapes. Exhibited at R.A. from 1871.

CORBOULD, Edward Henry (1815–1905)
Member R.I. 1838. Genre subjects. Exhibited 241 works at N.W.C.S., 17 at R.A., 1 at B.I., 13 at S.B.A.

CORBOULD, Henry (1787–1844)
Son of Richard. Illustrations and figure subjects. (*B.M.*)

CORBOULD, Richard (1757–1831)

Born London; father of Henry. Illustrations, landscapes and portraits. Exhibited 131 works, 100 at R.A., 27 at B.I. 1776–1817. (*B.M.*)

CORDINIER, R. W. Charles (fl. 1790–91)
Born Scotland; an amateur; studied at Foulis Academy Glasgow. Scottish scenes, some of them coastal. Exhibited 8 works at Free Society.

CORNER, George E. (fl. c. 1889)
Drawing master at Royal Military Academy, Woolwich. Domestic subjects. Exhibited 9 works at W.C.S. 1886–91.

CORNISH, William Permeanus (fl. 1875–92)
Landscapes. Exhibited 12 works at S.B.A., 3 at N.W.C.S.

COSTELLO, Louisa Stuart (1799–1870)
Born France; to London c. 1820. Miniatures and portraits. Exhibited 14 works at R.A. 1822–38.

COSWAY, Richard (1740–1821?)
Born Tiverton; awarded premiums by Society of Arts 1755 and 1758–60; studied at R.A. 1769; A.R.A. 1770, R.A. 1771. Leading miniature-painter. Exhibited 75 works, 45 at R.A. 1760–1808.

COSWAY, Mrs Richard (née Hadfield) (1759–1838)
Born Florence; member Florence Academy 1778; married Cosway 1781. Miniatures. Exhibited 42 works at R.A. 1781–1801.

COTES, Francis (1726–70)
Born Ireland; worked in London

and Bath. Landscapes in the Sandby style. (*V. & A.*)

COTES, Samuel (1734–1818)
Brother of Francis. Miniatures, crayon portraits and enamels. Exhibited 86 miniatures, 58 at R.A. 1760–89.

COTMAN, Anne (1812–62)
Daughter of J. S. and sister of M. E. and J. J. Works are rare. (*B.M.*)

COTMAN, Frederick George (1850–89)
Born Ipswich; nephew of J. J.; member R.I. 1882. Figure subjects. Exhibited 160 works, 44 at N.W.C.S., 39 at R.A., 9 at S.B.A., 1870 onwards. (*Norwich*)

COTMAN, John Joseph (1814–78)
Born Yarmouth; son of J. S.; of the Norwich School. Drawing master and landscape-painter. Exhibited 9 works, 1 at R.A., 8 at B.I. 1852–56.

COTMAN, John Sell (1782–1842)
Born Norwich; father of M. E. and J. J.; to London 1800, where befriended by Dr Monro; returned to Norwich 1806; member Associated Artists in Water Colours and O.W.C.S., president Norwich S.A. 1811; taught drawing in Norwich, and at King's College School London. Landscapes and marines. Exhibited 51 works at O.W.C.S., 30 at R.A., 9 at B.I., 1 at S.B.A. (*Norwich, Leeds, V. & A., B.M., Whitworth*)

COTMAN, Miles Edmund (1810–58)
Born Norwich; son of J. S., whom he assisted at King's College, London; later was

drawing master at North Walsham. River and sea views in his father's style, but tighter. Exhibited 19 works at S.B.A., 4 at R.A., 10 at B.I. (*Norwich, Newcastle, Whitworth, V. & A., B.M.*)

COULDERY, Thomas W. (fl. 1883–93)
Domestic subjects. Exhibited 7 works at N.W.C.S., 3 at R.A., 4 at S.B.A.

COUTTS, Hubert Herbert (fl. 1874–93)
Worked in Ambleside. Exhibited 13 works at N.W.C.S.

COVENTRY, Robert McGowan (1855–1914)
Born Glasgow; assoc. R.S.A., member R.S.W. North Sea marines and Dutch harbours. Exhibited from 1890 at R.A.

COWELL, Emma (fl. 1849–56)
Landscapes, mostly in Worcester, Norfolk and Enfield. Exhibited 8 works at B.I., 5 at R.A. and 12 at R.S.B.A.

COWEN, William (1797–1861)
Worked in Rotherham. Founder member N.W.C.S. 1831. Continental and Irish views. Exhibited 91 works, 15 at N.W.C.S., 16 at R.A., 32 at B.I., 13 at S.B.A. 1811–60. (*B.M.*)

COWPER, Douglas (1817–39)
Born Gibralter. Dramatic subjects. Exhibited 17 works, 6 at R.A., 3 at B.I., 8 at S.B.A. 1837–39.

COWPER, Frank Cadogan (1877–1958)
Assoc. R.W.S. 1904; R.W.S. 1911; R.A. Subject pictures, portraits.

COX, David (1783–1859)
Born Deritend, Birmingham;
apprenticed to a miniature
painter, and a pupil of Joseph
Barber; then scene-painter in
Birmingham; to London 1804,
where taught by John Varley;
taught at Great Marlow and
Sandhurst Military Colleges
1813–14 and visited France;
drawing master in Hereford
1815–27; worked in London until
1841, when he settled in Harborne,
Birmingham; made regular visits
to Bettws-y-Coed in North Wales;
president Associated Artists in
Water Colours and member
o.w.c.s. Inimitable landscapes,
many in North Wales and
seascapes. Exhibited 973 works,
849 at o.w.c.s., 13 at R.A., 3 at
B.I., 4 at S.B.A., 1805–59.
(*Birmingham, Hereford, Oxford,
Whitworth, V. & A., B.M.*)

COX, David Jr (1809–85)
Born Dulwich; son and pupil of
David; member N.W.C.S. 1845–46,
assoc. O.W.C.S. then R.W.S.
Landscapes in his father's style,
some done conjointly with him.
Exhibited 670 works, 579 at
O.W.C.S., 87 at N.W.C.S., 3 at R.A.
1827–84. (*Whitworth,
Scarborough, B.M.*)

COZENS, Alexander (1717–86)
Born Russia; father of John
Robert; studied in Italy; in
England by 1742; back in Italy
1763–64; taught drawing at
Christ's Hospital, London, at
Bath, and at Eton; travelled with
his friend Beckford. Landscapes.
Exhibited 33 works, 18 at
Society of Artists, 7 at Free
Society, 8 at R.A., 1760–81.
(*Whitworth, Newcastle, Leeds,
V. & A., B.M.*)

COZENS, John Robert (1752–97)
Son of Alexander; much travelled;
became insane in 1794 and placed
under the care of Dr Monro.
Landscapes usually in blues, faint
greens and greys. Exhibited 6
works, 5 at Society of Artists,
1 at R.A. (*Whitworth,
Birmingham, Newcastle, Bedford,
Cambridge, Oxford, V. & A.,
B.M.*)

CRAIG, Frank (1874–1918)
Born London; studied at R.A.;
worked for Harper's magazines,
and others. Mostly black and
white illustrations. Exhibited
after 1890 at S.B.A.

CRAIG, William Marshall
(fl. 1788?–1828)
Worked in Manchester 1788; in
London 1791 as drawing master
and illustrator; watercolour
painter to the Queen 1812; court
painter to Duke of York c. 1820;
member Associated Artists in
Water Colours. Landscapes.
Exhibited 259 works, 152 at R.A.
1788–1828. (*Newport, B.M.*)

CRANE, Thomas (1808–59)
Born Chester; assoc. Liverpool
Academy 1835, member 1838;
treasurer 1842–44. Miniatures,
genre and landscapes. Exhibited 15
works at R.A. 1842–58.

CRANE, Walter (1845–1915)
Apprenticed to engraver W. J.
Linton, and much influenced by
Pre-Raphaelites; principal R.C.A.,
member R.I. 1882–86; assoc.
R.W.S. 1880, member 1902.
Illustrator and figure subjects.
Exhibited (278 works, 67 at
O.W.C.S., 13 at N.W.C.S., 2 at R.A.
1862–93. (*Liverpool, V. & A.,
B.M.*)

CRAWFORD, William (d. 1869)
Of Ayr; assoc. R.S.A. 1862. Crayon
portraits. Exhibited 23 works
1852–68 at R.A.

CRAWHALL, Joseph (1861–1913)
Born Morpeth; animals and birds;
also exhibited 1 landscape at R.A.
1883. (*Glasgow, B.M.*)

CRESWICK, Thomas (1811–69)
Born Sheffield; pupil of J. Barber in
Birmingham; in London 1828;
A.R.A. 1842, R.A. 1851. Carefully
drawn landscapes in Wales,
Ireland and the North of England,
usually with streams. Exhibited
266 works, 139 at R.A., 80 at B.I.,
46 at S.B.A. 1828–70. (*V. & A.,
B.M.*)

CRIDDLE, Mrs Harry (née Mary
Ann Alabaster) (1805–80)
Born Holywell, Flintshire; pupil of
G. Hayter 1824–26 and of Miss S.
Setchel 1846; member O.W.C.S.
Genre, and illustrations of the
poets. Exhibited 149 works at
O.W.C.S., 11 at R.A., 18 at B.I.,
14 at S.B.A. 1837–79.

CRISTALL, Joshua (1767?–1847)
Born Cornwall; at first a china-
painter at Caughley, Shropshire;
studied at R.A. and under Dr
Monro; worked also at Goodrich,
Herefordshire, and at Hastings;
Founder member and president
O.W.C.S. Classical figures in
landscapes, rustic groups and
sentimental genre. Exhibited 376
works at O.W.C.S., 3 at R.A.,
3 at B.I. 1803–47. (*Hereford,
Glasgow, Newcastle, Whitworth,
V. & A., B.M.*)

CROCKET, Henry Edgar
(1874–1926)
A.R.W.S. 1908; R.W.S. 1913.
Landscapes.

CROCKFORD, George
(fl. 1835–65)
Pupil and imitator of G. Arnald as
regards oil painting. Landscapes
in Britain and on the Continent.
Exhibited 70 works at S.B.A.,
13 at R.A., 14 at B.I. 1835–65.

CROFTON CROKER, Marianne
(d. 1854)
Daughter of Francis Nicholson.
Landscapes in her father's style.

CROLL, Francis (1827–54)
Born Edinburgh; pupil of Dobbie,
R. C. Bell and Sir W. Allen.

CROME, John (1768–1821)
Born Norwich; known as 'Old
Crome', the son of a weaver;
apprenticed to Frank Whisler, a
sign-painter; patronised by Sir W.
Beechey; founded the 'Norwich
School'; drawing master at
Norwich Grammar School; to
Paris 1814; co-founder of Norwich
Society 1803, president 1810.
Landscapes. Exhibited 19 works.
13 at R.A., 6 at B.I. 1806
onwards. (*Doncaster, Ipswich,
Norwich, Whitworth, V. & A.,
B.M.*)

CROME, John Bernay (1794–1842)
Son of John, and taught by him.
Landscapes, often in sepia mono-
chrome, and unusually fine
moonlight effects. Exhibited 97
works, 7 at R.A., 35 at B.I., 55 at
S.B.A. 1811–43. (*Norwich, B.M.*)

CROMEK, Robert Hartley
(1771–1812)
Born Hull; father of T. H.; pupil
of Bartolozzi; an engraver of
Stothard's works.

CROMEK, Thomas Hartley
(1809–73)
Born London; son of R. H.; pupil

of J. Hunter at Wakefield, and J. Rhodes at Leeds; travelled abroad 1831–49; assoc. N.W.C.S. 1850. Landscapes, and architectural subjects in Rome and Athens. Exhibited 60 works at N.W.C.S.; 6 at R.A. 1835–72.

CROMPTON, James Shaw (1853–1916)
Member R.I. 1898. Domestic subjects. Exhibited 11 works at S.B.A., 15 at N.W.C.S.

CRONE, Robert (fl. 1770–99)
Born Ireland; pupil of R. Wilson in Rome. Landscapes, mostly Italian, in Wilson's style and on Wilson's special paper. Exhibited 26 works at R.A. 1770–78.

CROSSE, Lawrence (d. 1724)
Miniatures and watercolour copies of Old Masters.

CROSSE, Richard (1742–1810)
Born Knowle, Devon; was deaf and dumb; awarded premium of Society of Arts 1758. Miniatures. Exhibited 75 works, 14 at Soc. of Artists, 20 at Free Soc., 41 at R.A.

CROTCH, Dr William (1775–1847)
Born Norwich; a musical prodigy and well-known composer; pupil of Malchair. Landscapes in the Gainsborough manner. Exhibited 2 works at R.A. 1823. (*B.M.*)

CROUCH, William (fl. 1830–50)
Italian landscapes, about which little is known. (*B.M., Newport*)

CROWE, Eyre (1824–1910)
Born Chelsea; A.R.A. Historical subjects and genre. Exhibited 95 works, 84 at R.A., 2 at B.I., 1 at S.B.A., 1846 onward.

CROWQUILL, Alfred
See Forrester, Alfred Henry.

CROWTHER, John (fl. 1876–92)
Architectural subjects. Exhibited 3 works at N.W.C.S., 5 at R.A.

CROXFORD, William Edward (fl. 1871–92)
Landscapes. Exhibited 7 works at S.B.A., 3 at R.A., 4 at N.W.C.S.

CROZIER, Anne Jane (fl. 1868–86)
Exhibited 4 works at N.W.C.S., 4 at R.A.

CRUIKSHANK, George (1792–1878)
Born Bloomsbury; son of Isaac. Illustrator, particularly of Dickens and 'Pilgrim's Progress'. Exhibited 23 works, 8 at R.A., 15 at B.I. 1830–67. (*Newport, V. & A., B.M.*)

CRUIKSHANK, Isaac (1756?–1810?)
Born Edinburgh. Illustrator and caricaturist. Exhibited 3 works at R.A. 1789–92. (*V. & A., B.M.*)

CRUIKSHANK, Robert Isaac (fl. 1811–17)
Son of Isaac, for a time in service of East India Company. Portraits and book illustrations. Exhibited 8 works at R.A. 1811–17.

CUITT, George, Sr (1743–1818)
Born Yorkshire; in Italy 1769; thereafter lived in Richmond, Yorks. Portraits and landscapes in body-colour. Exhibited 14 works at R.A. 1776–1818. (*B.M.*)

CUITT, George, Jr (1779–1854)
Born Richmond, Yorks.; son of George Sr; drawing master at Chester; a fine etcher. Landscapes and fine studies of ruined abbeys. (*B.M., Newport*)

CULLUM, John (fl. 1833–49)
Landscapes near his home in
Battersea, and in Kent. Exhibited
27 works, 8 at s.b.a., 6 at r.a.,
7 at b.i.

CUMBERLAND, George
(1758?–1848)
Miniatures, landscapes and figure
subjects, some of which were
engraved by W. Blake. Exhibited
3 miniatures at r.a. 1773–76.

CUNDELL, H. (fl. 1838–58)
Landscapes and marines.
Exhibited 14 works at r.a.
(*B.M.*)

CUNNYNGHAME, D. (fl. c. 1782)
A Scottish topographer.
(*Edinburgh*)

CURNOCK, James (1812–70)
Worked in Bristol; member r.c.a.
Landscapes and portraits.
Exhibited 21 works, 8 at s.b.a.,
13 at r.a. 1847–62.

CURNOCK, James Jackson
(1839–91)
Son of James; also worked in
Bristol. Landscapes. Exhibited 56
works at s.b.a., 19 at n.w.c.s.,
17 at r.a.

CURREY, Fanny (fl. 1880–93)
Worked in Lismore, Ireland.
Landscapes. Exhibited 18 works at
n.w.c.s., 17 at r.a., 3 at s.b.a.

CURTIS, Charles M. (1795–1839)
Born London. (His brother was
the author of 'British
Entomology'.) Natural history
subjects. Exhibited 2 works, 1 at
s.b.a., 1 at n.w.c.s. 1827–32.

CURTIS, John (fl. 1790–97)
Pupil of W. Marlow. Landscapes.

DADD, Frank (fl. 1851–1929)
Worked at Lewisham; member
r.i. 1884. Genre. Exhibited 77
works, 19 at n.w.c.s., 7 at r.a.,
9 at s.b.a.

DADD, Richard (1819–87)
Born Chatham; studied at r.a.;
visited Middle East 1842–43;
returned insane, murdered his
father, and fled to France; on his
return spent from 1844 in Bedlam
and from 1861 in Broadmoor.
Landscapes and religious and
mythological subjects of fanciful,
imaginative variety. Exhibited 25
works, 16 at s.b.a., 4 at r.a.,
5 at b.i. 1837–42.
(*Newcastle, V. & A., B.M.*)

DAGLEY, Richard (d. 1841)
Educated at Christ's Hospital
London; apprenticed to a
jeweller; worked in London and
Doncaster; fl. from 1780.
Domestic subjects, portraits and
genre. Exhibited 72 works, 65 at
r.a., 3 at s.b.a. 1785–1833.

DAGNALL, T. W. (fl. 1785–1835)
Landscapes, coastal scenes and
marines, chiefly in North Wales
and the Isle of Man. Exhibited 52
works, 27 at s.b.a., 9 at r.a.,
15 at b.i. 1824–36.

DAKIN, Joseph (fl. 1850–90)
Landscapes. Exhibited 94 works,
51 at s.b.a., 14 at r.a., 8 at b.i.

DALL (or DAHL), Nicholas
Thomas (d. 1777)
Born Denmark; fl. from 1740; in
London by 1754; a scene-painter
at Covent Garden; a.r.a.
Gentlemen's country seats and

landscapes. Exhibited 55 works, 37 at Soc. of Artists, 18 at R.A. 1761–76. (*B.M.*)

D'ALMAINE, William Frederick (fl. 1846–64)
Figures. Exhibited 12 works at R.A.

DALTON, Richard (d. 1791)
A Yorkshire amateur and an authority on Art; fl. from 1720. Drew scenes during extensive travels, and became Surveyor of the Royal pictures.

DALTON, Mrs S. (fl. 1808–09)
A Yorkshire amateur who lived near Marsham; patroness and pupil of J. C. Ibbetson. Riverside and cottage scenes. Exhibited 3 works at R.A.

DANBY, Francis (1793–1861)
Born near Wexford, Ireland; pupil of J. A. O'Connor at Dublin; to Bristol 1813 and later to London; A.R.A. 1825; to Switzerland 1829; back in England 1841; from 1847 at Exmouth. Landscapes, simple and direct at first but later of dramatic historical type. Exhibited 67 works, 48 at R.A., 17 at B.I., 2 at S.B.A. 1820–60. (*Bristol, B.M.*)

DANBY, James Francis (1816–75)
Son of Francis. Landscapes in Britain, France, Italy and Switzerland. Exhibited 154 works, 67 at S.B.A., 35 at R.A., 42 at B.I. 1842–76.

DANBY, Thomas (1817?–86)
Born Bristol; son of Francis; member O.W.C.S. then R.W.S. Marine and landscapes. Exhibited 234 works at O.W.C.S., 32 at R.A., 42 at B.I. (*V. & A., B.M.*)

DANCE, George (fl. 1770–1800)
An architect; R.A. Sketches for improvements to ways between London Bridge and the Tower, and also portraits. Exhibited 27 works, 3 at Soc. of Artists, 24 at R.A.

DANCE, Nathaniel (fl. 1769–1800)
Elected R.A., but resigned 1790, married Mrs Dunner, and took the name of Holland. Historical subjects. Exhibited 28 works, 3 at Soc. of Artists, 24 at R.A.

DANCE, W., Jr (fl. 1819–59)
Of Holloway. Miniatures.

DANCKERTS, Henrik (1630?–80)
Born the Hague; visited England 1650 and settled by 1666; to Amsterdam 1679. Pen and wash drawings of Wales and London. (*B.M.*)

DANIELL, Abraham (d. 1803)
Died at Bath. Miniatures.

DANIELL, Rev. Edward Thomas (1804–42)
Born London; educated at Norwich and Balliol College, Oxford; pupil of J. S. Cotman and J. Crome, and friend of J. Linnell; travelled on the Continent and in Asia Minor. Landscapes. Exhibited 8 works, 4 at R.A., 4 at B.I., 1836–40. (*Norwich, Whitworth, B.M.*)

DANIELL, Samuel (1775?–1811)
Brother of William; travelled to South Africa and Ceylon, where he died. Animals and natives in landscapes. Exhibited 7 works, 1 at Soc. of Artists, 6 at R.A. 1791–1812. (*V. & A., B.M.*)

DANIELL, Thomas (1749–1840)
Born Kingston-on-Thames; apprenticed to a coach-painter;

**Pembroke Castle from
the South West**

Edward Dayes
(1763–1804)

Signed, and dated 1789
13¾" x 23¼"

The colours of this drawing are so soft, and at the same time so harmonious and gay, that the castle itself is barely visible in the left background. As usual the overall effect is blue. The preliminary penwork is delicate and careful, and the tree drawing shows the characteristic spreading out at the edges of the foliage into widespread fingers. The well-placed figures are rather elongated, as so many of Dayes's figures are. But they are typically graceful and elegant and full of meticulous detail. Dayes is a figure of great importance in the history of English watercolour painting. He was among the most outstanding of the early topographers. Also, he exerted a marked influence upon the works of his pupil Girtin and Turner just before the end of the eighteenth century. In fact, it is often extremely difficult to distinguish between the work of the three artists.

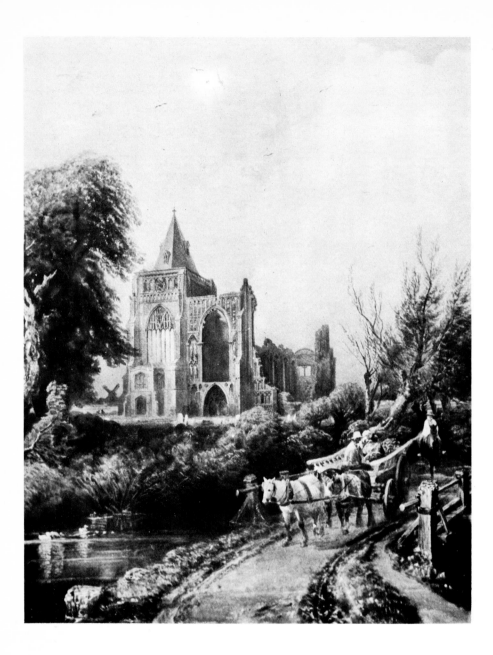

Crowland Abbey, Lincolnshire

Peter de Wint
(1784–1849)
31" x 25¼"

This very important drawing is probably the No. 20 which was exhibited at the 1835 exhibition of the Old Watercolour Society. In certain respects it is perhaps uncharacteristic of De Wint's work. It lacks his well-known panorama, for instance, and his effective way of leaving his foreground unfinished, to look after itself so to speak. Nevertheless, in the original can be seen the artist's inimitable mosaics of added tints flooded into a wet wash, the indeterminate trees, and the scraping with a knife.

Distinctive above all is the direct use of strong colour, roughly applied. De Wint's colour technique in watercolours is comparable to that of Constable in oils. The careful drawing of the abbey itself, which contrasts noticeably with the rather summary treatment of the horses, cart and figures, is exceptional. So is the unfaded blue sky, which is difficult to photograph successfully.

studied at R.A. 1773; to India with his brother William 1783; back in England 1793; A.R.A. 1796, R.A. 1799. Landscapes. Exhibited 125 works at R.A. 1772–84 and 1795–1828, and 10 at S.B.A. (*R.I.B.A., V. & A., B.M.*)

DANIELL, William (1769–1837)
Brother of Samuel and nephew of Thomas, with whom he went to India 1783; A.R.A. 1807, R.A. 1822. Landscapes. Exhibited 168 works at R.A., 64 at B.I. 1795–1838. (*Whitworth, V. & A., B.M.*)

DARBISHIRE, Henry Astley (fl. 1857–70)
An architect. Architectural views. Exhibited 6 works at R.A.

DARBY, Matthew
Late 18th century and lived at Bath. Published engravings of H. W. Bunbury's works. Caricatures.

DARCEY, W. (fl. c. 1778)
Lived in Portsmouth; accompanied an Embassy to China, where he painted Chinese scenes. Also a miniaturist.

DARLEY, J. F. (fl. 1886–93)
Landscapes. Exhibited 10 works at S.B.A.

DARVALL, Henry (fl. 1850–90)
Landscapes. Exhibited 65 works, 13 at S.B.A.

DAVEY, Robert (fl. 1782–93)
A drawing teacher at Addiscombe Military Academy.

DAVIDSON, Alexander (1838–97)
Lived in Glasgow; member R.S.W. Genre. Exhibited 7 works at S.B.A.

DAVIDSON, Charles (1824–1902)
Born Falmouth; studied under

J. Absolon; for 28 years at Redhill; and at Falmouth 1882 until his death; friend of Samuel Palmer, J. Linnell and the Varleys; member N.W.C.S., 1847–1853 and O.W.C.S. Landscapes with fine foliage treatment. Exhibited 800 works at O.W.C.S., 114 at N.W.C.S., 4 at R.A., 6 at B.I., 24 at S.B.A. 1844–93. (*V. & A., B.M.*)

DAVIES, Edward (1841–1920)
Lived in Leicester. Member R.I. 1896. Landscapes. Exhibited 48 works, 24 at N.W.C.S., 16 at R.A.

DAVIS, Edward Thomas (1833–1867)
Born Worcester. Genre.

DAVIS, F. (1750–90)
Birds.

DAVIS, Frederick William (1862–1919)
Member R.I. 1897. Member R.B.A. Domestic scenes.

DAVIS, Henry William Banks (1833–1914)
A sculptor; studied at R.A., A.R.A. 1873, R.A. 1877. Landscapes. Exhibited 141 works, 100 at R.A., 5 at B.I., 17 at S.B.A., 1853 onward

DAVIS, John Scarlett (1804–45)
Born Leominster; studied drawing under Witherington, and portraiture under Lawrence; also studied at R.A. 1820–22 and at the Louvre; to Wales 1822; to London and Yorkshire 1829. Drawings in the style of Bonington, and architectural drawings in the style of J. S. Cotman. Exhibited 27 works, 14 at S.B.A., 7 at R.A., 6 at B.I. 1822–44. (*Hereford, Whitworth, B.M., V. & A.*)

E

DAVIS, Lucien (1860–1930)
Member R.I. 1893. Domestic scenes. Exhibited 17 works R.A. 1878–1893.

DAVIS, Samuel (1757–1809?)
Born West Indies; sailed to Bengal 1780–81 and visited South Africa and St Helena; Accountant-General in Bengal. Drawings of views in India and of other places visited during his travels.
(*V. & A., B.M.*)

DAVIS, Capt. Thomas (fl. c. 1795)
Chinese scenes, perhaps made during the Macartney mission, which he accompanied.

DAVISON, Nora (fl. 1881–93)
Landscapes. Exhibited 20 works at S.B.A.

DAVY, Rev. H. (fl. 1820–27)
Lived at Henstead, Suffolk; tutor to Sir George Beaumont, and friend of T. Hearne. Suffolk landscapes.

DAWE, Henry (1790–1848)
Born London; an engraver; studied under his father Philip and at R.A.; assisted J. M. W. Turner in the 'Liber Studiorum'; member S.B.A. 1830. Exhibited 77 works, 1 at R.A., 4 at B.I., 72 at S.B.A. (1824–1945)

DAWE, Philip (fl. c. 1760)
Father of Henry; worked under Hogarth. Engraved many of Morland's works.

DAWSON, Henry (1811–78)
Born Hull; moved to Nottingham and back to Hull before settling in London. Landscapes, marines, and views of London from the Thames. Exhibited 85 works, 6 at S.B.A., 28 at R.A., 33 at B.I.

DAWSON, Nelson (fl. 1885–1941)
Member R.B.A. Member Royal Society Portrait Painters—West of England Academy. Assoc. R.W.S. 1921. Landscapes. Exhibited 83 works, 56 at S.B.A., 8 at N.W.C.S., 14 at R.A.

DAY, Alexander (1770–1841)
Studied in Italy. Miniatures.

DAY, Thomas (1738–1808)
Miniatures and landscapes in the style of E. Dayes. Exhibited 61 works, 6 at Soc. of Artists, 4 at Free Soc., 51 at R.A.

DAY, William (fl. 1768–1805)
Topography in the style of F. Towne, mostly in Wales. Exhibited 21 works at R.A.
(*V. & A.*)

DAYES, Edward (1763–1804)
Pupil of W. Pether; studied at R.A. 1780; draughtsman to the Duke of York; pupil of T. Girtin. Landscapes, usually with figures. Exhibited 69 works, 64 at R.A.
(*Hereford, Whitworth, Newport, V. & A., B.M.*)

DEACON, Augustus Oakley (fl. 1840–62)
Landscapes and views of churches, mostly in Derbyshire. Exhibited 52 works, 9 at R.A., 10 at B.I., 10 at S.B.A.

DEACON, James (1728–50?)
Classical landscapes, mostly in grey monochrome, and miniatures.
(*B.M., Cottonian College, Plymouth*)

DEAKIN, Peter (fl. 1855–79)
Friend and executor of David Cox. Landscapes. (*V. & A.*)

DEAN, Frank (or Frankland) (b. 1865)

Born Leeds; studied in London at the Slade under Legros, and in Paris, 1882–86, under Lefebre and Boulanger; member R.B.A. 1894, but resigned 1897. Landscapes and domestic subjects. Exhibited 6 works, 4 at R.A., 2 at S.B.A. 1885–90.

DEAN, John (d. 1798)
A mezzotint engraver, engraving many of his own works and those of Gainsborough, Reynolds, and others.

DEANE, William Wood (1825–73)
Born Islington; an architect; to Rome 1850; to Venice 1865; medallist at Vienna Exhibition 1873; member N.W.C.S. 1867, assoc. O.W.C.S. Landscape and architecture in Italy, Kent, Wales and the Lake District. Exhibited 209 works, 58 at O.W.C.S., 102 at N.W.C.S., 23 at R.A., 4 at B.I., 13 at S.B.A. (*Newcastle, V. & A.*)

DEARMAN, Elizabeth (fl. 1828–46)
Rural scenes. Exhibited 23 works.

DEARMAN, Thomas (d. 1857?)
Of Guildford. Landscapes and cattle. Exhibited 6 at R.A., 4 at B.I., 12 at S.B.A., 1 at N.W.C.S.

DEARMER, Thomas (fl. 1840–67)
Landscapes in the Thames Valley and in Sussex, Ireland, Wales and Italy, 1863. Exhibited 21 works at R.A., 14 at B.I., 23 at R.S.B.A.

DE CORT, Hendrick Franz (1742–1810)
Born Antwerp. Views with ruins in pencil and monochrome. (*Bath*)

D'EGVILLE, J. F. (fl. 1837–80)
Member N.W.C.S. Landscapes. Exhibited 256 works at N.W.C.S. (*V. & A.*)

D'EGVILLE, J. Hervé (d. 1880)
Assoc. N.W.C.S. 1840, member 1848. Landscapes in Venice, Wales and south east England; fl. from 1860. (*V. & A.*) (*Note.* There is some confusion regarding the two D'Egvilles. Details given here are according to Graves.)

DE LA COUR, F. J. (fl. c. 1806)
Marines, with curly, stylised waves, in the stained drawing technique.

DELACOUR, William (1700?–68)
Born France; a Rococo designer who worked in London producing pattern books; to Dublin 1747 as a stage designer; later the first master of Edinburgh School for Drawing. (*B.M.*)

DELAMOTTE, Philip Henry (1820–89)
Son of William Alfred; Master at King's College, London. Landscapes and buildings. Exhibited 16 works, 2 at S.B.A., 2 at R.A. (*B.M.*)

DELAMOTTE, William Alfred (1775–1863)
Studied at R.A. and taught by B. P. West; at Oxford for a time; in Paris 1802; drawing master at Great Marlow Military Academy c. 1803; also pupil of Malchair. Assoc. O.W.C.S. 1806. Landscapes, some influenced by Taverner. Exhibited 84 works, 11 at O.W.C.S., 53 at R.A., 13 at B.I., 7 at S.B.A. (*Sheffield, Whitworth, B.M.*)

DE LOTZ, George Gregor (1819–79)
Son of a French officer and a Scotswoman; to London as a house-painter. Drew for his own amusement. (*V. & A.*)

DE LOUTHERBOURG, Philip
James (1740–1812)
Born Strasbourg; the son of a
miniature painter; pupil of
Casanova and Carlo Vanloo;
member Academie Royale 1767;
to England 1771; A.R.A. 1780, R.A.
1781. Landscapes, battle scenes,
coastal views and theatrical
scenery. Worked for Garrick at
Drury Lane. Exhibited 155 works,
147 at R.A., 3 at S.B.A. 1772–1814.

DE MARTINO, Chevalier Eloardo
(d. 1910)
Born near Naples; marine painter
to the Court of Dom Pedro; to
London 1875; marine painter to
Queen Victoria and Edward VII;
died London. Naval reviews and
marines. Exhibited 4 works at
Grosvenor Gallery 1879.

DENBY, William (1819–75)
Born Great Bookham, Surrey;
pupil of William Dyce; head of
Antique Dept. at South Kensington
School. Scriptural subjects.
Exhibited 13 works, 7 at R.A.,
3 at B.I., 3 at S.B.A. 1850–69.

DENHAM, John Charles
(fl. 1796–1860)
Friend of J. S. Cotman and
Girtin; amateur treasurer of the
Sketching Society. Landscapes.
Exhibited 63 works at R.A.

DENNING, Stephen Poyntz
(1795–1864)
Curator of Dulwich Gallery 1821.
Miniature portraits and miniature
copies of Old Masters. Exhibited
52 works, 48 at R.A., 2 at B.I.,
2 at S.B.A. 1814–52.

DENNIS, John (fl. 1800–32)
Once better known than nowadays.
Landscapes, mostly in Wales and
a few in Switzerland. Exhibited 38
works, 28 at R.A., 10 at B.I.

DENNISTOUN, William
(1838–84)
Worked in Capri. Landscapes and
architectural subjects. Exhibited 1
work at N.W.C.S.

DERBY, Alfred Thomas (1821–73)
Son of William. Miniatures.
Exhibited 36 works, 6 at S.B.A.,
22 at R.A., 8 at B.I. 1839–72.

DERBY, William (1786–1847)
Born Birmingham; pupil of
J. Barber; to London 1808.
Portraits and miniatures.
Exhibited 86 works, 15 at S.B.A.,
5 at N.W.C.S., 49 at R.A., 16 at
B.I.

DES GRANGES, David (1611–75)
Born London; of Huguenot
parents. Miniatures.

DE TABLEY, Lord (Sir J. F.
Leicester) (1762–1827)
Patron and collector. Miniatures.

DETMOLD, Charles Maurice
(1883–1908)
Worked on his paintings with
brother Edward Julian; exhibited
at R.A. at the age of 13. Illustrated
Kipling's 'Jungle Book' 1903;
Assoc. Royal Society of Painters,
Etchers and Engravers. Fish,
birds and animals.

DEVERELL, Walter Howell
(1828–54)
Worked with the Pre-Raphaelites;
introduced Mrs Elizabeth Siddal
to D. G. Rossetti. Historical
subjects. Exhibited 9 works,
4 at R.A., 1 at B.I., 2 at S.B.A.

DE VILLE, Joseph Vicars (or
Vickers) (1856–1924)
Born Eaton, Derbys.; worked for

many years with a Birmingham firm of colour merchants; member R.S.B.A. 1917. Landscapes and domestic subjects. Exhibited 11 works, 10 at R.A. 1887–93.

DEVIS, Anthony Thomas (1729–1817)
Brother of Arthur, an oil painter, and uncle of Arthur William; drawing teacher in London; won premiums at Society of Arts 1763. Landscapes. Exhibited 4 works at R.A. 1772–81. (*Newport, Newcastle, Whitworth, Preston, V. & A., B.M.*)

DEVIS, Arthur William (1763–1882)
Born London; accompanied Capt. Wilson round the world in the *Antelope*; then to Bengal, returning 1795. Eastern scenery, landscapes with historical connections. Exhibited 92 works, 1 at O.W.C.S., 13 at Free Soc., 65 at R.A., 13 at B.I.

DE WILDE, Samuel (1748?–1832)
Born Holland; studied at R.A. 1769. Illustrations and dramatic portraits. Exhibited 120 works, 5 at S.B.A., 9 at Soc. of Artists, 103 at R.A., 1776–1832. (*V. & A., B.M.*)

DE WINT, Peter (1784–1849)
Born Stone, Staffs., of Dutch descent; pupil of John Raphael Smith; also studied at R.A. 1807; member Associated Artists in Water Colours and O.W.C.S. Landscapes and still life. Much imitated by many pupils. Exhibited 454 works, 417 at O.W.C.S., 13 at R.A., 11 at B.I. 1807–49. (*Lincoln, Birmingham, Whitworth, V. & A., B.M.*)

DIBDIN, Thomas Colman (1810–93)
At one time a GPO clerk; author of books on drawing, and claimed to be the inventor of cromolithography. Town scenes, some in France and Switzerland, and scenes of local industrial interest. Often painted in the style of S. Prout. Exhibited 203 works, 15 at R.A., 15 at B.I. 1831–83, 79 at S.B.A. (*Gateshead, Newcastle, V. & A., B.M.*)

DICKINSON, John Reed (fl. 1867–81)
Lived for some time at Hampstead; travelled to Russia and America. Domestic subjects. Exhibited 44 works at S.B.A., 8 at R.A.

DICKINSON, Lowes Cato (1819–1908)
Born Kilburn; visited Italy and Sicily 1850–53; taught drawing at Working Men's Colleges. Portraits. (*V. & A.*)

DICKSEE, Sir Frank Bernard (1853–1928)
Member R.I. 1891, P.R.A., A.R.S.A., H.R.O.I.

DICKSEE, Herbert Thomas (1862–1942)
Studied at the Slade in London under Legros. Voyaged round the world; drawing master at City of London School. Animals, atmospheric effects in landscape backgrounds. Exhibited 26 works, 25 at R.A., 1 at S.B.A. 1881–93.

DIGHTON, Denis (1792–1827)
Born London; son of Robert and brother of Richard, a portrait-painter; studied at R.A. 1807; military painter to Prince Regent 1815; military subjects and landscapes in the Varley style; caricatures in the style of his

father. Exhibited 34 works, 17 at R.A., 8 at B.I., 1811–25. (*V. & A., B.M.*)

DIGHTON, Robert (1752?–1814) Father of Denis. Portrait painter and caricaturist, some in miniature style. Exhibited 20 works, 14 at Free Soc., 6 at R.A. 1769–99. (*Newport, V. & A., B.M.*)

DIGHTON, William Edward (1822–53) Pupil in London of W. J. Müller and F. Goodall; travelled in the Holy Land. Landscapes. Exhibited 27 works, 10 at R.A., 6 at B.I. 1843–53. (*V. & A.*)

DILLON, Frank (1823–1909) Studied at R.A. and under James Holland; travelled in Spain, Italy, Norway, Egypt and Japan; member R.I. 1882. Landscapes, mostly abroad; 10 drawings of Cairo in V. & A. Exhibited 221 works, 40 at R.A., 34 at B.I., 48 at N.W.C.S., 1850–93, 48 at N.W.C.S.

DINGLE, T. (fl. 1846–88) Small landscapes, many of them copies of the works of Turner, for connoisseurs' collections. Exhibited 26 works, 8 at R.A., 4 at B.I., 14 at S.B.A., 1846–88, 14 at S.B.A.

DINSDALE, George (fl. 1808–29) Probably of Yorkshire, but worked also in Scotland, Ireland and Cheltenham. Landscapes. Exhibited 81 works, 8 at O.W.C.S., 14 at R.A., 23 at B.I., 4 at S.B.A.

DITCHFIELD, Arthur (1842–88) Born London; studied at Leigh's School, London, and R.A. 1861; much travelled. Landscapes. Exhibited 122 works, 4 at

N.W.C.S., 12 at R.A., 3 at B.I., 5 at S.B.A. (*V. & A., B.M.*)

DIXEY, Frederick Charles (fl. 1877–95) Marines. Exhibited 19 works, 4 at N.W.C.S., 1 at R.A., 10 at S.B.A.

DIXON, Charles (fl. 1846–1900) Views of shipping on the Thames, and views in Liverpool, Isle of Wight and Plymouth. Exhibited 10 works, 8 at R.A., 1 at N.W.C.S. 1889–93.

DIXON, Charles Edward (1872–1934) Member R.I. 1900.

DIXON, John (d. 1715) Pupil of Lely. Miniatures.

DIXON, Nicholas Said to be brother of John. Miniatures.

DIXON, Percy (1862–1924) Member R.I. 1915. Landscapes. Exhibited 31 works, 18 at N.W.C.S., 1 at R.A., 12 at S.B.A.

DIXON, Robert (1780–1815) Born Norwich; a theatrical scene-painter; vice-president Norwich Society 1809. Dark-toned landscapes, carefully detailed. Exhibited at R.A. 1798 and at Norwich. (*Norwich, Whitworth, V. & A., B.M.*)

DIXON, Samuel (fl. 1748–64) Of Dublin; studied under R. West at Dublin Society's School; probably invented 'embossed pictures'. Flowers and birds on vellum.

DOBBIN, John (fl. 1842–84) Landscapes, some in Britain others in France, Holland, Spain and

Germany. Exhibited 146 works, 38 at R.A., 4 at B.I., 102 at S.B.A.

DOBSON, John (1787–1865)
Born Chirton, North Shields; articled to a Newcastle builder; pupil of John Varley; fellow R.I.B.A. Architectural subjects, sometimes coloured by T. M. Richardson, J. W. Carmichael and others. Exhibited 2 works at R.A. (*Newcastle, B.M.*)

DOBSON, Robert (fl. 1860–90)
Of Liverpool and Birkenhead; studied at Birkenhead School of Art. Genre. (*Walker Gallery*)

DOBSON, William Charles Thomas (1817–98)
Born Hamburg; studied at R.A. 1836; member of Etching Club 1842; headmaster of Government School of Design; in Birmingham 1843. Studied in Italy and Germany; A.R.A. 1860, R.A. 1872, H.R.A. 1895; member O.W.C.S. 1870. Genre, portraits and scriptural subjects. Exhibited 179 works, 117 at R.A., 9 at S.B.A. 1842–92, 53 at O.W.C.S.

DODD, Charles Tattershall (1815–78)
Born Tonbridge; taught drawing at Tunbridge Wells; drawing master at Tonbridge School 1837 until his death. Large landscapes. Exhibited 38 works, 11 at R.A., 26 at B.I., 1 at S.B.A. 1832–92. (*Tunbridge Wells, V. & A.*)

DODD, Francis (1874–1949)
Born Holyhead; trained at Glasgow, and lived at Blackheath. Assoc. R.W.S. 1923, member 1929, A.R.A. 1927, R.A. Topographer of the Home Counties. (*Whitworth*)

DODD, Robert (1747–1816)
Marine and architectural subjects. Exhibited 3 works at Soc. of Artists in 1780. (*Greenwich*) (*Note.* His work cannot easily be distinguished from that of his brother Ralph, who exhibited 62 works 1779–1809.)

DODGSON, George Haydock (1811–80).
Born Liverpool; worked for a time under George Stephenson; member N.W.C.S. (1844–47) and O.W.C.S. Landscapes. Exhibited 414 works, 353 at O.W.C.S., 48 at N.W.C.S., 3 at R.A. 1835–80. (*Newcastle, Whitworth, V. & A.*)

DOLLMAN, Herbert P. (fl. 1874–92)
Member R.I. 1886–1901. Domestic subjects. Exhibited 27 works, 3 at N.W.C.S., 5 at R.A., 9 at S.B.A.

DOLLMAN, John Charles (1851–1934)
Born at Hove; assoc. R.W.S. 1906, member 1913. Domestic subjects. Exhibited 96 works, 12 at N.W.C.S., 25 at R.A., 16 at S.B.A.

DONALD, John Milne (1819–66)
Born Nairn; studied in Glasgow and Paris. Scottish landscapes, much influenced by Samuel Bough. Exhibited 3 works 1844–47.

DONALD-SMITH, Helen (fl. 1883–93)
Landscapes. Exhibited 35 works, 1 at R.A., 3 at S.B.A., 13 at N.W.C.S.

DONALDSON, Andrew Benjamin (1790–1846)
Born Comber, near Belfast, the son of a weaver; taught drawing at

Glasgow. Landscapes and architectural subjects. Exhibited 261 works, 97 at S.B.A., 15 at N.W.C.S., 26 at R.A., 5 at B.I.

DONALDSON, Andrew Brown (fl. 1860–1890)
Born London; studied at R.A. Historical subjects, and views of towns. Exhibited at R.A. and B.I. 1862–98.

DONALDSON, John (1737–1801)
Born Edinburgh; to London 1762; member Incorp. S.A.; for a time painted figure subjects on Worcester porcelain. Miniatures and etchings. Exhibited 26 works, 14 at Soc. of Artists, 8 at Free Soc., 4 at R.A., 1761–91.

DONKIN, Alice (fl. 1871–92)
Of Oxford. Domestic subjects. Exhibited 20 works, 3 at N.W.C.S., 12 at R.A.

DONN, William (fl. 1770–75)
An architect. Some drawings, artistic as well as technical, were engraved. Exhibited 6 works, 4 at Free Soc., 2 at R.A.

DONNE, B. J. M. (fl. 1822–91)
Landscapes. Exhibited 30 works, 11 at N.W.C.S., 4 at Free Soc., 2 at R.A.

DONOWELL, John (fl. 1735–86)
An architect. Topography in pen and Indian ink wash. Exhibited 16 works, 9 at Soc. of Artists, 2 at Free Soc., 5 at R.A. (*V. & A.*, *B.M.*)

DORRELL, Edmund (1778–1857)
Born Warwick; member O.W.C.S. Landscapes and rustic scenes. Exhibited 88 works, 59 at O.W.C.S., 15 at R.A., 14 at S.B.A. (*Whitworth, V. & A.*)

D'ORSAY, Count Alfred Guillaume Gabriel (1798?–1852)
Born Paris; an army officer; to England 1821 and married the daughter of the Earl of Blessington. Exhibited 17 at R.A. and 3 at S.B.A. 1843–48.

DOUGLAS, Sir William Fettes (1822–91)
Born Edinburgh; visited Italy 1857; curator of the National Gallery, Scotland; assoc. R.S.A. 1851, member 1854, secretary 1869 and president 1882. Knighted 1882. Exhibited 16 works, 9 at R.A., 1 at Grosvenor Gallery, 1862–90. (*V. & A.*)

DOWBIGGIN, E. (fl. 1820–24)
Son of a Mayfair gilder. Landscapes. Exhibited 5 works, 2 at R.A., 2 at B.I., 1 at S.B.A.

DOWNES, Annabel (fl. 1885–90)
Portraits. Exhibited 11 works, 3 at N.W.C.S., 6 at R.A.

DOWNING, H. E. (d. 1835)
Member N.W.C.S.; member R.I. 1834. Landscapes and town views. Exhibited 70 works, 54 at N.W.C.S., 8 at R.A., 2 at B.I., 6 at S.B.A. 1827–33.

DOWNMAN, John (1750–1824)
Born Devon; studied under B. West, and from 1769 at R.A.; to Cambridge 1777, Plymouth 1806, Exeter 1807, and London, before returning to Exeter 1818; A.R.A. 1795. Portraits and a few landscapes. Exhibited 341 works, 333 at R.A. 1768–1819. (*Fitzwilliam, V. & A., B.M.*)

DOYLE, John (1797–1868)
Born Dublin; well-known as 'H.B.'; to London 1822. Caricatures, including many political subjects. (*B.M.*)

DOYLE, Richard (1824–83)
Son of John, a miniaturist and
caricaturist. Illustrator of
Thackeray and Dickens, and
designed the title page of *Punch*.
Caricatures and fanciful composi-
tions. Exhibited 63 works, 2 at
R.A., 61 at Grosvenor gallery,
1868–83. (*V. & A., B.M.*)

DRAGE, J. Henry (fl. 1882–93)
Worked in Croydon. Landscapes.
Exhibited 11 works, 5 at N.W.C.S.,
3 at R.A.

DRUCE, Melville (fl. c. 1893)
Illustrations.

DRUMMOND, James (1816–77)
Born Edinburgh; studied under
Sir W. Allan and at Trustees
Academy; curator National
Gallery, Scotland, 1868; assoc.
R.S.A. 1845, member 1852.
Scottish topography and historical
subjects. Exhibited 25 works,
6 at S.B.A., 11 at R.A., 5 at B.I.
(*Edinburgh*)

**DRUMMOND, Samuel
(1765–1844)**
Served at sea as a boy. Marines,
rare in watercolour. Exhibited 409
works, 5 at N.W.C.S., 8 at Soc. of
Artists, 303 at R.A., 84 at B.I.,
9 at S.B.A.

DUASSUT, Curtius (fl. 1889–93)
Landscapes. Exhibited 34 works,
4 at N.W.C.S., 7 at R.A., 19 at
S.B.A.

DUBOURG, Victoria (fl. 1882–93)
Flowers. Exhibited 40 works,
24 at N.W.C.S., 6 at R.A., 5 at
S.B.A.

**DUCROS, Abraham Louis Rodolphe
(1748–1810)**
In Rome c. 1770, where he was

possibly influenced by J. R.
Cozens. His work was introduced
to Britain by Sir R. Colt Hoare.

DUDLEY, Robert (fl. 1865–91)
Marines. Exhibited 47 works,
6 at N.W.C.S., 24 at R.A., 5 at
S.B.A.

**DUFF, John Robert Keithley
(1862–1938)**
Member R.I. 1913. Member
Royal Society of Painter-Etchers
and Engravers. Rustic scenes.

**DUFFIELD, Mrs William (née
Mary Elizabeth Rosenberg)
(1819–1914)**
Born Bath, the daughter of painter
T. E. and granddaughter of
silhouettist C. C.; married
William Duffield, flower painter,
1850; wrote a treatise on flower
painting. Member R.I. 1861.
Fruit and flowers. Exhibited 393
works, 341 at N.W.C.S., 12 at R.A.,
28 at S.B.A. 1850–93. (*V. & A.*)

DU FRESNOY, F. (fl. 1801–06)
Landscapes in Sussex, Wales,
Isle of Wight and Greenwich.
Exhibited 6 works at R.A.

DUGGAN, Peter Paul (d. 1861)
Of Irish birth; to America when
young; lived in England for many
years; died in Paris. Worked in
crayon.

DUGUID, Henry G. (fl. 1831–60)
An Edinburgh topographer.
(*Edinburgh*)

DUJARDIN, John (fl. 1820–63)
An industrious and once very
popular landscapist. Exhibited 95
works, 32 at S.B.A., 4 at R.A.,
59 at B.I.

DUJARDIN, John, Jr (fl. 1837–58)

Probably son of the above. Landscapes, marines and coastal scenes. Exhibited 14 works, 5 at R.A., 6 at B.I., 3 at S.B.A.

DULAC, Edmund (1882–1953)
Born Toulouse; worked in London as a romantic illustrator. (*B.M.*)

DU MAURIER, George Louis Palmella Busson (1831–96)
Born Paris; an analytical chemist; studied art in Paris and Antwerp; assoc. R.W.S. 1881. Illustrations for *Punch* (1865) and for many books, chiefly humorous, in black and white. Exhibited 144 works, 38 at O.W.C.S., 39 at R.A.

DUNBAR, W. Nugent (fl. c. 1830)
Sketches of Italy, and scriptural subjects. Exhibited 4 works at S.B.A.

DUNCAN, Edward (1803–82)
Born London; articled to engraver Robert Havell; member N.W.C.S. 1833–47 and O.W.C.S. Marines, coastal scenes and landscapes. Exhibited 558 works, 332 at O.W.C.S., 188 at N.W.C.S., 7 at R.A., 13 at B.I., 18 at S.B.A. 1830–82. (*Birmingham, Newport, Whitworth, V. & A.*)

DUNCAN, Walter (fl. 1869–93)
Assoc. R.W.S. Historical subjects. Exhibited 251 works, 224 at O.W.C.S., 8 at R.A., 3 at S.B.A.

DUNKARTON, Robert (1744–1811?)
Born London; pupil of Pether fl. 1768–79. Crayon portraits.

DUPONT, Gainsborough (1767–97)
An engraver; pupil and nephew of Thomas Gainsborough, and worked in his style. Portraits.

Exhibited 26 works at R.A. 1790–98.

DYCE, Rev. Alexander (1798–1869)
Born Edinburgh; an amateur; cousin of William; to London 1825 to devote himself to literary work. Flowers. (*V. & A.*)

DYCE, William (1806–64)
Born Aberdeen; studied at R.S.A.; made two long visits to Rome; settled in Edinburgh 1820; assoc. R.S.A. 1835; A.R.A. 1844, R.A. 1848; painted the frescoes in the Houses of Parliament; head of Government School of Design. Landscapes and historical subjects. Exhibited 45 works, 41 at R.A., 4 at B.I. 1827–61. (*Edinburgh, Ashmolean, Aberdeen, V. & A., B.M.*)

DYER, Eleanor H. (fl. 1867–92)
Worked at Eynsford, Kent. Landscapes. Exhibited 3 works at N.W.C.S.

DYER, Gertrude M. (fl. 1891–93)
Worked at Leatherhead. Flowers. Exhibited 2 works at N.W.C.S.

DYER, Rev. John (1699–1758)
Born Wales; studied in London and Rome 1724–25. Poet and painter.

EAGLES, Rev. John (1783–1855)
Connected with Bristol; friend and pupil of W. J. Müller; also studied in Italy; rejected as member O.W.C.S. 1824 because of amateur status. Landscapes, mostly in the Bristol Avon Valley, a soft grey predominating. Exhibited 6 works, 1 at R.A., 5 at B.I. 1805–52.

EARL, William Robert
(fl. 1823–67)
Coastal views in England,
Scotland, Belgium and Germany.
Exhibited 114 works, 19 at R.A.,
52 at B.I., 43 at S.B.A.

EARLE, Augustus (fl. 1806–38)
Known as 'the wandering artist';
studied in London; then went to
America, Africa, New Zealand,
Australia, and around the
Mediterranean; accompanied
Capt. Fitzroy in *Beagle* to
South America. Historical
subjects. Exhibited 11 works at
R.A.

EARLE, Charles (1832–93)
Member Institute of Painters in
Oil Colours and R.I. 1882.
Landscapes. Exhibited 272
works, 81 at N.W.C.S., 24 at R.A.,
3 at B.I., 25 at S.B.A.

EARLE, James (fl. 1787–96)
Worked in London. Portraits.
Exhibited 18 works, 17 at R.A.

EARLOM, Richard (1748–1822)
Born London; pupil of Cipriani;
engraved for Boydell. Flowers
after the Dutch masters. Exhibited
2 works, 1 at Soc. of Artists,
1 at Free Soc. 1762–67.

EARP, Henry (fl. c. 1850)
A distinctive watercolourist, about
whom little is known.
(*Note*. Another Henry Earp
painted animals at Brighton c.
1870–90, and exhibited 6 works at
S.B.A. and N.W.C.S.)

EAST, Sir Alfred (1849–1913)
Born Kettering; studied at
Glasgow School of Art under
Robert Greenlees and in Paris
under Fleury and Bouguereau; in
Japan 1889, later on the Continent,

then London 1903; member R.I.
1887, A.R.A. 1899, R.A.
1915; president R.S.B.A. 1906;
knighted 1910. Exhibited 116
works, 25 at N.W.C.S., 22 at R.A.,
30 at S.B.A. (*V. & A.*)

EAST, H. S. (fl. c. 1910)
Landscapes. (*V. & A.*)

EASTLAKE, Caroline H.
(fl. 1868–73)
Of Plymouth. Flowers. Exhibited
28 works.

EASTLAKE, Charles H.
(fl. 1889–93)
Of Balham. Landscapes and
domestic scenes. Exhibited 7
works, 2 at R.A., 5 at S.B.A.

EASTLAKE, Sir Charles Lock
(1793–1865)
Born Plymouth; the son of a
lawyer; studied under B. R.
Haydon 1808; and R.A. 1809; to
Paris 1814–15, later to Greece and
Italy; A.R.A. 1827, R.A. 1830,
president R.A. 1850; keeper of
National Gallery 1843 and
director 1855; writer on art.
Historical subjects and portraits.
Exhibited 69 works, 51 at R.A.,
18 at B.I. 1813–55. (*Newport,
B.M.*)

EASTWOOD, Francis H.
(fl. 1875–90)
Landscapes. Exhibited 44 works,
11 at N.W.C.S., 5 at R.A., 16 at
S.B.A.

EATON, Charles Warren
(fl. 1890–91)
Landscapes. Exhibited 15 works,
2 at N.W.C.S., 7 at R.A., 5 at
S.B.A.

EBURNE, Emma Sophia
See Oliver, Mrs William.

EDDINGTON, William Clarke
(fl. 1861–85)
Of Worcester. Landscapes.
Exhibited 59 works, 5 at N.W.C.S.,
12 at R.A., 19 at S.B.A.

EDDIS, Eden Upton (1812–1901)
Pupil of Sass; a lifelong friend of
George Richmond. Portraits.
Exhibited 157 works, 130 at
R.A., 16 at B.I., 11 at S.B.A.,
1834–83.

EDEN, William (fl. 1866–90)
Of Liverpool. Landscapes.
Exhibited 65 works, 2 at N.W.C.S.,
13 at R.A., 5 at S.B.A.

EDGE, John William
(fl. 1785–1834)
Topography and marines.
Exhibited 7 works at N.W.C.S.
(*V. & A.*)

EDRIDGE, Henry (1769–1821)
Born Paddington; apprenticed to
W. Pether; studied at R.A. 1784;
visited France 1817–19; friend of
T. Hearne, J. Farington and Dr
Monro; A.R.A. 1820. Miniatures,
genre, landscapes and architectural
subjects, many in Paris and in
towns in Normandy, in the style
of S. Prout, but more lively.
Exhibited 260 works at R.A.
1786–1821. (*Newcastle,
Whitworth, V. & A., B.M.*)

EDWARD, Albert (fl. 1885–86)
Views in Venice. Exhibited 2
works at N.W.C.S.

EDWARDS, Catherine Adelaide
See Sparkes, Mrs J.

EDWARDS, Edward (1738–1806)
Born London; premiums from
Society of Arts; studied at St
Martin's Lane Academy and at
R.A. 1769; visited Italy 1775–76;

scene-painter at Newmarket
Theatre; member Incorp. S.A.
but resigned 1770; A.R.A. 1773;
professor of perspective at R.A.
1788. Landscapes and portraits.
Exhibited 112 works, 6 at Soc.
of Artists, 1 at Free Soc., 104
at R.A., 1 at S.B.A., 1776–1806.
(*V. & A., B.M.*)

EDWARDS, Edwin (1823–79)
Born Framlingham, Suffolk; best
known as an etcher. Landscapes.
Exhibited 159 works, 54 at R.A.,
3 at B.I., 1 at S.B.A. 1861–80.

EDWARDS, Rev. E. (fl. c. 1809)
A little-known landscapist. His
views of Donnington Castle and
Battle Abbey were engraved in the
'Antiquarian Repository'.

EDWARDS, George (1694–1773)
Born Stratford; travelled on the
Continent 1716–31; librarian to
College of Physicians 1733. Birds
and animals, and a natural history
illustrator. (*B.M., V. & A.*)

EDWARDS, George H.
(fl. 1883–93)
Domestic subjects. Exhibited 11
works, 5 at S.B.A., 6 at N.W.C.S.

EDWARDS, Lionel Dalhousie
Robertson (1877–1970?)
Member R.I. 1927. Hunting
scenes.

EDWARDS, Pryce Carter
(fl. c. 1830)
A follower of Cotman. (*Cardiff*)

EDWARDS, Sydenham Teak
(1768?–1819)
Writer of botanical books and
illustrator of the *Botanical
Magazine*, the *Sportsman's
Magazine* and other works. Plants
and animals. Exhibited 12 works

at R.A. 1792–1814. (*Kew, V. & A., B.M.*)

EDY, John William (fl. 1791–1820)
Travelled in Scandinavia and
Switzerland. Marines.
(*Greenwich*)

EGERTON, Jane Sophia
(fl. 1844–57)
Member N.W.C.S.; assoc. 1845.
Portraits. Exhibited 25 works
at N.W.C.S. and 3 at R.A.

EGGINGTON, Roycliffe
(born 1875)
Member R.I. 1912; member
R.C.A. Landscapes.

EGINGTON, Francis (1737–1805)
Born Handsworth, Yorks.
A clever painter on glass.

EGLEY, William (1798–1870)
Born Doncaster. Miniatures and
portraits, especially of children.

EGLINTON, Samuel (fl. 1847–59)
Of Liverpool. Landscapes.
Exhibited 24 works, 5 at N.W.C.S.,
2 at R.A., 13 at B.I., 4 at S.B.A.

ELEN, Philip West (fl. 1838–72)
Streams and pools, mountains and
castles in Wales, and Devon rivers.
Exhibited 242 works, 64 at R.A.,
57 at B.I., 46 at S.B.A.

ELEY, Mary (fl. 1874–90)
Domestic subjects. Exhibited 42
works, 14 at R.A., 11 at S.B.A.,
7 at N.W.C.S.

ELGOOD, George Samuel
(fl. 1881–1943)
Of Leicester. Landscapes.
Member R.I. 1882; member
R.O.I. Exhibited 81 works, 64 at
N.W.C.S., 5 at S.B.A.

ELLICOMBE, Sir Charles Grene,
Major-General (1783–1871)
Studied at Royal Marine Academy,
Woolwich; Colonel Commandant
R. E. Ciudad Rodrigo. Landscape
sketches. Exhibited 2 works at
R.A. 1810.

ELLIOT, Capt. Robert, RN
(fl. c. 1780–1810)
Travelled widely, and made
sketches, some of which were used
by S. Prout and Clarkson Stanfield.

ELLIOT, Capt. William
(fl. 1784–91)
A naval captain and painter of
marines and Eastern views.
Exhibited 20 works 1784–91.
(*Note*. Probably the Capt. Robert
Elliot listed by Graves, and the
Capt. Robert or Robert Lewis
Elliot (1790–1849) listed by
Clifford.)

ELLIS, Arthur (fl. 1874–92)
Domestic subjects. Exhibited 27
works, 8 at R.A., 9 at S.B.A., 3 at
N.W.C.S.

ELLIS, C. Wynn (fl. 1880–93)
Domestic subjects. Exhibited 19
works, 4 at R.A., 2 at S.B.A., 8 at
N.W.C.S.

ELLIS, Edwin (1841–95)
Born Nottingham; pupil of H.
Dawson; member S.B.A. 1875.
Marines and landscapes. Exhibited
145 works, 99 at S.B.A., 25 at
R.A. (*V. & A.*)

ELLIS, Tristram J. (fl. 1868–93)
Landscapes. Exhibited 95 works,
19 at R.A., 2 at S.B.A., 25 at
Grosvenor gallery, 8 at N.W.C.S.

ELLIS, William (1747–1810)
Born London, the son of an
engraver; pupil of Woollett. Best

known as an engraver, but also a few landscapes. (*B.M.*, *V. & A.*)

ELMORE, Alfred (1815–81)
Born Co. Cork; studied at R.A.;
travelled to Paris, Munich and
Rome, and worked at Paris; R.A.
Landscapes in the style of
Bonington and Delacroix.
Exhibited 95 works, 72 at R.A.,
10 at B.I., 10 at S.B.A. 1834–80.
(*V. & A.*, *B.M.*)

ELTON, Samuel Averill (1827–86)
Master of Darlington School of
Art. Landscapes. Exhibited 6
works, 2 at R.A., 2 at S.B.A.,
1860–84. (*V. & A.*)

EMANUEL, Frank Lewis
(1865–1948)
Collector and topographer.
Exhibited 10 works, 5 at R.A.,
2 at S.B.A., 1888–93.

EMERY, Charles E. (fl. c. 1872)
An example in V. & A.

EMERY, John (1777–1827)
Born Sunderland; an actor.
Marines and Northern coastal
views, with a few near Brighton
and Dover, in the manner of J. S.
Cotman, and rustic figures.
Exhibited 19 works at R.A.
1801–17.

EMES, John (fl. 1783–1810)
Probably a pupil of Woollett and an
engraver; collaborated with B. T.
Pouncy. Views in the Lake
District and of gentlemen's seats,
with beautiful treatment of
foliage. Exhibited 8 works at R.A.
(*Whitworth*, *V. & A.*, *B.M.*)

EMSLIE, Alfred Edward
(fl. 1848–93)
Assoc. R.W.S. 1888. Domestic
subjects. Exhibited 184 works,

56 at R.A., 25 at S.B.A., 19 at
O.W.C.S., 6 at N.W.C.S.

EMSLIE, Mrs A. E. (fl. 1888–93)
Domestic subjects. Exhibited 24
works, 6 at R.A., 2 at N.W.C.S.

EMSLIE, John Phillipp
(fl. 1869–85)
Domestic subjects. Exhibited 55
works, 2 at R.A., 32 at S.B.A.,
1 at N.W.C.S.

ENGLEHEART, Francis
(1775–1849)
Born London; brother of George;
a successful engraver.

ENGLEHEART, George
(1752–1829)
Born Kew; pupil of G. Barret Sr
and Reynolds. Landscapes and fine
miniatures. Exhibited 85 works at
R.A.

ENGLEHEART, Henry
(1801–1885)
Son of George. Architectural
subjects of great beauty and
refinement.

ENGLEHEART, John Cox Dillman
(1783–1862)
Nephew and pupil of George.
Miniatures. Exhibited 157 works
at R.A. and 2 at B.I. 1801–28.

ESSEX, Richard Hamilton
(1802–55)
Assoc. O.W.C.S. 1823–37. Gothic
architecture. Exhibited 85 works,
71 at O.W.C.S., 12 at R.A., 2 at
S.B.A. (*V. & A.*)

ESTALL, William Charles
(1857–97)
Born London; educated in
Manchester; studied in London,
France and Germany. Landscapes
with cattle or sheep, with

atmospheric effects of evening, moonlight or mist. Exhibited 29 works, 3 at R.A., 12 at S.B.A., 1 at N.W.C.S.

ETTWELL, Elliot John (1840–80) Buildings in the Birmingham district. (*Birmingham*)

ETTY, William (1787–1848) Born York; apprenticed to a Hull printer; to London 1806 to study art; studied at R.A. 1807 and in Lawrence's studio; visited Italy 1816 and 1822, Paris 1830; to York 1848; A.R.A. 1824, R.A. 1828. Pen and pencil sketches. Exhibited 218 works, 138 at R.A., 78 at B.I. 1811–50.

EVANS, Bernard Walter (1843–1922) Born Birmingham; cousin of George; studied at the age of 9 under Samuel Lines; to London 1864; member R.I. (1888) and R.S.B.A. English and French landscapes. Exhibited 94 works, 13 at R.A., 18 at R.B.A., 10 at N.W.C.S. 1871–93 (*Newcastle, V. & A.*)

EVANS, Frederick M. (fl. 1886–93) Domestic subjects. Exhibited 15 works, 11 at N.W.C.S., 4 at R.A.

EVANS, Helena (fl. 1891–93) Flowers. Exhibited 4 works at N.W.C.S.

EVANS, John (fl. 1849–91) Landscapes. Exhibited 55 works, 16 at N.W.C.S., 1 at R.A., 18 at S.B.A.

EVANS, Richard (1784?–1871) Studied at R.A. 1815; for a time assistant to Lawrence. Copied Old Masters in Rome. Exhibited 48 works, 42 at R.A., 6 at B.I., 1816–56.

EVANS, Samuel T. G. (1829–1904) Born Eton; son of Evans of Eton; member O.W.C.S. Landscapes. Exhibited 235 works, 228 at O.W.C.S., 7 at R.A.

EVANS, William 'of Bristol' (1809–58) Lived alone in North Wales; visited Italy 1852; assoc. O.W.C.S. Landscapes. Exhibited 49 works, 47 at O.W.C.S. (*Newport, B.M.*)

EVANS, William, 'of Eton' 1798–1877) Born Eton, the son of Eton College's drawing master, whom he succeeded 1818; studied medicine; taught art by De Wint and W. Collins; housemaster at Eton 1840; assoc. O.W.C.S. 1828, member 1830. Landscapes. Exhibited 264 works, all at O.W.C.S. (*V. & A., B.M.*)

EVERITT, Allan Edward (1824–82) Born Birmingham; pupil of David Cox. Old buildings, mostly in Birmingham. Exhibited 7 works at R.A. 1853–58.

EVES, Reginald Grenville (1876–1941) Member R.I. 1933, R.A. 1939, R.O.I. Landscapes.

EWBANK, John Wilson (1799–1847) Born Gateshead; studied in Edinburgh under Alexander Nasmyth. East Scottish coastal scenes. Exhibited 2 works at R.A. 1832. (*Edinburgh, Gateshead, B.M.*)

EYRE, Edward (fl. 1771–92) An amateur; in Bath 1772–76.

Landscapes. Exhibited 15 works at
R.A. (*V. & A., B.M.*)

EYRE, John (fl. 1877–89, d. 1927)
Member R.I. 1917. Domestic
subjects. Exhibited 27 works,
5 at N.W.C.S., 8 at R.A., 14 at S.B.A.

FAED, John (1820–1902)
Born Kirkudbrightshire, brother of
Thomas; studied at Trustees
Academy, Edinburgh; in London
1862–80; member R.S.A. Genre.
Exhibited 43 works, 40 at R.A.,
3 at S.B.A. (*Edinburgh*)

FAED, Thomas (1826–1900)
Born Gatehouse of Fleet, near
Dumfries, studied at Edinburgh
School of Design; to London 1852;
became blind 1893; assoc. R.S.A.
1849, hon. R.S.A. 1892; A.R.A.
1861, R.A. 1864. Scottish peasant
life and landscapes. Exhibited 99
works, 98 at R.A., 1851 onward.
(*Whitworth, V. & A.*)

FAGAN, Louis A. (1846–1903)
Director of print room at B.M.;
widely travelled, and a brilliant
scholar. An accomplished water-
colourist.

FAHEY, Edward Henry
(1844–1907)
Born Brompton, London; studied
architecture at Kensington and
R.A.; visited Italy 1866; assoc. R.I.
1870, member 1876. Landscapes
and genre. Exhibited 246 works,
127 at N.W.C.S., 38 at R.A., 7 at
S.B.A., 1863–93. (*V. & A.*)

FAHEY, James (1804–85)
Born Paddington; studied anatomy
in Paris; painted in Paris and
Munich; drawing master at

Merchant Taylor's School; sec.
N.W.C.S. 1834. Scottish peasant
life and landscapes. Exhibited
509 works, 485 at N.W.C.S., 16
at R.A., 3 at B.I., 5 at S.B.A.

FAIRHOLT, Frederick William
(1814?–66)
Born London, of German parents;
a drawing teacher. Theatrical
scenery and illustrations. (*V. & A.,
B.M.*)

FAIRLESS, Thomas Kerr
(1823–53)
Born Hexham, Northumberland;
studied under Nicholson of
Newcastle. Landscapes. Exhibited
22 works 1848–53.

FARINGTON, George (1754–88)
Born Warrington; taught by
Benjamin West; gold medallist at
R.A. 1780. Portraits. Exhibited 4
works 1773–82 at R.A., 5 at B.I.,
7 at S.B.A.

FARINGTON, Joseph (1747–1821)
Born Leigh, Lancs.; studied under
R. Wilson 1763 and at R.A. 1769;
member Incorp. S.A. 1768; A.R.A.
1783, R.A. 1785. Topographical
landscapes with strong pen work,
often in monochrome. Exhibited
110 works, 27 at Soc. of Artists,
83 at R.A. 1765–1813. (*Liverpool,
Newcastle, Nottingham, Whitworth,
V. & A., B.M.*)

FARMER, Emily (1826–1905)
Taught by her brother Alexander
(d. 1869). Member N.W.C.S.
1854. At first miniatures, then
genre, especially groups of
children. Exhibited 86 works, 83
at N.W.C.S., 3 at R.A.

FARNBOROUGH, Lady Amelia
Long (née Hume) (1760's?–1837)
Said to have been Girtin's

Harvest Time

J. Frederick Tayler
(1802–89)
9″ x 12¾″

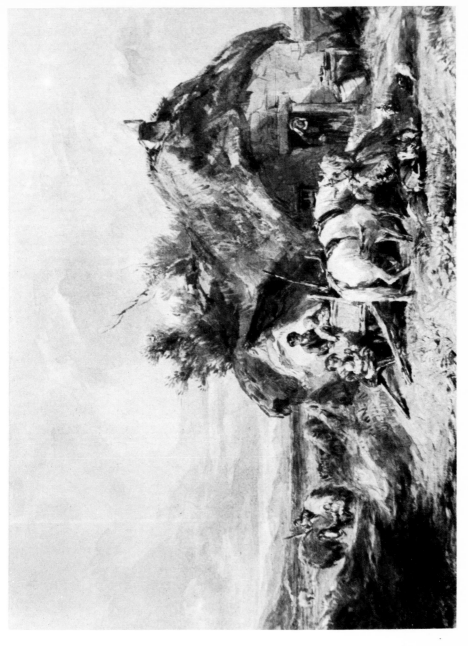

Tayler is a much underrated
watercolourist who is best
known for his sporting
subjects – his drawings of
poachers, gamekeepers, otter
hunts, Scottish crofters and so
forth. Such a work as this is a
refreshing change. John
Ruskin for one praised Tayler's
powerful sketching. Certainly
his incisive, almost slashing
brushwork, in which every
seemingly careless stroke is
in fact essential, is the best aid
to recognising his work.
Another clue is the use of pure
Chinese white to represent
the highlights on, for example,
the shining hindquarters of
his horses.

The Water Frolic

Joseph Mallord William Turner
(1775–1851)

20" x 26¾"

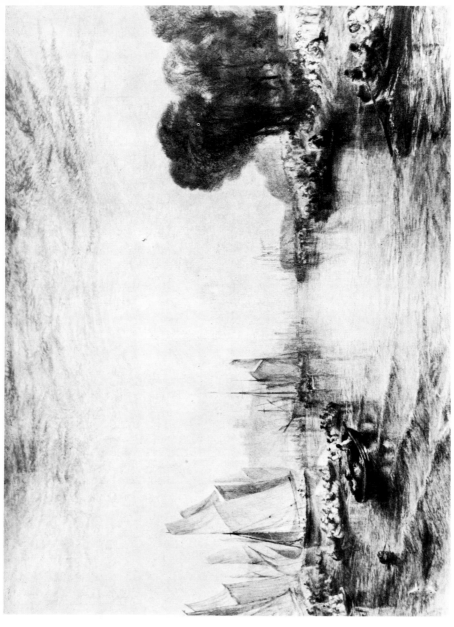

The finest work of Turner, more
perhaps than that of any other
watercolourist, really demands
to be reproduced in colour.
Otherwise, as in the case of
this beautiful example, the
glory of translucent, glowing
sunlight is lost. The
composition, with the activity
on the left balanced by the
typically yellowish-brown trees
on the right, is arranged so
that the flood of yellow light
from the early evening sun falls
uninterrupted onto the water.
And the wavelets highlighted
in the foreground balance the
fleecy clouds in the sky. The
figures and the details of the
boats and shipping are
carefully drawn and sparingly
touched with reddish-brown.
We must suppose that the
drawing belongs to Turner's
middle period. It is skilful
and elaborate, yet by no means
artificial or vulgar. It
foreshadows to some extent
the artist's later preoccupation
with colour for its own sake,
with a resultant showiness
and even a vulgarity, which
here is entirely absent.

favourite pupil; taught also by De Wint and H. Edridge. Landscapes, sometimes in chalk in Dr Monro's style or in pencil in the Edridge style, and sometimes in monochrome. Exhibited 34 works at R.A. 1807–22 (*Leeds, V. & A., B.M.*)

FARQUHARSON, David (1840–1907)
Born Blairgowrie, Perthshire; assoc. R.S.A. 1882, A.R.A. 1904. Landscapes. Exhibited 18 works at R.A. 1877 onward.

FARRIER, Robert (1796–1879)
Born Chelsea; studied at R.A. 1820. Miniatures and domestic subjects. Exhibited 121 works, 32 at S.B.A., 35 at R.A., 50 at B.I., 32 at S.B.A., 1818–72.

FARRON, Lulu (fl. 1887–92)
Portraits. Exhibited 5 works, 4 at N.W.C.S.

FAUERMANN, Anne Charlotte
See Turnbull, Mrs Valentine.

FEARNSIDE, William (fl. 1791–1801)
Landscapes in body-colour. Exhibited 8 works at R.A. 1791–1801. (*V. & A.*)

FEARY, John (fl. 1770–88)
Pupil of R. Wilson. Topographical views. Exhibited 29 works at R.A.

FEDDEN, Romilly (fl. c. 1910)
Landscapes. (*V. & A.*)

FERGUSON, James (1710–76)
Born Banffshire; a noted astronomer. Portraits in blacklead.

FERGUSON, James (fl. 1817–57)
A Scottish artist who lived in Edinburgh. Scottish views, mostly around that city. Exhibited 20 works, 5 at S.B.A., 10 at R.A., 5 at B.I.

FERGUSON, William J. (fl. 1849–78)
Landscapes. Exhibited 102 works, 46 at S.B.A., 2 at N.W.C.S., 21 at R.A., 8 at B.I.

FERNYHOUGH, William (fl. 1804–15)
Born Litchfield, Staffs.; possibly a pupil of J. Glover or J. Barber.

FERRIER, George Stratton (d. 1912)
Member R.I. 1898, R.S.W.

FICKLIN, Alfred (fl. 1865–89)
Of Kingston-on-Thames. Landscapes. Exhibited 9 works, 3 at N.W.C.S., 2 at B.I., 4 at S.B.A.

FIDLER, Gideon M. (fl. 1881–93)
Of Salisbury. Domestic subjects. Exhibited 13 works, 9 at N.W.C.S. 1 at R.A., 1 at S.B.A.

FIELD, Frances A. (fl. 1882–89)
Of Oxford. Flowers. Exhibited 11 works, 6 at N.W.C.S., 2 at R.A., 3 at S.B.A.

FIELD, Walter (1837–1901)
Born Hampstead; a descendant of Oliver Cromwell; taught by J. R. Herbert and the engraver John Pye; assoc. R.W.S. Landscapes, especially of Thames Valley. Exhibited 275 works, 149 at O.W.C.S., 41 at R.A., 9 at B.I., 2 at S.B.A. (*V. & A.*)

FIELDING, Anthony Vandyke Copley (1787–1855)
Second son of N. T., pupil of John Varley; assoc. O.W.C.S. 1810, member 1812, treasurer 1817, secretary 1818 and president 1831;

gold medallist Paris Salon 1824.
Landscapes and marines.
Exhibited 1,789 works, 1,671 at
o.w.c.s., 17 at r.a., 100 at b.i.
(*Manchester, Newport, Gateshead,
Whitworth, V. & A., B.M.*)

FIELDING, John (1758–?)
An engraver; studied under
Bartolozzi.

FIELDING, Nathan Theodore
(fl. 1775–1814)
Father of A. V. C., N. L., T., and
T. H. A. Pen and wash figure
subjects in the Francis Wheatley
style but heavier. Exhibited 11
works, 3 at o.w.c.s., 4 at Soc. of
Artists, 1 at Free Soc., 3 at b.i.

FIELDING, Newton Limberd
Smith (1799–1856)
Born Huntingdon (or Durham?),
youngest son of N. T.; taught W.
Callow and the family of Louis
Philippe. Highly esteemed in
France. Animals, birds, and slight
landscapes. Exhibited 12 works
at minor exhibitions 1851.
(*Newport, V. & A., B.M.*)

FIELDING, Thales (1793–1837)
Third son of N. T.; worked in
Paris; a friend of Delacroix;
drawing master at Woolwich
Military Academy; assoc. o.w.c.s.
1829. Landscapes. Exhibited 155
works, 88 at o.w.c.s., 19 at r.a.,
21 at b.i., 27 at s.b.a. (*Newport,
Whitworth, V. & A., B.M.*).

FIELDING, Theodore Henry
Adolphus (1781–1851)
Eldest son of N. T.; lived at
Croydon; drawing master at
Addiscombe Military Academy.
(*B.M., V. & A.*)

FIELDING, Mrs Theodore Henry
Adolphus (née Walter)

Member o.w.c.s., 1821. Subjects
include flowers, birds, insects and
fruit. Exhibited 32 works, 31 at
o.w.c.s., 1 at b.i.
(*Note.* Some confusion still exists
between the names of the
Fieldings. Thus, Nathan Theodore
is sometimes referred to as
Theodore Nathan.)

FILDES, Sir S. Luke (1844–1927)
Born Liverpool; best known as an
illustrator; a.r.a. 1879, r.a. 1887;
knighted 1906. Exhibited 48
works, 11 at r.a., before 1893.

FINCH, Francis Oliver (1802–62)
Born London; studied under John
Varley and at Sass's Academy;
friend of Samuel Palmer; visited
Paris 1852; member o.w.c.s.
1827. Landscapes, often in the
style of G. Barret Jr. Exhibited
286 works, 272 at o.w.c.s., 14 at
r.a. (*Cardiff, Newcastle,
Whitworth, V. & A., B.M.*)

FINDEN, William (1787–1852)
A line engraver. Illustrations for
'Arctic Voyagers' and many other
travel books.

FINDLATER, William
(fl. 1800–21)
A portrait painter, but also
landscapes and battle scenes.
Exhibited 34 works, 1 at o.w.c.s.,
25 at r.a., 8 at b.i.

FINDLAY, J. (fl. 1827–31)
Views of London buildings, and of
buildings, in Windsor and
Winchester. Exhibited 8 works,
5 at s.b.a., 3 at b.i.

FINN, Herbert J. (fl. 1886–93)
Of Deal. Domestic subjects, and
some landscapes. Exhibited 3
works at s.b.a.

FINNEMORE, Joseph (1860–1939)
Member R.B.A.; member R.I. 1898
and R.C.A. Domestic subjects.
Exhibited 14 works, 9 at S.B.A.,
4 at N.W.C.S., 1 at R.A.

FINNEY, Samuel (1721–1807)
Born Cheshire; portrait painter to
Queen Charlotte. Miniatures on
ivory. Exhibited 10 works, 6 at
Soc. of Artists, 4 at Free Soc.
1761–66.

FINNIE, John (1829–1907)
Born Aberdeen; to London 1853;
headmaster Liverpool School of
Art 1856–96; treasurer R.C.A.
Exhibited 107 works, 36 at R.A.,
6 at B.I., 44 at S.B.A., 3 at
N.W.C.S.

FIRMINGER, Rev. T. A. C.
(fl. 1835–71)
Member N.W.C.S. 1834–44.
Views of ruins. Exhibited 71
works, 2 at R.A., 1 at B.I., 68 at
N.W.C.S.

FISCHER, John George Paul
(1786–1875)
Born Hanover; pupil of H.
Bamberg; to England 1810, and
patronised by Royalty. Miniatures,
theatrical scenery, frescoes and
landscapes.

FISHER, Amy E. (fl. 1866–90)
Domestic subjects and views of
towns. Exhibited 49 works, 5 at
N.W.C.S., 13 at R.A., 10 at S.B.A.

FISHER, Edward (1730–85)
Born Ireland; engraver and artist.
Engraved portraits after Sir
Joshua Reynolds.

FISHER, Sir George Bulteel
(1764–1834)
Commandant of Woolwich
garrison. An amateur artist, who
made tinted landscape drawings
during service in Spain, Canada,
and England. (*Whitworth, B.M.,
V. & A., Leeds. Newcastle*)

FISHER, John (1748–1825)
Bishop of Salisbury; patron of
Constable; visited Italy 1785–86.
Landscapes in pale greys, blues and
greens. (*Whitworth*)

FISHER, Jonathan (d. 1809)
Born Dublin; self-taught; patron-
ised by Lord Portarlington; fl.
from 1763. A set of views of the
Killarney district published 1770,
and many later publications, all of
Irish views. Exhibited in Dublin
1768–1801. (*B.M., V. & A.*)

FISHER, J. H. Vignoles
(fl. 1884–93)
Landscapes. Exhibited 16 works,
6 at N.W.C.S., 4 at R.A., 4 at S.B.A.

FISHER, Mark (1841–1923)
Born Boston U.S.A. Studied
Paris. Member R.I. 1881, A.R.A.
1911, R.A. Landscapes, castles.
His daughter was Margaret
Fisher Prout, A.R.A., R.W.S.,
R.W.A.

FISHER, Thomas (1782–1836)
An India Office clerk. Archi-
tectural subjects. Exhibited 3
works at R.A. 1804–07. (*B.M.*)

FISK, William Henry (1827–84)
Son and pupil of William Fisk, a
painter; also studied at R.A.;
lectured on art at the University
College School, London, anatom-
ical draughtsman College of
Surgeons. Landscapes. Exhibited
36 works, 5 at S.B.A., 11 at R.A.,
7 at B.I. (*V. & A.*)

FITZGERALD, John Anster
(fl. 1845–93)

Of Newington. Domestic subjects. Exhibited 193 works, 62 at s.b.a., 12 at n.w.c.s., 33 at r.a., 27 at b.i.

FLATMAN, Thomas (1637–88)
Born London; a lawyer.
Miniatures.

FLAXMAN, John (1755–1826)
Born York; studied at r.a. 1769; to Italy 1787, and well received in Rome; back in England 1794; employed as modeller by Wedgwood; professor of Sculpture at r.a. from 1810; a.r.a. 1797, r.a. 1800. Pen and chalk sketches for classical sculptures. (*V. & A.*)

FLEETWOOD-WALKER, Bernard (1893–1965)
Assoc. r.w.s. 1940, r.w.s. 1945, r.a. 1956. Member Royal Institute of Oil Painters and Royal Society Portrait Painters. Figure studies and portraits.

FLEMING, John (fl. 1792–1845)
Born and lived in Greenock; first exhibited in Greenock, and at Glasgow Institution 1821. Scottish landscapes, and illustrations for books of Scottish scenery, engraved by Joseph Swan.

FLEMWELL, George Jackson (1865–1928)
Born Mitcham; studied under W. P. Frith, and at Antwerp; worked for ten years in Australia; founder and president Australian Academy; died Lugano. Domestic subjects. Exhibited at r.a.

FLETCHER, J. (fl. c. 1836)
Contributed drawings to illustrate Virtue's 'Surrey and Sussex' 1836.

FLETCHER, Watson (1842–1907)

Pupil of David Roberts. Views of continental cathedrals.

FLINT, Robert Purves (1883–1947)
Born Edinburgh; assoc. r.w.s. 1932, r.w.s. 1937. Land and seascapes.

FLINT, Sir William Russell (1880–1969)
Born Edinburgh, apprenticed to an Edinburgh lithographer; r.s.w., President r.w.s., 1936–56, r.a. 1933; knighted 1947. Worked for *Illustrated London News*. Semi-nudes in Spanish settings, historical subjects, landscapes, beach scenes, and 'English nudes'. (*Examples in all leading galleries.*)

FLORENCE, Henry Louis (1844–1916)
Soane medallist r.i.b.a. and vice-president 1869; gold medal r.a. 1870; designed many important buildings. Building interiors. (*V. & A.*)

FLOWER, John (1795–1861)
Born Leicester; taught in London by De Wint; became a drawing master. Landscapes. (*B.M.*)

FOLDSTONE, Anne
See Mee, Mrs.

FORBES, Mrs Elizabeth Stanhope (née Armstrong) (1859–1912)
Born Canada; studied art at Art Students' League, New York; married Stanhope Forbes, r.a. 1889; assoc. r.w.s. Landscapes and genre. Exhibited 8 works, 4 at r.a., 1890 onwards.

FORD, Richard (1796–1858)
Famous traveller in and writer on

Spain. Sketches, mostly in Spain
and Italy.

FORDE, Samuel (1805–28)
Born Cork; studied at Cork School
of Art. Mostly architectural, and a
few portraits and religious
subjects. (*V. & A.*)

FORREST, Thomas Theodosius
(1728–84)
Pupil of G. Lambert. Landscapes
in the manner of his teacher,
W. Taverner and J. Skelton.
Exhibited 15 works, 8 at Soc. of
Artists, 7 at R.A. 1762–81.
(*Cortauld, V. & A., B.M.*)

FORRESTER, Alfred Henry
(1805–72)
Born London; worked under
pseudonym of 'Alfred Crowquill'
as a caricaturist for many journals
and magazines. Domestic subjects.
Exhibited 4 works at R.A. 1845–46.

FORRESTER, James (1729–75)
Probably of Dublin, visited Rome
1760. Bold landscapes in ink and
bistre washes. Exhibited 1 work at
R.A. 1771. (*V. & A.*)

FORSTER, J. (fl. 1788–89)
An Edinburgh topographer.
(*Edinburgh*)

FORSTER, Mary
See Mrs Lofthouse.

FORSTER, Thomas
Early 18th century miniaturist on
vellum in pencil.

FORSYTH, Gordon Mitchell
(1879–1950)
Member R.I. 1927. Land and
seascapes.

FORTYE, W. H. (fl. 1875–86)

Landscapes. Exhibited 8 works,
5 at N.W.C.S.

FOSBROOKE, Leonard
(fl. 1884–92)
Of Ashby-de-la-Zouch, Leics.
Landscapes. Exhibited 15 works,
9 at N.W.C.S., 5 at R.A., 1 at
S.B.A.

FOSTER, Amy H. (fl. 1886–92)
Of Teignmouth; later became Mrs
R. K. Leather. Landscapes.
Exhibited 7 works, 5 at N.W.C.S.

FOSTER, Herbert Wilson
(fl. 1870–93)
Figure subjects. Exhibited 22
works, 6 at N.W.C.S., 14 at R.A.

FOSTER, Mary (1853–85)
Assoc. R.W.S. 1884. Landscapes
and flowers.

FOSTER, Myles Birket (1825–99)
Born North Shields; worked
under Peter Landells, a wood
engraver; illustrations for *Punch,
Illustrated London News*, and other
magazines; after 1859 concent-
rated on watercolour; travelled
widely on the Continent; assoc.
O.W.C.S. 1860, member 1862.
Stippled sentimental landscapes
with figures, genre. Exhibited 353
works, 332 at O.W.C.S., 16 at R.A.,
2 at S.B.A. (*Newcastle, Liverpool,
V. & A., B.M.*)

FOSTER, William (fl. 1870–93)
Of Witley, Surrey. Domestic
subjects. Exhibited 82 works, 9 at
N.W.C.S., 26 at R.A., 11 at S.B.A.

FOWLER, Monro (fl. 1884–88)
Of Southampton. Landscapes.
Exhibited 7 works, 3 at N.W.C.S.,
4 at S.B.A.

FOWLER, Robert (1853–1926)

Of Liverpool. Member R.I. 1891.
Figure subjects. Exhibited 58
works, 20 at N.W.C.S., 13 at R.A.,
13 at S.B.A.

FOWLER, William (fl. 1825–67)
Landscapes. Exhibited 197 works,
7 at N.W.C.S., 23 at R.A., 72 at
B.I., 72 at S.B.A.

FOX, Charles (1749–1809)
Born Falmouth; at one time a
bookseller; travelled widely.
Miniatures and landscapes, some
in Norway, Sweden and Russia.

FOX, Edward (fl. 1813–54)
Lived in Brighton from c. 1829.
Landscapes in the Brighton area.
Exhibited 52 works, 11 at O.W.C.S.,
28 at R.A., 11 at B.I., 2 at S.B.A.

FRANCIA, François Louis Thomas
(1772–1839)
Born Calais; father of Count A. T.,
who painted in a very similar
style; early to London, and first
exhibited at R.A. 1795; painter in
watercolours to the Duchess of
York; to France 1817, where he
taught R. P. Bonington and
W. Wyld; member and secretary
Associated Artists in Water
Colours. Exhibited 201 works,
85 at R.A. 1795–1821. (*Newport,
Whitworth, Newcastle, Nottingham,
Dublin, V. & A., B.M.*)

FRANCIS, Eva (fl. 1891–93)
Of Southsea. Flowers. Exhibited
3 works at N.W.C.S.

FRANCIS, J. (fl. c. 1816)
Landscapes in Hampshire by him
were engraved in the 'Antiquarian
Repository'.

FRANKLAND, Sir Thomas, Bart.
(1750–1831)
Pupil of Malchair.

FRANKLIN, George (fl. 1825–47)
Landscapes around London, Isle of
Wight, and on the Rhine.
Exhibited 20 works, 9 at R.A.,
8 at B.I., 3 at S.B.A.

FRANKLIN, John (fl. 1830–68)
Historical buildings. An example
named 'The Doge's Palace' in
V. & A. Exhibited 31 works,
9 at R.A., 10 at B.I., 9 at S.B.A.
(*V. & A., B.M.*)

FRASER, Alexander (1828–99)
Born near Linlithgow; the son of
an amateur painter; assoc. R.S.A.
1858, member 1862. Landscapes.
Exhibited 25 works, 11 at R.A.,
1 at B.I., 8 at S.B.A. 1866–89.
(*Edinburgh, B.M.*)

FRASER, Alexander (1785?–1865)
Of Edinburgh; in London with
Wilkie, as his assistant; assoc.
R.S.A. Figure and domestic
subjects. Exhibited 176 works,
32 at R.A., 97 at B.I., 37 at
S.B.A. 1810–59. (*Edinburgh,
B.M.*)

FRASER, Claud Lovat (1890–1921)
Born London; studied under
Sickert; badly wounded during
First World War and invalided
out of the army. Landscapes and
battle scenes. (*V. & A.*)

FRASER, John (fl. 1879–93)
Member R.B.A. Marines. Exhibited
130 works, 13 at N.W.C.S., 35 at
R.A., 72 at S.B.A.

FRASER, Robert W. (fl. 1874–93)
Of Bedford. Landscapes. Exhibited
87 works, 14 at N.W.C.S., 29 at
R.A., 18 at S.B.A.

FREEBAIRN, Robert (1765–1808)
Articled to P. Reinagle, and pupil
of R. Wilson; assoc. O.W.C.S.

1806. Landscapes. Exhibited 84 works, 8 at o.w.c.s., 54 at r.a., 22 at b.i.

FREEMAN, M. Winifred
(fl. 1886–93)
Domestic subjects. Exhibited 14 works, 11 at n.w.c.s.

FREEMAN, William Philip Barnes
(1813–97)
Son of William, an amateur friend of J. Crome; a frame-maker at Norwich. Marines. Exhibited 1) work at s.b.a. 1862. (*Norwich*)

FRIPP, Alfred Downing (1822–95)
Brother of G. A. and grandson of N. Pocock; educated at Bristol; to London 1840, and studied at b.m. and r.a. 1842; visited Ireland and Wales; toured Italy 1859; member and secretary o.w.c.s. Landscapes and figure subjects. Exhibited 273 works, 265 at o.w.c.s., 1 at r.a., 2 at b.i., 5 at s.b.a. (*Whitworth, V. & A.*)

FRIPP, Charles Edwin (1854–1906)
Son of G. A.; studied in Germany; war correspondent 1878–1900. Assoc. r.w.s. 1911. Figure and military subjects. Exhibited 29 works, 23 at o.w.c.s., 2 at r.a. (*V. & A.*)

FRIPP, Constance (fl. 1869–72)
Of Southampton. Landscapes. Exhibited 17 works, 3 at n.w.c.s., 1 at r.a., 7 at s.b.a.

FRIPP, George Arthur (1813–96)
Born Bristol; brother of A. D. and grandson of N. Pocock; studied under J. B. Pyne and S. Jackson; assoc. o.w.c.s. 184–, member 1845; secretary o.w.c.s. 1848. Portraits and landscapes in his brother's style. Exhibited 597 works, 581 at o.w.c.s., 4 at r.a.,

7 at b.i., 4 at s.b.a. (*Newport, Whitworth, V. & A.*)

FRITH, William Powell
(fl. 1840–1902)
Figure subjects. Exhibited from 1838.

FROST, George (1744–1821)
Of Ipswich, imitator of Gainsborough; friend of Constable. Landscapes, many around Ipswich. (*B.M., Ipswich*)

FROUDE, Rev. Robert Hurrell
(1771–1854)
Landscapes, especially village street scenes in monochrome and colour.

FRY, Lewis G. (b. 1860)
Born Clifton, Bristol; studied in London at Francis Bate's School and at the Slade. Landscapes. Exhibited at r.a., r.b.a. and r.w.s.

FRYER, E. (fl. c. 1817)
Landscapes and old buildings. One such, in Somerset, was engraved for the 'Antiquarian Repository'.

FRYER, T. (fl. c. 1816)
Possibly a brother of E. Some of his views in Northumberland were engraved for the 'Antiquarian Repository'.

FUGE, James (d. 1838)
Member n.w.c.a. 1831. Landscapes. Exhibited 8 works, 3 at n.w.c.s., 2 at b.i., 3 at s.b.a.

FULLERTON, C. A. (fl. c. 1829)
His drawing 'Edinburgh from the Golf Course' is in the V. & A.

FULLERTON, Mrs Elizabeth S.
(fl. 1890–93)
Of Paisley. Flowers. Exhibited 6 works, 4 at n.w.c.s., 2 at r.a.

FULLEYLOVE, John (1847–1908)
Born Leicester; trained as an
architect; member R.I. 1879; vice-
president Institute of Oil Painters.
Old buildings, mostly in the
Middle East, Italy and France, and
views of towns. Exhibited 167
works, 100 at N.W.C.S., 10 at R.A.,
16 at S.B.A. (*V. & A., B.M.*)

FURLONG, Marianne M.
(fl. 1891–93)
Of Woolwich. Flowers. Exhibited
5 works, 3 at N.W.C.S.

FURNESS, Harry (1854–1925)
Born Wexford, Southern Ireland;
studied at Hibernian Academy;
worked for *Illustrated London
News* and *Punch*. Caricatures. Ex-
hibited 6 works at R.A. from 1875.

FUSELI, Henry (1741–1825)
Born Zurich; took Holy Orders,
and for a time lived in Berlin; to
England c. 1763 and encouraged
by Reynolds c. 1767; spent 8 years
in Italy studying the works of
Michelangelo; back in England
1779; A.R.A. 1788, R.A. 1790;
professor of painting at R.A.
1799–1805 and from 1810; keeper
R.A. 1804. Mythological and
poetical subjects. Exhibited 75
works, 3 at Soc. of Artists, 69
at R.A., 3 at R.I., 1774–1825.
(*Auckland* (*N.Z.*), *V. & A., B.M.*)

FUSSELL, J.
Several artists of this name worked
during the 19th century, all of them
topographical including Joseph
Fussell (fl. 1821–45), who
exhibited 50 landscapes with
cattle, 24 at R.A., 17 at B.I., 8 at
S.B.A., 1 at N.W.C.S.

FYFE, William Baxter Collier
(1836–82)
Born Dundee; studied at Royal

Scottish Academy. Portraits and
domestic subjects. Exhibited 38
works, 26 at R.A., 2 at B.I., 4 at
S.B.A., 1865–82.

GAINES, G. (fl. 1770–87)
Views in London, Wiltshire, North
Wales and the Lake District.
Exhibited 16 works, 7 at Free
Soc., 9 at R.A.

GAINSBOROUGH, Thomas
(1727–88)
Born Sudbury, Suffolk; to London
1741; studied under Francis
Hayman, and at St Martin's Lane
Academy; returned to Sudbury
1745 and painted portraits; to
Ipswich 1746, Bath 1760; a
founder member of R.A. 1768;
settled in London 1774. Land-
scapes, usually in chalk and Indian
ink, or in pencil and wash, and
portraits. Exhibited 117 works,
18 at Soc. of Artists, 3 at Free
Soc., 96 at R.A. 1761–83.
(*V. & A., B.M.*)

GAMBLE, John (fl. c. 1792)
Perhaps learnt etching under
Basire. Detailed stained drawings.

GANDON, James (1742–1823)
Pupil of Sir William Chambers;
worked much in Dublin. Archi-
tectural subjects.
(*Note*. May be the Arthur J., who
however seems to have been born
c. 1773.)

GANDY, Herbert (fl. 1879–92)
Landscapes. Exhibited 23 works,
1 at N.W.C.S., 11 at R.A., 3 at S.B.A.

GANDY, Joseph Michael
(1771–1843)
An architect; studied under James

Wyatt, and at R.A. 1789; gold
medallist R.A. 1790; to Rome
1794; A.R.A. 1803. Imaginative
architectural subjects and
landscapes. Exhibited 126 works,
112 at R.A., 14 at B.I., 1789–1838.
(*Soane, V. & A., B.M.*)

GANTZ, J. (fl. 1810–20)
Scenes in India.

GARDELLE, Theodore (1722–61)
Born Geneva; studied in Paris, and
worked there and in Geneva,
Brussels and London. Miniatures.

GARDEN, W. F. (fl. 1882–90)
Of Bedford. Landscapes. Exhibited
13 works, 2 at N.W.C.S., 11 at R.A.

GARDNER, Daniel (1750–1805)
Born Kendal; a portrait painter;
studied at R.A., and silver medallist
1771; helped by Reynolds, whose
works he copied. Small portraits
in pastel and in body-colour.
Exhibited 1 work at R.A. 1771.

GARDNER, Edwin (fl. 1867–88)
Domestic subjects. Exhibited 18
works, 3 at N.W.C.S., 3 at R.A.,
11 at S.B.A.

GARDNER, Lord (fl. 1887–90)
Of Dorking. Landscapes.
Exhibited 5 works at N.W.C.S.

GARDNER, W. Biscombe
(1847?–1919)
Best known for his engravings.
Landscapes. Exhibited 105 works,
10 at N.W.C.S., 32 at R.A., 1 at S.B.A.

GARDNOR, Rev. John (or James?)
(1729–1808)
Vicar of Battersea, but originally
had a drawing academy. Land-
scapes, notably Rhine Valley
castle scenes. Exhibited 88 works,
27 at Soc. of Artists, 61 at R.A.
1763–96. (*V. & A.*)

GARLAND, Valentine Thomas
Of Winchester; fl. from 1884.
Domestic subjects. Exhibited
12 works, 8 at N.W.C.S., 4 at R.A.

GARNERAY, Ambroise Louis
(1783–1857)
Born Paris; at sea 1796–1806,
then captured and taken to
England, where he remained until
1814; during this period practised
art; patronised by Louis XVIII and
Duc d'Angoulême; director Rouen
Museum 1832. Painted on
porcelain at Sèvres. (*V. & A.*)

GARRARD, George (1760–1826)
Pupil of J. Gilpin; A.R.A. 1802.
Animals. Exhibited 238 works,
215 at R.A., 14 at B.I., 9 at S.B.A.
1781–1826. (*Liverpool, Newport,
Newcastle, V. & A., B.M.*)

GARRATT, Samuel (1865–1947)
Born Barwell, Leics.; studied at
Leicester School of Art; in
Burton-on-Trent 1899–1912,
Brecon 1912. Landscapes.
(*Newport*)

GARRAWAY, G. Hervey
(fl. 1870–91)
Of Liverpool. Figures. Exhibited
18 works, 2 at N.W.C.S., 4 at R.A.,
4 at S.B.A.

GARSIDE, Oswald (1879–1942)
Member R.I. 1916, R.C.A., R.W.A.
Landscapes.

GARVEY, Edmund (fl. 1767–1813)
Lived in Bath; A.R.A. 1770, R.A.
1783. Landscapes. Exhibited 137
works, 6 at Free Soc., 125 at
R.A., 6 at B.I., 1767–1809.

GASTINEAU, Henry
(1791?–1876)
Said to have studied at R.A.; assoc.
O.W.C.S. 1821, member 1823.

Wild and romantic scenery and coastal scenes. Exhibited 1,341 works, 1,310 at o.w.c.s., 26 at r.a., 3 at b.i. (*Newport, Liverpool, Newcastle, V. & A., B.M.*)

GAUCI, Paul (fl. 1834–66)
Landscapes. Exhibited 8 works, 1 at n.w.c.s., 4 at r.a., 1 at b.i., 2 at s.b.a. (*V. & A., B.M.*)

GAYWOOD, Richard (1630?–1711?)
Pupil of Hollar, and imitated his style.

GEIKIE, Walter (1795–1837)
Born Edinburgh; studied at Trustee's Academy, Edinburgh; assoc. Scottish Academy 1831, member 1834. Landscapes. Exhibited 2 works at r.a. 1818–35.

GENDALL, John (1790–1865)
Born Exeter; employed by Ackermann as a lithographer on the recommendation of Sir John Soane. Settled at Exeter. Landscapes. Exhibited 26 works, 25 at r.a., 1 at b.i. 1818–63. (*V. & A., B.M.*)

GENT, G. W. (fl. 1804–22)
Landscapes. Exhibited 9 works at r.a. (*V. & A., B.M.*)

GEORGE, Sir Ernest (1839–1922)
Born London; studied at r.a. 1858; gold medallist for architecture 1859; practised as an architect; president r.i.b.a. 1908; a.r.a. 1910, r.a. 1917; knighted 1911. Foreign views made during summer holiday tours. (*V. & A.*)

GERBIER, Sir Balthazar (1592–1628)
Born Middlesbrough; to Spain

with Prince Charles 1623; knighted 1628. Miniatures.

GERE, Charles March (1869–1957)
Born Gloucester. Assoc. r.w.s. 1921; r.w.s. 1926; a.r.a. 1934; r.a. 1939. Travelled Italy. Associate of William Morris. Landscapes with figures.

GESSNER, Johann Conrad (1764–1826)
Born Zurich; then studied at Dresden Academy; to Italy 1787; back in Zurich 1789–96, then to England; returned to Zurich 1804. Horses and military subjects. Exhibited 24 works at r.a., 1799–1803. (*V. & A.*)

GETHIN, Percy Francis (1875–1916)
Studied in Paris; taught at Liverpool School of Art and in London.

GHENT, Peter (fl. 1879–92)
Of Birkenhead; member r.c.a. Landscapes. Exhibited 39 works, 9 at n.w.c.s., 21 at r.a., 3 at s.b.a.

GIBB, Robert (1801–37)
Born Dundee. Landscapes. (*Edinburgh*)

GIBBONS, F. (fl. c. 1880)
Landscapes. (*V. & A.*)

GIBERNE, Edgar (fl. 1872–88)
Of Epsom. Domestic subjects. Exhibited 33 works, 4 at n.w.c.s., 4 at r.a., 3 at s.b.a.

GIBSON, Rev. John George (1759–1833)
Curate of Holybourne, Hants., from 1812. (*V. & A.*)

GIBSON, Patrick (1782–1829)
Pupil of Alexander Nasmyth,

member R.S.A. Topography, views of London in Indian ink monochrome and of Faroe Isles in colour. (*B.M.*, *Whitworth*, *Edinburgh*)

GIBSON, Richard (1615–90)
Known as Gibson 'the Dwarf'; pupil of F. Cleyn. Miniatures, and copies of Lely.

GIBSON, William (1644–1702)
Nephew and pupil of Richard. Miniatures, and copies of Lely.

GILBERT, Sir John (1817–97)
Born Blackheath; pupil of George Lance; assoc. O.W.C.S. 1852, member 1854 and president 1871; knighted 1872; A.R.A. 1872, R.A. 1876. Illustrations and historical scenes. Exhibited 375 works, 260 at O.W.C.S., 51 at R.A., 40 at B.I., 20 at S.B.A. (*Liverpool, Newcastle, V. & A., B.M.*)

GILCHRIST, Miss J. A.
(fl. 1885–88)
Of Sidmouth. Landscapes. Exhibited 3 works at N.W.C.S.

GILDER, Henry (fl. 1773–78)
Lived with Thomas Sandby at Windsor, where he probably studied to be an architect. Architectural studies. Exhibited 5 works at R.A. (*V. & A.*)

GILES, James William (1801–70)
Born Glasgow; pupil of artist father; also studied in Italy; member R.S.A. 1830. Highland scenery, in particular angling scenes. Exhibited 95 works, 2 at R.A., 80 at B.I., 13 at S.B.A. 1830–68. (*Edinburgh, B.M.*)

GILES, R. H. (fl. 1826–76)
Of Gravesend. Portraits. Exhibited

74 works, 3 at N.W.C.S., 48 at R.A., 22 at S.B.A.

GILFILLAN, John Alexander
(fl. 1820–70)
In early life a naval lieutenant; professor of painting at Glasgow Andersonian University 1830–40. Emigrated to New Zealand, and thence to Melbourne. Scottish landscapes and figure subjects. (*B.M., V. & A.*)

GILL, Edmund Marriner
(1820–94)
Born Clerkenwell; nicknamed 'Waterfall' because he was so fond of depicting them; spent his youth in Ludlow, Salop; in 1841 was influenced by an exhibition of the work of David Cox; studied at R.A. 1843. River subjects in Wales and Scotland. Exhibited 24 works, 11 at R.A., 6 at S.B.A. 1868–86. (*Newcastle, V. & A., B.M.*)

GILLETT, Frank Edward
(1874–1927)
Member R.I. 1909. Landscapes.

GILLIES, Margaret (1803–87)
Born London; brought up in Edinburgh; studied in London and Paris; assoc. O.W.C.S. 1852. Miniatures, and romantic and domestic subjects. Exhibited 384 works, 258 at O.W.C.S., 101 at R.A., 2 at B.I., 8 at S.B.A. (*V. & A., B.M.*)

GILLRAY, James (1757–1815)
Apprenticed to a heraldic engraver, but absconded to become a strolling player; studied at R.A.; died insane. Political and satirical caricatures (over 1,200 known). (*V. & A., B.M.*)

GILPIN, Capt. John Bernard
(1701–76)

Father of Sawrey and William; an amateur; commanded the Carlisle garrison 1745, and was also at Worcester and Plymouth. Topography at first, and later influenced by A. Cozens to paint Rosa-like landscapes in pen and wash. (*Carlisle*)

GILPIN, Sawrey (1733–1807) Born Carlisle; son of Capt. J. B.; pupil of marine painter Samuel Scott 1749; to Newmarket 1758 to study horses, and patronised by the Duke of Cumberland; painted animals in watercolours done by G. Barret Jr; president Incorp. s.a.; a.r.a. 1795, r.a. 1797. Animals and landscapes. Exhibited 120 works, 83 at Soc. of Artists, 36 at r.a., 1 at s.b.a. 1762–1808. (*V. & A., B.M.*)

GILPIN, Rev. William (1724–1804) Born near Carlisle; brother of Sawrey; ordained 1746; vicar of Boldre (New Forest) 1777; made many sketching tours which he illustrated in his published books as aquatints done by himself. Landscapes, mostly in pen and sepia wash. (*B.M., V. & A., Sheffield, Newcastle*).

GILPIN, William Sawrey (1762–1843) Son of Sawrey; Drawing Master Royal Military College, Great Marlow; founder member and first president o.w.c.s. 1804. Landscapes, many in the Constable style. Exhibited 86 works, 85 at o.w.c.s. (*Whitworth, V. & A., B.M.*)

GINNER, Charles (1878–1952) Born at Cannes. Assoc. r.w.s. 1938; r.w.s. 1945; c.b.e., a.r.a. Finest scenes of buildings.

GIRTIN, Thomas (1775–1802) Born Southwark; pupil of Fisher, an Aldersgate Street drawing master, and apprenticed to Edward Dayes; helped by Dr Monro; a close friend of Turner; toured the North of England with James Moore; to France 1801, returning the following year. An outstanding figure among watercolourists. Landscapes. Exhibited 33 works at r.a., 1794–1801. (*Oxford, Birmingham, Whitworth, V. & A., B.M.*)

GISBORNE, Rev. Thomas (1758–1846) Pupil of Warwick Smith and friend of W. Gilpin and Wright of Derby. Toured the Lake District with Wright 1793. (*Derby*)

GITTENS, Edith (fl. 1869–87) Of Leicester. Landscapes. Exhibited 10 works, 4 at n.w.c.s., 2 at r.a.

GLENNIE, Arthur (1803–90) Born Dulwich Grove; taught by Samuel Prout; made frequent visits to Rome, and settled there 1855; assoc. o.w.c.s. 1837, member 1858. Italian landscapes and architecture. Exhibited 410 works at o.w.c.s. 1837–90. (*V. & A.*)

GLINDONI, Henry Gillard (fl. 1872–93) Member r.b.a., assoc. r.w.s. 1883. Figure subjects. Exhibited 174 works, 51 at o.w.c.s., 29 at r.a., 71 at s.b.a.

GLOAG, Isobel Lilian (1865–1917) Born Kensington, of Scottish parents; studied at St John's Wood Art School, at the Slade under Legros, at South Kensington, and in Paris; member Royal Institute of Oil Painters. Romantic subjects,

flowers, portraits and interiors.
Exhibited 4 works, 3 at N.W.C.S.

GLOVER, John (1767–1849)
Born Houghton-on-the-Hill,
Leics,, the son of a farmer; self-
taught except for a few lessons
from W. Payne; to Litchfield 1794
as a drawing master; London
1805, Paris 1815, and later to
Switzerland and Italy; founder
member O.W.C.S. and twice its
president; left for Tasmania 1830
or 31. Landscapes, using his
'split brush' technique, in low
tones. Exhibited 445 works, 290
at O.W.C.S., 20 at R.A., 22 at B.I.,
113 at S.B.A., 1795–1832.
(*Newport, Newcastle, Liverpool,
Whitworth, V. & A., B.M.*)

GLOVER, William (fl. 1808–33)
Son and pupil of John; taught
drawing with Allport at Birming-
ham 1808; went with his father to
Tasmania. Landscapes. Exhibited
42 works, 24 at O.W.C.S., 1 at
R.A., 7 at B.I., 10 at S.B.A.
(*V. & A.*)

GODDARD, J. Bedloe (fl. 1875–93)
Of Christchurch, Hants. Land-
scapes. Exhibited 8 works, 2 at
N.W.C.S., 4 at S.B.A.

GODSELL, May E. (fl. 1884–93)
Of Stroud. Domestic subjects.
Exhibited 5 works, 2 at N.W.C.S.,
3 at R.A.

GOFF, Col. Robert Charles
(1873–1922)
Born Ireland; fought in the Crimea
and travelled widely; several
years in Florence and Switzerland;
friend of Charles Dickens; member
Royal Society of Painters, Etchers
and Engravers. Landscapes and
buildings. Exhibited 79 works, 22
at N.W.C.S., 20 at R.A., 5 at S.B.A.

GOLDICUTT, John (1793–1842)
Studied at R.A. 1812, and became
an architect; visited Italy 1817–19;
published many illustrated travel
books; hon. secretary R.I.B.A.
1834–36. Architectural subjects.
Exhibited 35 works at R.A.
1810–42. (*V. & A.*)

GOLDSMITH, Walter H.
(fl. 1880–93)
Of Maidenhead. Landscapes.
Exhibited 53 works, 5 at N.W.C.S.,
15 at R.A., 24 at S.B.A. (*V. & A.*)

GOMPERTZ, M. (or G.?)
(fl. 1827–43)
Figure subjects. Exhibited 20
works, 2 at N.W.C.S., 7 at R.A.,
1 at B.I., 10 at S.B.A. (*V. & A.*)

GOOCH, John (or James?)
(fl. 1813–33)
Of Norwich; moved later to
Twickenham. Landscapes.

GOOCH, Rev. John (fl. c. 1780)
Of Benacre, Suffolk; an archdeacon.
Drew local scenery at Oxford
(some examples engraved) and
country houses of his friends.

GOODALL, Edward Angelo
(1819–1908)
Son of E. Goodall (1795–1870)
a landscape engraver, and brother
of Frederick; artist to the Guinea
Boundary Commission 1841; war
correspondent in the Crimea 1854;
visited Rome; assoc. O.W.C.S. 1858,
member 1864. Landscapes,
interiors and figure subjects.
Exhibited 382 works, 328 at
O.W.C.S., 15 at R.A., 36 at B.I.,
2 at S.B.A. (*V. & A., B.M.*)

GOODALL, Frederick (1822–1904)
Brother of Edward Angelo;
Society of Arts silver medallist
1836–37; A.R.A. 1852, R.A. 1863,

H.R.A. 1902. Village scenes, Biblical scenes in the Nile region, and landscapes in France and England. Exhibited 240 works, 5 at N.W.C.S., 179 at R.A., 33 at B.I., 6 at S.B.A. (*Gateshead, Newcastle, V. & A., B.M.*)

GOODALL, Frederick Trevelyan (1848–71)
Born London; son of Frederick; studied at R.A., and a gold medallist. Genre and portraits. Exhibited 17 works at R.A. 1868–71. (*V. & A.*)

GOODALL, Herbert H. (d. 1907)
Fl. from 1878. Landscapes and buildings. Exhibited 6 works at S.B.A. 1890–92. (*V. & A., B.M.*)

GOODALL, J. Edward (fl. 1877–91)
Domestic subjects. Exhibited 33 works, 6 at N.W.C.S., 5 at R.A., 16 at S.B.A.

GOODALL, Walter (1830–89)
Studied at the Government School of Design and at R.A.; assoc. R.W.S. 1853, member 1861. Figure subjects. Exhibited 159 works, 156 at O.W.C.S., 3 at R.A.

GOODE, Louise
See Jopling, Mrs J. M.

GOODEN, James Chisholm (fl. 1835–75)
Author of 'Thames and Medway Admiralty Surveys' 1864; friend of G. Chambers and W. J. Müller. Landscapes and marines. Exhibited 31 works 1835–65. (*V. & A., B.M.*)

GOODMAN, Maude (fl. 1874–93)
Domestic subjects. Exhibited 74 works, 12 at N.W.C.S., 3 at R.A., 9 at B.I., 17 at S.B.A.

GOODWIN, Albert (1845–1932)
Widely travelled; much influenced by A. Hughes and J. Ruskin. Assoc. R.W.S. 1871, member 1881. Romantic landscapes with fine pen work and use of body-colour. (*V. & A., B.M., Maidstone, Newcastle*)

GOODWIN, Edward (or Edmund?) (fl. 1801–19)
In Manchester 1809, founder member Liverpool Academy 1810. Landscapes and interiors. Exhibited 42 works, 9 at O.W.C.S., 13 at R.A. (*Whitworth, V. & A., B.M.*)

GOODWIN, Harry (fl. 1867–93)
Of Maidstone. Domestic subjects. Exhibited 134 works, 17 at N.W.C.S., 15 at R.A., 27 at S.B.A.

GOODY, Florence (fl. 1888–92)
Of Lewisham. Domestic subjects. Exhibited 7 works, 3 at N.W.C.S., 1 at R.A., 3 at S.B.A.

GORDON, Lady Julia (née Bennet) (fl. 1797–1813)
Pupil of Girtin and perhaps of Turner. Landscapes.

GORE, Charles (1729–1807)
A wealthy amateur; friend of Goethe; after 1773 wintered in Lisbon; visited Italy 1774–77; in Rome he associated with Payne Knight and J. R. Cozens, who copied him. Marines. (*Thuringische Landesbibliothek, B.M.*)

GORE, William Henry (*fl.* 1880–93)
Member R.B.A. Domestic scenes. Exhibited 66 works, 12 at N.W.C.S., 18 at R.A., 21 at S.B.A.

GOTCH, Thomas Cooper (1854–1931)

Member R.I. 1912; V.P.R.W.A.;
P.R.B.A.; R.B.A. Landscapes.
Exhibited 54 works, 3 at N.W.C.S.,
11 at R.A., 22 at S.B.A.

GOULDSMITH, Harriet
See Arnold, H.

GOUPY, Joseph (1698–1763)
Born Nevers, France; to London
when young; scene-painter at
Covent Garden and Haymarket
Theatres; teacher of Princes
Frederick and George; a fashion-
able drawing master. Miniatures,
figure subjects, landscapes and
copies of Italian Masters.
Exhibited 2 works at Soc. of
Artists. (*B.M.*)

GOUPY, Lewis (Louis or Ludovic?)
(d. 1747)
Of French extraction; left
Kneller's circle to join that of
Chéron in 1720; travelled to Italy
with Burlington; a drawing
master, employed by J. Stuart to
paint fans.

GOW, Andrew Carrick
(1848–1920)
Born London; son and pupil of
James Gow, a genre painter;
studied at Heatherley's School of
Art; assoc. R.I. 1868, member
R.I. 1870, A.R.A. 1881, R.A. 1891,
keeper R.A. from 1911. Historical
subjects. Exhibited 94 works,
48 at N.W.C.S., 37 at R.A., 3 at
S.B.A.

GOW, David (fl. 1886–88)
Landscapes. Exhibited 5 works at
N.W.C.S.

GRACE, Alfred Fitzwalter
(1844–1903)
Born Dulwich; studied at
Heatherley's School of Art and at
R.A.; Turner gold medallist at

R.A.; member R.B.A.; friend of
Whistler. Landscapes, especially of
the South Downs. Exhibited 208
works, 10 at N.W.C.S., 48 at R.A.,
6 at B.I., 81 at S.B.A. (*V. & A.*)

GRACE, James Edward
(1851–1908)
Studied at Liverpool Institute and
at South Kensington; member
R.B.A. Book illustrations and land-
scapes. Exhibited 283 works, 14 at
N.W.C.S., 32 at R.A., 158 at S.B.A.

GRAHAM, Alexander (b. 1858)
An architect. Architectural
subjects. Exhibited 15 works,
10 at R.A. after 1875.

GRAHAM, Mrs W. J. (fl. c. 1884)
Flowers. Exhibited 3 works at
N.W.C.S.

GRAHAM, Lord William
(1807–78)
Pupil of De Wint, and painted in
his style.

GRAINGER, George A.
(fl. 1782–1836)
Landscapes, mostly in the New
Forest, Cambridgeshire,
Worcestershire and Isle of Wight.
Exhibited 20 works 1782–1836.

GRANT, Alice (fl. 1879–93)
Portraits. Exhibited 56 works,
7 at N.W.C.S., 3 at Free Soc.,
3 at R.A., 14 at S.B.A.

GRANT, Mary Isabella
(fl. 1870–93)
of Cullompton, Devon. Landscapes.
Exhibited 54 works, 41 at S.B.A.,
7 at N.W.C.S.

GRATTON (or GRATTAN),
George (1787–1819)
Born Dublin, and studied at Dublin
Society's Schools; at first painted

miniatures and portraits; member
Irish Society of Artists 1813.
Landscapes and figure subjects.
Exhibited 5 works, 3 at R.A., 2 at
B.I. from 1812. (*V. & A.*)

GRAVATT, Col. W.,
(fl. c. 1790)
A friend of Paul Sandby; inspector
of Royal Marine Academy,
Greenwich; F.R.S. Made sketches
of costume for 'Records of the
R.M.A.' 1851. (*B.M.*)

GRAVELOT, Hubert Francis (or
Henri Hubert?) (1699–1773)
Born France; to England 1733;
friend of Garrick. Delicately
painted figures in parks and
gardens, and in landscapes.
(*Note.* Born under the name of
Bourguignon.)

GRAY, Ronald (1868–1951)
Assoc. R.W.S. 1934; R.W.S. 1941.
Landscapes.

GRAY, Ronald (fl. 1891–2)
Portraits and dock scenes.
Exhibited 10 works at minor
exhibitions.

GRAY, S. (fl. 1800–30)
Surrey landscapes. Exhibited 6
works at R.A.

GRAY, Thomas (fl. 1881–93)
Of Turnham Green. Domestic
subjects. Exhibited 11 works, 5 at
N.W.C.S., 6 at S.B.A.

GREAVES, Henry (1850–1900)
and Walter (1846–1930)
Friends of Whistler. Drawings of
Chelsea. (*B.M., Whitworth,
Bedford*)

GREEN, Amos (1735–1807)
Born Halesowen, Worcs.; pupil of

A. Cozens; settled at Bath c. 1757;
married Harriet Lister 1796;
collaborated with George Stubbs.
Flowers, fruit and brown-toned
landscapes, many in the Lake
District. Exhibited 5 fruit
paintings at Soc. of Artists,
1760–65 (*V. & A., B.M.*)

GREEN, Benjamin Richard
(1808–76)
Born London; the son of portrait
painter James Green and miniature
painter Mary Green; studied at
R.A.; member N.W.C.S. 1834;
published books on perspective,
and taught art. Architectural
subjects. Exhibited 327 works,
243 at N.W.C.S., 40 at R.A., 38 at
S.B.A. (*V. & A., Newcastle*)

GREEN, Charles (1840–98)
Pupil of J. W. Whymper; member
Institute of Painters in Water
Colours 1867. Early black-and-
white work for periodicals, and
illustrations for Dickens novels;
genre later. Exhibited 184 works,
150 at N.W.C.S., 12 at R.A.
(*V. & A., B.M.*)

GREEN, David Goold (1854–1917)
Member Institute of Painters in
Water Colours 1897. Landscapes
and coastal scenes. Exhibited 88
works, 15 at N.W.C.S., 9 at R.A.,
40 at S.B.A.

GREEN, Henry Townley
(1836–99)
Brother of Charles; began career in
a bank; member Institute of
Painters in Water Colours 1879.
Black-and-white drawings, and
landscapes. (*V. & A., B.M.*)

GREEN, James (1771–1834)
Born Leytonstone, father of B. R.;
member and treasurer Associated

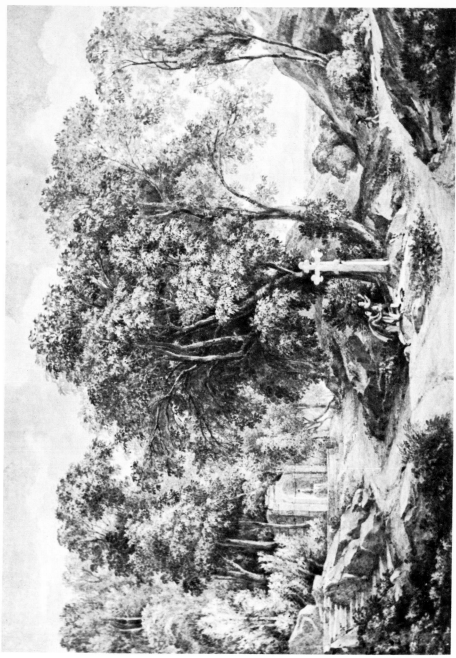

Between Rome and Ariccia

Joseph Michael Gandy
(1771–1843)

14″ x 20″

The full title of this drawing, inscribed on the mount in the artist's hand, is: 'Between Rome and Ariccia, the Island of Calypso in the distance'. Works by this pupil of the architect James Wyatt are rare, although he was a fairly prolific exhibitor. This competent example serves to emphasise that very many able watercolourists, whose work stands comparison with that of their famous contemporaries, still await deserved recognition. The treatment of trees and foliage, and of the characteristically drawn figures, should be compared with that shown in the drawing entitled 'Near Campistrello', illustrated in Plate 83 of Derek Clifford's 'Collecting English Watercolours' (1970).

The Falls at Tivoli

John Glover
(1767–1849)
9″ x 12¼″

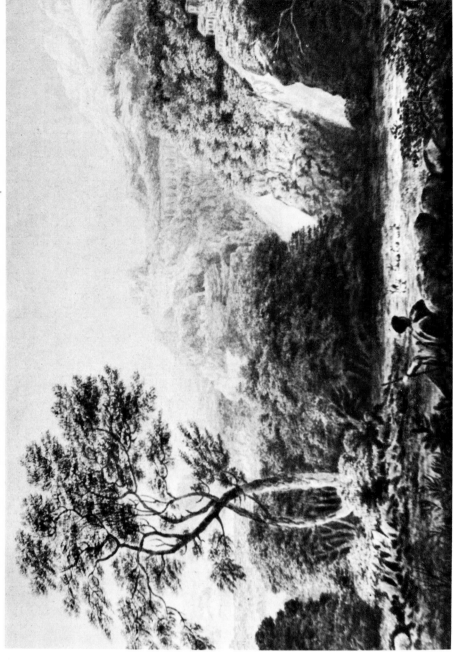

Before Glover emigrated to Tasmania in 1830 or 1831, he travelled much on the Continent. His work is known to collectors mainly by reason of his trick of binding together the hairs of his brush to form several tips, enabling him to paint foliage more quickly. The effect of this can be seen clearly here. So can his habit of flooding his middle distances with light from one side, particularly when he was depicting the glint of light upon a wooded hillside. Rather like John Varley, Glover liked to use a dark foreground with a figure or two, falling away to a valley, a lake or a river, on the far side of which is a hill or sometimes a castle. It is rare to find a good sky in his land-scapes because of the fading due to his use of indigo mixed with Indian red.

Artists in Water Colours. Miniatures and portraits. Exhibited 288 works, 206 at R.A., 30 at B.I., 9 at S.B.A. 1792–1834.

GREEN, Mrs James (née Byrne) (1776–1845)
Member Associated Artists in Water Colours. Miniatures and copies after Reynolds and Gainsborough. Exhibited 134 works, 94 at R.A., 6 at B.I., 2 at S.B.A., 1805–45.

GREEN, Nathaniel Everett (fl. 1854–90)
Landscapes. Exhibited 88 works, 12 at N.W.C.S., 18 at R.A., 1 at B.I., 24 at S.B.A.

GREEN, William (1760?–1823)
Born Manchester; worked with a Manchester surveyor before moving to London, where he studied aquatint; settled finally in the North when his health failed. Views in the Lake District. Exhibited 9 works, 4 at R.A. 1797–1811. (*V. & A., B.M., Newcastle, Whitworth*).

GREENAWAY, Kate (1846–1901)
Born Hoxton, London, the daughter of a wood engraver; studied at Islington School of Art, at Heatherley's School of Art, and at the Slade; member R.I. 1889. Illustrations for children's books. Exhibited 53 works, 6 at N.W.C.S., 6 at R.A., 11 at S.B.A. 1868–91. (*V. & A., B.M., Whitworth*)

GREENBANK, Arthur (fl. 1888–93)
Figure subjects. Exhibited 22 works, 8 at N.W.C.S., 5 at R.A., 4 at S.B.A.

GREENWOOD, John (1727?–92)
An American from Boston; to England 1763 via Surinam (1752–58) and Holland as an art dealer; studied under Thomas Johnson; later an auctioneer. Portraits and landscapes, and mezzotint engravings. *V. & A., B.M.*)

GREGORY, Charles (1849–1920)
Assoc. R.W.S. 1882, member 1883. Genre. Exhibited 122 works, 10 at R.A., 11 at S.B.A., 94 at O.W.C.S. after 1873. (*Liverpool, Melbourne*)

GREGORY, Edward John (1850–1909)
Assoc. R.I. 1891, member 1896, President 1898 A.R.A. Portraits. Exhibited 106 works, 55 at N.W.C.S., 18 at R.A.

GRESSE, John Alexander (1741–94)
Born London, of Swiss extraction; studied under Cipriani, Zuccarelli and others, and at St Martin's Lane Academy; premiums from Society of Arts 1755 onwards; a fashionable art teacher, among his pupils the daughters of George III. Miniatures and landscapes. (*V. & A., B.M.*)

GRESTY, Hugh b. 1899
R.I. 1935; member R.B.A. Harbour scenes and landscapes.

GREVILLE, Henry Richard
See Warwick, Lord.

GREY, Edith F. (fl. 1890–92)
Of Newcastle. Flowers. Exhibited 5 works, 3 at N.W.C.S., 2 at R.A.

GREY, Mrs Jane Willis (fl. 1877–93)
Domestic subjects. Exhibited 35 works, 7 at N.W.C.S., 4 at R.A., 18 at S.B.A.

GRIERSON, C. MacIvor
(1863–1939)
Member R.I. 1892. Domestic
subjects. Exhibited 27 works,
18 at N.W.C.S., 2 at R.A., 3 at
S.B.A.

GRIEVE, Thomas (1799–1882)
Son of theatrical painter J. H. and
himself a scene-painter at Covent
Garden and Drury Lane. Land-
scapes. Exhibited 5 works at R.A.
1825–28. (*V. & A.*)

GRIFFITH, Moses (1749–1809?)
Born Caernarvonshire; servant of
and draughtsman to the antiquary
Pennant; studied at Incorp. S.A.
1771. Landscapes. (*B.M., Derby,
Newcastle, Aberystwyth, Douglas*)

GRIFFITHS, John (1837–1918)
A Welshman; studied at the
National Art Training School
(now R.C.A.) and helped Godfrey
Sykes in the decoration of the
V. & A. museum; first principal
Bombay School of Art; supervised
the copying of paintings in the
temples of Ajanta 1872–85. Indian
subjects. Exhibited 20 works,
17 at R.A., 1869–93.

GRIFFITHS, Tom (fl. 1871–93)
Of Leeds. Landscapes. Exhibited
58 works, 2 at N.W.C.S., 17 at
R.A., 22 at S.B.A.

GRIMALDI, William (1751–1830)
Born Middlesex; studied under
T. Worlidge, and in Paris,
painted miniatures in Paris and in
England; miniature painter to
George III and George IV.
Exhibited 95 works, 89 at R.A.
1768–1830.

GRIMM, Samuel Hieronymus
(1733–94)
Born Burgdorf, near Berne; settled

in London 1765; employed by
Society of Antiquaries. Landscapes,
caricatures, and humorous
subjects. Exhibited 54 works,
46 at R.A. 1769–93. (*V. & A.,
Alton, Sheffield, Newcastle, Leeds,
B.M., Whitworth*).

GRISET, Ernest Henry
(1844–1907)
Born France; to London in the
1860's; illustrated books for the
Dalziel Bros., and drew for *Punch*.
Drawings of animals. Exhibited 2
works at S.B.A. 1871. (*V. & A.*)

GROGAN, Nathaniel (d. 1807?)
Born Cork; served in the army in
the American War of Independ-
ence. Landscapes and humorous
subjects. Exhibited 4 works at
Free Soc., 7 at R.A., 9 at S.B.A.
1782.

GROOME, William H. C.
(fl. 1881–92)
Of Ealing. Landscapes. Exhibited
26 works, 5 at N.W.C.S.

GROSE (or GROSSE) Capt. Francis
(1731–91)
Son of a Swiss jeweller; an
amateur, trained at Shipley's
Drawing School. Landscapes.
Exhibited 19 works, 16 at R.A.
1767–77. (*Hereford*)

GROVES, Mrs J. (fl. c. 1847)
Portraits. Exhibited 16 works,
5 at O.W.C.S., 11 at R.A.

GROVES, Robert E. (fl. 1887–93)
Marines. Exhibited 11 works,
8 at N.W.C.S., 1 at R.A., 2 at S.B.A.

GROVES, Thomas (fl. 1881–89)
Of Leicester. Landscapes.
Exhibited 11 works, 8 at N.W.C.S.,
2 at R.A., 1 at S.B.A.

GRUNDY, Robert Hindmarsh (1816–65)
An amateur, of Liverpool; friend of David Cox; a founder of the Print-Sellers Association. Landscapes. (*V. & A.*)

GUILDING, Rev. Landsdown (1798–1831)
Born Kingston, Jamaica; a naturalist. Landscapes of the West Indies.

GÜLICH, John Percival (1865–99)
Born Wimbledon; drew for the *Graphic* and other journals. Black-and-white studies, and etchings. Member R.I. 1897. Exhibited 12 works, 2 at N.W.C.S., 1 at R.A., 9 at S.B.A.

GULLY, J.
Little known. Exhibited a landscape at R.A. 1871. (*V. & A.*)

GUYS, Ernest Adolphe Constantin (1805–92)
Born Flushing, Cornwall, of French extraction; drew for the *Illustrated London News*; was drawing master in the Girtin family; settled in Paris after 1860. Drawings of Parisian life. (*V. & A.*)

GWATKIN, Stewart Beauchamp (fl. 1888–93)
Domestic subjects. Exhibited 15 works, 6 at N.W.C.S., 9 at S.B.A.

GYFFORD, Edward (1772–1834)
Studied at R.A., and gold medallist 1792; published 'Designs for Small Picturesque Cottages and Hunting Boxes' 1807. Architectural subjects. Exhibited 5 works at R.A. 1791–99. (*V. & A., B.M.*)

GYLES, Henry
Lived in York 1640–1700.

Portraits in crayon, historical subjects and landscapes.

HAAG, Carl (1820–1915)
Born Bavaria; studied at Nuremburg and Munich 1834–46; to Brussels, then England and Italy 1847; studied at R.A. 1848; with Queen Victoria at Balmoral 1853; to Middle East 1854, Egypt 1873; died in Germany; assoc. O.W.C.S. 1850, member O.W.C.S. 1853. Figure subjects and landscapes. Exhibited 372 works, 343 at O.W.C.S., 11 at R.A., 3 at S.B.A. (*V. & A., Newcastle, Whitworth*)

HACCOU, Johannes Cornelis (1798–1839)
Born Middelburg, the Netherlands; pupil of J. H. Koekkock; painted in France and Germany, but settled in London, where he died. Landscapes. Exhibited 3 works, 1 at R.A., 2 at S.B.A., 1836–37.

HACKER, Arthur (1858–1919)
Member R.I. 1918, R.A., R.O.I. Domestic scenes.

HACKERT, Jakob Philipp (1737–1807)
Of German birth; lived for a long time in Rome; court painter to the King of Naples. Mostly views of Rome and Naples, and tinted drawings in the P. Sandby style, done in England. Exhibited 30 works at S.A. 1790–91. (*B.M.*)

HACKERT, Johann Gottlieb (1744–73)
Brother and pupil of J. P.; also taught by Le Sueur; to England 1772. Exhibited 49 works, 40 at

Soc. of Artists, 9 at R.A. 1771
onwards.

HADDEN, Nellie (fl. 1885–93)
Of Sunningdale. Domestic subjects.
Exhibited 9 works, 4 at N.W.C.S.,
2 at S.B.A.

HADDON, Arthur Trevor
(fl. 1883–93)
Portraits. Exhibited 35 works,
7 at R.A., 12 at S.B.A., 9 at
N.W.C.S.

HADEN, Sir Francis Seymour
(1818–1910)
Born London; studied medicine
and practised as a surgeon
1847–87; a fine etcher, and a
founder Royal Society of Painter-
Etchers and Engravers; knighted
1894. Landscapes. (*V. & A.*)

HADLEY, J. (fl. 1729–58)
An amateur landscapist of the
South and South-West of England.
(*V. & A.*)

HAGARTY, Mary S. (fl. 1885–92)
Of Liverpool. Landscapes.
Exhibited 17 works, 10 at N.W.C.S.,
4 at R.A., 3 at S.B.A.

HAGHE, Louis (1806–85)
Born Tournai, Belgium, the son of
an architect; early to England;
member R.I., N.W.C.S. 1835,
president 1873; member Belgian
Academy and Academy of
Antwerp. Scenes in old towns and
interiors of buildings and churches
in Belgium and northern France,
with figures and much use of
body-colour all drawn with the left
hand. Exhibited 225 works, 217 at
N.W.C.S., 8 at B.I. (*V. & A.,
Newcastle, Whitworth*)

HAGREEN, Henry Brown
(1831?–1912)

Master of architectural classes at
R.C.A. Landscapes. (*V. & A.*)

HAGUE, Joshua Anderson
(1850–1916)
Of Stockport; member R.I., R.B.A.,
and R.C.A. Landscapes. Exhibited
82 works, 18 at N.W.C.S., 31 at R.A.,
14 at S.B.A.

HAINES, William (1778–1848)
Miniatures and portraits.
Exhibited 86 works, 3 at O.W.C.S.,
57 at R.A., 19 at B.I., 7 at S.B.A.

HAINES, William Henry
(1812–84)
Born St Pancras; mostly self-
taught; trained as a picture
restorer; sometimes used the name
'William Henry'. Genre and
landscapes, some of views in
Venice; copied works of Guardi
and Canaletto. Exhibited 223
works, 30 at R.A., 40 at B.I., 108 at
S.B.A. (*V. & A.*)

HAITÉ, George Charles
(1855–1924)
Member R.B.A.; member R.I. 1901.
Landscapes. Exhibited 44 works, 7
at N.W.C.S., 10 at R.A., 19 at S.B.A.

HAKEWELL, James (1778–1843)
Trained as an architect; toured
widely for the purpose of
illustrating volumes of foreign
scenes (Italy 1818, Jamaica 1821).
Landscapes. Exhibited 10 oils at
R.A. but never exhibited his
watercolours.

HALE, William Matthew
(1837–1929)
Travelled widely in Europe.
Assoc. R.W.S. 1871, member 1881.
Marines. Exhibited 250 works,
229 at O.W.C.S., 4 at R.A., 3 at S.B.A.

HALFNIGHT, Richard William

(fl. 1878–92)
Landscapes. Exhibited 77 works,
10 at N.W.C.S., 7 at R.A., 41 at
S.B.A.

HALFPENNY, Joseph S.
(1748–1811)
Born Yorkshire, the son of a
gardener; apprenticed to a house-
painter; became a drawing master;
clerk of works to John Carr at the
restoration of York Minster, and
published 'Gothic Ornaments' (of
that building) 1795–1800.
Architectural and scriptural
subjects, and landscapes in the
style of J. P. Hackert. Exhibited
8 works R.A. (*V. & A.*, *B.M.*,
York)

HALFPENNY, William (b. 1722)
Alias of Michael Hoare, probably
related to Prince Hoare; published
books on architecture; fl. c. 1753.

HALKETT, George Rowland
(1855–1918)
Born Edinburgh; studied in Paris;
contributed to *Punch*; editor of
Pall Mall Magazine. Caricatures.

HALL, George Lothian (1825–88)
Visited Brazil 1848–54 and began
to paint on his return; to Wales
1880. Exhibited 118 works, 7 at
R.A., 8 at S.B.A. and at minor
exhibitions, 1856–78. (*B.M.*,
V. & A.)

HALL, Oliver (1869–1957)
Father of Claude Muncaster;
trained at the Royal College at
Lambeth and Royal College
Westminster; Travelled widely in
Italy and Spain; member R.W.S.
1919, A.R.A. 1920, R.A. 1927.
Landscapes. (*B.M.*, *Whitworth*
& Tate)

HALL, Sydney Prior (1842–1922)

Born Newmarket; artist for
Graphic during Franco-German
War 1870; accompanied members
of the Royal Family on tours
1875–1901. Historical subjects.
Exhibited 7 works at R.A., 14 at
Grosvenor gallery, 1 at N.W.C.S.
from 1874.

HALLEWELL, Col. Benjamin
(fl. 1865–69)
Of Stroud. Battle scenes. Exhibited
1 work at R.A.

HALLSWELLE, Keeley (1832–91)
Assoc. R.S.A. 1865, member R.I.
1882. Historical subjects,
landscape and genre. Exhibited
123 works, 34 at N.W.C.S., 36 at
R.A., 5 at S.B.A.

HAMBLE, J. R. (fl. 1803–24)
A friend of D. Cox. Landscapes.
Exhibited 3 works at R.A.

HAMILTON, Gertrude E. Demain
(fl. 1886–93)
Domestic subjects. Exhibited 14
works, 10 at O.W.C.S., 3 at R.A., 1
at S.B.A.

HAMILTON, T. (fl. c. 1830)
Views in Edinburgh, some
engraved.

HAMILTON, William
(1751–1801)
Born Chelsea; helped by Robert
Adam to visit Italy, where he
studied under Zucchi; also studied
at R.A. 1769; a fashionable figure
draughtsman; A.R.A. 1784, R.A.
1789. Historical and figure
subjects. Exhibited 82 works at
R.A. (*B.M.*, *V. & A.*, *Whitworth*)

HAMMOND, Arthur Henry
Knighton (1875–1970)
Member R.I. 1933, R.O.I., R.S.W.
Landscapes and figure studies.

HANBURY, Ada (fl. 1875–87)
Flowers. Exhibited 11 works,
2 at N.W.C.S., 5 at R.A.

HANBURY, Blanche (fl. 1876–87)
Flowers. Exhibited 28 works, 2 at
N.W.C.S., 2 at R.A., 11 at S.B.A.

HANCE, J. W. (fl. 1830–33)
Exhibited 8 works, 3 at N.W.C.S.,
5 at R.A.

HANCOCK, Charles (1819–69)
Of Marlborough. Sporting
subjects. Exhibited 146 works, 9 at
N.W.C.S., 23 at R.A., 55 at B.I., 47 at
S.B.A.

HAND, Thomas (fl. 1790–1804)
Studied under Morland, and made
copies of the Masters. Landscapes.
Exhibited 22 works, 21 at R.A.
1790–1804.

HANDASIDE, Charles
(fl. 1760–76)
Miniatures. Exhibited 15 works.

HARDIE, Martin (1875–1952)
Educated at St Paul's School and
Trinity College, Cambridge;
C.B.E., R.E.R.S.W., V.P.R.I., 1934.
Wrote 'Water Colour Painting in
Britain', 3 vols. published 1968.
Studied etching under Sir Frank
Short; Fellow Royal Society of
Painter-Etchers and Engravers.
Hon R.W.S. 1943; keeper V. & A.;
member R.I. 1924. (*Newport,
Newcastle, B.M., V. & A.*)

HARDING, George Perfect
(d. 1853)
Son of Sylvester; fl. 1802–40.
Miniatures and watercolour copies
of English historical portraits.
Illustrations for historical and
antiquarian books. Exhibited 22
works, 20 at R.A., 2 at S.B.A.

HARDING, James Duffield
(1797–1863)
Born Deptford; the son of a pupil
of P. Sandby; exhibited at R.A. at
the age of 14; some lessons from
S. Prout, and apprenticed to
engraver John Pye; visited Italy
1824 and 1830; assoc. O.W.C.S.
1820, member 1821; a litho-
grapher. Landscapes, often on
coloured paper. Exhibited 208
works, 143 at O.W.C.S., 35 at R.A.,
8 at B.I., 17 at S.B.A. (*B.M.,
V. & A., Stirling*)

HARDING, J. H. (d. 1846)
Father of James Duffield; a pupil of
P. Sandby; fl. from 1777. Stained
landscapes with figures. Exhibited
3 works at R.A., 1800–07.
(*V. & A.*)

HARDING, Sylvester (1745–1809)
Born Newcastle-under-Lyme;
to London 1775. Miniatures.
Exhibited 26 works, 3 at Free Soc.,
23 at R.A. 1776–1802.

HARDMAN, Mrs Thomas
(Emma L.) (fl. 1888–93)
Of Potter's Bar. Flowers.
Exhibited 12 works, 3 at N.W.C.S.,
2 at R.A., 7 at S.B.A.

HARDS, Charles G. (fl. 1883–91)
Domestic subjects. Exhibited 15
works, 4 at N.W.C.S., 6 at R.A., 3 at
S.B.A.

HARDWICK, John Jessop
(1831–1917)
Born Beverley, Yorks.; pupil of
Redgrave, Ruskin and D. G.
Rossetti; worked early in life for
Illustrated London News; assoc.
R.W.S. 1882. Landscapes and
flowers. Exhibited from 1850, 172
at O.W.C.S., 42 at R.A., 1 at B.I., 37
at S.B.A.

HARDWICK, Philip (1792–1869)
An architect; A.R.A. 1839, R.A.
1841. Architectural subjects.
Exhibited 23 works at R.A.,
1807–44.

HARDWICK, William Noble
(1805–65)
Member N.W.C.S. 1834; in Bath
1838. Landscapes. Exhibited 411
works, 329 at N.W.C.S., 8 at R.A.,
43 at B.I., 31 at S.B.A. (*V. & A.,
B.M.*)

HARDY, Dorofield (fl. 1882–92)
Domestic subjects. Exhibited 9
works, 4 at N.W.C.S., 1 at R.A., 1 at
S.B.A.

HARDY, Dudley (1867–1922)
Born Sheffield; studied abroad;
member Royal Institute of Painters
in Water Colours 1897 and the
R.O.I. Domestic subjects. Exhibited
53 works, 5 at N.W.C.S., 11 at R.A.,
31 at S.B.A. (*Leeds*)

HARDY, Heywood (fl. 1870–92)
Son of James Sr; of Bristol, and
settled in London 1870; assoc.
O.W.C.S. 1885–92; member Royal
Institute of Painters in Water
Colours, 1883–90. Landscapes
and animals. Exhibited 152 works,
31 at R.A., 9 at B.I., 16 at S.B.A.,
7 at O.W.C.S. (*V. & A.*)

HARDY, James, Sr (1801–79)
Of Bath. (*Blackburn*)

HARDY, James, Jr (1832–89)
Son of James Sr; assoc. Royal
Institute of Painters in Water
Colours 1874, member 1877.
Landscapes and sporting subjects.
Exhibited 119 works, 28 at
N.W.C.S., 9 at R.A., 8 at B.I., 46 at
S.B.A. (*Cardiff, V. & A.*)

HARDY, Thomas Bush (1842–97)

Born Sheffield; travelled early
to Holland and Italy; member
S.B.A. 1884. Marines and coastal
views, some of small size in
uncharacteristic fine detail.
Exhibited 141 works, 12 at
N.W.C.S., 32 at R.A., 81 at S.B.A.
(*Newport, B.M., V. & A.*)

HARE, Sir George (fl.1880–93)
(d. 1933)
Member R.I. 1892. Domestic
subjects. Exhibited 58 works, 4 at
N.W.C.S., 15 at R.A., 18 at S.B.A.

HARFORD, John Scandrett
(1786–1860)
An amateur; son of a Quaker; a
banker in Bristol; high sheriff of
Cardiganshire 1824; lived at
Blaize Castle (*V. & A.*)

HARGITT, Edward (1835–95)
Born Edinburgh; studied at an
Edinburgh art school, and under
Horatio McCulloch; Member
R.O.I.; assoc. R.I. 1867, member
1871; a well-known ornithologist.
Landscapes, some in Ireland.
Exhibited 339 works, 255 at
N.W.C.S., 19 at R.A., 11 at B.I., 1 at
S.B.A. (*V. & A.*)

HARGREAVES, George
(1797–1870)
Son of Thomas; member S.B.A.
1823; assoc. Liverpool Academy
1822 and member 1823–31.
Miniatures. Exhibited 7 works
1824–34, at S.B.A.

HARGREAVES, Thomas
(1775–1845)
Born Liverpool; in London 1793
and articled to Sir T. Lawrence;
returned to Liverpool as a
miniature-painter; member
Liverpool Academy and S.B.A.
1823. Miniatures. Exhibited 18

works, 9 at R.A., 9 at S.B.A. 1798–1831.

HARKER, Joseph Cunningham (1855–1927)
Born Manchester; apprenticed to scene-painter T. W. Hall.

HARLEY, George (1791–1871)
A drawing master; drew for Rowney and Forster's 'Lessons in Landscape' drawing books published 1820–22; published 'Guide to Pencil and Chalk Drawing from Landscape' 1848. Exhibited 17 works, 13 at O.W.C.S., 2 at R.A., 1 at S.B.A. (*V. & A., B.M.*)

HARLOW, George Henry (1787–1819)
Studied under De Cort and Samuel Drummond, and later under Sir T. Lawrence; visited Ireland 1803. Portraits, historical subjects, landscapes and coastal scenes. Exhibited 50 works, 45 at R.A., 5 at B.I. 1804–18. (*Newport, B.M., V. & A.*)

HARPER, Henry Andrew (fl. 1858–93)
Landscapes. Exhibited 118 works, 8 at N.W.C.S., 24 at R.A., 26 at S.B.A.

HARPER, John (1809–42)
An architect; friend of W. Etty and Clarkson Stanfield. Landscapes in Italy and Switzerland. (*V. & A.*)

HARPER, Thomas (fl. 1850–75)
Of Newcastle. Marines. Exhibited 4 works at S.B.A. (*Newcastle*)

HARRADEN, Richard Bankes (1778–1862)
Watercolours for topographical publications, in a weak P. Sandby style.

HARRINGTON, Jane, Countess of (née Seymour Fleming)
Perhaps a pupil of Warwick Smith; lady of the bedchamber to Queen Charlotte. Landscapes. (*B.M.*)

HARRIOT, W. H. (fl. 1811–46)
Pupil of S. Prout. Landscapes. Exhibited 57 works, 4 at R.A., 11 at B.I., 42 at S.B.A. (*B.M.*)

HARRIS, Daniel (fl. 1795–1834)
Views of Oxford colleges. (*V. & A.*)

HARRIS, Henry Hotham (1805–65)
Born Birmingham; pupil of William Rider of Leamington; member and secretary Birmingham Society of Artists 1852–59. Views in Birmingham. Exhibited 2 works at minor exhibitions 1865. (*Birmingham*)

HARRIS, J. (d. 1834)
Landscapes in the early tinted manner. Exhibited at R.A. 1802–13.

HARRIS, John (fl. 1797–1814)
An illustrator. Figures, birds and insects. (*V. & A.*)

HARRIS, Mrs John Dafter (née Frances Elizabeth Louise Rosenberg) (1822–73)
Member N.W.C.S. 1846. Flowers, genre and domestic subjects. Exhibited 142 works, 139 at N.W.C.S., 3 at R.A. (*V. & A.*)

HARRIS, Moses (1731–85?)
An entomological illustrator; R.A. 1785. (*Natural History Museum, South Kensington*)

HARRISON, Charles H. (1842–1902)
Of Yarmouth. Landscapes.

Exhibited 2 works at N.W.C.S.
1886.

HARRISON, Capt. George A.
(fl. 1884–90)
A sculptor, but exhibited 4
watercolours at N.W.C.S.

HARRISON, George Henry
(1816–46)
Born Liverpool, the son of Mrs M.
Harrison, flower painter; helped
in London by Constable; later
lived in Paris; assoc. O.W.C.S. 1845.
Landscapes and figure subjects.
Exhibited 49 works, 22 at O.W.C.S.,
14 at R.A., 2 at B.I., 11 at S.B.A.
(*V. & A.*)

HARRISON, Mrs George Henry
(née Mary Rossiter)
(1788–1875)
Born Liverpool; member N.W.C.S.
1853. Flowers and fruit. Exhibited
371 works, 322 at N.W.C.S., 20 at
R.A., 9 at B.I., 20 at S.B.A.
(*V. & A.*)

HARRISON, James (d. 1880?)
Probably a brother of George
Henry; an architect; fl. c. 1827.
Landscapes. A 'View near Ipswich'
is in the V. & A.
(*Note*. There are many J. Harrisons
listed in Graves. In the Bristol
Art Gallery are watercolour views
by a James Harrison, MD, who
was a friend of W. J. Müller.

HARRISON, J. C. (fl. 1822–91)
Domestic subjects. Exhibited 29
works, 14 at N.W.C.S., 2 at R.A.,
13 at S.B.A.

HARRISON, Maria
(fl. 1845–d. 1904)
Sister of George Harrison; assoc.
R.W.S. 1847. Flowers. Exhibited
456 works, 439 at N.W.C.S., 7 at
R.A., 1 at B.I., 9 at S.B.A.

HARRISON, Mlle. Pauline
(fl. 1834–35)
Of Edmonton. Flowers. Exhibited
7 works, 4 at N.W.C.S., 3 at S.B.A.

HART, J. Laurence (d. 1907)
Lived in Worcestershire, and later
as a hermit, at Morfa Nevin, near
Caernarvon. Local buildings.
(*Birmingham*)

HART, James Turpin (1835–99)
Born Nottingham; studied at the
Nottingham School of Design, and
at R.A. 1860–67, where he was silver
medallist; returned to Nottingham
as portrait painter and teacher; a
master at Nottingham School of
Art. Rustic scenes. (*Laing Gallery,
Leeds*)

HART, Solomon Alexander
(1806–81)
Born Plymouth; to London 1820;
studied at R.A. 1823; A.R.A. 1835,
R.A. 1840; visited Italy 1841 and
42; curator the Painted Hall at
Greenwich; professor of painting
at R.A. 1854–63; librarian at R.A.
1864–81. Landscapes, historical
subjects and portraits. Exhibited
184 works, 3 at N.W.C.S., 122 at
R.A., 25 at B.I., 34 at S.B.A.

HART, Thomas Gray (1797–1881)
Born Fareham, Hants.; to
Southampton 1825. Landscapes,
particularly in the New Forest.
Exhibited only in Southampton.

HARTLAND, Henry Albert
(1840–93)
Born Mallow, Co. Cork, the son of
a landscape gardener; assistant to
a Cork picture-dealer; and painted
scenery for Cork theatre; in
Wales 1870, Liverpool 1871,
London 1887, and Liverpool again
by 1890. Landscapes. Exhibited 44

works, 2 at N.W.C.S., 21 at R.A., 13 at S.B.A. (*Walker, V. & A.*)

HARTLEY, Alfred (fl. 1885–93)
Member R.B.A. Domestic subjects. Exhibited 52 works, 3 at N.W.C.S., 8 at R.A., 18 at S.B.A.

HARTLEY, Mrs (fl. c. 1775)
A skilled etcher, and exhibited 3 watercolour landscapes at S.A.

HARTRICK, Archibald Standish (1864–1950)
Assoc. R.W.S. 1910, R.W.S. 1920.

HARVEY, Sir George (1806–76)
Born St Ninian's, Perthshire; apprenticed to a bookseller; studied at Trustees' Academy, Edinburgh; assoc. Scottish Academy 1826, member 1830, president 1864–76. Historical subjects, genre and landscapes. Exhibited 25 works, 22 at R.A., 1 at B.I., 2 at S.B.A. 1832–72.

HARVEY, William (1796–1866)
Pupil of Thomas Bewick; also a well-known engraver. Landscapes in sunny tints, with complex foliage. (*Nottingham*)

HASELER, H. (fl. 1814–25)
Landscapes near Exeter and Sidmouth. Exhibited 9 works, 5 at O.W.C.S., 4 at R.A. (*V. & A.*)

HASLEHURST, Ernest William (1866–1949)
Born Walthamstow; studied at the Slade under Legros; member R.I. 1924, R.B.A., R.W.A., R.B.C.; designed landscape posters for L.N.E.R.; contributed to Black's 'Beautiful Britain'. Landscapes. (*Newport*)

HASSALL, John (b. 1868)
Member R.I. 1901. Member R.W.A.

Book illustrations (*V. & A.*)

HASSELL, Edward (d. 1852)
Son of engraver J. Hassell;

member S.B.A. 1840 and later secretary; Architectural subjects and landscapes. Exhibited 157 works, 135 at S.B.A., 13 at R.A., 9 at S.B.A. (*V. & A., B.M.*)

HASSELL (or HASSALL), John (1797–1825)
Friend and biographer of Morland. Topography. (*B.M., Haslemere, Newcastle*)

HASTIE, Grace H. (fl. 1874–93)
Flowers. Exhibited 60 works, 18 at N.W.C.S., 14 at R.A., 18 at S.B.A.

HASTINGS, Capt. Thomas (fl. 1813–31)
Brother of oil-painter Edward (fl. 1804–27) and best known for his etchings; collector of customs at Liverpool. Powerful marines and landscapes. Exhibited 5 works, 2 at R.A., 1 at B.I., 2 at O.W.C.S.

HASTLING, Annie E. (fl. 1883–93)
Of Sheffield. Domestic subjects. Exhibited 5 works, 4 at N.W.C.S.

HATHERELL, William (fl. 1879–93) (d. 1928)
Member R.I. 1888. Figure subjects. Exhibited 26 works, 11 at N.W.C.S., 6 at R.A., 3 at S.B.A.

HATTON, Brian (1887–1916)
Born Hereford; encouraged by George F. Watts, but self-taught. (*Hereford, B.M.*)

HATTON, Helen Howard (fl. 1879–93)
Figure subjects. Exhibited 34 works, 3 at N.W.C.S., 6 at R.A., 6 at S.B.A.

HAUGHTON, Moses (1734–1804)
Born Wednesbury, Staffs.; an
engraver. (His son Matthew
engraved for William Roscoe.)
Exhibited 13 works at R.A.,
1788–1804.

HAVELL, Edmund (fl. 1814–47)
Of Reading. Landscapes. Exhibited
18 works, 10 at O.W.C.S., 4 at R.A.,
4 at B.I.

HAVELL, Robert (fl. 1808–22)
Landscapes. Exhibited 12 works,
7 at O.W.C.S., 3 at R.A., 2 at B.I.

HAVELL, William (1782–1857)
Born Reading, the son of a
drawing master; founder member
O.W.C.S. 1804, retired c. 1814;
artist to Lord Amherst's Embassy
to China; in India 1817; rejoined
O.W.C.S. 1826–29, while he lived in
Italy. Landscapes. Exhibited 331
works, 154 at O.W.C.S., 103 at R.A.,
42 at B.I., 32 at S.B.A. (*Newcastle,
Whitworth, B.M., V. & A.*)

HAWARD, Francis (1759–97)
A mezzotint engraver; studied at
R.A.; A.R.A. Exhibited 6 works at
R.A. 1783–97.

HAWKINS, Henry (fl. 1820–81)
Portraits. Exhibited 214 works,
3 at O.W.C.S., 8 at R.A., 2 at B.I.,
200 at S.B.A.

HAWKSLEY, Dorothy W.
(1884–1948)
Member R.I. 1917–47. Landscapes
and flowers.

HAWKSWORTH, William Thomas
Martin (fl. 1881–93) (d. 1935)
Member R.I. 1934. Landscapes.
Exhibited 44 works, 3 at N.W.C.S.,
10 at R.A., 25 at S.B.A.

HAY, James (fl. 1887–92)
Of Edinburgh. Domestic subjects.
Exhibited 2 works at N.W.C.S.

HAY, Peter Alexander (b. 1868)
Member R.I. 1917, member R.S.W.
Landscapes.

HAY, T. Marjoribanks
(fl. 1886–93)
Of Edinburgh, Landscapes.
Exhibited 9 works, 4 at N.W.C.S.,
3 at R.A.

HAYDON, Benjamin Robert
(fl. 1807–45)
Of Plymouth. Historical subjects.
Exhibited 69 works, 12 at O.W.C.S.,
11 at R.A., 16 at B.I., 30 at S.B.A.

HAYES, Claude (1852–1922)
Born Dublin; son of Edwin; ran
away to sea; after a year in
America, returned and studied at
Heatherley's School, at R.A. for 3
years, and then at Antwerp under
Verlat; friend of J. Aumonier and
T. Collier; member Royal Institute
of Painters in Water Colours 1886.
Landscapes and domestic subjects.
Exhibited 193 works, 54 at
N.W.C.S., 40 at R.A., 41 at S.B.A.
(*V. & A., Newport, Newcastle,
Whitworth*)

HAYES, Edwin (1820–1904)
Born Bristol; member R.H.A. and
N.W.C.S. Marines and landscapes.
Assoc. N.W.C.S. 1860, member
1863. Exhibited 670 works, 338 at
N.W.C.S., 61 at R.A., 35 at B.I., 111
at S.B.A.

HAYES, Frederick William
(1848–1918)
Born New Ferry, Cheshire, the
son of artist parents; studied
architecture at Ipswich, and
painting at Liverpool; pupil of
Henry Dawson in London 1870;

returned to Liverpool and there a founder member Liverpool Water Colour Society; assoc. R.C.A. Landscapes. Exhibited 30 works, 3 at N.W.C.S., 17 at R.A., 4 at S.B.A.

HAYES, Michael Angelo (1829–77)
Born Waterford, Ireland; son of of Edwin; assoc. N.W.C.S. 1848, member R.H.A. 1854 and secretary 1856–70; member Royal Institute of Oil Painters. Military subjects. Exhibited 41 works, 35 at N.W.C.S., 1 at R.A.

HAYES, William (fl. 1775–94)
Figure subjects and birds.

HAYLEY, Robert (d. 1777)
Of Irish birth, and died in Dublin. Animals, mostly in chalk and crayon.

HAYLLAR, James (fl. 1851–93)
Member R.B.A. Figure subjects. Exhibited 367 works, 5 at N.W.C.S., 58 at R.A., 23 at B.I., 217 at S.B.A.

HAYLLAR, Kate (fl. 1883–93)
Of Wallingford, Berks. Domestic subjects. Exhibited 17 works, 2 at N.W.C.S., 9 at R.A., 6 at S.B.A.

HAYMAN, Francis (1708–76)
Born Exeter; pupil of Robert Brown; R.A. Illustrations. Exhibited 16 works, 10 of Soc. of Artists, 6 at R.A. 1760–72.

HAYTER, Sir George (1792–1871)
Born London; son of portrait-painter Charles; studied at R.A.; member Associated Artists in Water Colours; knighted 1842. Miniatures and historical subjects. Exhibited 98 works, 56 at R.A., 40 at B.I., 1 at S.B.A., 1809–59.

HAYWARD, Alfred Robert (1875–1971)
Member New English Art Club; Royal Society of Portrait Painters; assoc. R.W.S. Studied at Slade. Went on sketching tours with Wilson Steer. Landscape, Interiors, Venice.

HAYWARD, John Samuel (1778–1822)
Member of T. Girtin's Sketching Club and of Chalon's Sketching Society; influenced by Girtin, J. S. Cotman and S. Prout. Harbour scenes in the West Country, and Italian landscapes. Exhibited 47 works at R.A.

HAYWOOD, Hardy (b. 1843)
Assoc. R.W.S. 1885.

HAZLEHURST, Thomas (fl. 1760–1820)
Of Liverpool. Miniatures.

HAZLITT, John (1768–1837)
Born Wem, Salop; brother of writer William. Miniatures. Exhibited 133 works, 126 at R.A., 7 at B.I., 1788–1819.

HEAPHY, Elizabeth
See Murray, Mrs Henry John.

HEAPHY, Thomas (1775–1835)
Born London; apprenticed to engraver J. K. Meadows, and employed by R. Westall; member O.W.C.S. 1807; in the Peninsula War to paint camp scenes 1812; founder member and first president S.B.A. 1824; visited Italy 1831–32. Figure subjects and landscapes. Exhibited 133 works, 42 at O.W.C.S., 60 at R.A., 9 at B.I., 14 at S.B.A. (*V. & A.*, *B.M.*, *Newcastle*)

HEARNE, Thomas (1744–1817)
Born Brinkworth, Wilts.;

apprenticed to engraver W. Woollett; Society of Arts premium 1763; to Leeward Islands 1771 as draughtsman to the Governor. A fine topographical artist. Exhibited 78 works, 42 at Soc. of Artists, 12 at Free Soc., 24 at R.A. 1765–1806. (*V. & A., B.M., Newport, Newcastle, Leeds*)

HEATH, Charles (1785–1848)
A line engraver; member s.b.a. Exhibited 41 works, 11 at R.A., 30 at s.b.a., 1801–25.

HEATH, James (1757–1834)
Apprenticed to Joseph Collyer; engraved works by Stothard; engraver to R.A. 1791 and to the king 1794; A.R.A. Exhibited 29 works, 26 at R.A., 1790–1834.

HEATH, Margaret A. (fl. 1886–93)
Domestic subjects. Exhibited 11 works, 7 at N.W.C.S.

HEATH, William (1795–1840)
Illustrated many books, and much of his work aquatinted. Humorous subjects.

HEATH, W. H. (fl. 1821–47)
Of Tonbridge. Landscapes and genre. Exhibited 6 works, 1 at B.I., 5 at s.b.a.

HEATHCOTE, Evelyn (fl. 1833–88)
Of Winchester. Landscapes. Exhibited 3 works at N.W.C.S.

HEATHCOTE, John Mayer (1800–92)
Pupil of De Wint, with whose work his may well be confused. (*B.M.*)

HEATON, John (fl. 1884–89)
Of Datchett, Bucks. Landscape. Exhibited 6 works, 5 at N.W.C.S., 1 at s.b.a.

HEAVYSIDE, John Smith (1812–64)
Born Stockton-on-Tees; began as a wood engraver, and employed as illustrator of antiquarian books.

HEDLEY, Ralph (fl. 1879–93)
Of Newcastle. Domestic subjects. Exhibited 27 works, 6 at N.W.C.S. 21 at R.A.

HEELIS, Mrs William
See Potter, Beatrix.

HEGG, Mme Tevisa de Lauderset (1829–1911)
Member R.I. 1886.

HEITLAND, Ivy (1875–95)
Daughter of an artist and an infant prodigy; studied under Sir James Linton; made designs for printing. Genre. (*V. & A.*)

HEKEL, Augustin (1690?–1770)
Of German birth; early to England. Views around Richmond.

HELCHÉ, Arnold (fl. 1865–93)
Of Guernsey. Marines. Exhibited 109 works, 3 at N.W.C.S., 21 at R.A., 46 at s.b.a.

HEMING, Mrs
See Lowry, Matilda.

HEMY, Charles Napier (1841–1917)
Assoc. R.W.S. 1890, R.W.S. 1897 and R.I. 1884–88. Landscapes. Exhibited 196 works, 27 at O.W.C.S., 5 at N.W.C.S., 40 at R.A., 23 at s.b.a.

HEMY, Thomas Marie Madawaska (fl. 1873–93)
Of North Shields. Marines. Exhibited 56 works, 7 at N.W.C.S., 15 at R.A., 9 at s.b.a.

HENDERSON, Charles Cooper
(1803–77)
Son of John; trained for the law;
taught by S. Prout; visited Italy.
Horses and coaching subjects.
Exhibited 2 works at R.A.
(*V. & A., B.M.*)

HENDERSON, John (1764–1843)
A friend and neighbour of Dr
Monro. Monochrome landscapes
in blue and grey, copied by Girtin
and Turner. (*B.M.*)

HENDERSON, Joseph (1832–1908)
Born Stanley, Perthshire; member
R.S.W. Marines and domestic
subjects. Exhibited 31 works, 20
at R.A., 4 at S.B.A., 1871–92.

HENRY, C. Napier (1841–1917)
Assoc. R.W.S. 1890, member 1897,
R.A.

HENRY, William
See Haines, William Henry.

HENSHALL, J. S. (fl. c. 1830)
Topography in the South of
England.

HENSHALL, John Henry
(1856–1928)
Assoc. R.W.S. 1883, member 1891.
Figure subjects. Exhibited 79
works, 44 at O.W.C.S., 16 at R.A.,
9 at S.B.A. (*Birmingham, V. & A.*)

HENTON, G. W. Moore
(fl. 1884–93)
Of Leicester. Churches. Exhibited
13 works, 10 at N.W.C.S., 2 at R.A.

HERALD, James Watterson
(d. 1914)
Born Angus; studied art at
Dundee, Edinburgh, and
Herkomer's School at Bushey,
Herts.; lived at Croydon, and later
at Arbroath, where he died.

Figures, landscapes and marines.
(*V. & A.*)

HERBERT, Alfred (d. 1861)
Apprenticed to a bookbinder, and
self-taught; fl. 1844–60. Marines
and river scenes. Exhibited 43
works, 14 at R.A., 3 at B.I., 26 at
S.B.A. (*Newcastle, B.M.*)

HERBERT, Arthur John (1834–56)
Son of John Rogers; studied under
his father and at R.A. Landscapes.
Exhibited 2 works at R.A.
1855–56 (*V. & A.*)

HERBERT, Cyril Wiseman
(1847–82)
Born London; son of John Rogers;
H.R.A.; curator the Antique School
R.A. Domestic subjects. Exhibited
5 works at R.A. 1870–75.

HERBERT, John Rogers (1810–90)
Born Malden; studied at R.A.
1826; master at Government
School of Design; A.R.A. 1841,
R.A. 1846, H.R.A. 1886. Religious
and Italian subjects, and portraits.
Exhibited 140 works, 4 at N.W.C.S.,
102 at R.A., 26 at B.I., 7 at S.B.A.
(*V. & A.*)

HERBERT, Sydney (fl. 1865–87)
Of Cheltenham. Marines.
Exhibited 5 works, 4 at N.W.C.S.,
1 at S.B.A.

HERDMAN, Robert (1829–87)
Born Rattray, Perths.; studied at
Trustees' Academy, Edinburgh,
and under R. S. Lauder, also in
Italy; assoc. R.S.A. 1858, member
1863; member R.S.W. Portraits,
genre and scriptural subjects.
Exhibited 40 works, 38 at R.A.,
2 at B.I., 1861–87.

HERDMAN, William Garwin
(1805–82)

Born Liverpool; a drawing master and author; assoc. Liverpool Academy 1836, member 1838, secretary 1845–47. Exhibited 6 works, 5 at R.A.

HERDMAN, William H.
(fl. c. 1860)
Watercolours of Old Liverpool.
(*Walker*)

HERING, George Edwards
(1805–79)
Born London, the son of a German bookbinder; to Munich 1829, and thence to Venice for 2 years. Italian views and lake scenes. Exhibited 195 works, 88 at R.A., 36 at B.I., 10 at S.B.A., 1836–80.
(*V. & A.*)

HERIOT, George (1766–1844)
Born Haddington, the son of the sheriff of East Lothian; a cadet at Woolwich Military Academy, then a civil servant 1799–1816; deputy postmaster-general of Canada. Landscapes in Canada, Spain and France.

HERKOMER, Professor Sir Hubert (1849–1914)
Of Southampton; R.A., assoc. R.W.S. 1893, member 1894. Vice-president 1896–7, member R.I., 1871–90. Figure subjects. Exhibited 247 works, 47 at N.W.C.S., 87 at R.A.; 2 at S.B.A.

HERN, Charles E. (fl. 1884–93)
Landscapes. Exhibited 19 works, 8 at N.W.C.S., 5 at R.A., 6 at S.B.A.

HERRING, John Frederick
(1795–1865)
Originally a coachman. Horses and farmyard subjects against fine landscapes, a very few in water-colour. Always likely to be confused with his son's work

which is, however, inferior. Exhibited 167 works, 82 at S.B.A., 22 at R.A., 44 at B.I.

HEWETT, Sir Prescott Gardener, Bart. (1812–91)
An amateur; studied in Paris; surgeon to Queen Victoria and Prince of Wales 1875; hon. O.W.C.S. Landscapes. Exhibited 20 works, 16 at O.W.C.S.

HEWITT, Beatrice M.
(fl. 1884–93)
Portraits. Exhibited 10 works, 3 at N.W.C.S.
(*Note*. A Miss Hewitt of Fowey exhibited 4 flower paintings at N.W.C.S. in 1834.)

HEWLETT, James (1768–1836)
A Bath flower painter; member Associated Artists in Water Colours. Flowers, interiors, and rustic scenes with figures. Exhibited 53 works, at 11 O.W.C.S., 15 at R.A., 7 at B.I., 4 at S.B.A.
(*V. & A.*)

HICKEY, Thomas (1741–1824)
Born Dublin; a well-known portrait-painter; went with Lord Macartney to China, where he drew views in watercolour. Exhibited 16 works at R.A. 1772–92.

HICKIN, George (fl. 1858–77)
Of Greenwich. Still life. Exhibited 63 works, 24 at S.B.A., 7 at R.A., 6 at B.I. (*V. & A.*)

HICKS, Lilburne (d. 1861)
Member N.W.C.S. 1837, fl. 1830–60. Genre. Exhibited 77 works, 59 at N.W.C.S., 10 at R.A., 2 at B.I., 6 at S.B.A.

HICKSON, Margaret (fl. 1879–92)

Still life. Exhibited 25 works, 4 at
N.W.C.S., 7 at R.A., 7 at S.B.A.

HIGHMORE, Joseph (1692–1780)
Born London; pupil of portrait-
painter Sir Godfrey Kneller.
Portraits and historical subjects.
Exhibited 5 works, 3 at Soc. of
Artists, 2 at Free Soc. 1760–61.

HIGHMORE, Joseph, Jr (d. 1780)
Taught by his father. Landscapes,
mostly in oils.

HIGHMORE, Thomas
(1796–1844)
Born Suffolk; an engraver.
Architectural subjects. Exhibited
4 works 1824–30 at S.B.A.

HILDITCH, George (1803–57)
Born London; views in France in
the Bonington style. Exhibited 244
works, 73 at R.A., 89 at B.I., 52 at
S.B.A. 1823–56.

HILL, David Octavius (1802–70)
Born Perth; member R.S.A.
Scottish landscapes and subjects.
Exhibited 8 works, 4 at R.A., 1 at
B.I., 2 at S.B.A.
(*Edinburgh*)

HILL, Ellen G. (fl. 1864–93)
Figure subjects. Exhibited 50
works, 8 at N.W.C.S., 12 at R.A.,
2 at B.I., 1 at S.B.A.

HILL, James John (1811–82)
Born Birmingham; pupil of J. V.
Barber; member S.B.A. from 1842.
Rustic figure subjects. Exhibited
137 works, 10 at R.A., 5 at B.I., 122
at S.B.A. 1842–81.

HILL, Leonard Rowen (or Raven)
(fl. 1885–93)
Domestic subjects. Exhibited 23
works, 5 at N.W.C.S., 3 at R.A., 4 at
S.B.A.

HILLIARD, Laurence (fl. 1876–77)
Of Uxbridge. Still life. Exhibited
22 works; 7 at N.W.C.S.

HILLIARD, Nicholas (1537–1619)
Born Exeter, the son of a high
sheriff of Devon; apprenticed to a
jeweller and goldsmith; limner to
Queen Elizabeth. Miniatures on
card and vellum.

HILLS, Robert (1769–1844)
Born Islington; pupil of J. A.
Gresse; founder member O.W.C.S.
1804 and its first secretary; often
painted animals in watercolours
done by G. F. Robson and G.
Barret Jr. Animals in landscapes, at
first delicate, and later more
ambitious with 'hot' colouring.
Exhibited 646 works, 600 at
O.W.C.S., 44 at R.A., 2 at S.B.A.
(*B.M., V. & A., Newport,
Newcastle, Hereford, Whitworth,
Birmingham*)

HILTON, William (1786–1839)
Born Lincoln; pupil of John
Raphael Smith; friend and
brother-in-law of De Wint.

HINCHCLIFF, John James
(1805–75)
Son of the sculptor John E. An
engraver, for many years employed
by Hydrographic Dept. of the
Admiralty.

HINE, Harry (1845–1941)
Member R.I. 1879, member R.O.I.
Landscapes. Exhibited 173 works,
130 at N.W.C.S., 8 at R.A., 4 at
S.B.A.

HINE, Mrs Harry (née Colkett)
(fl. 1876–93)
Of St Albans. Exhibited 19 works,
12 at N.W.C.S., 2 at S.B.A.

HINE, Henry George (1811–95)

The Wye Bridge and Cathedral, Hereford

Nicholas Pocock
(1740–1821)
Signed, and dated 1795
16⅜″ x 24¼″

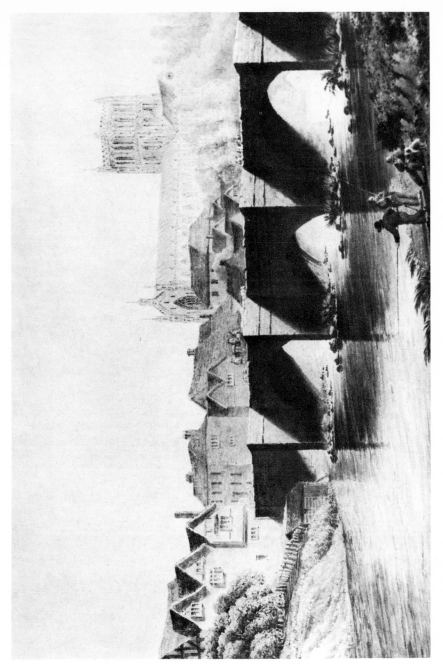

This particular subject was favoured by many artists, including G. F. Robson and David Cox (c.f. 'Old Houses, Hereford' in the Birmingham Art Gallery). It is not generally realised that Pocock, who is renowned as a painter of sea and shipping, was also a fine topographer and landscape-painter. This important example may well have been drawn during a tour of South Wales which he is believed to have made. The shadowy mass of the bridge is effectively contrasted with the carefully drawn delicacy of the cathedral stonework. The whole is tinted in soft tones of pale yellows and browns.

Kenilworth Castle

Michael 'Angelo' Rooker
(1743–1801)

Signed
9" x 11"

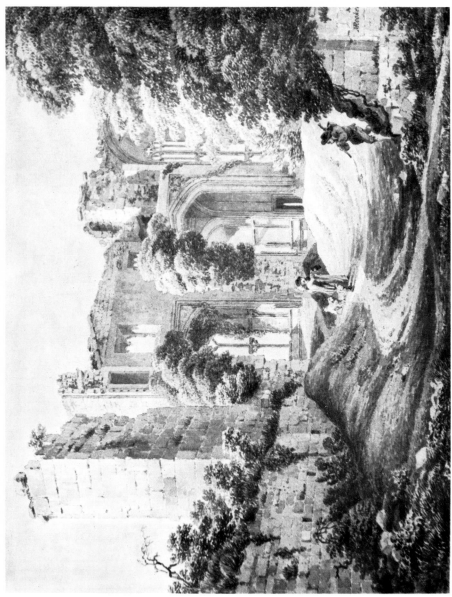

This drawing may be compared with another of the same subject illustrated by Iolo Williams in 'Early English Watercolours' (1970). Both are of the same size, both are in grey monochrome, and both done at the same time, when Rooker was on a Warwickshire walking tour. In fact, Williams refers in his text to 'a very pleasant series of wash drawings of Kenilworth, which came onto the market a few years ago'. The characteristic architectural drawing, the grassy slopes and the figures were washed in over extremely delicate ink outline, with no trace of pencil.

Born near Brighton; apprenticed to engraver H. Mayer; 2 years at Rouen, and returned to Brighton as a wood engraver and marine painter; influenced by Copley Fielding; drew for *Punch* and *Illustrated London News*; assoc. N.W.C.S. 1863, member 1864; vice-president R.I. 1887. Coastal scenes and views on the Sussex Downs. Exhibited 313 works, 306 at N.W.C.S., 2 at R.A., 4 at S.B.A. (*V. & A., B.M., Gateshead, Whitworth*)

HINE, William Egerton
(fl. 1873–92)
Landscapes. Exhibited 32 works, 6 at N.W.C.S., 2 at R.A., 8 at S.B.A.

HINES, Frederick (fl. 1875–93)
Landscapes. Exhibited 75 works, 3 at N.W.C.S., 14 at R.A., 48 at S.B.A.

HINKS, William (fl. 1781–97)
An Irish painter and engraver; drew illustrations for 'Tristram Shandy'. Portraits, miniatures and historical subjects.

HISCOX, George Dunkerton
(1840–1901)
Born near Wells, Somerset; studied at Bristol School of Art; a drawing master. Landscapes. Exhibited 50 works, 14 at R.A., 18 at S.B.A., 8 at N.W.C.S., from 1879.

HIXON, James Thompson
(1836–68)
Assoc. N.W.C.S. 1867. Eastern subjects. Exhibited 45 works, 10 at N.W.C.S., 5 at B.I., 5 at S.B.A.

HOARE, Peter Richard
(1772–1849)
Pen and sepia wash views.
(*B.M., Cardiff*)

HOARE, Prince (1755–1834)
Born Bath; studied under his father, William Hoare, R.A., and at R.A. 1772; to Rome 1776 working under Mengs; back in England 1780. Portraits and historical scenes. Exhibited 13 works at R.A. (*B.M.*)

HOARE, Sir Richard Colt
(1758–1838)
Brother of Peter Richard; of Stourhead, Wilts. Pen and sepia wash drawings of Tuscany scenes.
(*V. & A., B.M.*)

HOBDAY, William Armfield
(1771–1831)
Born Birmingham; apprenticed to an engraver; lived first in London, visiting Bath and Bristol yearly, and settled in Bristol c. 1802; to London 1812; became bankrupt 1829. Portraits. Exhibited 105 works, 103 at R.A., 2 at B.I., 1794–1830. (*Birmingham*)

HOBDEN, Frank (fl. 1879–93)
Domestic subjects. Exhibited 63 works, 17 at N.W.C.S., 5 at R.A., 14 at S.B.A.

HOBSON, Alice Mary (fl. 1879–93)
Born 1860. Of Leicester; member R.I. 1888. Landscapes. Exhibited 29 works, 27 at N.W.C.S.

HOBSON, Cecil James (1874–1915)
Member R.I. 1901. Landscapes.

HOBSON, Henry E. (fl. 1859–66)
Of Bath. Figure subjects. Exhibited 3 works, 1 at R.A., 2 at B.I.

HODGE, Francis Edwin (b. 1883)
Member R.I. 1931; member R.O.I. R.P.

HODGES, J. Sidney Willis
(1829–1900)

Born Worthing; a writer for art magazines. Portraits. Exhibited 50 works, 35 at R.A., 8 at B.I., 4 at S.B.A. from 1854.

HODGES, William (1744–97)
Born London; an errand boy at Shipley's Drawing School; pupil of R. Wilson; scene-painter at Derby; draughtsman to Captain Cook on his second voyage; to Madras 1780, Calcutta 1781, with Warren Hastings to Benares 1782; back in England 1784; painted scenery for Italian operas at the Pantheon; to Rome and St Petersburg 1790; A.R.A. 1786, R.A. 1787. Landscapes. Exhibited 105 works, 24 at Soc. of Artists, 7 at Free Soc., 74 at R.A., 1766–94. (*B.M., V. & A.*)

HODGSON, Charles (d. 1827)
Father of David Sr; a Norwich drawing master and friend of J. Crome; architectural draughtsman to the Duke of Sussex; fl. c. 1797. Buildings. Exhibited 5 works, 4 at R.A. (*Norwich*)

HODGSON, David, Sr (1798–1864)
Son of Charles and father of David Jr; copyist of J. Crome; painter of domestic architecture to the Duke of Sussex. Buildings. Exhibited 39 works, 1 at R.A., 27 at B.I., 11 at S.B.A., 1818–64. (*Norwich*)

HODGSON, David, Jr
Late 19th century. A drawing master. Marines.

HODGSON, Edward (1719–94)
Born Dublin. Fruit and flowers. Exhibited 7 works at R.A. 1780–88.

HODSON, Samuel John (1835–1908)
Studied at Leigh's and at R.A.

schools; fl. from c. 1858; assoc. R.W.S. 1882, member R.W.S. 1890 and S.B.A. Views of towns, and buildings with figures. Exhibited 139 works, 90 at O.W.C.S.

HOFLAND, Thomas Christopher (1777–1843)
Born Worksop; a little help from J. Rathbone, but otherwise self-taught; lived at Kew 1799–1806, where commissioned by George III to draw plants in the Royal collection; drawing master at various places until returning to London 1811; at Richmond c. 1815, Twickenham 1817; visited Italy 1840; died at Leamington; founder member S.B.A. 1824. Landscapes. Exhibited 339 works, 118 at S.B.A., 72 at R.A., 141 at B.I. (*V. & A.*)

HOGGETT, William (b. 1879)
Member R.I. 1925; member R.C.A. Landscapes.

HOLBEACH, Mary Ann
See Mordaunt, Lady.

HOLDING, Edgar Thomas (1870–1952)
Assoc. R.W.S. 1920, member 1929, treasurer 1930 (*V. & A.*) (*Note.* Fred Holding (1817–74) was a Manchester watercolourist.)

HOLDING, Henry James (1833–72)
Worked in Manchester, where he exhibited 6 works; died Paris. Landscapes.

HOLE, Henry
A wood engraver who worked under Thomas Bewick, assisting with his 'British Birds'.

HOLL, Francis (1815–84)
Born London; father of Frank;

engraved many plates of Royal Family; A.R.A. Exhibited 20 works at R.A. 1856–83.

HOLL, Frank (1845–88)
Born London; son of Francis; studied at R.A.; member S.B.A. and O.W.C.S. 1883. Flowers, domestic subjects and landscapes. Exhibited 132 works, 87 at R.A., 5 at S.B.A., 24 at Grosvenor gallery, 1864–88.

HOLL, William, Sr (1771–1839)
Father of William Jr and Francis; studied under Benjamin Smith; an engraver.

HOLL, William Jr. (1807–71)
Born Plaistow, Surrey; an engraver. Black and white drawings.

HOLLAND, James (1799–70)
Born Burslem, Staffs.; worked as a flower painter at the Davenport porcelain factory; to London 1819; visited Paris 1831, and toured in Italy; assoc. O.W.C.S. 1835; resigned and re-elected 1856, member 1857 and British Artists 1842–48. Flowers and continental views, particularly of Venice, in the Bonington style. Exhibited 437 works, 32 at R.A., 91 at B.I., 108 at S.B.A., 3 at N.W.C.S., 194 at O.W.C.S. (*V. & A., Manchester, Newport, Newcastle, Bedford, Hereford, Whitworth*)

HOLLAND, Nathaniel
See Dance, Nathaniel.

HOLLAR, Wenceslaus (1607–77)
Born Prague; to England with the Earl of Arundel 1637; taught drawing to the Prince of Wales; an etcher and engraver. Portraits and landscapes. (*B.M.*)

HOLLINS, John (1798–1855)
Born Birmingham, the son of a glass painter; to London 1822; visited Italy 1825–27; A.R.A. 1842. Portraits and historical subjects. Exhibited 143 works, 101 at R.A., 35 at B.I., 6 at S.B.A., 1819–55. (*V. & A.*)

HOLLIS, George (1793–1842)
Father of Thomas; an engraver; pupil of G. Cook. Landscapes in Oxfordshire.

HOLLIS, Thomas (1818–43)
Son of George, whom he assisted; studied under H. W. Pickersgill, and at R.A. Architectural subjects.

HOLLOWAY, Charles Edward (1838–97)
Born Christchurch, Hants.; studied at Leigh's School; in London with F. Walker, G. Green and C. D. Linton; associated with William Morris making stained glass until 1866; visited Venice 1875 and 1895; assoc. N.W.C.S. 1878, member 1879; A.R.A. 1875, R.A. 1879. Almost impressionist landscapes of the Fen district and Thames. Exhibited 167 works, 70 at N.W.C.S., 32 at R.A., 7 at S.B.A. (*Whitworth, V. & A.*)

HOLLOWAY, Thomas (1748–1827)
Born London; apprenticed to a seal engraver; engraved for Boydell. Portraits. Exhibited 35 works, 16 at Soc. of Artists, 19 at R.A., 1773–92.

HOLMES, Sir Charles John (1868–1936)
Director National Gallery; Assoc. R.W.S. 1924, member 1929, vice-president 1935. Landscapes.

HOLMES, G. (fl.1786–1804)

Probably Irish; protégé of
Ackerman, the print dealer.
Landscapes, mostly in Ireland.
Exhibited 7 works at R.A.

HOLMES, James (1777–1860)
Member Associated Artists in
Water Colours, O.W.C.S., and S.B.A.
1826–48. Miniatures, portraits and
genre. Exhibited 225 works, 32 at
O.W.C.S., 18 at R.A., 3 at B.I., 142 at
S.B.A.

HOLMES, Sophia (fl. 1886–91)
Of Dublin. Flowers. Exhibited 8
works, 6 at N.W.C.S., 1 at R.A.

HOLROYD, Sir Charles
(1861–1917)
Born Leeds; studied at the Slade,
and in Italy for 2 years; assisted
Legros for many years; keeper
Tate Gallery, and director
National Gallery 1906–16;
member Royal Society of Painter-
Etchers and Engravers. Land-
scapes. (*Leeds, V. & A.*)

HOLST, Theodor M. von
(1810–44)
Born London; studied at B.M. and
R.A., and under H. Fuseli. Figures
and historical subjects. Exhibited
50 works, 24 at R.A., 20 at B.I., 6 at
S.B.A. 1827–45.

HOLWORTHY, James
(1781–1841)
Born Bosworth; studied under
John Glover; married daughter of
Wright of Derby; a friend of
Turner; founder member O.W.C.S.
Landscapes and rustic figure
subjects. Exhibited 39 works, 36 at
O.W.C.S., 3 at R.A. (*V. & A.*)

HOLYOAKE, Rowland
(fl. 1880–93)
Domestic subjects. Exhibited 93

works, 5 at N.W.C.S., 12 at R.A., 58
at S.B.A.

HOME, Robert (d. 1836)
Pupil of Angelica Kauffmann, and
also studied in Rome; widely
travelled. Portraits. Exhibited 23
works at R.A. 1770–1813.

HONE, Horace (1756–1825)
Son of Nathaniel; lived for some
time in Dublin; A.R.A. 1779.
Miniatures and chalk portraits.
Exhibited 159 works, 158 at R.A.

HONE, Nathaniel (1718–84)
Born Dublin; self-taught; worked
at York; to London 1750;
founder member R.A.
Minatures. Exhibited 101 works,
32 at Soc. of Artists, 69 at R.A.
1760–84.

HOOD, John (fl. 1762–71)
A Limehouse shipwright. Marines
and shipping. Exhibited 22 works,
21 at Free Soc., 1 at Soc. of
Artists.

HOOD, Thomas (1799–1855)
Born London; drew humorous
subjects for many comic
publications.

HOOKER, W. J. (fl. c. 1816)
An amateur. Architectural
subjects, some drawings re-
produced in the 'Antiquarian
Itinerary'.

HOOPER, Luther (fl. 1870–91)
Domestic subjects. Exhibited 35
works, 4 at N.W.C.S., 5 at R.A.,
6 at S.B.A.

HOOPER, S.
An 18th century artist who did
illustrations for 'Gough's
Monumental Antiquities'.

HOPKINS, Arthur (1848–1930)
Studied at R.A. 1872; drew for
Punch, Graphic and *Illustrated
London News;* assoc. R.W.S. 1877,
member 1896, and treasurer 1898;
member Royal British Colonial
Society of Artists. (*Leeds*)

HOPLEY, Edward William John
(1816–69)
Trained first to be a doctor, then
became a subject painter.
Allegorical subjects. Exhibited 48
works, 15 at R.A., 26 at B.I., 7 at
S.B.A., 1844–69.

HOPPNER, John (1759–1810)
Born Whitechapel; studied at R.A.
1775, and gold medallist 1782;
portrait-painter to the Prince of
Wales; A.R.A. 1793, R.A. 1795.
Portraits and landscapes, often in
black chalk in the Gainsborough
style. Exhibited 168 works at R.A.
(*V. & A., B.M.*)

HOPPNER, Richard Belgrave
(fl. 1807–27)
Son of John; an amateur; travelled
abroad. Marines. Exhibited 28
works, 7 at R.A., 21 at B.I.

HOPWOOD, Henry Silkstone
(1860–1914)
Studied at Manchester School of
Art; visited Australia 1888–90;
studied in Antwerp and Paris;
worked much in France, North
Africa and Japan; assoc. O.W.C.S.
1896, member 1908. Landscape
and domestic subjects. Exhibited 4
works, 2 at N.W.C.S., 2 at R.A.
(*V. & A.*)

HORE, James (fl. 1829–30)
Drawings of Pisa and Corfu.

HORNOR, Thomas (fl. 1800–44)
Welsh landscapes. (*B.M.*)

HORSLEY, Hopkins Horsley
Hobday (1806–92)
Born Birmingham; apprenticed to
a papier-mâché maker; travelled
in France, Switzerland, and Italy
1833–40. Landscapes. Exhibited
107 works, 36 at S.B.A., 23 at R.A.,
21 at B.I. (*Birmingham*)

HORWICK, Emanuel Henry
(fl. 1886–90)
Domestic subjects. Exhibited 6
works, 5 at N.W.C.S.

HOSKINS, John (1664–?)
Born London; taught Samuel and
Alexander Abraham Cooper.
Miniatures.

HOUGH, William (1857–90)
Of Coventry; later to London.
Flowers and fruit in the style of
William Henry Hunt. Exhibited
79 works, 3 at N.W.C.S., 28 at R.A.,
1 at B.I., 14 at S.B.A. (*Glasgow*)

HOUGHTON, Arthur Boyd
(1836–75)
Of Richmond; studied at Leigh's
School; assoc. O.W.C.S. 1871.
Illustrations and views. Exhibited
36 works, 11 at O.W.C.S., 10 at R.A.,
40 at B.I., 3 at S.B.A. (*V. & A.*)

HOUSTON, George (b. 1869)
Member R.I. 1920; member R.C.A.,
R.S.W. Landscapes.

HOUSTON, John Adam
(1802–84)
Born Wales; studied at Trustees'
Academy, Edinburgh, in Germany,
and at Paris; assoc. R.S.A. 1842,
member 1845; assoc. N.W.C.S.
1874, member 1879. Genre.
Exhibited 161 works, 81 at N.W.C.S.,
45 at R.A., 21 at B.I., 5 at S.B.A.

HOWARD, E. Stirling (fl. 1834–70)
Of Sheffield. Landscapes.

Exhibited 6 works, 2 at R.A., 3 at S.B.A.

HOWARD, Frank (1805–66)
Pupil of his father Henry and of Lawrence; won many awards but died destitute. Mythological subjects. Exhibited 78 works, 43 at R.A., 26 at B.I., 9 at S.B.A. 1824–46.

HOWARD, Henry (1769–1847)
Born London; father of Frank; taught by Philip Reinagle; R.A., and professor of painting R.A. Poetical and classical subjects. Exhibited 333 works, 259 at R.A., 72 at B.I., 2 at S.B.A. 1794–1847.

HOWARD, Hugh (1675–1737)
Born Dublin; worked for some years in Dublin before going to England, to a Government appointment. Collected drawings and prints, some of which were purchased by the B.M.

HOWARD, Vernon (1840–1902)
Drawing master at Boston, Lincs.; lived for a time at Sutton, Lincs., and at Kidderminster and Grantham. Landscapes. Exhibited 26 works, 11 at N.W.C.S., 1 at R.A. (*V. & A.*)

HOWARD, William
Late 17th century artist. Pupil of Hollar, whose style he copied.

HOWE, James (1780–1836)
Born Peeblesshire. Animals, landscapes and genre. (*V. & A.*)

HOWITT, Samuel (1765?–1822)
Self-taught; brother-in-law of Thomas Rowlandson, and worked somewhat in his style; many years in Bengal; published several illustrated sporting books. Animals and landscapes. Exhibited

16 works, 3 at Soc. of Artists, 10 at R.A., 1783–1815. (*Whitworth, V. & A., B.M.*)

HOWLETT, Bartholomew (1767–1827)
Born Louth. Architectural subjects, of which he left a large collection on his death. Exhibited 1 work at R.A. 1803.

HOWSE, George (d. 1860)
Member N.W.C.S. 1834; visited France; fl. from 1830. Landscapes, coastal scenes, and views of towns. Exhibited 567 works, 531 at N.W.C.S., 26 at R.A., 6 at B.I., 4 at S.B.A. (*Dublin, V. & A.*)

HOWSE, John (fl. 1772–93)
Miniatures.

HUDSON, William (d. 1847)
Of Croydon; member N.W.C.S. 1834; fl. from 1803. Portraits. Exhibited 213 works, 15 at N.W.C.S., 161 at R.A., 37 at S.B.A.

HUGHES, Arthur Foord (fl. 1878–93)
Of Wallington, Surrey. Domestic subjects. Exhibited 21 works, 5 at N.W.C.S., 3 at R.A., 2 at S.B.A.

HUGHES, Edward Robert (1851–1914)
Born London; worked with William Holman Hunt; member R.W.S. 1895, vice-president 1901–03. Domestic subjects and Italian literary subjects. Exhibited 66 works, 14 at O.W.C.S., 15 at R.A.

HUGHES, Louisa M.
See Watts, Mrs J. T.

HUGHES-STANTON, Sir Robert Edwin Pelham (1870–1937)
Assoc. R.W.S. 1909, member 1915, vice-president 1919, president

1920. Knighted 1923. A.R.A. 1913;
R.A. 1920.

HUGHES, Thomas John
 (fl. 1879–92)
 Domestic subjects. Exhibited 13
 works, 3 at N.W.C.S., 7 at S.B.A.

HULK, William F. (fl. 1875–93)
 Cattle. Exhibited 130 works, 13 at
 N.W.C.S., 45 at R.A., 43 at S.B.A.

HULL, Clementina M.
 (fl. 1866–91)
 Landscapes. Exhibited 16 works,
 4 at N.W.C.S., 2 at R.A., 4 at S.B.A.

HULL, Mary A. (fl. 1877–86)
 Of Leicester. Fruit. Exhibited 4
 works, 3 at N.W.C.S., 1 at R.A.

HULL, Thomas H. (fl. 1775–1827)
 Miniatures. Exhibited 73 works at
 R.A.

HULL, William (1820–80)
 Born Graffham; studied at B.M.
 1840 and then at Manchester
 School of Design; on the Continent
 as a tutor 1841–44, and thereafter
 lived in Manchester; member
 Manchester Academy of Fine Arts.
 Landscapes. Exhibited 29 works,
 8 at R.A., 3 at S.B.A. 1858–7

HULLEY, Thomas (fl. 1798–1817)
 Worked in Bath as a drawing
 master, but nothing else known.
 (*V. & A.*)

HULME, Frederick William
 (1816–84)
 Born Swinton; to London 1844;
 painted much around Bettws-y-
 Coed. Landscapes. Exhibited 116
 works, 40 at R.A., 5 at B.I., 5 at
 S.B.A., 1845–84.

HUME, Mrs T. O. (née Dunn)
 (fl. 1870–92)

Domestic subjects. Exhibited 73
works, 3 at N.W.C.S., 32 at R.A.,
14 at S.B.A.

HUMPHREY, Ozias (1742–1810)
 Born Exeter; spent 4 years in
 Italy; visited India 1785–88;
 went blind 1797. Miniatures.
 Exhibited 58 works, 10 at Soc. of
 Artists, 48 at R.A. 1765–97.

HUMPHRIES, Capt.
 See Payne, William (*Note*).

HUMPHREYS, Henry Noel
 (1810–79)
 Born Birmingham. Book
 illustrations.

HUNN, Thomas H. (fl. 1878–90)
 Of Hackney. Landscapes.
 Exhibited 31 works, 4 at N.W.C.S.,
 7 at R.A., 13 at S.B.A.

HUNT, Alfred William (1830–96)
 Born Liverpool; distinguished
 academic career; pupil of D. Cox;
 member Liverpool Academy 1856
 and O.W.C.S. 1864; several years
 at Durham, but settled in London.
 Landscapes. Exhibited 395 works,
 334 at O.W.C.S., 37 at R.A., 6 at
 S.B.A. (*V. & A., Liverpool,
 Newcastle, Oxford*)

HUNT, Andrew (1790–1861)
 Born near Birmingham; father of
 Alfred William; pupil of S. Lines;
 to Liverpool 1817 and opened a
 drawing school. Landscapes and
 domestic subjects. Exhibited 7
 works, 2 at R.A., 3 at S.B.A.
 1852–56. (*Walker*)

HUNT, Arthur Acland
 (fl. 1863–87)
 Figure subjects. Exhibited 64
 works, 6 at N.W.C.S., 13 at R.A.,
 4 at B.I., 22 at S.B.A.

HUNT, Cecil Arthur (1873–1965)
Assoc. R.W.S. 1919, member 1925,
vice-president 1929–33. Travelled
widely on Continent. Famous for
mountain and industrial scenes.
(*V. & A., Fitzwilliam, Ashandean,
U.S.A., etc.*)

HUNT, Thomas (fl. 1881–91)
Of Glasgow; member R.S.W.
Domestic subjects. Exhibited 14
works, 4 at N.W.C.S., 10 at R.A.

HUNT, William Henry
(1790–1864)
Born Long Acre; apprenticed to
John Varley; studied at R.A. 1808;
befriended by Dr Monro; assoc.
O.W.C.S. 1824, member 1826;
member Amsterdam Royal
Academy. Early pen and wash
landscapes, and later fruit and
flowers ('Bird's Nest Hunt'), and
genre in watercolour and body-
colour, or in pastel. Exhibited 817
works, 796 at O.W.C.S., 14 at R.A.,
6 at B.I., 1 at S.B.A. (*V. & A.,
B.M., and many others*)

HUNT, William Holman
(1827–1910)
Born Cheapside; pupil of portrait-
painter H. Rogers; studied at R.A.
1845; a founder of the Pre-
Raphaelite Brotherhood; to the
Continent with D. G. Rossetti
1849, to Middle East 1854.
Assoc. O.W.C.S. 1869, member
1887. Rare landscapes in water-
colour. Exhibited 83 works, 38 at
O.W.C.S., 25 at R.A., 1 at B.I., 1 at
S.B.A., (*V. & A., B.M., Oxford,
Whitworth*)

HUNT, William Howes (1807–79)
A Yarmouth linen-draper turned
professional artist; influenced by
M. E. Cotman and the brothers
Joy; signature often identical
with that of William Henry.

Landscapes and marines. (*B.M.*)

HUNTER, Ada (fl. 1886–93)
Miniatures. Exhibited 9 works, 3
at N.W.C.S., 6 at R.A.

HUNTER, Blanche F. (fl. 1889–90)
Domestic subjects. Exhibited 3
works, 2 at N.W.C.S., 1 at R.A.

HUNTER, Colin (1841–1904)
Born Glasgow; self-taught; to
London after working in Glasgow
and Edinburgh; member R.I. 1882;
A.R.A. 1884, member R.S.W. and
Institute of Painters in Oil
Colours. Marines, fishing scenes
and rustic subjects with figures.
Exhibited 92 works, 67 at R.A.

HUNTER, Mason (fl. 1881–93)
Of Edinburgh. Landscapes.
Exhibited 10 works, 4 at N.W.C.S.,
4 at R.A., 1 at S.B.A.

HURST, Henry William Lowe
(known as Hal Hurst)
(1854–1921)
Member R.I. 1898. Landscapes.

HURTER, Johann Heinrich
(b. 1734)?
Born Schaffhausen, Switzerland;
worked for some time in England.
Crayon portraits. Exhibited only
enamelled miniatures, 11 at R.A.,
1779–81.

HUSON, Thomas (1844–1920)
Born Liverpool; member R.I.
1883, member Royal Society of
Painter-Etchers and Engravers.
Landscapes. Exhibited 135 works,
59 at N.W.C.S., 13 at R.A., 20 at
S.B.A. (*Walker*)

HUSEY, Agnes (fl. 1877–87)
Of Salisbury. Flowers.
Exhibited 8 works, 4 at N.W.C.S.,
1 at S.B.A.

HUSSEY, Giles (1710–88)
Born Dorset; pupil of Richardson.
Portraits and historical subjects.

HUTCHINSON, Henry (1800–31)
An architect, who executed the
additions to St John's College,
Cambridge. Architectural subjects.
(*Birmingham*)

HUTCHINSON, Samuel
(fl. 1770–1802)
Landscapes and marines.
Exhibited 2 works, 1 at Soc. of
Artists, 1 at R.A.

HUTTON, Alfred (fl. 1884–86)
Landscapes. Exhibited 5 works at
N.W.C.S.

HUTTON, W. (fl. c. 1782)
Scottish topography. (*Edinburgh*)

HUTTULA, Richard C.
(fl. 1866–87)
Domestic subjects. Exhibited 53
works, 4 at N.W.C.S., 28 at S.B.A.

HYDE, Henry James (fl. 1883–92)
Rustic scenes. Exhibited 18 works,
11 at N.W.C.S., 1 at S.B.A.

I'ANSON, Charles (fl. 1875–93)
Landscapes. Exhibited 63 works,
9 at N.W.C.S., 13 at R.A., 17 at
S.B.A.

IBBETSON, Julius Caesar
(1759–1817)
Born Scarborough; apprenticed to
a ship-painter at Hull; to London
1777 and patronised by Capt.
Baillie, Lord Bute and Lord
Dysart; with Cathcart's Embassy
to China 1788; lived in the Lake
District from 1798; spent some
time in Llanbedr, near Conway,

Caernarvon. Landscapes with
figures and animals. His son of the
same name painted much in his
style. Exhibited 87 works, 81 at
R.A., 6 at B.I., 1785–1818.
(*V. & A., B.M., Leeds, and others*)

IFFOLD or IFOLD, Frederick
(fl. 1846–47)
Figure subjects. Exhibited 17
works, 4 at R.A., 5 at B.I., 8 at
S.B.A.

ILLIDGE, Thomas Henry
(1799–1851)
Born Birmingham; pupil of
Mather Brown and William
Bradley; lived in Liverpool for a
time. Portraits. Exhibited 32
works, 14 at R.A., 5 at B.I., 13 at
S.B.A. 1826–51.

INCE, Charles (b. 1875)
Member R.I. 1927; member R.B.A.

INCE, Joseph Murray (1806–59)
Born Presteigne, Radnorshire;
pupil of D. Cox at Hereford
1823–26; to London 1826,
Cambridge 1832, and returned to
Presteigne c. 1835. Marines,
architectural subjects and land-
scapes. Exhibited 197 works, 9 at
N.W.C.S., 16 at R.A., 23 at B.I.,
137 at S.B.A. (*V. & A., B.M.,
Fitzwilliam*)

INCHBOLD, John William
(1830–88)
Born Leeds, the son of the
proprietor and editor of the *Leeds
Intelligencer*; trained as a draughts-
man with Day and Haghe,
lithographic printers in London;
studied watercolour under Louis
Haghe c. 1847 and at R.A.;
praised by Ruskin. Landscapes.
Exhibited 42 works, 30 at R.A.,
1 at B.I., 3 at S.B.A. 1849–87.
(*V. & A., Leeds, Ashmolean*)

INCHBOLD, Stanley (fl. 1884–92)
Of Bushey, Herts. Landscapes.
Exhibited 4 works, 3 at N.W.C.S.,
1 at S.B.A.

INGALL, J. Spence (fl. c. 1890)
Of Barnsley. Marines. Exhibited
at N.W.C.S. 1892.

INGALTON, William (1794–1866)
Born Worplesdon, Surrey; an
architect. Domestic and rustic
scenes. Exhibited 33 works, 9 at
R.A., 19 at B.I., 5 at S.B.A., 1816–26.

INGHAM, Charles Cromwell
(1796–1863)
Born Dublin; studied at Dublin
Academy; founder and vice-
president National Academy of
Design; died New York.
Portraits of New York Beauties.
Portraits. Exhibited 1 work at R.A.
1845.

INGLEBY, John (fl. c. 1770)
Travelled widely with Thomas
Pennant, whose books he
illustrated. (*Aberystwyth*)

INGLIS, Hester
An ornamental designer in the
reigns of Elizabeth I and Charles
I. Presented to Elizabeth a copy of
the Psalms of David in her own
hand, now in the Library of Christ
Church College, Oxford. A
collection of her painted emblems
Royal Library.

INGRAM, William Ayerst
(1855–1913)
Of Scottish parentage, the son of a
Glasgow clergyman; pupil of J.
Steeple and A. W. Weeden; much
travelled; member R.S.B.A. 1883
and Royal Institute of Painters in
Water Colours 1907; president
Royal British Colonial Society of
Artists 1888. Landscapes.

Exhibited 120 works, 13 at
N.W.C.S., 16 at R.A., 80 at S.B.A.
(*V. & A.*)

INSKIPP, James (fl. 1790–1868)
Landscapes in Italy and in Britain,
and figure subjects. Exhibited 164
works, 24 at R.A., 83 at B.I., 56 at
S.B.A. 1816–64.

IRELAND, James (fl. 1885–87)
Of Liverpool. Domestic subjects.
Exhibited 5 works, 3 at N.W.C.S.,
2 at R.A.

IRELAND, Jane (fl. 1792–93)
Daughter of Samuel. Miniatures.
Exhibited 5 works at R.A.

IRELAND, Samuel (d. 1800)
Well-known illustrator of many
books of views in this country and
in Holland and France; fl. from c.
1782. Exhibited 5 works at R.A.
1782–84.

IRELAND, Thomas (fl. 1880–93)
Landscapes. Exhibited 81 works,
7 at N.W.C.S., 19 at R.A., 19 at
S.B.A.

IRTON, Major (fl. 1820–30)
Landscapes, some in Rome,
engraved in Rev. G. N. Wright's
'Rhine, Italy and Greece'.

IRVINE, James (1833–89)
Friend of George Paul Chalmers.
Portraits and domestic subjects.
Exhibited 2 works at R.A.
1882–84.

IRVING, J. Thwaite (fl. 1888–93)
Born Witley, Surrey. Landscapes
and marines. Exhibited 17 works,
1 at R.A., 3 at S.B.A., 1 at N.W.C.S.

ISRAELS, Joseph (1824–1911)
Born the Hague. Hon R.W.S., Hon.
R.I. 1872. Domestic subjects.

Exhibited 32 works, 7 at R.A., 21 at N.W.C.S. 1871–89.

IVEY, Marion Teresa (fl. 1884–88)
Domestic subjects. Exhibited 4 works, 2 at R.A., 1 at S.B.A., 1 at N.W.C.S.

JACK, Richard (b. 1866)
B.A., A.R.C.A., R.P. Member R.I. 1917. Portraits.

JACKSON, Arthur (fl. c. 1890)
Architectural subjects, churches, etc. Exhibited 1 work at N.W.C.S. 1890.

JACKSON, Emily F. (fl. 1875–87)
Of Carshalton. Flowers. Exhibited 60 works, 6 at N.W.C.S., 16 at R.A., 19 at S.B.A.

JACKSON, F. Hamilton (fl. 1870–93)
Member R.B.A. Landscapes. Exhibited 110 works, 9 at N.W.C.S., 20 at R.A., 46 at S.B.A.

JACKSON, Frederick William (1859–1918)
Born Middleton, Lancs.; studied at Oldham School of Art, Manchester Academy, and in Paris; much travelled but worked mostly in Yorkshire; member R.B.A. Landscapes. Exhibited 37 works, 19 at R.A., 13 at S.B.A., 1870–93.

JACKSON, Helen (fl. 1884–93)
Domestic subjects. Exhibited 10 works, 5 at R.A., 3 at S.B.A., 1 at N.W.C.S.

JACKSON, John (1801–48)
Born Ovingham, Northumberland; a wood engraver; studied under Thomas Bewick and William Harvey; published 'A Treatise on Wood Engraving'.

JACKSON, John (1778–1831)
Born Lastingham, Yorks.; patronised by Lord Mulgrave; studied at R.A. 1805; A.R.A. 1815, R.A. 1817. Travel sketches, miniatures and portraits. Exhibited 166 works, 146 at R.A., 20 at B.I., 1804–30.

JACKSON, John Adams (1825–79)
Born Bath; a sculptor, who did many clever drawings of the human form.

JACKSON, John Richardson (1819–77)
Born Portsmouth; a mezzotint engraver. Portraits. Exhibited 27 works 1854–76 at R.A.

JACKSON, Samuel (1794–1869)
Born Bristol; assoc. O.W.C.S. 1823–48. Landscapes in England, Wales, West Indies, Switzerland and Egypt. Exhibited 51 works, 49 at O.W.C.S., 1 at B.I., 1 at S.B.A. (*V. & A., B.M., Bristol, Newport*)

JACKSON, Samuel Phillips (1830–1904)
Born Clifton; son of Samuel; assoc. O.W.C.S. 1853, member 1876. River scenes and marines. Exhibited 866 works, 841 at O.W.C.S., 16 at R.A., 9 at B.I. (*V. & A., B.M., Bristol, Gateshead, Newcastle*)

JACKSON, William (1730–1803)
Born Exeter; an amateur; friend of Gainsborough; also a composer. Landscapes.

JACOB, Edith (fl. 1888–93)
Flowers. Exhibited 5 works at N.W.C.S.

JACOBS, Louisa (fl. 1884–91)
A sculptress, working in London.
Figure subjects. Exhibited 11
works, 3 at R.A., 5 at S.B.A., 1 at
N.W.C.S.

JAGGER, Charles (b. 1770)
Died Bath. Miniatures.

JAMES, Arthur C. (fl. 1889–90)
Of Eton. Landscapes. Exhibited 4
works at N.W.C.S.

JAMES, Edith Augusta (1857–98)
Born Eton; studied in Paris under
Chaplin and Luminais. Flowers,
portraits, and latterly interiors of
St Paul's Cathedral. Exhibited in
Paris, and at R.A. 1886–96.
(*V. & A.*)

JAMES, Francis Edward
(1849–1920)
A country gentleman who became
an artist; friend of H. B. Brabazon;
member New English Art Club;
assoc. R.W.S. 1908, member 1916.
Landscapes, church interiors and
flowers. Exhibited 17 works at
S.B.A., 1884–88. (*V. & A.*)

JAMES, William (fl. 1761–71)
Pupil of Canaletto c. 1746, and
imitated his style and that of
Samuel Scott. Landscapes.
Exhibited 25 works, 18 at Soc. of
Artists, 7 at R.A. (*V. & A.*)

JAMESON, George (1586–1644)
Born Aberdeen, the son of an
architect; pupil of Rubens.
Miniatures.

JAMESON, J. B. (fl. c. 1886)
A drawing master at the Royal
Marine Academy, Greenwich.

JAMESON, Rosa (fl. 1886–91)
Domestic subjects. Exhibited 11

works, 3 at N.W.C.S., 4 at R.A., 1 at
S.B.A.

JAQUES, Julia (fl. 1826–36)
Worked in London. Portraits.
Exhibited 31 works, 13 at R.A.,
17 at S.B.A., 1 at N.W.C.S.

JARVIS, George (fl. 1874–90)
Worked in London. Domestic
subjects. Exhibited 16 works, 3 at
R.A., 9 at S.B.A., 1 at N.W.C.S.

JARVIS, John Wesley (1780–1834)
Born South Shields; nephew of
evangelist John Wesley; died
Philadelphia.

JARVIS, Matthew (fl. 1879–87)
Of Liverpool. Landscapes.
Exhibited 6 works, 3 at N.W.C.S.,
1 at R.A., 2 at S.B.A.

JEAN, P. (1755–1802)
Born Jersey; settled in England,
and for a time served in the Navy.
Miniatures. Exhibited 118 works
at R.A.

JEAVONS, Thomas (1816–67)
A line engraver, working on
landscapes and marines after
E. W. Cooke.

JEAYES, H. (fl. c. 1808)
Landscapes.

JEENS, Charles Henry (1827–1879)
Born Uley, Glos.; a line engraver,
working on postage stamps.
Exhibited 6 works at R.A.
1860–76.

JEFFEREYS, James (1757–84)
Born Maidstone, the son of a
coach-painter. His mythological
subjects were engraved by
Woollett. Exhibited 11 works,
8 at Soc. of Artists, 3 at R.A.
1773–83.

JEFFERSON, John (fl. c. 1814)
Topographical landscapes.

JELLEY, James Valentine
(fl. 1885–91)
Born Birmingham. Landscapes.
Exhibited 14 works, 12 at R.A.,
1 at N.W.C.S.

JENKINS, D.
Late 18th century artist, working
in London. Engraved his own work
and some works after Angelica
Kauffmann.

JENKINS, Emily Vaughan
(fl. 1890–91)
Of Oxford. Buildings. Exhibited
3 works, 2 at N.W.C.S., 1 at S.B.A.

JENKINS, Joseph John (1811–85)
Born London, the son of an
engraver; assoc. N.W.C.S. 1842,
member 1843–47; assoc. O.W.C.S.
1849, member F.S.A. 1850 and
secretary 1854–64. Figures and
landscapes. Exhibited 348 works,
273 at O.W.C.S., 61 at N.W.C.S., 1 at
R.A., 2 at B.I., 11 at S.B.A. (*V. & A.,
National Gallery of Ireland*)

JENKINS, Thomas (d. 1798)
Born Devon; accompanied
Richard Wilson to Rome; a dealer
in antiquities.

JENKINSON (fl. 1840's)
Little known, but in the V. & A.
are some continental drawings
dated from 1842–47.

JENNER, G. P. (fl. 1834–40)
Historical subjects. Exhibited 7
works, 2 at N.W.C.S., 5 at R.A.

JENNINGS, Edward (fl. 1865–88)
Landscapes. Exhibited 33 works,
2 at N.W.C.S., 11 at R.A., 9 at S.B.A.

JERMYN, Miss H. (fl. c. 1810)

Landscapes.

JERMYN, Paulina
See Trevelyan, Lady Paulina.

JEWITT, Thomas Orlando Sheldon
(1799–1869)
A wood engraver, and illustrator
of architectural works.
(*Whitworth*)

JOBBINS, William H.
(fl. 1872–86)
Of Nottingham. Landscapes.
Exhibited 9 works, 4 at R.A., 2 at
S.B.A., 1 at N.W.C.S.

JOBLING, Robert (1841–1923)
Born Newcastle-upon-Tyne;
a glass-maker; studied at
Newcastle School of Art, and
turned professional artist 1890;
president Bewick Art Club 1910.
Marines. Exhibited 16 works, 13
at R.A., 3 at S.B.A., 1878–92.
(*Newcastle*)

JOHNS, Ambrose Bowden
(1776–1858)
Born Plymouth. Landscapes.
Exhibited 20 works, 13 at R.A.,
3 at B.I., 4 at S.B.A., 1814–47.

JOHNSON, Alfred J. (fl. 1875–87)
Worked in London. Domestic
subjects. Exhibited 27 works, 6 at
R.A., 7 at S.B.A., 1 at N.W.C.S.

JOHNSON, Charles Edward
(1832–1913)
Member R.I. 1882. Landscapes.
Exhibited 144 works, 22 at
N.W.C.S., 71 at R.A., 4 at B.I., 6 at
S.B.A.

JOHNSON, Cyrus (1848–1925)
Member R.I. 1887. Domestic
subjects. Exhibited 111 works,
25 at N.W.C.S., 35 at R.A., 8 at
S.B.A.

JOHNSON, Edward Killingworth
(1825–96)
Born Stratford; self-taught;
assoc. R.W.S. 1866, member 1876.
Genre and landscapes. Exhibited
190 works, 176 at O.W.C.S., 3 at
R.A., 7 at S.B.A.

JOHNSON, Ernest Borough
(b. 1867)
Member R.I. 1906. Landscapes.

JOHNSON, Harry John (1826–84)
Born Birmingham; son of artist
W. B. Johnson; studied under
S. Lines and W. J. Müller, and at
Birmingham Societp of Artists;
toured with Müller in the Levant;
spent much time in Wales with
D. Cox; member R.I. 1870.
Landscapes. Exhibited 65 works,
19 at R.A., 39 at B.I., 6 at S.B.A.
(*V. & A., Birmingham*)

JOHNSON, Isaac (1754–1835)
Antiquary and surveyor. Tree
studies.

JOHNSON, Mabel (fl. 1880's)
Of London. Landscapes. Exhibited
1 work at N.W.C.S. 1889.

JOHNSON, Robert (1770–96)
Born Shotley, Northumberland;
apprenticed to the engraver
Thomas Bewick. Miniatures.

JOHNSON, Thomas (fl. c. 1651–75)
One of the early founders of the
English School of watercolour
drawing, whose work is rarely
seen. One example, the 'Baths at
Bath', dated 1672, is in the B.M.

JOHNSTON, Alexander (1815–91)
Born Scotland; studied at
Edinburgh Academy. Domestic
subjects. Exhibited 147 works,
77 at R.A., 49 at B.I., 17 at S.B.A.
(1836–86)

JOHNSTON, Henry (fl. 1834–58)
Member N.W.C.S. Landscapes with
figures. Exhibited 37 works, 34 at
N.W.C.S., 3 at R.A.

JOHNSTONE, George Whitton
(1849–1901)
Born Glamis, Angus; assoc. R.S.A.,
member R.S.W. Scottish landscapes.
Exhibited 7 works at R.A.
1885–92.

JOHNSTONE, William Borthwick
(1804–68)
Born Edinburgh; a solicitor; first
curator National Gallery of
Scotland, and a writer on art;
visited Italy 1842–43; assoc.
Scottish Academy 1840, member
1848. Landscapes with figures,
historical subjects and genre.
Exhibited 8 works at minor
galleries, 1848–53.

JOLI, Antonio (1700?–1777)
Born Italy; taught by Pannini in
Rome, then moved to Naples, and
thence to England. Landscapes,
particularly of the Thames Valley
from Richmond to Windsor.
(*Temple Newsam*)

JONES, Adrian (fl. 1884–93)
A sculptor. Exhibited 15 works,
9 at R.A., 10 at N.W.C.S., 4 at
Grosvenor gallery.

JONES, Charles (fl. 1860–91)
Of Barnham, Sussex; member
R.C.A. Cattle. Exhibited 101
works, 10 at N.W.C.S., 12 at R.A.,
12 at B.I., 61 at S.B.A.

JONES, Charlotte (d. 1847)
Miniatures. Exhibited 41 works
at R.A., fl. 1801–23.

JONES, Eliza (fl. 1807–52)
Miniatures. Exhibited 142 works,
9 at O.W.C.S., 98 at R.A., 35 at B.I.

JONES, Frederick (fl. 1867–85)
Landscapes. Exhibited 4 works,
1 at R.A. (*V. & A.*)

JONES, George (1786–1869)
Studied at R.A., a captain of
militia in Paris 1815; friend of
Turner; R.A. Battle scenes, land-
scapes on blue paper in blue and
brown wash. Exhibited 368 works,
5 at O.W.C.S., 221 at R.A., 141 at
B.I., 1 at S.B.A. (*B.M., Liverpool,
Newport, Birmingham*)

JONES, G. Smetham (fl. 1888–93)
Domestic subjects. Exhibited 6
works, 4 at N.W.C.S., 1 at R.A., 1 at
S.B.A.

JONES, Henry Festing
(fl. 1851–1928)
An amateur; friend and biographer
of S. Butler. Landscapes and
Alpine views. (*B.M.*)

JONES, Inigo (1573–1652)
Born London; architect and stage
designer; to Italy and Denmark
before 1604; revisited Italy
1613–14. Architectural subjects,
costume and landscapes. (*B.M.,
R.I.B.A., Chatsworth*)

JONES, J. Clinton (fl. 1885–89)
Born Conway, North Wales;
member R.C.A. Landscapes.
Exhibited 5 works, 4 at R.A., 1 at
N.W.C.S.

JONES, Maud Raphael (fl. 1889–93)
Of Bradford. Rustic subjects.
Exhibited 24 works, 3 at N.W.C.S.,
10 at R.A.

JONES, Owen (1809–74)
Born London; an architect; pupil
of Louis Vulliamy; studied at R.A.
1830; travelled in France, Italy,
Egypt and Spain; superintended
the decoration of the building for
the Great Exhibition of 1851, and
designed various courts for the
Crystal Palace 1852. Foreign
architectural subjects. Exhibited
12 works at R.A. (*V. & A.*)

JONES, Reginald (fl. 1880–93)
Of Eltham. Landscapes. Exhibited
32 works, 9 at N.W.C.S., 8 at R.A.,
13 at S.B.A.

JONES, S. J. E. (fl. 1820–46)
Landscapes in Kent, Derbyshire,
Wales and Essex. Sporting
subjects. Exhibited 47 works,
19 at S.B.A., 14 at R.A., 14 at B.I.,
(*V. & A.*)

JONES, Theodore (fl. 1879–89)
Worked in London. Landscapes.
Exhibited 16 works, 4 at R.A.,
11 at S.B.A., 1 at N.W.C.S.

JONES, Thomas (1742–1803)
Studied at R.A. 1762; pupil of
R. Wilson 1763; visited Calais
1767, Italy 1776–83. Landscape.
(*B.M.*)

JONES, Sir Thomas Alfred
(1823?–93)
Studied at Royal Dublin Society
and R.H.A.; member R.H.A. 1861
and president from 1870.
Portraits and figure subjects.
Exhibited 5 works at R.A.
(*V. & A.*)

JONES, T. Hampson (fl. 1874–92)
Of Liverpool. Landscapes.
Exhibited 31 works, 3 at N.W.C.S.,
20 at R.A.

JONES-PARRY, Thomas P.
(fl. 1884–88)
Of Wrexham. Landscapes.
Exhibited 3 works at N.W.C.S.

JOPLING, Joseph Middleton
(1831–84)

Born London; self-taught; director fine arts section Philadelphia International Exhibition; assoc. N.W.C.S. 1859. Figure subjects and landscapes. Exhibited 240 works, 126 at N.W.C.S., 30 at R.A., 21 at S.B.A. (*V. & A., B.M.*)

JOPLING, Mrs J. M.
(née Louise Goode)
(1843–1933)
Studied in Paris 1865; first woman member Royal Society of Portrait Painters. Portraits and landscapes. Exhibited 137 works, 2 at N.W.C.S., 41 at R.A., 11 at S.B.A.

JOSEPH, George Francis
(1764–1846)
Studied at R.A.; A.R.A. 1813. Historical subjects in the style of R. Westall. Exhibited 160 works, 146 at R.A., 14 at B.I., 1788–1846.

JOWETT, Percy Hague
(1882–1955)
Principal Royal College of Art; assoc. R.W.S. 1936, member 1938, hon. treasurer 1948. Landscapes, interiors, etc.

JOY, John Cantiloe (1806–66)
and William (1803–67)
'The brothers Joy'. Born Great Yarmouth; usually worked together; to Portsmouth 1832, and employed by the Government to draw types of craft used by fishermen; afterwards in London, Chichester, Putney, and back to London. Marines. Exhibited 13 works, 2 at R.A., 2 at B.I., 9 at S.B.A., 1823–45. (*V. & A., B.M., Norwich, Yarmouth*)

JOY, Thomas Musgrove
(fl. 1831–67)
Of Maidstone. Historical subjects. Exhibited 200 works, 67 at R.A., 82 at B.I., 50 at S.B.A., 1 at N.W.C.S.

JOYCE, Mary (fl. 1880–93)
Of Norwood. Domestic subjects. Exhibited 17 works, 9 at N.W.C.S., 3 at R.A., 5 at S.B.A.

JUKES, Francis (1746–1812)
Born Martley, Worcs. Engraved Walmsley's 'Views of Ireland' and Nicholson's 'Views of England'. Landscapes. (*Nottingham*)

JUNE, John (fl. 1760–80)
Engraved after Hogarth; painted and engraved race-horses, some after Sartorius.

JUSTYNE, P. William
(fl. 1837–38)
Landscapes. Exhibited 3 works, 1 at R.A., 2 at S.B.A. (*Nottingham*)

JUTSUM, Henry (1816–69)
Born London; pupil of James Stark 1839; assoc. N.W.C.S. 1843, resigned 1848 when he turned to oils. Landscapes in the style of Bonington. Exhibited 203 works, 34 at N.W.C.S., 68 at R.A., 75 at B.I., 19 at S.B.A. (*V. & A., Newport, Maidstone*)

KAUFFMAN, Maria Anna Angelica Catharina (1741–1807)
Born Coire (or Chur), Switzerland, the daughter of a portrait-painter; to Italy with her father 1752; accompanied the wife of the English Ambassador to England 1766; founder member R.A. 1768; in 1782 married Venetian painter Antonio Zucchi and returned to Italy; moved to Rome 1782. Portraits and classical subjects. Exhibited 82 works, 5 at Free Soc., 77 at R.A. 1765–97. (*V. & A.*)

A Composition from Nature

Samuel Hieronymus Grimm
(1733–94)
12¾" x 20¼"

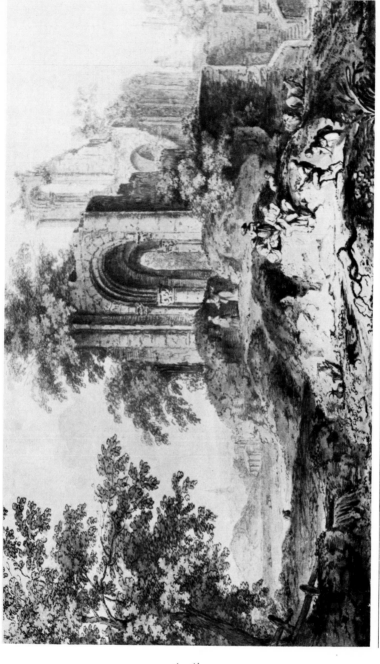

It is not so long ago that this
fine, early drawing was
unattributed at the London
auction, where it was
purchased. But in fact it is
illustrated in Rotha M. Clay's
book on the artist, and
appeared on exhibition in 1939.
Although Grimm is a com-
paratively minor artist, his work
very nearly approaches that of
Paul Sandby in its clean and
precise outlines, effective use
of light and shade, and
grouping of figures, which are
always alive and aptly placed.
Gilbert White, author of 'The
Natural History of Selborne',
for which Grimm did the
title-page vignette, had a poor
opinion of the artist's trees.
But those in this drawing are
very well represented, drawn
and shaded in Indian ink, and
lightly tinted in the usual
manner of the late eighteenth-
century topographers.

At Bailey's Hill, Kent

Robert Hills
(1769–1844)
Signed, and dated
11¼" x 16"

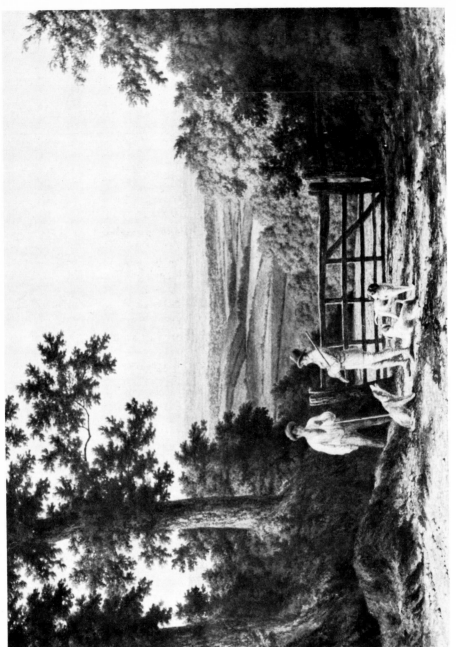

Hills is probably the best known
of all early nineteenth-century
animal painters in watercolour,
and his subjects are invariably
placed in fine landscapes.
He is also known to have
drawn the animals in land-
scapes by G. F. Robson,
G. Barrett Jr. and others. He
worked in two styles. At first
he preferred subdued, almost
silvery tones, making much use
of fine stippling on the animals'
coats. Later, and somewhat less
effectively, he worked in hot,
reddish colours, paying
less attention to detail. This
particular drawing is in the
earlier style, and is among
many featuring the same
locality. It was probably shown
at the Old Watercolour
Society's 1818 Exhibition
under the title of 'Road Scene
nearby Bailey's Hill, Kent'.

KAY, A. (fl. c. 1814)
Probably Scottish. Some drawings
of Edinburgh aquatinted c. 1814.
(*V. & A.*)

KAY, John (1742–1830)
Born near Dalkeith, Edinburgh;
apprenticed to a barber. Miniatures.

KEAN, Michael (d. 1823)
Born Dublin; studied at Dublin
Society's Schools 1771; became a
partner in Derby China Works;
died London. Miniatures, and
portraits in crayon. Exhibited 26
works, 4 at Free Soc., 22 at R.A.
1765–90.

KEARNAN, Thomas (fl. 1821–50)
Employed by A. C. Pugin, e.g. on
the illustrations of his 'Paris'
1828; member N.W.C.S. 1837.
Landscapes. Exhibited 28 works,
25 at N.W.C.S., 2 at R.A., 1 at S.B.A.

KEARNEY, William Henry
(1800?–58)
Founder member N.W.C.S. 1833
and subsequently vice-president.
Portraits, landscapes and genre.
Exhibited 187 works, 170 at
N.W.C.S., 9 at R.A., 6 at S.B.A.
(*V. & A., B.M., Dublin*)

KEARSLEY, Harriet (fl. 1824–81)
Member S.B.A.; Society of Arts
silver medallist 1827. Copies of
Old Masters. Exhibited 90 works,
44 at R.A., 20 at B.I., 25 at S.B.A.,
1 at N.W.C.S. (*V. & A.*)

KEATE, George (1729–97)
Born Trowbridge; intended for the
Bar but became an artist; friend of
Voltaire; published illustrated
travel books depicting scenes
abroad and in Britain; member
Incorp. S.A. Landscapes. Exhibited
36 works, 6 at Soc. of Artists, 30
at R.A. 1766–89. (*V. & A.*)

KEATING, George (b. 1762)
Born Ireland; fl. 1775–99; a
mezzotint and stipple engraver,
working in London. Exhibited 3
works at Free Society.

KEELEY, John (fl. 1883–92)
Of Birmingham; member R.B.A.;
a follower of D. Cox. Landscapes.
Exhibited 10 works, 8 at N.W.C.S.,
2 at S.B.A.

KEELING, William Knight
(1807–86)
Born Manchester; apprenticed to a
wood-engraver; early to London to
assist W. Bradley, portrait-painter;
returned Manchester c. 1835;
president Manchester Academy
of Fine Arts 1864–78; member
N.W.C.S. 1841. Exhibited 62 works,
60 at N.W.C.S., 1 at R.A., 1 at B.I.
(*V. & A.*)

KEENAN, J. (fl. 1791–1815)
Lived at Bath, Exeter, London and
Windsor; portrait-painter to
Queen Charlotte 1809. Portraits
and miniatures. Exhibited 67
works, 66 at R.A., 1 at B.I.

KEENE, Charles Samuel (1823–91)
Born Hornsey, Middx; trained as
a wood-engraver; drew for *Punch*.

KEENE, W. C. (fl. 1877–91)
Landscapes. Exhibited 23 works,
2 at N.W.C.S., 6 at R.A., 11 at S.B.A.

KELLY, Richard Barrett Talbot
(b. 1896)
Member R.I. 1925–40. Landscapes.

KELLY, Robert George
(1861–1934)
Of Birkenhead; member R.I. 1907.
Landscapes. Exhibited 21 works,
5 at N.W.C.S., 2 at R.A., 12 at S.B.A.

KEMP, G. M. (fl. 1850–60)

Architectural views in Edinburgh, some engraved in Fullarton's 'Scotland'.

KEMP, John (fl. 1868–76)
Probably a student at York School of Art; master Gloucester School of Art. Landscapes. Exhibited 11 works, 4 at s.b.a. (*V. & A.*)

KEMP-WELCH, Miss Lucy (b. 1869)
Member R.I. 1907. R.B.C., R.B.A., R.C.A. Flowers, landscapes, etc.

KENDRICK, Emma Eleonora (1788?–1871)
Daughter of a sculptor; wrote on, and painted miniatures. Exhibited 192 works, 18 at o.w.c.s., 10 at N.W.C.S., 89 at R.A., 1 at B.I., 74 at S.B.A.

KENNEDY, Mrs C. N. (née Lucy Marwood) (fl. 1886–93)
Domestic subjects. Exhibited 9 works, 3 at N.W.C.S.

KENNEDY, Edward Sherard (fl. 1863–90)
Historical subjects. Exhibited 49 works, 4 at N.W.C.S., 18 at R.A., 9 at S.B.A.

KENNEDY, Mrs E. S. (née Florence Laing) (fl. 1880–93)
Domestic subjects. Exhibited 10 works, 4 at R.A., 1 at S.B.A., 1 at Grosvenor gallery.

KENNEDY, John (fl. c. 1865)
Master of Dundee School of Art. (*V. & A.*)

KENNEDY, R. (fl. c. 1830)
Probably the Kennedy whose work is represented by an 'Exterior of London Bridge Theatre' in V. & A.

KENNEDY, William Denholm (1813–65)
Born Dumfries; friend of William Etty. Figure subjects. Exhibited 90 works, 52 at R.A., 22 at B.I., 16 at S.B.A., 1833–65.

KENNINGTON, Thomas Benjamin (fl. 1880–93)
Domestic subjects. Exhibited 87 works, 3 at N.W.C.S.

KENNION, Charles James (fl. 1804–53)
Son of Edward. Landscapes. Exhibited 38 works, 26 at R.A., 5 at S.B.A.

KENNION, Edward (1744–1809)
Father of C. J.; a drawing master in London 1789; F.S.A.; published 'The Elements of Landscape'. Landscapes, especially tree studies. Exhibited 32 works, 24 at Soc. of Artists, 8 at R.A. 1790–1807.

KENT, William (1684–1748)
Served with Lord Burlington in an artistic capacity. Italianate designs for furniture, gardens and houses, and illustrations. (*V. & A.*, *B.M.*)

KENWELL, Anna Maria
See Charretie, Mrs John.

KERR, George C. (fl. 1873–93)
Marines. Exhibited 58 works, 19 at N.W.C.S., 11 at R.A., 20 at S.B.A.

KERRY, William Lewis (1818–93)
Born Sefton, Liverpool; head-master Liverpool School of Art; and member Liverpool Academy. Exhibited 18 works, 4 at R.A., 1 at S.B.A., 2 at Grosvenor gallery 1865–81. (*Walker*)

KETTLE, Sir Rupert A. (1817–94)
Of Wolverhampton; an amateur, who became a Middle Temple

barrister 1845; judge of
Worcestershire County Courts
1859–92; knighted 1880. Land-
scapes and scriptural subjects.
Exhibited 2 works, 1 at B.I., 1 at
N.W.C.S., 1864–84. (*V. & A.*)

KIDD, John Bartholomew
(fl. 1833–58)
Of Edinburgh; pupil of Rev. J.
Thomson; a drawing master at
Greenwich; member Royal
Scottish Academy. Exhibited 1
work 1833 at B.I.

KILBURNE, George Goodwin
(1839–1924)
Member R.I. Accurately drawn
interiors with figures. Exhibited
220 works, 163 at N.W.C.S., 20 at
R.A., 5 at S.B.A.

KILBURNE, George Goodwin
(fl. 1871–93)
Member R.B.A. Sporting subjects.
Exhibited 66 works, 19 at R.A., 32
at S.B.A.

KILBURNE, Miss S. E.
(fl. c. 1871)
Worked in London. Domestic
subjects. Exhibited at S.B.A.

KILLMISTER, C. Gordon
(fl. 1880's)
Lived in London. Drawings of
buildings. Exhibited at N.W.C.S.
1889.

KINDERSLEY, Fanny K.
(fl. 1883–85)
Domestic subjects. Exhibited 3
works at N.W.C.S.

KINDON, Miss M. E. (fl. 1874–93)
Of Croydon. Domestic subjects.
Exhibited 44 works, 9 at N.W.C.S.,
8 at R.A., 21 at S.B.A.

KING, Agnes Gardner (fl. 1882–92)

Miniatures. Exhibited 27 works,
15 at N.W.C.S., 2 at R.A., 9 at S.B.A.

KING, Anne
See Waldegrove, Anne, Countess
of.

KING, Cecil George Charles
(1887–1942)
Member R.I. 1924; member R.O.I.
Landscapes.

KING, Daniel (fl. c. 1656)
An amateur; pupil of W. Hollar.
Landscapes, and views of buildings
for Dugdale's 'Monasticon' and for
his own folio of 'Cathedrals'.

KING, Elizabeth Thompson
(fl. 1880–91)
Domestic subjects. Exhibited 13
works, 2 at R.A., 4 at S.B.A., 2 at
N.W.C.S.

KING, Haynes (1831–1904)
Born Barbados; member S.B.A.
1864. Domestic subjects.
Exhibited 256 works, 40 at R.A.,
10 at B.I., 161 at S.B.A., 4 at
N.W.C.S.

KING, J. Arthur (fl. 1876–85)
Landscapes. Exhibited 13 works,
2 at R.A., 3 at S.B.A., 1 at N.W.C.S.

KING, John Baragwanath
(1864–1939)
Born Penzance; patronised by
Edward VII and Queen Alexandra.
Landscapes. (*Newport*)

KING, Lydia B. (fl. 1886–90)
Domestic subjects. Exhibited 8
works, 2 at R.A., 3 at S.B.A., 2 at
N.W.C.S.

KING, W. Gunning (fl. 1878–93)
Worked in London. Figure
subjects. Exhibited 30 works.

A Dictionary of Watercolour Painters

KING, Henry John Yeend
(1855–1924)
Member R.B.A.; member R.I. 1887,
vice-president 1901. Domestic
subjects. Exhibited 227 works,
38 at N.W.C.S., 12 at R.A., 4 at
S.B.A., 6 at Grosvenor gallery.

KINGDON, Walter (fl. 1879–87)
Worked in London. Figure sub-
jects. Exhibited 2 works, 1 at R.A.

KINGSLEY, Lydia (fl. 1890–93)
Still-life. Exhibited 5 works, 3 at
N.W.C.S., 1 at R.A., 1 at S.B.A.

KINSLEY, Albert (fl. 1881–93)
(b. 1852)
Member R.I. 1896; assoc. R.C.A.,
member R.B.A. Landscapes.
Exhibited 85 works, 13 at N.W.C.S.,
15 at R.A., 45 at S.B.A.

KIRBY, John Joshua (1716–74)
Born Parham, Suffolk; worked at
Ipswich as a coach- and house-
painter before moving to London;
a friend of Gainsborough; taught
drawing to the Prince of Wales;
clerk of works at Kew Palace;
president Incorp. S.A. 1770. Old
style topography of views of Kew,
Richmond, St Albans and
Glastonbury. Exhibited 12 works
at S.A.

KITCHEN, Thomas (fl. 1750?–80)
Mostly worked in oils, but also
some drawings of rocks, ruins and
parkland engraved by Sparrow.

KITCHINGHAM
(or KITCHINMAN or
KITCHINGMAN), John
(1741?–81)
Studied at Shipley's School and at
R.A.; a student of boat construction.
Marines and shipping. Exhibited
40 works, 9 at Free Soc., 31 at R.A.
1766–81.

KNAGGS, Nancy (fl. 1887–93)
Marines. Exhibited 15 works, 3 at
N.W.C.S., 1 at R.A., 11 at S.B.A.

KNAPPING, M. Helen (fl. 1876–90)
Of Blackheath. Flowers. Exhibited
23 works, 3 at N.W.C.S.

KNIGHT, Clara (fl. 1880–89)
Landscapes. Exhibited 18 works,
2 at N.W.C.S., 2 at R.A., 7 at S.B.A.

KNIGHT, John Baverstock
(1785–1859)
A land surveyor; toured the
British Isles and the Continent.
Landscapes reminiscent of F.
Towne and John White Abbott.
(*V. & A., B.M., Liverpool,
Whitworth*)

KNIGHT, John Prescott (1803–81)
Born Stafford; studied under R.
Sass and G. Clint, and at R.A. from
1823; A.R.A. 1836, R.A. 1844;
professor of perspective R.A. 1839,
secretary, R.A. 1840. Portraits
and genre. Exhibited 276 works,
227 at R.A., 22 at B.I., 26 at S.B.A.,
1 at N.W.C.S. 1824–78.

KNIGHT, John William Buxton
(1842–1908)
Born Sevenoaks; worked at Knole
Park with James Holland; studied
at R.A. 1859 on advice of Sir E. H.
Landseer; gold medal in Paris
1889; member S.B.A. Landscapes.
Exhibited 173 works, 71 at S.B.A.,
1 at N.W.C.S., 46 at R.A.

KNIGHT, Joseph (1838–1909)
Born Manchester, the son of a
painter and engraver; lost his left
arm as a boy; studied at the
Manchester Academy of Fine Arts,
and became member 1868; to
London 1871; settled in North
Wales 1875; member R.I. 1882.
Member R.C.A.; assoc. member

Royal Society of Painter-Etchers
and Engravers. Landscapes.
Exhibited 241 works, 60 at
N.W.C.S., 61 at R.A., 1 at S.B.A.
(*Walker*)

KNIGHT, Dame Laura
(1877–1970)
Assoc. R.W.S. 1919, member 1928.
Studied Nottingham. A.R.A. 1927;
R.A. 1936; D.B.E. 1929. Circus,
ballet, landscapes and portraits.

KNIGHT, Mary Anne (1776–1851)
Pupil of A. Plimer. Miniatures.
Exhibited 32 works, 2 at O.W.C.S.,
30 at R.A. 1803–31.

KNIGHT, William (fl. 1829–46)
Of Chelmsford. Landscapes.
Exhibited 19 works, 4 at N.W.C.S.,
15 at S.B.A.

KNOWLES, Davidson (fl. 1879–93)
Member R.B.A. Landscapes.
Exhibited 65 works, 10 at R.A.,
33 at S.B.A.

KNOWLES, George Sheridan
(1863–1931)
Member R.I. 1892 and R.O.I.,
assoc. R.C.A. Domestic subjects.
Exhibited 51 works, 12 at O.W.C.S.,
9 at R.A., 27 at S.B.A.

KNYFF, Leonard (1650–1721)
Born Amsterdam; to England
1712. Made drawings of mansions
and parks for 'Britannia Illustrata'
engraved by John Kip.

KOTEY, R. J.
Mid-19th century. Landscapes.
(*Walker*)

LA (or LE) CAVE, Peter
(fl. 1799–1806)

Very little known, but probably of
French descent; a drawing master.
Landscapes with figures and cattle,
in stained drawing technique,
using a great deal of blue and
bluish-green. Exhibited 2 works at
R.A. 1801. (*V. & A., B.M.,
Sheffield, Newcastle*)

LACON (fl. c. 1757)
Worked in Bath. Portraits.

LADBROOKE, John Bernay
(1803–79)
Son of Robert; pupil of his uncle,
J. Crome. Exhibited 48 works, 35
at S.B.A., 3 at R.A., 10 at B.I.
1821–72.

LADBROOKE, Robert
(1770–1842)
Father of John Bernay; co-founder
with J. Crome (his brother-in-law)
of the Norwich Society 1803.
Landscapes, mostly in oils, and a
copyist. Exhibited 13 works, 5 at
R.A., 8 at B.I. 1811–22. (*B.M.*)

LADD, Anne (1746–70)
Born London. Still-life, fruit and
portraits. Exhibited 2 works at
Soc. of Artists. 1769.

LADELL, Edward (fl. 1856–86)
Of Colchester. Fruit and still-life.
Exhibited 31 works, 21 at R.A.,
5 at B.I., 2 at S.B.A.

LAING, Florence
See Kennedy, Mrs E. S.

LAING, James G. (fl. 1833–92)
Of Glasgow; member R.S.W.
Landscapes. Exhibited 22 works,
3 at N.W.C.S., 16 at R.A., 1 at S.B.A.

LAMBERT, Clement (fl. 1880–92)
Of Brighton. Landscapes.
Exhibited 67 works, 10 at O.W.C.S.,
8 at R.A., 20 at S.B.A.

LAMBERT, George (1700?–65)
Born Kent; friend of Hogarth;
first president Incorp. s.a.;
possibly taught W. Taverner and
J. Skelton. Theatrical scenery and
landscapes. 15 works engraved.
(*B.M.*)

LAMBERT, James, Sr (1725–88)
Born Jevington, Sussex; an
organist at Lewes, to where he
removed early; premium at Society
of Arts 1770. Topography.
Exhibited 54 works, 17 at Soc. of
Artists, 30 at Free Soc., 7 at r.a.
1761–68. (*V. & A.*)

LAMBERT, James Jr (1742–99)
Son of James Sr, and work almost
identical; a heraldic painter.
Landscape, fruit, flowers and
genre. Exhibited 23 works, mostly
flowers, 18 at Free Soc., 5 at r.a.
1769–78.

LAMBORNE, Peter Spendelove
(or Spendlove) (1722–74)
Born London; best known as an
engraver and etcher; member
Incorp. s.a. 1766. Miniatures and
architectural subjects, mostly of
Cambridge colleges. Exhibited 19
works at Free Society 1760–74.

LAMI, Louis Eugène (1800–90)
Born Paris; studied under Gros
and Vernet, and at the École des
Beaux-Arts; worked much in
England. Battle scenes, historical
subjects, and scenes of fashionable
London life. Exhibited 1 work at
r.a. 1850. (*V. & A.*)

LAMONT, Thomas R. (d. 1898)
Lived first in Greenock, and then
in London, studied in Paris;
assoc. o.w.c.s. 1866. Genre.
Exhibited 112 works, 103 at
o.w.c.s., 4 at r.a. (*V. & A.*)

LANCASTER, Hume (d. 1850)
Fl. 1836–49; died Erith.
Marines. Exhibited 132 works,
23 at r.a., 31 at b.i., 78 at s.b.a.

LANCASTER, Percy (b. 1878)
Member r.i. 1921; a.r.e., r.b.a.,
a.r.c.a., a.r.b.c. Landscapes, etc.

LANCE, George (1802–64)
Born Little Easton, Essex; pupil of
Hayden, and studied at r.a. Fruit,
flowers and portraits. Exhibited
235 works, 14 at n.w.c.s., 38 at
r.a., 135 at b.i., 48 at s.b.a.
1824–64.

LANCON, August (d. 1885)
Of French birth, but worked in
London. London views.

LANDELLS, Ebenezer (1808–60)
Born Newcastle-upon-Tyne;
father of R. T.; pupil of Thomas
Bewick. Illustrated for *Punch*,
Illustrated London News, and other
magazines.

LANDELLS, Robert Thomas
(1833–77)
Son of Ebenezer; a special artist
on staff of *Illustrated London News*,
for whom he depicted the Crimean,
Danish, Austro-Prussian and
Franco-German wars. In later life
he painted these battle scenes in
oil and watercolour.

LANDOR, A. Henry Savage
(d. 1924)
Born Florence; grandson of writer
Walter Savage Landor; studied at
Florence and Paris, but worked in
London; died in Florence.

LANDSEER, Charles (1799–1879)
Son of John, and elder brother of
Sir E. H.; lessons from Hayden
and from his r.a. father; also
studied at r.a. 1816; a.r.a. 1837,

R.A. 1845, keeper R.A. 1851–73. Historical subjects and landscapes. (*B.M.*)

LANDSEER, Sir Edwin Henry
(1802–73)
Born London; youngest son of artist and engraver John, and brother of Charles; early talent for animal painting; studied at R.A. 1816; A.R.A. 1826, R.A. 1831; knighted 1850; a great sculptor, who modelled the lions at the foot of Nelson's Column in Trafalgar Square. Animal subjects, many sketches for oils. (*V. & A., B.M.*)

LANDSEER, George (1834?–78)
Son of Thomas; spent much time in India. Landscapes (many Indian), portraits and genre. Exhibited 34 works, 21 at R.A., 12 at B.I., 1 at S.B.A., 1850–58.

LANDSEER, Jessica (fl. 1816–66)
Landscapes. Exhibited 32 works, 9 at O.W.C.S., 10 at R.A., 7 at B.I., 6 at S.B.A.

LANDSEER, Thomas (fl. 1832–77)
Son of John, and brother of Charles and Sir E. H.; best known as an engraver; A.R.A. Landscapes. Exhibited 6 works at R.A.

LANE, John Bryant (1788–1868)
Born Cornwall. Portraits. Exhibited 22 works, 16 at R.A., 3 at B.I., 3 at S.B.A. 1831 onwards.

LANE, Richard James (1800–72)
Born Hereford; his mother was a niece of Gainsborough; litho-grapher to the Queen. Exhibited 83 works, 67 at R.A., 16 at S.B.A. 1824–72.

LANE, S. (1780–1859)
Born King's Lynn; taught by

Joseph Farington and Lawrence; deaf and dumb from childhood. Portraits. Exhibited 222 works, 217 at R.A., 1 at B.I., 4 at S.B.A. 1804–57.

LANE, Theodore (1800–28)
Pupil of J. C. Barrow. Humorous genre and miniatures. Exhibited 17 works, 7 at R.A., 7 at B.I., 3 at S.B.A. 1816–28.

LANGLEY, Batty (fl. 1724–51)
Brother of Thomas; a celebrated architect, who illustrated his own technical books with architectural subjects in landscapes.

LANGLEY, Thomas (d. 1751)
Brother of Batty. Architectural and antiquarian subjects.

LANGLEY, Walter (1852–1922)
Born Birmingham; apprenticed to a lithographer; studied art under D. W. Raimbach; to Newlyn, Cornwall, 1882, Birmingham 1886, and settled in Penzance 1889; founder member Birmingham Art Circle; assoc. R.S.B.A. 1881, member 1884; member R.I. 1883. Domestic subjects. Exhibited 39 works, 30 at N.W.C.S., 1 at R.A., 4 at S.B.A. (*Birmingham*)

LAPORTE, George Henry
(1799–1873)
Member N.W.C.S. 1834. Sporting and animal subjects. Exhibited 208 works, 160 at N.W.C.S., 9 at R.A., 21 at B.I., 18 at S.B.A.

LAPORTE, John (1761–1839)
Probably French; pupil of J. M. Barralet; in Rochester 1787, and drew in the Isle of Wight 1789; visited the Continent; a drawing master, who taught Dr Monro; taught drawing at Addiscombe

Military Academy; member Associated Artists in Water Colours. Landscapes. Exhibited 289 works, 14 at N.W.C.S., 110 at R.A., 102 at B.I., 18 at S.B.A.

LAPORTE, Mary Ann (fl. 1813–45)
Member N.W.C.S. 1835. Portraits. Exhibited 22 works, 15 at N.W.C.S., 4 at R.A., 3 at S.B.A.

LAROON, Marcellus (1679–1772)
'The Younger', son of Marcellus 'the Elder' (1653–1702); of Dutch birth; an army officer. Interior conversation pieces, landscapes and battle scenes. (*B.M.*)

LAUDER, Charles James (d. 1920)
Son of a portrait-painter; studied under Heath Wilson in Glasgow; member Royal Institute of Fine Arts, Glasgow, and R.S.W. Venetian views and Thames scenes.

LAUDER, Robert Scott (1802–69)
Born Edinburgh; a founder member R.S.A. Historical subjects. Exhibited 101 works, 25 at R.A., 11 at B.I. 1827–61.

LAUDERDALE, J. (fl. c. 1817)
Scottish views, some engraved in the 'Antiquarian Repository'.

LAW, David (1831–1902)
Born Edinburgh; first taught by a landscape engraver; painted in style of Birket Foster. Landscapes. Exhibited 154 works, 45 at R.A., 83 at S.B.A., 1 at N.W.C.S.

LAWRANSON
(or LAWRENSON), Thomas (d. 1778)
Original fellow S.A.; fl. from 1760's. Landscapes and portraits mostly in oils. Exhibited 26 works, 21 at Soc. of Artists, 2 at Free Soc. 1762–77.

LAWSON, Cecil Gordon (1851–82)
Born Wellington, Salop, the son of portrait-painter William; self-taught, and at first imitated the fruit pieces of William Henry Hunt; to London 1861. Landscapes. Exhibited 55 works, 18 at R.A., 12 at S.B.A., 18 at Grosvenor gallery, 1869–82. (*V. & A., B.M., Whitworth, Birmingham*)

LAWSON, Mrs Cecil
(née Constance B. Philip)
(fl. 1880–92)
Flowers. Exhibited 56 works, 13 at N.W.C.S., 14 at R.A., 3 at S.B.A.

LEADER, Benjamin Williams (1831–1923)
Born Worcester; studied at R.A. 1853; A.R.A. 1883, R.A. 1898. Marines.

LEAKEY, James (1775–1865)
Born Exeter. Landscapes and genre. Exhibited 12 works at R.A. 1821–46.

LEAR, Edward (1812–88)
Born Holloway, of Dutch descent; famous as a humorous writer ('Book of Nonsense', 'Nonsense Rhymes' and so on); draughtsman of Zoological Society 1831; employed by the Earl of Derby 1832–36; taught drawing in Rome, and travelled much elsewhere; gave lessons to Queen Victoria 1845. Mediterranean pen and wash landscapes, often with copious pencilled notes. Exhibited 37 works, 19 at R.A., 5 at B.I., 4 at S.B.A., 3 at Grosvenor gallery 1836–79. (*V. & A., B.M., Liverpool, Harvard*)

LEATHER, Mrs R. K.
See Foster, Amy H.

LE CAPELAIN, John (1814?–48)
A Channel Islander. Landscapes,
mostly in Jersey, and marines.
Exhibited 2 works, 1 at N.W.C.S.,
1 at S.B.A. (*B.M., St Helier,
Jersey*)

LEE, Frederick Richard
(1798–1897)
Born Barnstaple; entered the army,
but retired through ill-health;
studied at R.A. 1818; worked with
T. S. Cooper; A.R.A. 1834, R.A.
1838, H.R.A. 1871. Landscapes and
still life. Exhibited 326 works, 171
at R.A., 131 at B.I., 24 at S.B.A.
1822–70.

LEE-HANKEY, William Lee
(1869–1952)
Born Chester. Member R.I. 1898,
res. Elected A.R.W.S. 1925, R.W.S.
1926, V.P., R.W.S. 1947. Member
R.E. and R.O.I. Landscapes, figures,
portraits.

LEE, James (fl. 1873–91)
Animals. Exhibited 14 works,
3 at N.W.C.S., 6 at R.A., 3 at S.B.A.

LEE, Joseph (1780–1859)
Miniature portraits and copies of
Old Masters.

LEE, Sydney (1866–1949)
Assoc. R.W.S. 1942, member 1945.,
R.A.

LEE, William (1810–65)
Assoc. N.W.C.S. 1845, member
1848; connected with the Langham
School. French and English figure
subjects and landscapes. Exhibited
100 works, 91 at N.W.C.S., 3 at
R.A., 3 at S.B.A. (*V. & A., Dublin*)

LEECH, George William
(1894–1959)
Member R.I. 1935. Landscapes,
figures.

LE FLEMING, Mildred (fl. 1884–91)
Of Ambleside. Landscapes.
Exhibited 3 works at N.W.C.S.

LEGAT, Francis (1755–1809)
Studied at Edinburgh under A.
Runciman; to London 1780;
engraver to the Prince of Wales.
Landscapes and figures. Exhibited
2 engravings at R.A. (*V. & A.*)

LEGROS, Alphonse (1837–1911)
Born Dijon; apprenticed to a
decorator; to Paris 1851 as a
scene-painter; to London at the
suggestion of Whistler; professor
of fine arts University College
1876. Figure subjects, portraits
and landscapes. Exhibited 174
works, 37 at R.A., 59 at Grosvenor
gallery, 1864–89. (*V. & A.,
Birmingham*)

LEIGH, Clara Maria (d. 1838)
Daughter of artist Jared; married
Francis Wheatley, and after his
death, Alexander Pope. Flowers,
fruit and miniatures. Exhibited 45
works, 41 at R.A., 2 at B.I., 2 at
S.B.A., 1808–38. (*V. & A.,
Nottingham*)

LEIGH, James Matthew (or
Mathews) (1808–60)
Pupil of W. Etty; established an
art school in Newman Street,
London. Scriptural subjects.
Exhibited 77 works, 25 at R.A.,
23 at B.I., 29 at S.B.A. 1825–49.

LEIGH, Jared (1724–69)
An amateur. Marines. Exhibited
23 works 1761–67 at Free Society.

LEIGHTON, Frederick, Lord
Leighton of Stretton (1830–96)
Born Scarborough; studied in
Rome under Meli, at Florence
Academy, and at Frankfurt under
Steinle; spent some time in

Brussels and Paris; to London
1859; A.R.A. 1864, R.A. 1869,
president R.A. 1878; member
O.W.C.S. 1886. Mythological
subjects. Exhibited 243 works,
152 at R.A., 21 at S.B.A., 4 at
O.W.C.S., 54 at Grosvenor gallery
1855–93. (*V. & A.*)

LEITCH, Richard Principal
 (fl. 1844–65)
 Travelled much abroad. Coastal
 and river scenes, with shipping.
 Exhibited 15 works, 10 at R.A.,
 5 at S.B.A. (*V. & A.*)

LEITCH, William Leighton
 (1804–83)
 Born Glasgow; employed for a
 time by a sign-painter; scene-
 painter at Glasgow Theatre Royal
 1824, and thence to London;
 studied in Italy for 5 years;
 taught watercolour painting to
 Queen Victoria; friend of Clarkson
 Stanfield and David Roberts;
 member N.W.C.S. 1862 and later
 vice-president. Landscapes, mostly
 Scottish. Exhibited 220 works,
 201 at N.W.C.S., 11 at R.A., 2 at
 B.I., 2 at S.B.A. (*V. & A., B.M.,
 Edinburgh, Glasgow, Sheffield,
 Newcastle, Whitworth,
 Birmingham, Leeds*)

LELY, Sir Peter (1618–80)
 Born Soest, the Netherlands;
 settled in London 1641; portrait-
 painter to Charles I, Cromwell,
 and Charles II, who knighted him
 1679; painted most of the crowned
 heads in Europe. Mainly portraits
 in oils.

LEMAN, Robert (1799–1863)
 A leading amateur in the Norwich
 Society, and associate of T. Lound;
 influenced by J. Middleton and
 H. Bright, his earlier work by J. S.
 Cotman. (*Norwich, V. & A., B.M.*)

LE MARCHANT, John Gaspard
 (1766–1812)
 Friend of George III, and
 initiated Sandhurst Military
 Academy.

LE MOYNE DE MORGUES,
 Jacques (d. 1588)
 Born Dieppe; to Florida 1564; to
 London after the St Bartholomew's
 Day Massacre of 1572, and
 employed by Raleigh; friend of
 geographer Richard Hakluyt and
 poet Sir Philip Sidney. Flowers and
 fruit. (*V. & A.*)

LEMPRIERE, Capt. (fl. c. 1778)
 Probably of the Channel Isles.
 Coastal views engraved by
 W. H. Toms, published 1779.

LENS, Andrew Benjamin
 (fl. 1764–1879)
 Exhibited 11 miniatures, 6 at Soc.
 of Artists, 5 at Free Soc.

LENS, Bernard (1682–1740)
 Born London, of Dutch ancestry,
 the son of an engraver and drawing
 master; studied in London and
 became a leading miniaturist—to
 George I and George II among
 others—and drawing master to the
 nobility, and to Christ's Hospital.
 Miniatures, landscapes and
 architectural drawings. (*Bath,
 B.M.*)
 (*Note.* Six artists of this family are
 recorded, mostly miniaturists.)

LE PIPER, Francis (1698?–1740)
 Humorist and wanderer. Land-
 scape sketches and a few portraits.

LESLIE, Charles Robert
 (1794–1859)
 Born Clerkenwell, of American
 parentage; to America 1799,
 where educated; back to England
 1811; studied under B. P. West

and Washington Allston, and
at R.A. 1813; A.R.A. 1821, R.A.
1824; drawing master at West
Point, U.S.A., 1833; professor of
painting at R.A. 1848–52; author
of 'Lives of Constable and
Reynolds'. Numerous genre
derived from standard authors.
Exhibited 88 works, 76 at R.A.,
11 at B.I., 1 at O.W.C.S. 1813–59.

LESLIE, G. (fl. 1832–35)
Game. Exhibited 12 works, 4 at
N.W.C.S., 4 at R.A., 4 at S.B.A.

LESSORE, Jules (1845–1892)
Born Paris; son of artist E. A.
Lessore; studied under his father
and F. J. Barrias; worked
principally in England, member
Royal Institute of Painters in
Water Colours 1888. Landscapes
and genre. Exhibited 77 works,
29 at N.W.C.S., 9 at R.A., 21 at
S.B.A. (*V. & A., B.M.*)

LEWIS, Charles George
(1808–80)
Born Enfield; son and pupil of
F. C. and brother of J. F.; an
etcher and engraver.

LEWIS, Charles James (1839–92)
Member Royal Institute of
Painters in Oil Colours; member
R.I. 1882. Landscapes and genre.
Exhibited 383 works, 72 at
N.W.C.S., 49 at R.A., 26 at B.I., 43 at
S.B.A.

LEWIS, Frederick Christian
(1779–1856)
Born London; apprenticed to
Stadler, an engraver; studied at
Belgian Academy and R.A.;
aquatinted Girtin's Paris etchings,
and made stipple engravings after
chalk portraits by Lawrence.
Landscapes, some in Devon; early
work in the style of Girtin.

Exhibited 160 works, 29 at
O.W.C.S., 56 at R.A., 51 at B.I., 24 at
S.B.A. (*V. & A.*)

LEWIS, George Lennard
(1826–1913)
Member S.B.A. until 1903. Land-
scapes. Exhibited 106 works, 7 at
N.W.C.S., 32 at R.A., 7 at B.I., 26 at
S.B.A. (*V. & A., B.M.*)

LEWIS, George Robert
(1782–1871)
Brother of F. C.; studied at R.A.;
travelled with T. C. Dibdin on
the Continent, and studied under
F. O. Finch; much influenced by
J. Linnell. Landscapes, portraits
and figure subjects. Exhibited 95
works, 5 at N.W.C.S., 45 at R.A.,
18 at B.I., 20 at S.B.A. (*B.M.*)

LEWIS, John Frederick (1805–76)
Born London; son of F. C.;
painted at first in oils; lived much
in Spain and Egypt; assoc. O.W.C.S.
1827; member 1829 and president
1855–58; A.R.A. 1859, R.A. 1865,
H.R.A. 1876. Interiors of harems,
and other Eastern scenes, and
animals. Exhibited 212 works, 100
at O.W.C.S., 82 at R.A., 25 at B.I.,
5 at S.B.A. (*V. & A., B.M.,
Newport, Bedford, Whitworth,
Birmingham*)

LEWIS, William (1804–38)
Brother of F. C. An amateur.
Landscapes. Exhibited 212 works,
129 at R.A., 35 at B.I., 22 at S.B.A.,
1 at N.W.C.S. (*V. & A.*)

LEYDE, Otto Theodor (1835–97)
Of Edinburgh; assoc. R.S.A. 1870,
member 1880; member R.S.W.
Figure subjects. Exhibited 5
works, 3 at R.A. 1877–88.

LIDDELL, T. Hodgson
(1860–1925)

Born Edinburgh; studied at Royal High School, Edinburgh; travelled in China; author and illustrator. Landscapes.

LINDNER, Moffat Peter (1852–1949)
Born Birmingham; assoc. R.W.S. 1917, member 1930; member of R.O.I. and R.W.A. Landscapes. Exhibited 44 works, 3 at N.W.C.S., 11 at R.A., 12 at S.B.A.

LINDSAY, Sir Coutts, Bart. (1824–1907)
Portraits. Exhibited 67 works, 11 at N.W.C.S., 10 at R.A.

LINDSAY, Lady, of Balcarres (fl. 1876–92) (d. 1912)
Wife of Sir Coutts; member R.I. 1879. Domestic subjects. Exhibited 114 works, 51 at N.W.C.S., 53 at Grosvenor gallery.

LINDSAY, Thomas (1793?–1861)
Born London; worked first at Mile End, then at Greenwich; settled near Brecon, South Wales; member N.W.C.S. 1833. Welsh scenery. Exhibited 351 works, 347 at N.W.C.S., 4 at S.B.A. (*V. & A., B.M.*)

LINES, Henry Harris (1801–89)
Born Birmingham; member S.B.A. 1826; Society of Arts silver medallist 1824 or 1825; settled in Worcester c. 1830, where a drawing master. Landscapes. Exhibited 28 works, 18 at R.A., 2 at B.I., 8 at S.B.A. (*V. & A., Birmingham*)

LINES, Samuel (1778–1863)
Born Birmingham; father of H. H. and S. R.; designed clock faces and papier-mâché; a drawing master of repute in Birmingham from 1807; a founder Birmingham School of Art 1821. Landscapes. Exhibited 4 works, 1 at N.W.C.S., 3 at R.A. (*Birmingham*)

LINES, Samuel Restall (1804–33)
Born Birmingham; son of Samuel; an etcher and lithographer, and art teacher. Old building interiors and exteriors. Exhibited 13 works, 11 at N.W.C.S., 2 at S.B.A. (*V. & A., Birmingham*)

LINES, Vincent (1909–68)
Studied at Central School under Hartnick and later at R.C.A. Assoc. R.W.S. 1939, member 1940. V. Pres. 1966–68. Principal of Hastings Art School. Member N.E.A.C. and R.W.A. Travelled widely in France. Landscapes. Exhibited at R.A. (*V. & A., B.M., (Imp. War Mns.)*)

LINNELL, Hannah
See Palmer, Mrs Samuel.

LINNELL, John (1792–1882)
Born Bloomsbury, the son of a carver and gilder; studied under J. Varley with W. Mulready, and at R. A. 1805; friend and patron of W. Blake; brother-in-law of S. Palmer, member O.W.C.S. 1812-20. At first miniatures and portraits, and landscapes later. Exhibited 322 works, 53 at O.W.C.S., 177 at R.A., 92 at B.I., 1807–81. (*V. & A., B.M., Newport, Whitworth, Leeds*)

LINTON, Sir James Dromgale (1840–1916)
Born London; studied at Leigh's School; drew for the *Graphic*; member Royal Institute of Painters in Water Colours 1870 and president 1884; resident R.O.I. 1883; knighted 1885. Historical and figure subjects. Exhibited 167 works, 8 at R.A., 4 at S.B.A.

LINTON, James W. R.
(fl. 1890–93)
Domestic subjects. Exhibited 8
works, 6 at N.W.C.S.

LINTON, William (1791–1876)
Born Liverpool; settled in London;
a founder S.B.A. 1823; visited
Italy 1828–29, Greece and Sicily
1840. Landscapes in the Lake
District, and copies of works of
R. Wilson. Exhibited 248 works,
11 at O.W.C.S., 57 at R.A., 78 at B.I.,
101 at S.B.A., 1 at N.W.C.S.
(*V. & A.*)

LIOTARD, Jean Étienne (1702–89)
Born Geneva; the son of a
jeweller; to Paris 1723 and studied
under J. B. Massé and
F. Lemoyne; much travelled, and
twice worked in England.
Miniatures and crayon portraits.
Exhibited 7 works at R.A.
1773–74. (*V. & A.*)

LISTER, Harriet
(Mrs Amos Green)
(fl. 1780–1810)
Married Amos Green 1796.
Landscapes in the Lake District,
almost identical with those of her
husband. Exhibited 1 work at R.A.
1784.

LITTLE, Robert (1854–1944)
Of Edinburgh; member R.S.W.,
assoc. O.W.C.S. 1892, member
1899. Domestic subjects.
Exhibited 46 works, 22 at O.W.C.S.,
8 at N.W.C.S., 9 at R.A.

LITTLEJOHNS, John (b. 1874)
Member R.I. 1931, R.B.A., A.R.B.C.,
F.R.S.A. Landscapes.

LIVERSEEGE, Henry (1803–32)
Born Manchester; to London
1827. Illustrations in the form of
imaginary portraits of Scott and
Shakespeare characters, and genre.
Exhibited 18 works 1828–32.
(*V. & A., B.M., Gateshead,
Whitworth*)

LIVESAY, Richard (1750?–1823)
Pupil of B. P. West; lived at
Windsor. Portraits, genre,
marines and landscapes. Exhibited
98 works at R.A., 5 at R.A., 5 at
B.I., 8 at S.B.A., 1776–1821.

LLOYD, Mrs Hugh
See Moser, Mary.

LLOYD, R. Malcolm (fl. 1879–92)
Of Catford Bridge, London.
Landscapes. Exhibited 62 works,
6 at N.W.C.S., 9 at R.A., 33 at S.B.A.

LLOYD, Thomas James
(1849–1910)
Of Walmer, Kent; assoc. O.W.C.S.
1878, member 1886. Landscapes.
Exhibited 186 works, 83 at
O.W.C.S., 38 at R.A., 21 at S.B.A.

LLOYD, W. Stuart (fl. 1875–93)
Landscapes. Exhibited 181 works,
13 at N.W.C.S., 25 at R.A., 117 at
S.B.A.

LOAT, Samuel (fl. 1810–32)
An architect, whose professional
drawings are more artistic than
technical. Exhibited 7 works, 4 at
R.A., 3 at S.B.A.

LOCH, Alice Helen (fl. 1882–88)
Landscapes. Exhibited 4 works,
3 at N.W.C.S., 1 at S.B.A.

LOCKE, William (1767–1847)
Pupil and friend of H. Fuseli;
after 1819 lived mostly in Paris
and Rome. Figure subjects.
(*V. & A., B.M., Ashmolean*)
(*Note.* J. Lock (fl. c. 1812), a
painter of coastal and river scenes,
was probably a relation.)

LOCKER, Edward Hawke
(1777–1839)
Born East Malling, Kent; an
amateur; employed Navy Pay
Office 1795; civil secretary to Sir
Edward Pelew 1804–14; to Spain
with Lord Russell 1813; secretary
of Greenwich Hospital 1819;
established the gallery of naval
pictures at Greenwich 1823; friend
of Southey and Scott. Landscapes,
some in Spain, but he did not
exhibit. (*V. & A., Bath*)

LOCKHART, William Ewart
(1846–1900)
Born Dumfriesshire; studied at the
Trustees' Academy, Edinburgh;
assoc. R.S.A. 1870, member 1878;
assoc. R.W.S. 1878; made many
visits to Spain; settled in London
1896. Portraits, genre and
landscapes. Exhibited 63 works,
39 at O.W.C.S., 19 at R.A.

LOFTHOUSE, Mrs
(née Mary Forster)
(1853–85)
Of Trowbridge; daughter of an
artist; assoc. O.W.C.S. Landscapes.
Exhibited 32 works at O.W.C.S.

LONGBOTTOM, Robert I.
(fl. 1830–45)
Dogs and horses, with some Welsh
landscapes. Exhibited 32 works,
3 at N.W.C.S., 10 at R.A., 5 at B.I.,
14 at S.B.A.

LONGCROFT, Thomas
(fl. 1786–1811)
Views of India in wash and Indian
ink, and in watercolour. (*V. & A.,
B.M.*)

LONGLEY, Stanislaus Soutten
(b. 1894)
Member R.I. 1932; member R.B.A.
Landscapes.

LORIMER, John Henry
(1856–1936)
Of Edinburgh; member R.S.W.,
assoc. R.S.A., assoc. R.W.S. 1908,
member 1932. Domestic subjects.
Exhibited 46 works, 2 at N.W.C.S.,
21 at R.A.

LOUISE, H.R.H. Princess
(fl. 1868–92)
Hon. R.S.W. Landscapes. Exhibited
31 works, 21 at O.W.C.S., 3 at R.A.

LOUND, Thomas (1803–61)
Of Norwich; pupil of J. S. Cotman;
member Norwich Society. Norfolk
landscapes and coastal scenes, and
copied works by D. Cox Sr,
J. Crome and J. Stannard.
Exhibited 28 works, 18 at R.A.,
10 at B.I., 1846–57. (*Norwich,
B.M., V. & A., Whitworth*)

LOUTHERBOURG, Philip James de
See De Loutherbourg, Philip James

LOVE, Horace Beavor (1780–1838)
Born Norwich; member Norwich
Society. Best known as a
miniaturist and portrait-painter.
Some landscapes. Exhibited 4
works, 4 at S.B.A., 1833–36.
(*V. & A., B.M.*)

LOVER, Samuel (1797–1868)
Born Dublin; a well-known writer;
member R.H.A. 1822. Miniatures.
Exhibited 58 works at R.A.
1832–62.

LOW, Charles (fl. 1870–93)
Landscapes. Exhibited 64 works,
7 at N.W.C.S., 9 at R.A., 42 at S.B.A.

LOWENSTAM
(or LOWENSTEIN?) Leopold
(fl. 1879–93)
Best known as an etcher. Land-
scapes. Exhibited 26 works, 2 at
N.W.C.S., 17 at R.A.

LOWENTHAL, Bertha
(fl. 1888–93)
Flowers. Exhibited 7 works, 2 at
N.W.C.S., 2 at R.A., 2 at S.B.A.

LOWRY, Matilda (Mrs Heming)
(fl. 1804–15)
Daughter of W. Lowry. Land-
scapes and portraits. Exhibited
4 works at R.A. (*B.M., V. & A.*)

LOWRY, Wilson (1762–1824)
Born Whitehaven, Cumberland,
father of Matilda. Mechanical and
architectural.

LUCAN, Lady (née Mary Smith)
(1740–1815)
Miniatures, and copies of
miniatures by A. A. Cooper,
J. Hoskins and others.

LUCAS, Arthur (fl. 1881–93)
Landscapes. Exhibited 30 works,
3 at N.W.C.S., 1 at R.A.

LUCAS, George (fl. 1863–93)
Landscapes. Exhibited 76 works,
12 at N.W.C.S., 25 at R.A., 29 at S.B.A.

LUCAS, John Seymour (1849–1923)
A.R.A. and member R.I. 1877.
Historical subjects. Exhibited 116
works, 14 at N.W.C.S., 64 at R.A.,
17 at S.B.A.

LUCAS, Ralph W. (1796–1874)
Lived for a long time at
Greenwich, but worked in all
parts of England and Scotland.
Landscapes and architectural
subjects. Exhibited 77 works, 2 at
N.W.C.S., 44 at R.A., 12 at B.I., 19 at
S.B.A.

LUCAS, Samuel (1805–70)
Born Hitchin, Herts.; worked much
in North Wales. Landscapes and
marines. Exhibited 15 works, 7 at
R.A., 4 at B.I., 2 at S.B.A., 1830–66.

LUCAS, William (1838–1895)
Assoc. R.I. 1864 until 1882.
Portraits and domestic subjects.
Exhibited 130 works, 100 at
N.W.C.S., 15 at R.A., 2 at B.I., 12 at
S.B.A.

LUDBY, Max (1858–1943)
Of Cookham-on-Thames; member
R.B.A. and R.I. 1891. Landscapes.
Exhibited 100 works, 21 at
N.W.C.S., 5 at R.A., 55 at S.B.A.

LUKER, G. Lewis (fl. 1876–91)
Architectural subjects. Exhibited
16 works, 8 at N.W.C.S., 2 at R.A.,
6 at S.B.A.

LUKER, William, Jr (fl. 1870–93)
Son of W. Luker (Eastern
scenes); of Faringdon, Berks.
Domestic subjects. Exhibited 32
works, 6 at N.W.C.S., 7 at R.A., 10
at S.B.A.

LUNDGREEN or LUNDGREN,
Egron Sillif (1815–75)
Born Sweden; pupil of L. Cogniet
in Paris; to London 1853;
travelled in Italy and Spain; with
Lord Clyde to India 1857, and on
his return did work for Queen
Victoria; visited Egypt 1861;
member O.W.C.S. 1865. Portraits
and landscapes. Exhibited 95
works, 93 at O.W.C.S., 2 at R.A.

LUNTLEY, James (fl. 1851–58)
Portraits. Exhibited 7 works
6 at R.A., 1 at B.I.

LYNDON, Herbert (fl. 1879–93)
Landscapes. Exhibited 46 works,
4 at N.W.C.S., 10 at R.A., 18 at S.B.A.

MAAS (or MAES), Dirk
(1656–1715)

Born Haarlem, the Netherlands; pupil of Mompers, Berchem and Huchtenburg; worked at Haarlem and the Hague, and in England in the reign of William III. Landscapes. (*V. & A., B.M.*)

MACBEAN, Lt.-Gen. Forbes (1725–1800)
Of Woolwich; inspector-general of the Portuguese Artillery 1765–69; in Canada 1769–73. Landscapes.

MACBETH, James (fl. 1872–89)
Landscapes. Exhibited 71 works, 9 at N.W.C.S., 15 at R.A., 7 at S.B.A.

MACBETH, Robert Walker (1848–1910)
Born Glasgow; assoc. O.W.C.S. 1895, member 1901. Member R.I., A.R.A. and R.A. 1903. Domestic subjects. Exhibited 223 works, 42 at O.W.C.S., 70 at R.A.

MACBETH-RAEBURN, Henry (fl. 1881–93) (b. 1859)
Of Edinburgh. Member R.S.W. Domestic subjects. Exhibited 28 works, 4 at N.W.C.S., 17 at R.A., 1 at S.B.A.

McBRIDE, Alexander (fl. 1889–91)
Of Glasgow; member R.S.W. Landscapes. Exhibited 4 works at N.W.C.S.

McCALLUM, Andrew (1821–1902)
Born Nottingham; of Highland descent; left home when 21 to study art; studied at Nottingham School of Art and Government School of Design at Somerset House; taught at Manchester School of Art 1850–52; headmaster Stourbridge Art School 1852–54; visited Italy 1854–57. Landscapes. Exhibited 72 works, 53 at R.A., 4 at B.I., 5 at S.B.A., 1 at

Grosvenor gallery, 1849–89. (*V. & A.*)

McCALLUM, John Thomas Hamilton (1843–96)
Member Institute of Painters in Oil Colours, R.S.W. and R.I. 1882. Scenes of fishermen's life. Exhibited 173 works, 28 at N.W.C.S., 21 at R.A., 13 at S.B.A.

McCLOY, Samuel (fl. 1859–91)
Master of Waterford School of Art. Fruit and landscapes. Exhibited 11 works, 1 at N.W.C.S., 1 at R.A., 9 at S.B.A.

McCORMICK, Arthur David (1860–1943)
Member R.I. 1906, F.R.G.S. Landscapes.

McCRACKEN, Katherine (fl. 1877–93)
Of Blackheath. Landscapes. Exhibited 23 works, 13 at N.W.C.S.

McCULLOCH, Horatio (1805–67)
Born Glasgow; studied under J. Knox; assoc. Scottish Academy 1834, member 1838. Scottish landscapes. Exhibited 7 works, 2 at R.A., 1 at B.I. (*Edinburgh*)

McCULLOCH, James (fl. 1872–93)
Landscapes. Exhibited 116 works, 16 at N.W.C.S., 4 at R.A., 74 at S.B.A.

MACDONALD, John B. (d. 1901)
Of Edinburgh; fl. 1866–76; assoc. R.S.A. 1862, member 1877. Landscapes and historical subjects. Exhibited 6 works at R.A.

McDOUGAL, John (fl. 1877–93)
Of Liverpool. Marines. Exhibited 37 works, 4 at N.W.C.S., 18 at R.A., 7 at S.B.A.

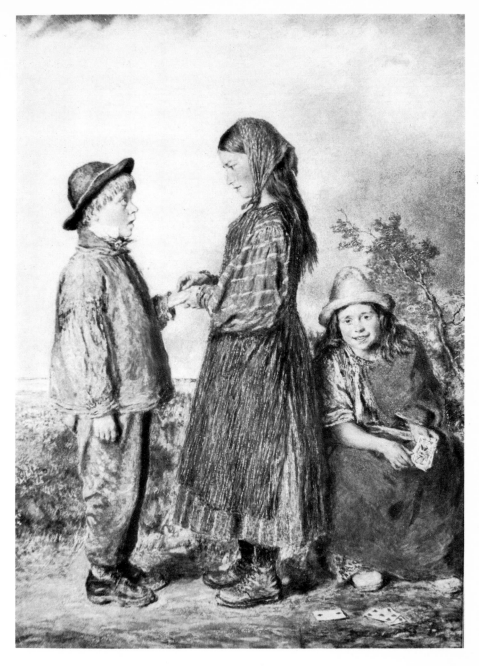

The Fortune Tellers

William Henry Hunt
(1790–1864)
Signed
29" x 20½"

Hunt is better known for his drawings of fruit and flowers, often accompanied by the bird's nest which earned him his nickname of 'Bird's Nest Hunt'. Undoubtedly that kind of work brought him a living, but drawings such as 'The Fortune Tellers' suggest that his true forte, and probably his preference lay in the characterisation of rustic children. The expressions on the three faces speak for themselves. The painting is a good example of the use of body-colour applied thick and heavy (and thus far removed from true watercolour technique). There is much use of fine stippling for faces and hands. The clothing is rendered in short, bold brush-strokes with a great deal of knife-work to give texture. Other classes of Hunt's work include chalk sketches of children and occasionally landscapes.

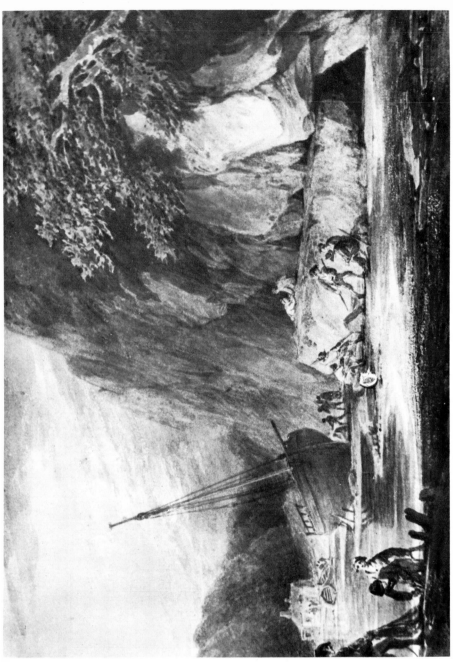

A Cornish Creek

William Payne
(fl. 1776–1830)
8¼" x 11¼"

Payne worked mostly in Devon and Cornwall, although he also painted in Wales (after about 1809) and in the Lake District (after 1811). This example shows his characteristic figure drawing, which is even more indistinct and shadowy in his lesser works. The granulated texture of the foreground is also typical. He achieved this effect by the simple trick of dragging the brush. The picture cannot unfortunately show the lavish use of his own particular 'Payne's grey' or the rare presence of a blue sky, for most of his drawings have faded to dark brown, orange and grey. Some of Payne's earlier work, however, is quite unlike what is usually accepted as being typical. It is carefully drawn and colourfully tinted in an inferior Paul Sandby style.

MACDOUGALL, Norman M.
(fl. 1874–85)
Figure subjects. Exhibited 26
works, 3 at N.W.C.S., 5 at R.A., 12
at S.B.A.

McEVOY, Ambrose (1878–1927)
Son of a friend of Whistler;
studied at the Slade; A.R.A., assoc.
R.W.S. 1926. Studies of women and
children.

McEWAN, Tom (1861–1914)
Of Scottish birth, and worked in
Glasgow; member R.S.W.
Domestic subjects. Exhibited
1 at R.A. 1887.

MACGREGOR, William York
(1855–1924)
Born Finnart, Perths.; studied in
Glasgow, and at the Slade; assoc.
R.S.A. 1897, member 1921.
Landscapes and fruit. Exhibited 2
at R.A. 1883–85.

McGUINESS, Bingham
(fl. 1882–92)
Of Dublin. Landscapes. Exhibited
11 works, 10 at N.W.C.S.

MACINTOSH, John Macintosh
(1847–1913)
Born Inverness; studied at
Heatherley's Art School, West
London School of Art, and in Paris;
member S.B.A. 1889–1904;
member Dudley Art Gallery
Society; secretary Newbury Art
Society. Berkshire landscapes.
Exhibited 87 works, 14 at N.W.C.S.,
18 at R.A., 45 at S.B.A. (*V. & A.*)

MacKELLAR, Duncan (1849–1908)
Studied at Glasgow and London.

MACKENZIE, Frederick
(1787–1854)
Pupil of engraver J. A. Repton;
early employed by John Britton; in

Bristol and Bath 1813; member
Associated Artists in Water
Colours; assoc O.W.C.S. 1813,
member 1822 and later, 1831,
treasurer until his death. Gothic
buildings. Exhibited 115 works,
92 at O.W.C.S., 1st R.A., 1st S.B.A.
(*V. & A., Bath, Newcastle,
Whitworth*)

MACKENZIE, J. Hamilton
(1875–1926)
Studied at Glasgow and Florence;
assoc. R.S.A., member R.S.W.;
president Glasgow Art Club.

McKEWAN (or McKEWEN)
David Hall (1816–73)
Born London; studied under
D. Cox Sr; assoc. N.W.C.S. 1848,
member 1850; published 'Lessons
on Trees in Water Colours' 1859.
Landscapes and interiors.
Exhibited 542 works, 498 at
N.W.C.S., 22 at R.A., 2 at B.I., 20 at
S.B.A. (*V. & A., B.M.*)

MACKIE, Charles H. (1862–1920)
Born Aldershot; studied at R.S.A.;
assoc. R.S.A. 1902, member 1917;
member R.S.W. Exhibited 3 at R.A.,
1889–93.

MACKINNON, W. (fl. 1798–1800)
A pupil of F. Towne. Landscapes.
(*B.M., V. & A.*)

McLACHLAN, Thomas Hope
(1845–97)
Of Ealing; called to the Bar,
member New English Art Club
and Institute of Painters in Oil
Colours. Landscapes with figures.
Exhibited 87 works, 34 at R.A.,
18 at Grosvenor gallery.

McLAURIN, Duncan (d. 1921)
Born Glasgow; studied at
Edinburgh School of Design.
Landscapes and cattle.

MACLEARY, Kenneth (1802–78)
Born Oban; studied at Edinburgh.
Miniatures and portraits.

MACLISE, Daniel (1806–70)
Born Cork; as a boy studied at
Cork School of Art; to London
1827; studied at R.A. 1828, and a
silver and gold medallist; A.R.A.
1835, R.A. 1840, declined the
presidency 1866; hon. member
N.W.C.S. 1867. Portraits and
historical subjects. Exhibited 124
works, 83 at R.A., 20 at B.I., 21 at
S.B.A., 1929–71. (*V. & A.*)

McMILLAN, Emmeline
(fl. 1885–91)
Of Wimbledon. Domestic subjects.
Exhibited 5 works, 3 at N.W.C.S.,
2 at R.A.

MACPHEARSON, John
(fl. 1839–84)
Marines. Exhibited 22 works, 1 at
R.A., 12 at S.B.A., 1 at N.W.C.S.

MACPHERSON, Barbara H.
(fl. 1882–85)
Of Kilburn. Landscapes.
Exhibited 8 works, 4 at N.W.C.S.

MACPHERSON, M. (fl. 1828–34)
Member N.W.C.S. Portraits.
Exhibited 3 works, 1 at N.W.C.S.,
2 at R.A.

McQUOID, Percy T. (1852–1925)
Member R.I. 1882. Domestic
subjects. Exhibited 127 works, 25
at N.W.C.S.

MacQUOID, Thomas Robert
(1820–1912)
Member R.I. 1882. Churches.
Exhibited 253 works, 66 at
N.W.C.S., 23 at R.A., 15 at S.B.A.

McTAGGART, William
(1835–1910)

Born Aros; studied at Trustees'
Academy, Edinburgh; member
R.S.A. 1870, vice-president R.S.W.
1878. Landscapes and marines.
Exhibited 11 works at R.A.,
1855–89.

MacWHIRTER, John (1839–1911)
Born near Edinburgh; studied at
Trustees' Academy Edinburgh,
and under R. S. Lauder; travelled
much abroad; settled in London
1869; published 'Landscape
Painting in Water Colours' 1901;
Member R.I. 1882–88; assoc.
R.S.A. 1867; A.R.A. 1879, hon.
R.S.A. 1882, and R.A. 1893.
Landscapes. Exhibited 121 works,
11 at N.W.C.S., 78 at R.A.
(*Edinburgh, Newport, V. & A.*)

MADDOX, Richard Willes
(fl. 1873–92)
Of Southampton. Historical
subjects. Exhibited 20 works, 3 at
N.W.C.S., 2 at R.A., 4 at S.B.A.

MAGRATH, William (fl. 1879–93)
Domestic subjects. Exhibited 21
works, 5 at N.W.C.S., 6 at R.A., 6 at
S.B.A.

MAGUIRE, Bertha (fl. 1883–93)
Flowers. Exhibited 7 works at
N.W.C.S.

MAGUIRE, Helena J. (fl. 1881–93)
Domestic subjects. Exhibited 33
works, 21 at N.W.C.S., 7 at R.A.,
4 at S.B.A.

MAHONEY, James (1810–79)
Born Cork; studied at Rome, and
settled in Cork on his return,
exhibiting in Dublin; assoc. R.H.A.
1856, resigned 1859; to London,
and assoc. N.W.C.S. 1867; drew for
Illustrated London News and other
periodicals. Genre. Exhibited 21
works, 10 at N.W.C.S., 6 at R.A.

MAISEY, Thomas (1787–1840)
Born Beckford, Glos.; drawing
teacher at Dr Mayo's Prep. School
at Cheam, and at Miss Shepheard's
School, Kensington; founder
member N.W.C.S. 1831–32 and
president 1833. Landscapes.
Exhibited 41 works, 28 at N.W.C.S.,
5 at R.A., 6 at S.B.A., 2 at O.W.C.S.
(*V. & A., B.M.*)

MAITLAND, Paul Fordyce
(1863–1909)
Born Chelsea, of Scottish descent;
studied as a boy at Royal College
of Art, and afterwards under
T. C. Roussel; influenced by
Whistler; art examiner to the
Board of Education 1893–1908.
Views in Chelsea and Kensington.
(*V. & A.*)

MALCHAIR (or MELCHAIR)
John Baptiste (1731–1812)
Born Cologne; a cathedral
chorister; to London c. 1754, and
taught drawing and music; lived
later at Lewes and Bristol; settled
in Oxford 1760; toured Wales
1795; a central figure of the
Oxford School, and taught
W. P. Amherst, Lord Aylesford,
W. H. Barnard, Sir George
Beaumont, T. Skippe and other
notables. Exhibited 1 work at
R.A. 1773. (*Oxford, V. & A.*)

MALCOLM, James Peller
(1767–1815)
Born Philadelphia; studied at R.A.;
draughtsman for topographical
books; protégé of B. West and
Wright of Derby. Antiquarian
subjects and landscapes, and some
London views. Exhibited 2 works
at R.A. 1791.

MALIPHANT, William
(fl. 1887–93)
Domestic subjects. Exhibited 11

works, 3 at N.W.C.S., 2 at R.A., 5 at
S.B.A.

MALTON, James (1760?–1803)
Born Marylebone; son of Thomas
Sr, with whom he went to Dublin
1785 to be employed by architect
James Ganden; published works on
art and architecture. Architectural
topography. Exhibited 59 works,
7 at Soc. of Artists, 2 at Free Soc.,
50 at R.A., 1761–80. (*B.M.,
V. & A., R.I.B.A., Whitworth,
National Gallery of Ireland*)

MALTON, Thomas, Sr (1726–1801)
Father of James; kept a shop in the
Strand; moved to Dublin 1785.
Architectural subjects, interiors.
Exhibited 5 works at R.A.
1772–85.
(*V. & A., Whitworth,
Birmingham*)

MALTON, Thomas, Jr (1748–1804)
Son of Thomas and brother of
John; studied at R.A. and gold
medallist 1782; scene-painter at
Covent Garden; master of
J. M. W. Turner. Street scenes
and architectural topography.
Exhibited 130 works, 2 at Free
Soc., 128 at R.A. 1768–1803.
(*V. & A., Newcastle, B.M.,
Whitworth*)

MANBY, Thomas (fl. 1670–95)
Visited Italy. Landscapes in
monochrome wash. (*B.M.*)

MANDER, W. H.
Late 19th century artist.
Landscapes in England and Wales.

MANLY, Alice Elfrida (fl. 1872–93)
Landscapes. Exhibited 44 works,
3 at N.W.C.S., 14 at R.A., 14 at S.B.A.

MANLY, Eleanor E. (fl. 1875–93)
Domestic subjects. Exhibited 29

works, 6 at N.W.C.S., 8 at R.A., 6 at S.B.A.

MANLY, Mrs Sarah (fl. 1887–92)
Flowers. Exhibited 4 works, 3 at N.W.C.S., 1 at R.A.

MANN, James Scrimgeour (1883–1946)
Member R.I. 1932. Landscapes.

MANN, Joshua Hargrave Sams (fl. 1849–84)
Member R.B.A. Domestic subjects. Exhibited 218 works, 2 at N.W.C.S., 34 at R.A., 29 at B.I., 128 at S.B.A.

MANSKIRSH (or MANSKIRCH) Franz Joseph (1770–1827)
In London c. 1793 and employed by Ackermann on illustration. Battle scenes and landscapes in the styles of Girtin and Morland. Exhibited 12 works, 10 at R.A., 2 at B.I., 1793–1819. (*Whitworth, Ashmolean*)

MANSON, George (1850–76)
Born Edinburgh; a wood engraver and painter in water-colours. Works show great delicacy and use of fine colours. Exhibited 7 works, 1 at R.A., 1873–75.

MANTELL, Gideon Algernon (1790–1852)
A geologist and surgeon. Landscapes. (*Lewes, B.M., Brighton*)

MAPLESTONE, Florence E. (fl. 1868–85)
Historical subjects in a neater Cattermole style. Exhibited 21 works, 2 at N.W.C.S., 19 at S.B.A.

MAPLESTONE, Henry (d. 1884)
Member N.W.C.S.; fl. c. 1841. Landscapes. Exhibited 362 works,

349 at N.W.C.S., 11 at S.B.A. (*National Gallery of Ireland*)

MARCHANT, Miss M. M. (née Lady Thynne)
Landscapes in the Aylesford style.

MARGETSON, William Henry (1861–1940)
Member R.I. 1909. Member R.O.I.

MARGETTS, Mrs Mary (d. 1886)
Member N.W.C.S. 1842; fl. c. 1841. Flowers. Exhibited 125 works, 124 at N.W.C.S., 1 at R.A.

MARKES, Albert Ernest (1865–1901?)
Son of R. Markes, a Newquay marine painter; colour-blind and could use only one eye. Land-scapes and marines, usually signed 'Albert'. (*V. & A., B.M.*)

MARKS, George (fl. 1876–93)
Of Penge. Landscapes. Exhibited 122 works, 16 at N.W.C.S., 45 at R.A., 29 at S.B.A.

MARKS, Henry Stacy (1829–98)
Born London, the son of a coachbuilder; painted heraldic devices on carriage panels; studied at Leigh's School, and R.A. 1851; with Calderon to Paris and entered École des Beaux-Arts; back in London 1853; A.R.A. 1871, R.A. 1878, H.R.A. 1896; member O.W.C.S. 1883. Shakespearean subjects at first, and later natural history, especially birds; some illustrative and decorative work. Exhibited 361 works, 150 at O.W.C.S., 84 at R.A., 4 at B.I., 3 at S.B.A. (*V. & A., Birmingham*)

MARLOW, William (1740–1813)
Born Southwark; studied with marine painter Samuel Scott, and

at St Martin's Lane Academy;
visited France and Italy 1765–68;
member Incorp. S.A. Marines and
topography. Exhibited 152 works,
125 at Soc. of Artists, 2 at Free
Soc., 25 at R.A., 1762–1807.
(*V. & A.*, *B.M.*, *Oxford*, *Bedford*,
Whitworth)

MARNY, Paul (1829–1914)
Born Paris; at first worked in
Belfast in an architect's office;
moved later to Birmingham; but
worked mostly at Scarborough.
Marines, coastal scenes and street
scenes, in a distinctive palette of
bluish-grey and brown. Exhibited
2 works, 1 at R.A. 1866–90.
(*Whitby*)

MARRABLE, Mrs Madeline
Frances (née Cockburn)
(d. 1916)
President Society of Women
Artists; fl. 1864–92; painted
Edward VII and members of the
Royal Family; travelled
extensively on the Continent.
Portraits and landscapes.
Exhibited 38 works, 6 at R.A., 7 at
S.B.A., 2 at N.W.C.S., 6 at Grosvenor
gallery.

MARRIS, Robert (fl. 1770–88)
Nephew-in-law of Anthony Devis,
and painted much in his style.
Landscapes. Exhibited 14 works,
10 at R.A., 4 at Free Soc. (*B.M.*,
Preston)

MARRYAT, Capt. Frederick
(1792–1848)
Saw much naval action, and best
known as a prolific writer of
adventure stories; lived in
Brussels, Canada and USA. A
skilled draughtsman and
caricaturist.

MARSH, Arthur H. (fl. 1842–1909)

Assoc. R.W.S. 1870, member R.B.A.
Landscapes. Exhibited 139 works,
108 at O.W.C.S., 16 at R.A., 3 at
S.B.A.

MARSHALL (or MARSHAL),
Alexander (fl. 1660–90)
Flowers, and copies of Van Dyck.
(*B.M.*)

MARSHALL, Benjamin
(1767–1835)
Painted horses at Newmarket and
London. Contributed to *Sporting
Magazine*. Exhibited 13 works at
R.A. 1800–19.

MARSHALL, Charles (1806–90)
Articled to Marinari, a Drury
Lane scene-painter, and himself
worked as a scene-painter at
Covent Garden and at Drury Lane;
introduced limelight to the stage.
Landscapes. Exhibited 312 works,
19 at N.W.C.S., 54 at R.A., 52 at B.I.,
149 at S.B.A. (*V. & A.*)

MARSHALL, Herbert Menzies
(1843–1913)
Born Leeds; studied architecture
in Paris and at R.A.; assoc.
O.W.C.S. 1879, member 1883,
vice-president 1898–1900;
professor of painting Queen's
College London 1904. Landscapes.
Exhibited 331 works, 277 at
O.W.C.S., 2 at R.A., 8 at S.B.A.
(*V. & A.*)

MARSHALL, J. Miller
(fl. 1886–90)
Of Norwich. Landscapes.
Exhibited 6 works, 3 at N.W.C.S.,
2 at R.A., 1 at S.B.A.

MARSHALL, Roberto Angelo
Küttermaster (fl. 1864–90)
Landscapes. Exhibited 41 works,
10 at N.W.C.S., 11 at R.A., 14 at
S.B.A.

MARSHALL, Thomas Falcon
(1818–78)
Born Liverpool; to London 1844;
assoc. Liverpool Academy 1843,
member 1846. Landscapes,
portraits, genre and historical
subjects. Exhibited 146 works,
60 at R.A., 40 at B.I., 43 at S.B.A.
1839–78. (*V. & A.*)

MARTEN, John, 'of Canterbury'
(fl. 1782–1808)
Architectural subjects. Exhibited
4 works, 2 at N.W.C.S., 2 at R.A.
(*V. & A.*)

MARTEN, John, Jr (fl. 1821–34)
Probably son of John; lived at
Canterbury and Hastings. Local
scenery. (*V. & A.*)
(*Note.* R. H. Marten, recorded as a
watercolour painter, may have
been related to John Jr.)

MARTENS, Conrad (1801–78)
Born London; taught by Copley
Fielding; emigrated to
Montevideo 1832; to Sydney
1835. Landscapes, mostly in
Australia and South America, and
fine moonlight scenes. Exhibited 7
works at R.A. 1833–37.

MARTIN, Ambrose (fl. 1830–44)
Member N.W.C.S. 1833–34.
Landscapes. Exhibited 15 works,
3 at N.W.C.S., 3 at R.A., 2 at B.I.,
7 at S.B.A.

MARTIN, David (1736–98)
Born Fife; pupil of Allan Ramsay;
chief painter to the Prince of Wales
of Scottish scenes. Landscapes
and portraits. Exhibited 75 works,
73 at R.A., 2 at S.B.A., 1765–90.

MARTIN, Elias (1739–1818)
Born Stockholm; trained as a
cabinet-maker; studied in Paris
1766; to England 1768, and A.R.A.

1770; painter to the King of
Sweden 1780; in Bath 1788–91;
died at Stockholm. Landscapes.
Exhibited 48 works, 1 at Free Soc.,
47 at R.A., 1769–90. (*V. & A.,
Whitworth*)

MARTIN, John (1789–1854)
Born near Hexham, Northumber-
land; pupil of B. Musso at
Newcastle; to London 1806; a
founder of S.B.A., and member
Belgian Academy; member R.I.
1836. Landscapes, and biblical and
historical subjects. Exhibited 212
works, 18 at N.W.C.S., 83 at R.A.,
37 at B.I., 62 at S.B.A. (*V. & A.,
B.M., Newport, Liverpool,
Newcastle, Whitworth*)

MARTINEAU, Edith (1842–1909)
Studied in Liverpool, then at
Leigh's School and R.A.; assoc.
R.W.S. 1888. Exhibited 166 works,
9 at N.W.C.S., 25 at R.A., 6 at S.B.A.,
74 at O.W.C.S. (*V. & A.*)

MARTINEAU, Gertrude
(fl. 1862–91)
Figure subjects. Exhibited 67
works, 5 at N.W.C.S., 12 at R.A.,
9 at S.B.A.

MARWOOD, Lucy
 See Kennedy, Mrs C. N.

MASON, Abraham John (b. 1794)
Born London. Engraver of
Cruikshank's illustrations to
'Tales of Humour and Gallantry'.

MASON, Frank Henry (b. 1876)
Member R.I. 1929; member R.B.A.
Seascapes.

MASON, George Hemming
(1818–72)
Born Wetley Abbey, Staffs.;
studied medicine; to the Continent
1843, and lived in Rome for
several years; back in England

1858; A.R.A. 1869. Landscapes,
animals and genre. Exhibited 37
works, 25 at R.A., 1857–72.

MASSEY, Henry G. (fl. 1884–91)
Domestic subjects. Exhibited 16
works, 10 at N.W.C.S., 4 at R.A.,
2 at S.B.A.

MASSIOT, Gamaliel
Little known. Drawing master at
Sandhurst Military Academy
1744–68.

MASSON, Andrew (1750–1825)
Born Edinburgh; assisted
J. M. W. Turner in 1824 by
making wave studies from Bell
Rock Lighthouse. Landscapes.

MATANIA, Fortimino, (b. 1881)
Holy member R.I. 1917. Historical
and allegorical subjects.
Illustrations.

MATHEWS, Charles James
(1803–78)
Articled to A. C. Pugin 1819, and
travelled with him; to Ireland
1823; then with Lord Blessington
to Italy; employed by John Nash;
comedy actor of repute, who
became manager of the Lyceum.
Landscapes. Exhibited 1 work at
R.A. 1835.

MATHEWS, Mrs F. C.
(fl. 1880–92)
Landscapes. Exhibited 6 works,
4 at N.W.C.S., 1 at S.B.A.

MATTHISON, William
(fl. 1885–93)
Of Banbury. Landscapes.
Exhibited 21 works, 4 at N.W.C.S.,
17 at S.B.A.

MAUD, W. T. (1865–1903)
Illustrator and war artist in black
and white; died Aden.

MAUNDRELL, Charles Gilder
(fl. 1884–91)
An amateur; was refused member-
ship of O.W.C.S. Genre and
landscapes. Exhibited 19 works,
8 at N.W.C.S., 5 at R.A., 3 at S.B.A.
(*Tate*)

MAURER, Jacob (fl. 1740's)
A Swiss engraver. Made many
topographical drawings of London
1741–46.

MAWLEY, George (1838–73)
Born London; studied at R.A.
Landscapes. Exhibited 106 works,
24 at R.A., 26 at S.B.A. 1858–72.

MAXWELL, Hamilton
(1830–1923)
Born Glasgow; to Australia 1852;
back in Scotland by 1881;
president Glasgow Arts Club.
Landscapes. Exhibited 4 works,
1 at R.A., 1 at S.B.A., 2 at N.W.C.S.

MAY, Arthur Powell (fl. 1875–93)
Landscapes. Exhibited 48 works,
9 at N.W.C.S., 1 at R.A., 22 at S.B.A.

MAY, Philip William, 'Phil May'
(1864–1903)
Born near Leeds; scene-painter
at Grand Theatre, Leeds; toured
with strolling players for 6 years,
and returned to Leeds 1882;
visited Australia 1885–88; on his
return became a successful black-
and-white artist; member R.I.
1897. Illustrations, especially
caricatures. (*Leeds, V. & A.,
Newport*)

MAY, Walter William (1831–96)
Assoc. N.W.C.S. 1871, member
1873. Member Institute of Painters
in Oil Colours. Marines, coastal
scenes and ships, largely in
monochrome. Exhibited 344

works, 281 at N.W.C.S., 5 at R.A., 1 at B.I., 12 at S.B.A.

MAYER, L. (fl. c. 1790)
Little known, but in the Whitworth is his 'View in Suffolk'.

MAYOR, Barnaby (fl. 1767–74)
Landscapes. Exhibited 15 works at Soc. of Artists.

MAYOR, William Frederick
'Fred Mayor' (1866–1916)
Born Winksley, Yorks.; studied at Royal College of Art, and in Paris; visited Morocco 1900. Genre. (*V. & A.*)

MEADOWS, James Edwin
(fl. 1828–81)
Worked in London. Landscapes. Exhibited 140 works, 26 at R.A., 17 at B.I., 55 at S.B.A.

MEADOWS, Joseph Kenny
(1790–1874)
Born Cardiganshire; became known as a wood-engraver of illustrations in *Punch* and other periodicals; illustrated Shakespeare 1843, New Testament 1847 and 'Don Quixote' 1872. Portraits and figure subjects. Exhibited 5 works, 1 at R.A., 4 at S.B.A. 1830–38. (*V. & A.*)

MEDLAND, John (fl. 1875–92)
Churches. Exhibited 9 works, 3 at N.W.C.S., 2 at R.A., 1 at S.B.A.

MEDLAND, Thomas
(fl. 1777–1833)
Drawing master at Haileybury School. Architectural subjects and landscapes, many in Hertfordshire, some in the style of Rooker. Exhibited 35 works, 30 at R.A., 5 at B.I.

MEDLYCOTT, Hubert J.
(fl. 1878–93)
Of Somerset. River scenes. Exhibited 53 works, 15 at N.W.C.S., 24 at S.B.A.

MEE, Mrs (née Anne Foldstone)
(1775?–1851)
Daughter of a portrait-painter; patronised by the Prince of Wales. Miniatures. Exhibited 42 works, 39 at R.A., 3 at B.I. 1804–37.

MEEN, Mrs Margaret
(fl. 1775–1810)
Flowers. Exhibited 9 works, 6 at R.A. (*V. & A.*)

MELVILLE, Arthur (1855–1904)
Born Loanhead-of-Guthrie, near Edinburgh; studied at Edinburgh School of Art, and from 1877 in Paris and Graz, Austria; visited Egypt, India and Persia 1881–82; in Scotland for some time, then to London; at Witley, Surrey 1897; assoc. R.S.A. 1886, assoc. R.W.S. 1888, member 1900. Genre and figure subjects. Exhibited 51 works, 19 at O.W.C.S., 13 at R.A., 8 at N.W.C.S. (*V. & A.*)

MENPES, Mortimer L.
(1860–1938)
Member R.B.A.; member R.I. 1897, F.R.G.S. Domestic subjects. Exhibited 91 works, 6 at N.W.C.S., 30 at R.A., 30 at S.B.A.

MENZIES, Mrs John (fl. 1880–85)
Of Hull. Landscapes. Exhibited 6 works, 3 at N.W.C.S., 3 at R.A.

MERCER, Frederick (fl. 1872–93)
Of Birmingham. Landscapes. Exhibited 14 works, 4 at N.W.C.S., 6 at S.B.A.

MERCIER, Philip, Jr (d. 1793)
Son of Philip Mercier, portrait and

conversation-piece painter
(1689–1760); fl. c. 1779.
Landscapes.

MERRITT, Thomas Light
(d. 1870)
Born Chatham; drawing master at
Maidstone; fl. c. 1847. Figure
subjects and flowers. Exhibited 1
work at R.A. 1847.

METZ, Conrad Martin
(1755–1827)
Taught F. Nicholson. Pastoral
mythological subjects and
portraits. Exhibited 35 works, 2 at
Soc. of Artists, 3 at Free Soc., 30 at
R.A. 1774–94.

MEVES, Augustus (d. 1818)
Miniatures.

MEYER, Beatrice (fl. 1873–93)
Historical subjects. Exhibited 71
works, 4 at N.W.C.S., 48 at S.B.A.,
1 at R.A.

MEYER, Hendrik (1737–1804?)
A Dutchman who settled in
London 1788. Landscapes.
Exhibited 13 works at R.A.,
1790–1804. (*Newcastle*)

MEYER, Jeremiah (1735–89)
Born Tübingen, Germany, the son
of an artist; studied at Shipley's
Academy in St Martin's Lane, and
under C. F. Zincke; founder
member and keeper R.A.; director
Incorp. S.A. Miniatures. Exhibited
31 works, 13 at Soc. of Artists, 18
at R.A., 1760–83.

MEYERHEIM, Robert Gustav
(1847–1920)
Born Danzig; studied at
Düsseldorf Academy; to England
c. 1887, and settled at Horsham.
Member R.I. 1898. Landscapes and
figure subjects. Exhibited 62

works, 2 at N.W.C.S., 30 at R.A., 14
at S.B.A. (*Birmingham*)

MEYRICK, Myra (fl. 1889–91)
Of Aylsham, Norfolk. Views in
Algiers. Exhibited 4 works, 3 at
N.W.C.S., 1 at R.A.

MIDDIMAN, Samuel (1750–1831)
Best known as an engraver, but
although a prolific typographer,
his works are unaccountably
scarce. Landscapes. Exhibited 21
works, 6 at Soc. of Artists, 1 at
Free Soc., 11 at R.A., 3 at B.I.
1772–1824. (*Nottingham*)

MIDDLETON, J. J. (fl. c. 1812)
Architectural drawings, published
in his 'Grecian Remains in Italy'.

MIDDLETON, John (1827–56)
Born Norwich; pupil of
R. Ladbrooke, J. Stannard and
H. Bright of the Norwich School.
Landscapes in the style of W.
Callow. Exhibited 29 works, 14 at
R.A., 15 at B.I., 1847–55. (*Norwich,
B.M., Whitworth*)

MILES, Edward (fl. 1775–97)
Of Yarmouth; miniature-painter
to Queen Charlotte and the
Duchess of York. Miniatures.
Exhibited 53 works at R.A.

MILLAIS, Sir John Everett, Bart.
(1829–96)
Born Southampton; spent his
early childhood in Jersey and
Brittany; studied at Sass's School,
and at R.A. at the age of 11; A.R.A.
1853, R.A. 1863, president R.A.
1896; hon. R.I. 1867; helped to
found the Pre-Raphaelite
Brotherhood. Landscapes and
figure subjects. Exhibited 227
works, 1 at N.W.C.S., 180 at R.A.,
2 at B.I., 34 at Grosvenor gallery.

(*V. & A., Whitworth, Birmingham*)

MILLAIS, William Henry
(fl. 1853–92)
Landscapes. Exhibited 19 works,
10 at N.W.C.S., 7 at R.A.

MILLARD, Charles S. (fl. 1866–89)
Landscapes, mostly in North
Wales. Exhibited 7 works, 3 at
N.W.C.S., 2 at S.B.A.

MILLER, James (fl. 1773–1814)
One of three brothers, the others
being John and John Frederick,
who are easily confused. Views of
London, Richmond and Chatham
in the P. Sandby style. Exhibited
52 works, 41 at Soc. of Artists, 11
at R.A., 1773–82. (*V. & A., B.M.*)
(*Note.* There are at least 24
painters named Miller, of whom 12
have the initial J. It is difficult to
differentiate between them.)

MILLINGTON, James Heath
(d. 1873)
Born Cork; studied at R.A. 1826,
fl. 1831–70. Miniatures.
Exhibited 57 works, 27 at R.A.,
8 at B.I., 22 at S.B.A.

MILLS, S. F. (fl. 1858–82)
Master at the Metropolitan
School of Art, Spitalfields.
Landscapes and domestic scenes.
Exhibited 47 works, 10 at R.A.,
13 at S.B.A. (*V. & A.*)

MITCHELL, Philip (1814–96)
Born Devonport; worked at
Falmouth and Plymouth; visited
Norway; assoc. member N.W.C.S.
1854, member 1879; member R.I.
West Country landscapes and
marines. Exhibited 338 works at
N.W.C.S.

MITCHELL, Thomas (fl. 1735–90)

A naval officer. Landscapes and
marines. Exhibited 36 works, 20
at Free Soc. 16 at R.A., 1763–89.
(*B.M.*)

MITFORD, Bernard (1777–1842)
Born Osbaldeston, near Preston.
Caricatures.

MOGFORD, John (1821–85)
Born London, the son of a painter;
studied at Government School of
Design at Somerset House, and at
R.A.; married the daughter of
F. Danby 1843; member R.I. 1867.
Marines and rocky coastal scenes.
Exhibited 392 works, 292 at
N.W.C.S., 33 at R.A., 28 at B.I., 20 at
S.B.A. (*V. & A., Wolverhampton*)

MOGFORD, Thomas (1809–68)
Born Exeter; possibly brother of
John; pupil of J. Gendall at Exeter.
Devonshire scenery. Exhibited 79
works, 43 at R.A., 11 at B.I., 23 at
S.B.A., 1838–66. (*B.M.,
Nottingham*)

MOIRA, Gerald Edward
(1867–1959)
Born London. A.R.W.S. 1917;
R.W.S. 1932, vice-president 1953.
Principal Edinburgh College of
Art. A.R.W.A., hon. A.R.I.B.A.,
president R.O.I. Murals.
Landscapes with figures.

MOLE, John Henry (1814–86)
Born Alnwick, Northumberland;
self-taught; member R.I. 1848,
vice-president 1884. Figure
subjects, landscapes and
miniatures. Exhibited 712 works,
679 at N.W.C.S., 11 at R.A., 1 at B.I.,
5 at S.B.A. (*V. & A., Newcastle,
Newport, Gateshead*)

MONAMY, Peter (1670–1749)
Born Jersey; apprenticed to a

London house-painter. Marines and ships. (*V. & A., B.M.*)

MONRO, Alexander
Son of Dr T. (*B.M.*)

MONRO, Henry (1791–1814)
Son of Dr T.; studied at R.A. 1806. Historical subjects and landscapes. Exhibited 17 works, 15 at R.A., 2 at B.I. 1811–14. (*V. & A., B.M.*)

MONRO, John (1801–80)
Son of Dr T. Views of cottages. (*V. & A.*)

MONRO, Dr Thomas (1759–1833)
Born London; specialised in lunacy; an amateur artist; probably had lessons from J. Laporte; patron of many young artists who later became famous, including P. de Wint, J. M. W. Turner, T. Girtin, J. Varley, J. Cristall, William Henry Hunt, and J. Linnell; was himself befriended by J. R. Cozens, H. Edridge and T. Hearne. Landscapes, mostly in Indian ink and charcoal. (*V. & A., B.M., Leeds, Sheffield, Newport*)

MONTAGUE, Alfred (fl. 1832–83)
Travelled in Holland, Belgium and France. Landscapes, and views of old continental cottages, in the early style of D. Cox. Exhibited 323 works, 23 at R.A., 51 at B.I., 156 at S.B.A. 1832–83.

MONTALBA, Clara (1839–1929)
Born in Cheltenham, died in Venice; assoc. R.W.S. 1874, member 1890. Buildings. Exhibited 148 works, 86 at O.W.C.S., 17 at R.A., 1 at B.I., 12 at S.B.A.

MONTBARD, Georges
(fl. 1874–86)
Landscapes. Exhibited 47 works, 4 at N.W.C.S., 2 at R.A., 6 at S.B.A.

MOODY, John Charles (b. 1884)
Member R.I. 1931; member Royal Society Painter-Etchers and Engravers. Resident, Society Graphic Artists. Street scenes. Buildings.

MOORE, Albert Joseph (1841–93)
Born York, the 14th child of portrait-painter William Moore, and brother of Edwin, Henry and John Collingham; to London 1853, and studied at R.A. 1858; visited Rome 1859; assoc. R.W.S. 1884. Greek figure subjects. Exhibited 104 works, 16 at O.W.C.S., 42 at R.A., 2 at S.B.A., 1 at N.W.C.S. (*V. & A.*)

MOORE, Charles (1800–33)
Worked for Britton and Ackermann; assoc. O.W.C.S. 1822. Architectural subjects. Exhibited 8 works at O.W.C.S.

MOORE, Edwin (fl. 1855–85)
Brother A. J. Landscapes. Exhibited 40 works, 3 at N.W.C.S., 11 at R.A.

MOORE, George Belton (1805–75)
Drawing master at Woolwich Military Academy and at University College, London; a writer on art. Architectural subjects and landscapes. Exhibited 140 works, 32 at R.A., 31 at B.I., 29 at S.B.A. 1830–70.

MOORE, Henry (1831–95)
Born York; brother of A. J.; studied at York School of Design, and R.A. 1853; member S.B.A. 1866–75 and O.W.C.S. 1880; A.R.A. 1885, R.A. 1893; Chevalier de la Légion d'Honneur. Marines.

Exhibited 550 works, 55 at
O.W.C.S., 107 at R.A., 15 at B.I.,
174 at S.B.A., 23 at Grosvenor
gallery. (*V. & A., Birmingham*)

MOORE, James (1762–99)
Pupil of G. Robertson; an
antiquary, for whom E. Dayes and
T. Girtin worked and whose
sketches they copied; visited
Switzerland. (*Oxford*)

MOORE, John Collingham
(1829–80)
Born Gainsborough, Lincs.;
brother of A. J.; studied at R.A.
1850; lived for a long time in
Italy. At first portraits, and later
views in Florence, Rome and
Naples districts. (*V. & A.*)

MOORE, J. Marchmont
(fl. 1832–35)
Domestic subjects. Exhibited 18
works, 3 at N.W.C.S., 6 at R.A., 9 at
S.B.A.

MOORE, William (fl. 1855–88)
Of York. Landscapes. Exhibited
71 works, 8 at N.W.C.S., 9 at R.A.

MORDAUNT, Lady
(née Mary Ann Holbeach)
(1778?–1842)
One of the best known amateurs of
her day. Landscapes, often chalk
and monochrome wash. (*B.M.*)
(*Note*. Sir Charles Mordaunt was
also an amateur water-colourist.)

MORE, Jacob, 'of Rome' (1740–93)
Born Edinburgh; pupil of
A. Runciman, and J. Norie; to
Rome 1773, where he was praised
by Goethe. Highland landscapes.
Exhibited 22 works, 11 at Soc. of
Artists, 11 at R.A. (*Edinburgh,
B.M.*)

MORGAN, Frank Somerville

(fl. 1883–88)
Domestic subjects. Exhibited 7
works, 5 at N.W.C.S., 2 at S.B.A.

MORGAN, Frederick (fl. 1865–93)
Of Aylesbury. Domestic subjects.
Exhibited 103 works, 3 at N.W.C.S.,
46 at R.A., 4 at B.I., 23 at S.B.A.

MORGAN, Walter Jenks
(1847–1924)
Born Bilston, Staffs.; apprenticed
in Birmingham to a lithographer;
studied at Birmingham School of
Art and Birmingham Society of
Artists, where he won a 3-year
scholarship to South Kensington;
stayed in London and drew
illustrations for periodicals;
returned to Birmingham 1889;
member R.B.A. 1884 and R.B.S.A.
1890. Figure subjects, some
domestic. Exhibited 90 works, 5 at
R.A., 70 at S.B.A., 1 at N.W.C.S.
1876–93. (*Birmingham*)

MORIN, Edward (fl. 1858–78)
Assoc. N.W.C.S. 1858. Domestic
subjects. Exhibited 25 works, 23 at
N.W.C.S.

MORISON, Douglas (1810–47?)
Born Tottenham; pupil of J. F.
Tayler; member N.W.C.S.
1836–38; assoc. O.W.C.S. 1844;
author of a description of Haddon
Hall. Landscapes, and interiors
and exteriors of buildings.
Exhibited 36 works, 17 at O.W.C.S.,
13 at N.W.C.S., 6 at R.A.

MORLAND, George (1763–1804)
Born Haymarket; brother-in-law
of William Ward (of London);
trained by his father, a portrait-
painter, and studied at R.A.; copied
Dutch Masters; toured France.
Isle of Wight coastal scenes,
farmyard scenes, and genre, all
rare in watercolour. Exhibited 105

works, 34 at Soc. of Artists, 33 at
Free Soc., 38 at R.A. 1773–1804.
(*V. & A., B.M., Newport*)

MORLEY, Harry (1881–1943)
Born Leicester; A.R.W.S. 1927,
R.W.S. 1931, vice-president
1937–41. Landscapes.

MORRIS, J. R. (fl. c. 1806)
One drawing in the La Cave style
in V. & A.

MORRIS, Robert (fl. 1774–90)
Probably an amateur. Landscapes,
some Welsh. Exhibited 6 works,
4 at Soc. of Artists, 1 at R.A., 1 at
S.B.A.

MORRIS, William (1834–96)
Born Walthamstow; a painter,
designer, decorator and teacher.

MORROW, Albert G. (d. 1927)
Born Comber, Co. Down; studied
at South Kensington; a book and
magazine illustrator. Domestic
subjects. Exhibited 4 works at R.A.
1890–93.

MORTIMER, John Hamilton
(1741–79)
Born Eastbourne; studied under
R. E. Pine in London, later under
Reynolds and Cipriani; vice-
president Incorp. S.A. 1773; A.R.A.
1778. Illustrations and portraits.
Exhibited 105 works, 89 at Soc. of
Artists, 3 at Free Soc., 13 at R.A.,
1762–79. (*V. & A., B.M., Bristol,
Liverpool, Birmingham, Leeds*)

MORTON, Andrew (1802–45)
Born Newcastle; studied at R.A.
Portraits. Exhibited 97 works, 58
at R.A., 35 at B.I., 4 at S.B.A.,
1821–45. (*Newcastle*)

MORTON, Henry (fl. 1807–25)
Flowers. Exhibited 20 works,

3 at O.W.C.S., 11 at R.A.

MOSELEY, Mrs
See Chalon, Henry Bernard.

MOSER, George Michael
(1704–83)
Born Schaffhausen, Switzerland,
the son of a sculptor; to England at
an early age; manager of St
Martin's Lane Academy; member
Incorp. S.A. 1766, founder
member (1768) and keeper R.A.;
drawing master to George III.
Designed for enamel watchcases.
Exhibited 16 works, 13 at Soc. of
Artists, 3 at R.A. 1760–70.

MOSER, Mary (Mrs Hugh Lloyd)
(1744–1819)
Born London; daughter of George
Michael; foundation member R.A.
1768; employed as decorator by
Queen Charlotte. Flowers and
fruit. Exhibited 42 works, 10 at
Soc. of Artists, 32 at R.A.
1760–92. (*V. & A.*)

MOSER, Oswald (b. 1874)
Member R.I. 1909; member R.O.I.
Landscapes.

MOSER, Robert James (fl. 1871–93)
Landscapes. Exhibited 15 works,
8 at N.W.C.S., 5 at R.A., 1 at S.B.A.

MOSES, Henry (1782–1870)
Born London; one of the foremost
line engravers of his day.
Marines. Exhibited 2 works at
S.B.A.

MOSS, W. G. (fl. 1780–1827)
Perhaps of Norwich; said to have
travelled and worked with Girtin.
Landscapes. Exhibited 25 works,
19 at R.A., 3 at B.I., 3 at S.B.A.

MOSSMAN, David (fl. 1853–88)
Of Newcastle. Miniatures.

Exhibited 27 works, 8 at N.W.C.S., 10 at R.A., 9 at S.B.A.

MOTT, Mrs (fl. c. 1830)
Italian sketches, engraved in W. Brockedon's work on that country.

MOTTRAM, Charles Sim (fl. 1876–93)
Member R.B.A. Marines. Exhibited 118 works, 16 at N.W.C.S., 28 at R.A., 68 at S.B.A.

MUCKLEY, William J. (fl. 1858–93)
Of Wolverhampton; member R.B.A. Flowers. Exhibited 114 works, 5 at N.W.C.S., 52 at R.A., 2 at B.I., 21 at S.B.A., 26 at Grosvenor gallery.

MUIRHEAD, David (1867–1930)
Born Edinburgh. A.R.W.S. 1924, A.R.A. 1928. Landscapes and buildings.

MUIRHEAD, John (1863–1927)
Born Edinburgh; studied at Edinburgh; member R.S.W. 1893 and R.B.A. Landscapes. Exhibited 1881 onwards, 4 at R.A. before 1893.

MÜLLER, William James (1812–45)
Born Bristol, the son of the museum curator; studied under J. B. Pyne; in Norfolk and Suffolk 1831, North Wales 1833; toured Continent 1834; to Greece and Egypt 1838, London 1839, France 1840; with government expedition to Lycia 1843–44; taught W. E. Dighton and Rev. J. Eagles; much influenced by D. Cox, and gave him lessons in oil painting. Landscapes. Exhibited 40 works, 17 at R.A., 14 at B.I., 9 at S.B.A. (*Bristol, V. & A., B.M.,*

Birmingham, Liverpool, Manchester)

MULREADY, Mrs (née Elizabeth Varley) (fl. 1811–19)
Wife of William, and daughter of J. Varley. Landscapes. Exhibited 30 works, 11 at O.W.C.S., 13 at R.A., 5 at B.I.

MULREADY, William (1786–1863)
Born Ennis, Ireland; studied at R.A. at the age of 14; pupil-teacher under J. Varley, and married Elizabeth Varley 1803; A.R.A. 1815, R.A. 1816; designed the first Rowland Hill penny postage envelope 1840. Landscapes and portraits. Exhibited 83 works, 77 at R.A., 5 at B.I., 1 at S.B.A. 1804–62. (*V. & A., B.M.*)

MUNN, Paul Sandby (1773–1845)
Born Greenwich, the son of a landscape-painter, and godson of Paul Sandby; visited Wales with J. S. Cotman 1800, and Yorkshire 1804; assoc. O.W.C.S. 1806. Landscapes. Exhibited 69 works, 40 at O.W.C.S., 29 at R.A. (*V. & A., Newport, Newcastle, Whitworth, Leeds*)

MUNNINGS, Sir Alfred James (1878–1959)
Born Mendham, Suffolk. A.R.W.S. 1921, R.W.S. 1929, P.R.A. Horses, Gypsies. Landscapes. (*Tate, etc.*)

MUNTZ, John Henry (fl. 1755?–75)
A Swiss, in H. Walpole's employ at Strawberry Hill. Classical landscapes. Exhibited 5 works at Soc. of Artists 1762.

MURRAY, Charles Fairfax (1849–1919)
Sent to Italy by Ruskin to copy

Old Masters; collector of Pre-Raphaelite works. Domestic, and copies of Old Masters. Exhibited 28 works, 2 at R.A., 17 at Grosvenor gallery. (*Birmingham*)

MURRAY, Sir David (1849–1933) Born Glasgow; studied at night-classes at Government Art School, Glasgow; assoc. R.S.A. 1881, assoc. R.W.S. 1886; A.R.A. 1891, R.A. 1905; president R.I. 1917. Exhibited 175 works, 46 at O.W.C.S., 42 at R.A. 1875–93.

MURRAY, Frank (fl. 1876–92) Landscapes. Exhibited 56 works, 5 at N.W.C.S., 16 at R.A., 8 at S.B.A.

MURRAY, Mrs Henry John (née Elizabeth Heaphy) (d. 1882) Daughter of Thomas Heaphy, the first president S.B.A.; fl. from 1834; member N.W.C.S. 1861. Portraits and genre, often Eastern. Exhibited 70 works, 52 at O.W.C.S., 7 at R.A., 2 at S.B.A. 1846–82.

MUSS, Charles (1779–1824) Born Newcastle-upon-Tyne, the son of an Italian artist. Enamel copies of Old Masters. Exhibited 21 works at R.A. 1800–23.

MUTRIE, Martha Darley (fl. 1853–84) Of Manchester. Flowers. Exhibited 49 works, 3 at N.W.C.S., 43 at R.A., 1 at B.I.

NAFTEL, Maud (1856–90) Daughter of P. J.; studied at the Slade; assoc. R.W.S. 1887. Landscapes and flowers. Exhibited 53 works, 16 at O.W.C.S., 9 at R.A.

NAFTEL, Paul Jacob (1817–91) Born Guernsey; taught in Guernsey; from 1870 in London; assoc. O.W.C.S. 1850, member 1859. Landscapes, often of Channel Isles. Exhibited 691 works, 689 at O.W.C.S. (*V. & A., B.M.*)

NAFTEL, Mrs P. J. (fl. 1857–59) Wife of P. J. Domestic subjects. Exhibited 54 works, 9 at N.W.C.S., 10 at R.A., 13 at S.B.A.

NAIRN, George (1799–1857) Born Dublin; studied at Dublin Society's Schools; assoc. R.H.A. Exhibited at R.H.A.

NAISH, William (d. 1800) Born Axbridge, Somerset. Miniatures. Exhibited 42 works at R.A. 1786–1800.

NAPIER, Mrs Eva (fl. 1880's) Worked in London. Landscapes. Exhibited 3 works, 1 at R.A., 1 at S.B.A. 1885–89.

NASH, Edward (1778–1821) Pupil of S. Shelley; friend of Southey, Coleridge and Wordsworth; in India for a time. Miniatures. Exhibited 17 works at R.A. 1800–20.

NASH, Frederick (1782–1856) Born Lambeth; studied at R.A. from 1801, and taught by T. Malton Sr; employed by the architect Sir R. Smirke R.A.; draughtsman to the Society of Antiquaries 1807; a very fine architectural painter, much praised by Turner; member O.W.C.S. 1810–12 and re-elected 1824. Book illustrations and architectural topography. Exhibited 616 works, 472 at O.W.C.S., 51 at R.A., 63 at B.I., 7 at

s.b.a. (*V. & A., B.M.,
Whitworth, Nottingham*)

NASH, Joseph (1808–78)
Born Great Marlow, Bucks.;
studied under A. C. Pugin; assoc.
o.w.c.s. 1834, member 1842. At
first illustrated books, and
topography later. Exhibited 296
works, 276 at o.w.c.s., 3 at r.a.,
11 at b.i., 6 at n.w.c.s. (*V. & A.,
Newcastle, Whitworth,
Nottingham*)

NASH, Joseph, Jr (fl. 1859–93)
Member r.i. 1886–1907. Marines.
Exhibited 42 works, 18 at n.w.c.s.,
4 at r.a., 4 at s.b.a.

NASMYTH, Alexander
(1758–1840)
The son of an architect; father of
Anne, James, Jane and Patrick;
pupil of A. Runciman, and assistant
to A. Ramsay; visited Italy
1782–84. Landscapes, rare in
colour. Exhibited 30 works, 9 at
r.a., 18 at b.i., 3 at s.b.a.
1807–39. (*Edinburgh, B.M.*)

NASMYTH, Anne (b. 1798)
Daughter of Alexander. Scottish
scenery. (*Edinburgh*)

NASMYTH, James (1808–90)
Born Edinburgh; tenth child and
fourth son of Alexander; best
known as an engineer and the
inventor of the steam-hammer.
Landscapes.

NASMYTH, Jane (1778–1866?)
Sister of Patrick; lived first in
Edinburgh and later in Putney
with sisters (?) Barbara, Charlotte
and Margaret. Landscapes.
Exhibited 16 works, 5 at b.i., 11 at
s.b.a., 1826–66. (*V. & A.*)

NASMYTH, Patrick (christened

Peter) (1787–1831)
Born Edinburgh; son of
Alexander; to London 1807;
influenced by Hobbema and other
Dutch Masters; member s.b.a.
1823. Landscapes, mostly low-
toned, with delicately detailed
trees. Exhibited 121 works, 20 at
r.a., 78 at b.i., 23 at s.b.a.
1811–32. (*B.M., V. & A.,
Edinburgh, Newport*)

NATTES, John Claude (1765–1822)
Irish by birth; studied under
landscape-painter H. P. Deane;
travelled in Scotland 1797–1800,
Italy and Southern France
1820–22; many illustrations for
travel books; founder member
o.w.c.s. 1804 but expelled 1807.
Italian scenes 1781–84, and later
landscapes in Scotland and
England. Exhibited 84 works, 34
at o.w.c.s., 50 at r.a. (*V. & A.,
B.M., Newport, Whitworth,
Leeds*)

NATTRESS, George (fl. 1866–88)
Buildings. Exhibited 31 works,
3 at n.w.c.s., 22 at r.a., 3 at
n.w.c.s.

NAUGHTON, Elizabeth
(fl. 1860's–80's)
Worked in London. Landscapes.
Exhibited 13 works, 2 at s.b.a.,
1867–1882.

NAYLOR, Thomas (fl. 1778–84)
Marines, in the style of S. Atkins.

NEALE, John Preston (1780–1847)
For a time a post office clerk;
illustrated many books, and
travelled through Britain drawing
country seats and churches for
such works as 'Noblemen's Seats';
friend and sketching companion of
John Varley. Topographical
landscapes, often in pen and wash.

Exhibited 74 works, 7 at o.w.c.s.,
47 at r.a., 14 at b.i., 6 at s.b.a.
(*V. & A., B.M., Nottingham*)

NEALE, Samuel (1758–1824)
Landscapes and animals. (*V. & A.*)

NEEDHAM, Joseph G.
(fl. 1860's–70's)
Worked in London. Landscapes.
Exhibited 9 works, 2 at b.i., 7 at
s.b.a., 1860–74.

NESBITT, John (1831–1904)
Born Edinburgh. Marines and
landscapes. Exhibited 16 works at
r.a. 1870–88.

NESBITT, Sidney (fl. 1872–78)
Landscapes. Exhibited 8 works,
1 at r.a., 2 at s.b.a. (*V. & A.*)

NESFIELD, William Andrews
(1793–1881)
Born Chester-le-Street, the son of
the rector of Brancepath, Durham;
educated at Winchester, Trinity
College, Cambridge, and
Woolwich; in the army 1809—
serving in the Peninsular War and
in Canada—1816; influenced by
Turner and G. F. Robson; member
o.w.c.s. 1823–51. Highland
scenery with waterfalls (praised
by Ruskin), and fine Alpine scenes.
Later turned his attentions to
landscape gardening, and improved
Kew Gardens, St. James's Park,
etc. Exhibited 91 works at o.w.c.s.
(*V. & A., B.M., Newcastle*)

NETTLESHIP, John Trivett
(fl. 1871–93)
Animals. Exhibited 60 works, 3 at
n.w.c.s., 20 at r.a., 1 at s.b.a.

NEWCOMBE, Bertha
(fl. 1870's–1900)
Worked in London. Landscapes.
Exhibited 9 works at r.a., 8 at

s.b.a., 1 at n.w.c.s., 1876–1900.

NEWHOUSE, C. B. (fl. c. 1820)
Little-known painter of London
views.

NEWMAN, Catherine M.
(fl. 1886–92)
Flowers. Exhibited 6 works, 4 at
n.w.c.s., 1 at r.a.

NEWMAN, Henry Roderick
(d. 1918)
An American; worked mostly in
Florence, but also in Cairo and
England; employed by Ruskin to
make architectural records for
Sheffield Museum; fl. c. 1879.
Exhibited 5 works, 1 at r.a., 4 at
Grosvenor gallery (*Birmingham*)

NEWMARCH, Strafford
(fl. 1860's–70's)
Worked in London. Landscapes.
Exhibited 6 works, 1 at r.a., 1 at
b.i., 4 at s.b.a., 1866–74.

NEWTON, Alfred Pizzi (or Pizzey)
(1830–83)
Born Rayleigh, Essex; did
drawings for Queen Victoria;
travelled in Italy and Greece;
assoc. o.w.c.s. 1858, member
1879. Mountainous landscapes.
Exhibited 255 works, 249 at
o.w.c.s., 5 at r.a., 1 at s.b.a.
(*V. & A.*)

NEWTON, Mrs Charles J.
(née Mary Severn) (1832–66)
Daughter of Joseph Severn.
Portraits in crayon and water-
colour. Exhibited 11 works, 7 at
r.a., 1863–66.

NEWTON, Henry
No dates known, but lived in
Dublin. Six Irish views in
National Gallery of Ireland.

NEWTON, John Edward
(fl. 1858–83)
Member N.W.C.S. Fruit and
landscapes. Exhibited 37 works,
1 at N.W.C.S., 18 at R.A., 2 at B.I.,
11 at S.B.A.

NEWTON, Sir William John
(1785–1869)
Born London; son of engraver
James Newton; miniature-painter
to Queen Adelaide; knighted 1837.
Miniatures. Exhibited 380 works,
379 at R.A., 1 at B.I.

NIBBS, Richard Henry
(1816?–93)
Landscapes, some in France and
Holland, marines, and genre.
Exhibited 205 works, 42 at R.A.,
38 at B.I., 96 at S.B.A., 1841–89.
(*V. & A.*)

NICHOLL, Andrew (1804–86)
Born Belfast; apprenticed to a
printer, but left to study in London;
returned to Belfast until 1840,
when he settled in London; to
Colombo 1849 to teach at Colombo
Academy; returned to London,
then lived in succession in Dublin,
Belfast, and finally London; assoc.
R.H.A. 1837, member 1860.
3 at N.W.C.S., 10 at R.A., 4 at B.I.,
3 at S.B.A. (*V. & A., B.M.,
Belfast*)

NICHOLL, Mrs Samuel Joseph
(née Agnes Rose Bouvier)
(fl. 1874–92)
Domestic subjects. Exhibited 50
works, 14 at N.W.C.S., 8 at R.A.,
26 at S.B.A.

NICHOLL, William
(1794–1840)
Born Belfast; brother of Andrew;
an amateur; member Association
of Artists in Belfast. Landscapes.
(*V. & A., Linenhall Library,*

*Belfast, Weston Folk Museum,
Holywood, Co. Down*)

NICHOLLS, Charles Wynne
(1831–1903)
Born Dublin; member R.H.A.
Landscapes and domestic figure
subjects. Exhibited 72 works, 9 at
R.A., 7 at B.I. 39 at S.B.A.,
1855–86.

NICHOLS, Alfred
(fl. 1866–78)
Master of Bristol School of Art.
Landscapes. Exhibited 1 work
1866. (*V. & A.*)

NICHOLS, W. (1794?–1840)
Listed by some authorities as a
landscape-painter, but probably
William Nicholl, see above

NICHOLSON, Alfred (1788–1833)
Born Whitby; son of Francis; for a
time in the navy, and visited the
coasts of Holland and Portugal; to
Ireland 1813; settled in London
c. 1818 as a drawing master.
Landscapes in his father's style,
many in Ireland. (*V. & A.*)

NICHOLSON, Francis (1753–1844)
Born Pickering, Yorks.; father of
Alfred; had lessons from a
Scarborough artist, and painted
animals; visited London twice,
and settled in Whitby 1783–92;
then in turn to Knaresborough,
Ripon and finally London; a
founder member O.W.C.S. 1804 and
later president until 1813;
published 'Practice of Drawing . . .
in Water Colours' 1820; taught
H.R. Callender. Landscapes,
particularly with waterfalls or
rushing streams, and stormy
coastal scenes with shipwrecks.
Exhibited 318 works, 279 at
O.W.C.S., 6 at Soc. of Artists, 11 at
R.A., 1 at S.B.A. (*Scarborough,*

V. & A., B.M., York, Bristol, Leeds and others)

NICHOLSON, Isabella
(fl. 1828–47)
Flowers. Exhibited at Liverpool
Academy. (*Walker*)

NICHOLSON, William
(1784–1844)
Born Newcastle-upon-Tyne;
settled in Edinburgh 1820; a
founder member Scottish Academy
1826. Portraits. Exhibited 9
works, 7 at R.A., 2 at O.W.C.S.
1803–22. (*Newcastle, Edinburgh*)

NICOL, Erskine (1825–1904)
Born Leith; studied at Trustees'
Academy, Edinburgh, 1837;
drawing master at Leith High
School, and to Ireland 1845; to
Edinburgh c. 1850, London 1862;
member R.S.A. 1859, A.R.A. 1866.
Irish genre subjects. Exhibited 59
works, 53 at R.A., 6 at B.I. 1851
onwards. (*V. & A.*)

NIEMANN, Edmund John
(1813–76)
Born Islington; early employed at
'Lloyds', but left 1839 to paint;
to High Wycombe to work out-
doors; back in London 1850.
Landscapes. Exhibited 177 works,
29 at R.A., 45 at B.I., 40 at S.B.A.
1844–72. (*V. & A.*)

NIEMANN, Ernest
Son of Edmund John, and painted
in his style.

NIGHTINGALE, Frederick C.
(fl. 1865–85)
Of Wimbledon; an amateur.
Landscapes, and some views in
Venice. Exhibited 74 works at
minor exhibitions. (*V. & A.*)

NINHAM, Henry (1793–1874)

Born Norwich; son of John
Ninham, engraver and heraldic
painter; painted armorial bearings
on coaches, while exhibiting in
Norwich 1816–31. Landscapes and
old Norwich buildings. (*V. & A.,
B.M., Norwich*)

NISBET, Miss Noel (Mrs Laura
Bush) (b. 1887)
Member R.I. 1925. Flowers and
landscapes.

NISBET, Pollok Sinclair
(1848–1922)
Born Edinburgh; assoc. R.S.A.,
member R.W.S. Coastal scenes.
Exhibited from 1884.

NISBET, Robert Buchan
(fl. 1888–93) (b. 1857)
Of Edinburgh; assoc. R.S.A. and
member R.B.A., R.S.W. and R.I.
1892. Landscapes. Exhibited 45
works, 11 at N.W.C.S., 14 at R.A.,
18 at S.B.A. (*V. & A.*)

NISBETT, Ethel C. (fl. 1884–93)
Flowers. Exhibited 16 works, 6 at
N.W.C.S., 4 at R.A., 5 at S.B.A.

NIXON, James (1741?–1812)
Studied at R.A.; member Incorp.
S.A., A.R.A. 1778. Miniatures and
portraits. Exhibited 151 works, 11
at Soc. of Artists, 127 at R.A., 13 at
S.B.A. 1765–1807.

NIXON, Job (1891–1938)
Born Stoke-on-Trent. Prix de
Rome for Engraving 1920. Assoc.
Royal Society of Painter-Etchers
and Engravers; assoc. R.W.S. 1928,
member 1934. Buildings.

NIXON, John (d. 1818)
A London merchant, an etcher,
and an amateur artist; fl. c. 1781;
secretary of the Beefsteak Club,
and an eccentric. Caricatures,

landscapes, country estates and book illustrations. (*V. & A.*)

NIXON, Rev. Robert
(fl. 1790–1808)
Lived at Foots Cray, Kent, and worked also at Bath, Orpington, and Canterbury. Views of architectural and antiquarian interest. Exhibited 22 works, 18 at R.A., 4 at Soc. of Artists.

NOBLE, James Campbell
(1846–1913)
Born Edinburgh; assoc. R.S.A. 1879, member R.S.A. 1892. Landscapes. Exhibited from 1870, 9 works at R.A. before 1893.

NOBLE, John Sargeant (1848–96)
Studied at R.A.; influenced by Sir E. H. Landseer; member S.B.A. 1867. Animals and sporting subjects. Exhibited 143 works, 46 at R.A., 96 at S.B.A., 1866–93.

NOBLE, R. P. (fl. 1830's–60's)
Worked in Dublin and London. Landscapes. Exhibited 78 works, 35 at R.A., 1 at B.I., 38 at S.B.A. 1836–61.

NOBLETT, H. John (fl. 1822–35)
Member N.W.C.S. 1833. Landscapes. Exhibited 15 works, 8 at N.W.C.S., 1 at R.A., 6 at S.B.A.

NOEL, Mrs Amelia (fl. 1795–1804)
Allegorical subjects and landscapes, some engraved in 'Copper Plate Magazine' 1798 and in her own 'Views in Kent' 1797. Exhibited 25 works at R.A.

NORIE (or NORIO), Orlando
(fl. 1876–89)
Of Spanish birth. Battle scenes. Exhibited 5 works, 2 at N.W.C.S., 2 at R.A.

NORMAN, Mrs Caroline H.
(fl. 1874–91)
Of Davenport. Flowers. Exhibited 24 works, 8 at N.W.C.S., 9 at R.A., 2 at S.B.A.

NORMAN, Philip (fl. 1876–93)
F.S.A. Landscapes and drawings of old London. Exhibited 103 works, 22 at N.W.C.S., 15 at R.A., 6 at S.B.A., 17 at Grosvenor gallery. (*V. & A.*)

NORRIS, Charles. *See* Norns, J.

NORRIS, Hugh L. (fl. 1888–92)
Domestic subjects. Exhibited 7 works, 4 at N.W.C.S., 2 at R.A.

NORRIS, J. (fl. 1812–15)
Views in South Wales, 2 engraved by F. Stevens for Ackermann's 'Cottages'.
(*Note.* A Charles Norris, either a relative or the same, made drawings in and around Tenby, South Wales, which were etched in a volume.)

NORRIS, William (fl. 1885–93)
Rustic subjects. Exhibited 20 works, 4 at N.W.C.S., 4 at R.A., 7 at S.B.A.

NORTH, John William
(1842–1924)
Born near London; studied at Marlborough House School of Art, and under J. W. Whymper at Lambeth; member Royal Society of Painters in Water Colours 1883; R.W.A., hon R.S.W., A.R.A. 1893. Poetic landscapes and illustrations. Exhibited 141 works, 99 at O.W.C.S., 9 at R.A. (*V. & A.*, *Southampton*)

NORTHAMPTON,
Second Marquess of
(Joshua Alwyn Spencer, Lord

Compton) (1790–1851)
Visited Rome 1820–30. Italian
views.
(*Note*. Drawings by the
Marchioness (fl. 1820–30) while
in Rome with her husband are in
exactly the same style. Examples
are illustrated in D. Clifford's
'Collecting English Water-
colours'.)

NORTHCOTE, James (1746–1831)
Born Plymouth, the son of a
watchmaker, and trained as one; to
London 1771; studied under
Reynolds, and at R.A.; to Devon-
shire 1775 and painted portraits;
visited Italy 1777–80; A.R.A. 1786,
R.A. 1787; wrote on art, including
a life of Reynolds. Historical
subjects. Exhibited 266 works,
229 at R.A., 22 at B.I., 15 at S.B.A.
(*V. & A.*)

NOTTINGHAM, R.
Worked in London. Landscapes.
Exhibited 45 works, 12 at R.A., 1 at
B.I., 29 at S.B.A. 1853–63.

NOWELL, Arthur Trevethin
(1862–1940)
Member R.I. 1913. Landscapes.

NOWLAN, Frank (1835–1919)
Born Co. Dublin; to London 1857
and studied at Leigh's School and
at Langham School of Art;
employed by Queen Victoria,
Edward VII and other members of
the Royal Family. Miniatures and
domestic subjects. Exhibited 28
works, 5 at R.A., 5 at S.B.A.
1866–86. (*V. & A.*)

NOYES, Robert (1780?–1843)
Of Wolverhampton. Topography
in the style of F. Nicholson.

NURSEY, Claude Lorraine
(1820–73)

Born Woodbridge, Suffolk;
secretary Norwich Fine Art
Association. Landscapes and
marines. Exhibited 5 works, 1 at
B.I., 4 at S.B.A. 1844–71.

OAKES, John Wright (1820–87)
Born near Middlewich, Cheshire;
taught by a Mr Bishop of
Liverpool College; assoc.
Liverpool Academy 1847, member
1850 and hon. secretary 1853; to
London 1859; assoc. Institute of
Painters in Water Colours
1874–75, A.R.A. 1876, hon. R.S.A.
1883. Landscapes. Exhibited 155
works, 3 at N.W.C.S., 90 at R.A.,
28 at B.I., 11 at S.B.A. (*V. & A.*)

OAKLEY, Octavius (1800–67)
'Gipsy Oakley'; worked in Derby
and Leamington until 1841; in
London from 1842; assoc. O.W.C.S.
1842, member 1844. Portraits at
first, then landscapes, and figure
subjects, often featuring gipsy
boys. Exhibited 253 works, 221 at
O.W.C.S., 3 at R.A., 1 at S.B.A.
(*V. & A., B.M., Newport*)

OAKMAN, John (d. 1793)
A wood engraver, and illustrator
of children's books.

O'BRIEN, L. R. (fl. 1887–90)
Coastal scenes. Exhibited 7 works,
3 at N.W.C.S., 1 at R.A.

O'CONNOR, James A. (1791–1841)
Born Dublin; to England with
F. Danby and George Petrie;
visited the Continent; returned to
Ireland 1833. Landscapes, mostly
Irish. Exhibited 78 works, 21 at
R.A., 39 at B.I., 18 at S.B.A.
1822–40.

O'CONNOR, John (1832–89)
Born Co. Derry; scene-painter at Haymarket Theatre 1863, and a drawing master; assoc. R.H.A., member R.I. 1887. Landscapes and architectural subjects. Exhibited 143 works, 12 at N.W.C.S., 28 at R.A., 6 at B.I., 26 at S.B.A., 29 at Grosvenor gallery.

O'CONNOR, Roderick (1860–1940)
Born Ireland; studied in London, Antwerp and Rome, but exhibited little; to France 1883, and met Gauguin c. 1894. (*Bedford*)

OGBORNE, David (1700–68)
Born near Great Dunmow, Essex. Views of towns, and illustrations for guide books.

OGLE, John Connell (1842–64)
River views and marines. Exhibited 19 works, 5 at R.A., 7 at S.B.A. (*Newport*)

O'HARA, Helen (fl. 1884–93)
Of Portstewart, Londonderry. Domestic subjects. Exhibited 13 works at N.W.C.S.

O'KEEFE (or **KEEFE**), **Daniel** (d. 1787)
Brother of John; fl. 1771–83. Miniatures. Exhibited 25 works, 3 at Free Soc., 22 at R.A.

O'KEEFE, John (1784–1833)
Born Dublin; brother of Daniel. Humorous designs, miniatures and portraits.

O'KELLY, Aloysius C. (fl. 1876–92)
Figure subjects. Exhibited 50 works, 3 at N.W.C.S., 20 at R.A., 17 at S.B.A.

OLDFIELD, J. Edwin (fl. 1825–54)
Worked at Canterbury and in

Belgium. Landscapes. Exhibited 3 works, 2 at R.A., 1 at S.B.A. (*V. & A.*)

OLIVER, Isaac (1560–1617)
A London miniature-painter of French origin.

OLIVER, Peter (1594–1648)
Son of Isaac, and also painted miniatures; employed by Charles I to make miniature copies of his paintings.

OLIVER, William (1805–53)
Member N.W.C.S. 1834. A very quick landscapist, working in England, Switzerland, France, Italy, western Pyrenees and the Tyrol. Exhibited 444 works, 257 at N.W.C.S., 29 at R.A., 54 at B.I., 36 at S.B.A.

OLIVER, Mrs William (née Emma Sophia Eburne) (1819–85)
After the death of William, married John Sedgwick; accompanied William on his many tours, and painted in his style; member R.I. 1849. Landscapes. Exhibited 542 works, 366 at N.W.C.S., 34 at R.A., 19 at B.I., 39 at S.B.A. (*V. & A., Dublin*)

OLIVIER, Herbert Arnould (fl. 1883–93)
Member R.I. 1929, member R.P., R.B.C. Portraits. Exhibited 48 works, 7 at N.W.C.S., 26 at R.A.

O'NEIL, Henry Nelson (1817–80)
Born St Petersburg; A.R.A. 1860; wrote on art; died London. Historical subjects. Exhibited 142 works, 94 at R.A., 34 at B.I., 14 at S.B.A., 1838–79.

O'NEILL, Hugh (1784–1824)
Born Bloomsbury, the son of

architect Jeremiah; helped by Dr
Monro; became a drawing master
at Oxford, Edinburgh, Bath and
Bristol. Local views and buildings,
especially in Bristol. Exhibited 4
works 1812. (*V. & A., B.M.,
Bath, Whitworth*)

OPIE, John (1761–1807)
Born St Agnes, Cornwall; R.A.,
keeper R.A. 1806. Rustic and
domestic subjects, and some
historical. Exhibited 151 works,
143 at R.A., 8 at B.I. 1782–1807.

ORAM, Edward (fl. 1776–1810)
Son of William; became assistant
to De Loutherbourg. Landscapes.
Exhibited 32 works, 3 at Soc. of
Artists, 29 at R.A. (*V. & A.,
B.M.*)

ORAM, William (d. 1777)
'Master Carpenter of the King's
Works' 1748; a noted archi-
tectural designer and decorator of
his day; fl. c. 1730. Landscapes, in
chalk, wash and Indian ink in the
style of Richard Wilson, many
engraved.

ORCHARDSON, Sir William
Quiller
(1835–1910)
Born Edinburgh; R.A., member
R.S.A. Subjects from literature.

ORME, Daniel (1766?–1832)
A stipple engraver and miniature-
painter, but also landscapes.
Exhibited 39 works at R.A.
(*V. & A.*)

ORME, Ernest (fl. 1801–03)
Probably brother of William and a
relative of Daniel. Landscapes and
architectural subjects. Exhibited 3
works at R.A. (*V. & A.*)

ORME, William (fl. 1791–1819)

Probably brother of Ernest and
relative of Daniel; toured England
in search of subjects; a much-
employed topographical
draughtsman. Landscapes, and
Indian views after Colonel Ward.
Exhibited 20 works at R.A.
(*V. & A.*)

ORROCK, James (1829–1913)
Born Edinburgh; the son of a
dentist; studied first under White
at the Irving Academy, and later
under Ferguson of Leamington,
John Burgess and W. L. Leitch,
and at the Nottingham School of
Design; to London 1866; member
R.I.; assoc. N.W.C.S. 1871, member
1875; renowned collector of
pictures and antiques. Landscapes
in the Cox and De Wint styles.
Exhibited 274 works, 196 at
N.W.C.S., 13 at R.A., 6 at S.B.A. Up
to 1893. (*V. & A., Newport*)

OSBORNE, Walter P. (or F.)
(1860–1903)
Portraits and landscapes, mostly in
black and white. Exhibited 38
works, 17 at R.A., 1 at Grosvenor
gallery, from 1884.

OSCROFT, Samuel William
(fl. 1866–93)
Of Nottingham. Landscapes.
Exhibited 36 works, 14 at N.W.C.S.,
3 at R.A., 1 at S.B.A.

OVEREND, William Heysham
(1851–98)
Born Coatham, Yorks.; book
illustrator, and worked in black
and white for *Illustrated London
News*. Marines. Exhibited 23,
4 at R.A., 3 at S.B.A., works from
1872.

OWEN, Rev. Edward Pryce
(1788–1863)
Published some etchings of old

buildings in Shrewsbury.
Scriptural subjects. Exhibited 14
works, 8 at B.I., 4 at S.B.A.
1839–53.

OWEN, Samuel (1768?–1857)
Member Associated Artists in
Water Colours. Marines and
coastal scenes. Exhibited 37 works
8 at R.A. 1794–1810.
(*Birmingham, V. & A., B.M.,
Sheffield, Newcastle, Whitworth*)

OWEN, William (1769–1825)
Born Ludlow; educated at local
grammar school; to London 1786;
studied under C. Catton at R.A.
1791; also had lessons from Sir
Joshua Reynolds; A.R.A. 1804, R.A.
1806; portrait-painter to the
Prince of Wales. Portraits and
landscapes. Exhibited 210 works,
203 at R.A., 7 at B.I. 1792–1824.
(*V. & A.*)

PAGE, Wilkes (fl. c. 1718)
Marines. (*Greenwich*)

PAGE, William (1794–1860)
Studied at R.A. 1812; to Greece
and Turkey before 1824, and
perhaps China. Landscapes with
ruins in a yellow and brownish-
green palette. Exhibited 19 works
at R.A. 1816–60. (*R.I.B.A.,
B.M.*)

PAGET, Elise (fl. 1877–88)
Of Pinner. Domestic subjects.
Exhibited 21 works, 6 at N.W.C.S.,
2 at R.A., 10 at S.B.A.

PAIN, Robert Tucker (fl. 1863–77)
Of Frimley, Surrey. Landscapes.
Exhibited 44 works, 6 at R.A., 3 at
B.I., 6 at S.B.A. (*V. & A.*)

PAINE, James (fl. 1761–94)
Member St Martin's Lane
Academy. Architectural subjects.
Exhibited 52 works, 47 at Soc. of
Artists, 5 at R.A.

PALETHORPE, Miss M. C.
Landscapes. (*V. & A.*)

PALMER, Edith (1770–1834)
Of Bath. Landscapes around Bath
and in Wales, in the style of
J. Laporte. Exhibited 7 works at
B.I. 1813–15. (*V. & A.*)

PALMER, Samuel (1805–81)
Born Newington; self-taught, and
exhibited at R.A. at the age of 14;
visited Italy 1840; a friend of
William Blake; married daughter
of John Linnell; assoc. O.W.C.S.
1843, member 1854. Landscapes,
at first imaginative, then Italian
topography, and finally romantic
and sentimental. Exhibited 266
works, 178 at O.W.C.S., 57 at R.A.,
20 at B.I., 10 at S.B.A. (*V. & A.,
Manchester, B.M., Nottingham,
Birmingham*)

PALMER, Mrs Samuel
(née Hannah Linnell)
(fl. 1840–42)
Daughter of John Linnell; with
her husband to Italy 1840.
Landscapes. Exhibited 8 works,
5 at R.A., 3 at B.I.

PALMER, Harry Sutton
(1854–1933)
Born Plymouth; studied at South
Kensington Schools; member R.I.
1920. Landscapes. (*Whitworth,
V. & A., Gateshead*)

PALMER, William James
(fl. 1858–88)
Landscapes. Exhibited 34 works,
3 at N.W.C.S., 4 at R.A., 9 at S.B.A.

PAOLETTI, Antonio Silvio
(fl. 1881–91)
Domestic subjects. Exhibited 13
works, 2 at N.W.C.S., 4 at R.A., 1 at
S.B.A.

PAPWORTH, Wyatt A. (1822–94)
Curator Soane Museum; writer of
works on art and architecture.
Exhibited 16 works at R.A.

PARIS, Walter (fl. 1849–91)
Taught at Woolwich Military
Academy 1887–90. Landscapes.
Exhibited 27 works, 7 at N.W.C.S.,
2 at R.A., 7 at S.B.A. (*V. & A.*)

PARK, Thomas (b. 1760)
Mezzotint engraver and anti-
quarian. Architectural subjects.
Exhibited 5 works at R.A.
1780–81.

PARKE, E. Henry (1790?–1845)
A well-known architect and
draughtsman; visited Egypt 1831;
assistant to Sir John Soane.
Architectural subjects, landscapes
and naval subjects, mostly in Italy,
Sicily, Egypt, Malta and Genoa.
Exhibited 40 works, 33 at R.A., 7 at
N.W.C.S. 1815–35.

PARKER, Frederick (fl. 1833–47)
Castles, mostly in Scotland and on
the Rhine. Exhibited 47 works,
4 at N.W.C.S., 4 at R.A., 3 at B.I., 36
at S.B.A.

PARKER, Henry Perlee
(1795–1873)
Born Devonport, the son of a
drawing teacher; to Newcastle
1816; drawing master at Wesley
College, Sheffield, c. 1840; to
London c. 1844. Landscapes,
historical subjects and scenes of
fishermen and smugglers.
Exhibited 151 works, 4 at N.W.C.S.,
23 at R.A., 40 at B.I., 23 at S.B.A.

1817–63. (*V. & A.*)

PARKER, James (1750–1805)
Pupil of Basire; an engraver,
employed by Boydell in his
'Shakespeare'; a founder and
governor Society of Engravers.

PARKER, John (fl. 1762–85)
Pupil of George Smith of
Chichester; visited Italy 1775;
member R.W.S. Landscapes and
domestic subjects. Exhibited 271
works, 185 at O.W.C.S., 9 at R.A.,
4 at S.B.A.

PARKER, John (1839–1915)
Born Birmingham; member R.W.S.
and Birmingham Royal Society of
Artists. Landscapes and flowers.
(*Liverpool*)

PARKER, T. (fl. 1850–70)
Little known, but a fine landscape-
painter, as shown by his 'Jedburgh
Abbey', lithographed in colour for
Lawson's 'Scotland Delineated'.

PARKES, David (1763–1833)
A Shrewsbury schoolmaster and
amateur artist. A learned anti-
quary, he drew architectural
subjects for such books as
W. Pearson's 'Antiquities of
Shropshire' 1807.

PARKES, James (1794–1828)
Son of David; also a schoolmaster
(perhaps a drawing master) at
Shrewsbury, and an antiquarian.
Local views.

PARLBY, James (fl. 1870–73)
Landscapes and figure subjects.
Exhibited 7 works, 5 at S.B.A.
(*V. & A.*)

PARRIS, Edmund Thomas
(1793–1873)
Born Marylebone; apprenticed to a

firm of jewellers; studied at R.A. 1816; historical painter to Queen Adelaide 1838. Landscapes, historical and religious subjects and genre. Exhibited 86 works, 5 at N.W.C.S., 26 at R.A., 36 at B.I., 18 at S.B.A. (*V. & A., B.M.*)

PARROTT, William (1813–69)
Visited Paris 1842–43, Italy 1844–45 and Germany 1851; also made frequent visits to Brittany and Normandy. Figure subjects in the Bonington style, architectural subjects and landscapes. Exhibited 103 works, 25 at R.A., 19 at B.I., 25 at S.B.A. 1835 onwards. (*B.M.*)

PARRY, Thomas Gambier (1816–88)
Fresco painter and collector. Dark-toned landscapes, rather in the David Cox style.

PARRY, William (1742–91)
Born London; studied at Shipley's Drawing School; A.R.A.

PARS, Henry (1734–1806)
Brother of William; proprietor of Shipley's Drawing School 1761. His work is not known.

PARS, William (1742–82)
Born London; brother of Henry; studied at Shipley's Drawing School, St Martin's Lane School, Duke of Richmond's gallery, and at R.A. 1769; to Greece as draughtsman to the Dilettanti Society, and returned 1766; to Rome 1775, where he died; A.R.A. 1770, member Free S.A. Pen and wash landscapes, especially Irish, and portraits latterly. Exhibited 40 works, 2 at Soc. of Artists, 11 at Free Soc., 22 at R.A. 1760–76. (*V. & A., B.M., Leeds, Whitworth*)

PARSONS, Alfred (1847–1920)
Of Frome; member R.I., A.R.A. 1882, P.R.W.S. to 1898. Still-lifes. Exhibited 201 works, 20 at N.W.C.S., 39 at R.A., 9 at S.B.A.

PARSONS, Alfred (1847–1920)
Born Beckington, Somerset, assoc. R.W.S. 1899, member 1905, president 1913–20, A.R.A. 1897, R.A. 1911 (*Tate*)

PARSONS, Arthur Wilde (fl. 1867–93)
Marines. Exhibited 13 works, 6 at N.W.C.S., 1 at R.A., 6 at S.B.A.

PARSONS, Beatrice E. (fl. 1889–93)
Figure subjects. Exhibited 5 works, 4 at R.A. (*V. & A.*)

PARSONS, Letitia Margaret (fl. 1877–87)
Of Frome; probably related to Alfred Flowers. Exhibited 43 works, 6 at N.W.C.S., 9 at R.A., 1 at S.B.A.

PARTON, Ernest (fl. 1874–93)
Landscapes. Exhibited 154 works, 24 at N.W.C.S., 46 at R.A., 20 at S.B.A., 16 at Grosvenor gallery.

PASQUIER, E. J. (fl. 1828–32)
Member N.W.C.S. 1833–34. Landscapes. Exhibited 12 works, 7 at N.W.C.S., 5 at S.B.A.

PASTORINI, F. E. (fl. 1812–33)
An Italian miniaturist working in London. Exhibited 17 works, 3 at O.W.C.S., 14 at R.A.

PASTORINI, J. (1773–1839)
An Italian miniaturist working in London. Exhibited 19 works at R.A.

PATCH, Thomas (d. 1772)
Mezzotint engraver; went to Italy

with Sir Joshua Reynolds, where he
died.

PATERSON, Caroline
(later Mrs S. Sharpe)
(fl. 1878–92)
Domestic subjects. Exhibited 14
works, 3 at N.W.C.S.

PATERSON, Emily M.
(1855–1934)
Born Edinburgh; travelled much
on the Continent; member R.S.W.
Landscapes. Exhibited 2 works at
S.B.A. (*V. & A.*)

PATON, Waller Hugh (1828–95)
Of Edinburgh; assoc. R.S.A. 1857,
member 1865; member R.S.W.
Landscapes. Exhibited 36 works,
4 at N.W.C.S., 15 at R.A.

PATTEN, George (1801–65)
Son of a miniature-painter;
studied at R.A. 1816; practised as
a miniaturist until c. 1830, when he
turned to portraits in oils, and
subject painting; toured in Italy;
portrait-painter to Prince Albert
1840; lived much in Ross-on-Wye,
but finally settled in London;
A.R.A. 1837. Landscapes, mostly in
Herefordshire. Exhibited 147
works, 131 at R.A., 16 at B.I.
(*V. & A.*)

PATTEN, William (fl. 1791–1844)
Portraits. Exhibited 106 works,
8 at N.W.C.S., 90 at R.A., 3 at B.I.,
5 at S.B.A.

PATTERSON, Catherine P.
(fl. 1887–90)
Flowers. Exhibited 3 works at
N.W.C.S.

PATTERSON, James (1854–1932)
Born Glasgow; A.R.W.S. 1898,
R.W.S. 1918, R.S.A., elected
president R.S.W. in 1922.

Landscapes.

PAXTON, Sir Joseph (1801–65)
Born Milton Bryant, near
Woburn; best known as the
designer of the Great Exhibition
1851. An original sketch of this is
in the V. & A.

PAYNE, Henry A. (1868–1940)
Assoc. R.W.S. 1912, R.W.S. 1920.
Landscapes.

PAYNE, William (b. c. 1760–1830)
First employed in Plymouth
Dockyard; self-taught; in 1786,
while living at Plymouth,
exhibited local views at R.A.; to
London 1790, and became a
fashionable teacher; invented
'Payne's grey'; assoc. O.W.C.S.
1809. Landscapes, usually with
figures, and usually faded to a
distinctive orange-brown colour.
Exhibited 108 works, 17 at
O.W.C.S., 17 at Soc. of Artists, 22
at R.A., 50 at B.I., 2 at S.B.A.
(*V. & A., Exeter, Bradford,
Manchester, Sheffield, Newport,
Newcastle, Plymouth*)
(*Note.* Among pupils who closely
imitated Payne are J. M. Perry
(1807), J. W. Williams (1798),
J. Burbank and Capt. Humphries.)

PEAK (or PEAKE), James
(fl. 1730–70)
One of John Boydell's engravers
after the Masters, and an etcher.
A few landscapes. Exhibited 8
works at Soc. of Artists.

PEARCE, W. B. (fl. 1876–84)
A naturalist, working at London
Zoo. Coastal scenes and land-
scapes.

PEARD, Frances M. (fl. 1888–91)
Of Torquay. Landscapes.
Exhibited 3 works at N.W.C.S.

PEARSALL, Henry W.
(fl. 1824–61)
Lived first in London, and after
c. 1845 in Cheltenham. Land-
scapes with figures. Exhibited 41
works, 4 at N.W.C.S., 12 at R.A.,
12 at B.I., 12 at S.B.A.

PEARSON, Cornelius (d. 1891)
Born Boston, Lincs.; apprenticed
to a London engraver; fl. c. 1843.
Landscapes, chiefly in Wales,
Kent and Ireland, often in
collaboration with T. F.
Wainewright and bearing both
signatures. Exhibited 171 works,
5 at N.W.C.S., 4 at R.A., 145 at
S.B.A. (*Whitworth*)

PEARSON, John (1777–1813)
Born Ripon, Yorks.; probably
brother of William, and perhaps
taught by F. Nicholson; painted in
Shropshire for Lord Hill c. 1804;
influenced by Girtin. Landscapes.
Exhibited 10 works, 2 at R.A., 8 at
S.B.A., 1876–90. (*V. & A.,
Liverpool*)

PEARSON, John Loughborough
(1817–97)
Son of a watercolour painter;
R.A., F.S.A. Architectural subjects.
Exhibited 48 works at R.A.

PEARSON, William
(fl. 1798–1813)
Probably brother of John, and also
so influenced by Girtin that his
work is at times almost as good;
worked first in Yorkshire and
Durham, and later in Shropshire.
Landscapes. Exhibited 36 works,
18 at R.A. (*B.M., V. & A.,
Whitworth*)

PECKHAM, T., Sr (fl. c. 1794)
Drawing master at Addiscombe
Military College, the cadet school
of the East India Company.

PEDDER, John (1850–1929)
Of Liverpool; member R.I. 1898.
Landscapes. Exhibited 50 works,
15 at N.W.C.S., 19 at R.A., 5 at
S.B.A. (*Liverpool*)

PEEL, James (1811–1906)
Born Newcastle-upon-Tyne;
pupil of Dalziel, father of the
well-known engravers; to London
1840; member S.B.A. 1871.
Landscapes. Exhibited 503 works,
248 at S.B.A., 69 at R.A., 37 at B.I.
(*V. & A.*)

PEGRAM, Fred (1870–1937)
Member R.I. 1925. Illustrations.

PELHAM, James, Sr (1800–74)
Born London; son of James
Pelham, a miniaturist; painter to
Queen Charlotte; to Liverpool c.
1846; member and secretary
Liverpool Academy. Painted
portraits and miniatures in oils,
but some landscapes with figures
in watercolour. (*Liverpool*)

PELHAM, James, Jr (1840–1906)
Born Saffron Walden, Essex;
lived in Liverpool; member and
secretary Liverpool Academy,
treasurer and secretary Old
Liverpool Water Colour Society,
and member Old Liverpool
Sketching Club. Landscapes and
genre. Exhibited 5 works, 1 at
R.A., 1 at Grosvenor gallery,

PELLEGRINI, Carlo (1838–89)
Born Capua, near Naples; to
England 1865. Drew caricatures
for 'Vanity Fair' under the
pseudonym 'Ape'. Exhibited 11
works, 1 at R.A., 10 at Grosvenor
gallery, 1878–83.

PELTRO, John (1760–1808)
Well-known engraver, but also
painted landscapes.

PEMEL (or PEMELL), J.
(fl. 1838–51)
Landscapes and figure subjects.
Exhibited 19 works, 13 at R.A., 5
at B.I., 1 at S.B.A. (*V. & A.*)

PENLEY, Aaron Edwin (1807–70)
A miniature-painter in Manchester
1834–35; professor of drawing at
Addiscombe Military College
1855, and later at Woolwich
Royal Military College; water-
colour painter in ordinary to
William IV; wrote on watercolour
painting; member R.I. 1838–56 and
re-elected assoc. 1859. Landscapes.
Exhibited 348 works, 309 at
N.W.C.S., 18 at R.A., 1 at B.I., 20 at
S.B.A. (*B.M., Newcastle*)

PENLEY, Edwin A. (fl. 1853–72)
Landscapes in the style of A. E.
Exhibited 18 works, 11 at S.B.A.

PENNY, William (fl. c. 1816)
A Scottish engraver. Landscapes.
(*Edinburgh*)

PENSON, Frederick T.
(fl. 1891–92)
Of Stoke-on-Trent. Mythological
subjects and landscapes. Exhibited
2 works at R.A. (*V. & A.*)

PENSON, James (b. 1814)
Born Plymouth; studied at Sass's
Academy in London; fl. c. 1884.
Devonshire views.

PENSON, R. Kyrke (1805–86)
Lived in Carmarthen; member
R.I. 1836, F.S.A. Marines and
Welsh landscapes. Exhibited 145
works, 134 at N.W.C.S., 9 at R.A.,
1 at S.B.A.

PEPPERCORN, Arthur Douglas
(1847–1924)
Member R.I. 1897–1903.
Landscapes. Exhibited 63 works,

26 at S.B.A., 11 at R.A. (*V. & A.*)

PERIGAL, Arthur (1816–84)
Born London; assoc. R.S.A. 1841,
member 1868, and treasurer 1880.
Historical subjects, and landscapes
in the Scottish Highlands, Italy and
Norway. Exhibited 21 works, 11
at R.A., 2 at B.I., 1 at S.B.A., 1 at
N.W.C.S. (*Newcastle*)

PERRY, Alfred (fl. 1847–81)
Landscapes in Italy around Rome
and Naples, and in Kent, and
animal subjects. Exhibited 84
works, 30 at R.A. (*V. & A.*)

PERRY, J. M.
See Payne, William (*Note*).

PETHER, Sebastian
Known as 'Moonlight Pether'; son
of Abraham (1756–1812), nephew
of William and brother of Henry
(d. 1862). Cold moonlight effects,
many works likely to be attributed
to W. Payne. Exhibited 8 works,
5 at R.A., 2 at B.I., 1 at S.B.A.
1812–32.

PETHER, William (1731?–1821)
Born Carlisle; uncle of Sebastian;
engraver and miniaturist; taught
G. Arnold, E. Dayes and
H. Edridge. Exhibited 41 works,
20 at Soc. of Artists, 10 at Free
Soc., 11 at R.A. (*V. & A.*)

PETHERICK, Horace William
(1839–1919)
Worked for *Illustrated London
News*. Scriptural subjects.
Exhibited 6 works, 2 at R.A., 3 at
S.B.A. 1859–91.

PETIT, Rev. John Lewis (1801–68)
Archaeologist and amateur artist.
Architectural subjects.

PETITOT, Jean (1607–91)

Born Geneva, the son of a
sculptor and architect; worked in
England and France as a
miniaturist. Returned to Switzer-
land 1687.

PETRIE, Elizabeth C. (fl. 1879–90)
Landscapes. Exhibited 16 works,
4 at N.W.C.S., 11 at S.B.A.

PETRIE, George (1789–1866)
Born Dublin, the son of a portrait-
painter; studied at Dublin
Society's Schools; to Wales 1810,
London 1813; member R.H.A. 1828
and librarian 1830, later president;
wrote on archaeology. Archi-
tectural subjects. Exhibited 2
works at R.A.

PETRIE, Graham (1859–1940)
Member R.I. 1903–37, member
R.O.I. Landscapes and figure
subjects. Exhibited 13 works, 3 at
N.W.C.S., 1 at R.A., 5 at S.B.A.
(*V. & A.*)

PETTY, W. R. (fl. 1886–93)
Domestic subjects. Exhibited 9
works, 5 at N.W.C.S., 1 at R.A., 1 at
S.B.A.

PHILLIP, Colin Bent (1856–1932)
Assoc. R.W.S. 1886, member 1898.
Landscapes. Exhibited 80 works,
59 at O.W.C.S., 12 at R.A.

PHILLIP, John (1817–67)
Born Aberdeen; sent to London
1836 by Lord Panmure to study
under T. M. Joy; studied at R.A.
1837; to Aberdeen 1840 but soon
returned to London; visited Spain
1852; A.R.A. 1857, R.A. 1859.
Portraits, and historical and
domestic subjects, mostly Spanish
after 1852. Exhibited 73 works,
55 at R.A., 12 at B.I., 6 at S.B.A.
(*V. & A., Edinburgh*)

PHILLIPS, Giles Firman
(1780–1867)
Member N.W.C.S. 1831; published
'The Theory and Practice of
Painting in Water Colours' 1838.
Views on the Thames, and
marines. Exhibited 103 works, 16
at N.W.C.S., 17 at R.A., 10 at B.I.,
50 at S.B.A. (*V. & A.*)

PHILLIPS, Lawrence Barnett
(1842–1922)
A watch-maker, and inventor of
watch movements; retired from
business 1882 to paint; also an
etcher. Buildings. (*V. & A.*)

PHILLIPS, Thomas (1770–1845)
Born Dudley, Worcs.; at first a
glass painter, but later painted
portraits of Royalty, and so on;
R.A. Exhibited 342 works, 341 at
R.A., 1 at B.I. 1792–1845.

PHILLIPS, W. (fl. c. 1803)
A little-known landscape-painter.

PHILLOTT, Constance
(fl. 1842–1931)
Assoc. R.W.S. 1882. Domestic
subjects. Exhibited 119 works,
57 at O.W.C.S., 15 at R.A., 5 at
S.B.A.

PHILP, James George (1816–85)
Born Falmouth; assoc. N.W.C.S.
1856, member 1863. Landscapes.
Exhibited 364 works, 347 at
N.W.C.S., 9 at R.A., 5 at S.B.A.
1848–85.

PHYSICK
A large family working c.
1800–70, most of them sculptors.
Some were portraitists, and
several, including T. and William,
painted watercolour landscapes or
marines.

PICKEN, Andrew (1815–45)

Known as a lithographer, but painted a few landscapes.

PICKERING, George (1794–1857)
Born Yorkshire; perhaps a pupil of John Glover; a drawing master in Chester; hon. member Liverpool Academy. Drew landscapes for Ormerod's 'History of Cheshire'. Cottage scenes. Exhibited 15 works, 11 at o.w.c.s., 4 at s.b.a. (*V. & A.*)

PICKERSGILL, Frederick Richard (1820–1900)
Born London; nephew of H. W. Pickersgill r.a., and pupil of his uncle W. F. Witherington r.a.; studied at r.a. 1840; a.r.a. 1847, r.a. 1857, keeper and trustee r.a. 1873–87, h.r.a. from 1888. Scenes from Shakespeare, Milton, and so on, and historical subjects. Exhibited 56 works, 50 at r.a., 6 at b.i. 1839–75.

PICKERSGILL, Henry William (1782–1875)
Born London; studied under G. Arnald, and at r.a. 1805; a.r.a. 1822, r.a. 1826. Portraits. Exhibited 410 works, 384 at r.a., 26 at b.i. 1806–72. (*Newport*)

PIDGEON, Henry Clark (1807–80)
Taught drawing in London; professor at Liverpool Institute c. 1843; assoc. Liverpool Academy 1847, member 1848, hon. secretary 1850 and retired 1865; assoc. n.w.c.s. 1846, member 1861. Antiquarian subjects, and landscapes in the upper Thames Valley. Exhibited 279 works, 258 at n.w.c.s., 4 at r.a., 2 at b.i., 5 at s.b.a. (*Liverpool*)

PIGOTT, W. H. (fl. 1869–93)
Of Sheffield. Domestic subjects.

Exhibited 13 works, 7 at n.w.c.s., 4 at r.a., 2 at s.b.a.

PIKE, W. H. (fl. 1874–93)
Of Plymouth. Landscapes. Exhibited 85 works, 8 at n.w.c.s., 2 at r.a., 60 at s.b.a.

PILKINGTON, Sir William, Bart. (1775–1850)
Friend of Sir George Beaumont, and follower of R. Wilson; travelled in Italy. Landscapes and architectural subjects. Exhibited 4 works at r.a.

PILLEAU, F. Startin (fl. 1882–92)
Churches. Exhibited 10 works, 9 at n.w.c.s.

PILLEAU, Henry (1813–99)
Deputy-general to Hospitals, and therefore widely travelled; member r.i. 1882. Topographical drawings of Venice, Middle East and India. Exhibited 313 works, 76 at n.w.c.s., 25 at r.a., 10 at b.i., 30 at s.b.a. (*V. & A.*)

PILLEMENT, Jean (1728?–1808)
Born Lyons; worked as a draughtsman in Paris at the Gobelins factory; appointed painter to the King of Poland; to England by 1757, Austria 1767, Portugal 1780; taught drawing in England. Chinoiserie in every medium, and some English views. Exhibited 12 works, 8 at Soc. of Artists, 4 at Free Soc. 1760–80. (*V. & A., Nottingham, B.M.*)

PILSBURY, Wilmot (1840–1908)
Studied at Birmingham School of Art and Art Training School, South Kensington; headmaster Leicester School of Art; assoc. r.w.s. 1881, member 1898. Domestic subjects. Exhibited 311 works, 230 at o.w.c.s.

PINE, Simon (d. 1772)
Born Dublin, the son of an
engraver. Miniature-painter in
Ireland and at Bath; fl. 1765–71.
Exhibited 18 works, 15 at Soc. of
Artists, 3 at R.A.

PINWELL, George John
(1842–75)
Born High Wycombe; studied at
St Martin's Lane School and
Heatherley's School of Art;
became a book illustrator, and
from 1864 worked for the
Dalziel brothers; assoc. o.w.c.s.
1869, member 1870. Domestic
subjects. Exhibited 68 works, 60
at o.w.c.s. (*Newcastle, Whitworth,
V. & A.*)

PISSARRO, Camille (1830–1903)
Born West Indies; to Paris 1855,
where he met Corot, Monet and
others later to become Impres-
sionists; in London 1870. A figure
subject 'Midday Rest' is in Leeds
City Art Gallery.

PITCHER, William John Charles
(1858–1925)
Member R.I. 1920. Landscapes.

PITMAN, Janetta (fl. 1880–90)
Of Nottingham. Still-lifes.
Exhibited 30 works, 9 at N.W.C.S.

PITT, William (fl. 1853–90)
Of Birmingham. Landscapes.
Exhibited 87 works, 4 at R.A., 10
at B.I., 55 at S.B.A., 1 at N.W.C.S.
(*V. & A.*)

PIXELL, Maria (fl. 1793–1811)
Perhaps a pupil of S. Gilpin.
Landscapes. Exhibited 34 works,
31 at R.A., 3 at B.I.

PLACE, Francis (1647–1728)
Studied law in London; friend of
W. Hollar; lived at York but

travelled extensively throughout
Britain; a noted etcher, engraver,
antiquarian and potter. Views in
pen, lightly washed with bistre,
still-life, birds, fish and flowers.
(*V. & A., B.M., Cardiff, York*)

PLACE, George (fl. 1791–97)
Son of a Dublin linen-draper;
studied at Irish Academy Schools;
to London 1791, but later moved
to Yorkshire. Miniatures.
Exhibited 43 works at R.A.

PLATT, Henry (fl. 1825–65)
Rustic subjects. Exhibited 64
works, 9 at N.W.C.S., 7 at R.A., 22
at B.I., 26 at S.B.A.

PLATT, John (1732–1803)
Born Winchester; to London 1756,
and studied under R. Wilson;
later returned to Winchester.
Miniatures. Exhibited 40 works
1764–1803.

PLIMER, Andrew (1763–1837)
Born Wellington, Salop; son of a
watch-maker, and trained as such;
travelled for a time with gypsies;
became servant to R. Cosway.
Miniatures. Exhibited 55 works,
50 at R.A., 3 at B.I., 2 at S.B.A.
1786–1830.

PLIMER, Nathaniel (1757–1822?)
Born Wellington, Salop; brother
of Andrew; became assistant to
H. P. Bone. Miniatures. Exhibited
33 works, 5 at Soc. of Artists, 28 at
R.A. 1787–1815.

POCOCK, H. Childe (fl. 1880–92)
Domestic subjects. Exhibited 16
works, 8 at N.W.C.S., 2 at R.A., 5 at
S.B.A.

POCOCK, Isaac (1782–1853)
Born Bristol; son of Nicholas;
studied under G. Romney in 1798

and later under W. Beechey;
member Liverpool Society of
Artists 1812. Domestic subjects.
Exhibited 120 works, 73 at R.A.,
47 at B.I. 1803–18.

POCOCK, Lexden L. (1850–1919)
Born London; son of Lewis
Pocock, F.S.A.; studied at the
Slade school, and later at R.A.;
studied and taught for 2 years in
Rome; member of council Dudley
Art Society. Landscapes and figure
subjects. Exhibited 73 works, 8 at
N.W.C.S., 19 at R.A., 19 at S.B.A.
(*V. & A.*)

POCOCK, Nicholas (1741–1821)
Son of a Bristol merchant, and
father of Isaac; grandfather of
G. A. Fripp; commanded a
merchant vessel, then settled in
London 1789, where he was
encouraged by Reynolds; founder
member O.W.C.S. Marines and
landscapes (the best are Welsh),
often attributed to De Louther-
bourg. Exhibited 322 works, 184
at O.W.C.S., 113 at R.A., 25 at B.I.
(*V. & A., B.M., Sheffield,
Newport, Greenwich, Norwich*)

POCOCK, William Fuller
(1779–1849)
An architect. Exhibited 21 works
at R.A. 1799–1841.

POINGDESTRE, Charles H.
(fl. 1849–90)
Sporting subjects. Exhibited 50
works, 9 at N.W.C.S.

POLLACK, Solomon (1757–1839)
Born the Hague; worked in
London and Dublin, and died in
Chelsea. Miniatures. Exhibited 72
works, 67 at R.A., 5 at S.B.A.
1790–1835.

POLLEN, John Hungerford

(1820–1902)
F.S.A., Fellow of Merton College,
Oxford, where he painted the
chapel ceiling; helped Rossetti and
Burne-Jones decorate Oxford
Union 1857; professor of fine arts
Roman Catholic University,
Dublin; editor of V. & A.
catalogues. Historical subjects.
Exhibited 5 works, at R.A.
(*V. & A.*)

POOLE, Christopher (fl. 1882–91)
Landscapes. Exhibited 40 works,
9 at N.W.C.S., 5 at R.A., 25 at S.B.A.

POOLE, Paul Falconer (1807–79)
Born Bristol; self-taught; A.R.A.
1846, R.A. 1861, H.R.A. 1879,
member R.I. 1878. Historical
subjects. Exhibited 95 works,
4 at N.W.C.S., 65 at R.A., 13 at B.I.,
13 at S.B.A. (*V. & A., B.M.,
Gateshead, Newport*)

POPE, Alexander (d. 1835)
Born Cork, the son of a miniature-
painter; studied at Dublin Art
School; to London 1783.
Miniatures. Exhibited 67 works at
R.A. 1787–1821.

POPE, Mrs Alexander
See Leigh, Clara Maria.

POPE, Henry Martin (1843–1908)
Born Birmingham; apprenticed to
a lithographer; studied painting
under H. H. and Samuel Lines and
Edward Warson; worked much in
North Wales with B. W. Evans.
Landscapes. Exhibited 7 works,
2 at N.W.C.S., 5 at S.B.A.
(*Birmingham*)

POPERT, Charlotte (fl. 1883–89)
Domestic subjects. Exhibited 5
works, 4 at N.W.C.S., 1 at S.B.A.

PORTER, Sir Robert Kerr

(1777–1842)
Born Durham; studied at R.A.
1790; member of Girtin's Sketch
Club 1799; scene-painter at
Lyceum Theatre 1800; historical
painter to the Czar in Russia 1804;
as an army captain visited also
Sweden, Germany, Spain, Persia
and Mesopotamia. Battle scenes.
Exhibited 39 works, 38 at R.A., 1 at
S.B.A., 1792–1832. (*B.M.,
V. & A.*)

POTTER, Beatrix
 (Mrs William Heelis)
 (1866–1943)
 Born London; lived there and in
 the Lake District; famous writer
 and illustrator of children's books,
 also some landscapes and
 historical drawings. (*Tate, Armitt
 Library, Ambleside*)

POTTS, John Joseph (1844–1933)
 Born Newcastle-upon-Tyne; a
 founder of the Bewick Club.
 Landscapes, mostly Welsh.
 (*Newcastle*)

POUNCY (or POUNCEY)
 Benjamin Thomas (d. 1799)
 Born Lambeth; brother-in-law of
 the engraver Woollett, who taught
 him; from c. 1780 at Lambeth, and
 was deputy librarian at the
 Palace, fl. 1772–89. Landscapes.
 (*Maidstone, V. & A., Whitworth*)

POWELL, Alfred (fl. 1866–92)
 Landscapes. Exhibited 115 works,
 20 at N.W.C.S., 17 at R.A., 52 at
 S.B.A. (*V. & A.*)

POWELL, C. F. (fl. 1831–35)
 Landscapes. Exhibited 29 works,
 8 at N.W.C.S., 5 at R.A., 16 at S.B.A.

POWELL, C. M. (d. 1824)
 Began life as a sailor; self-taught;
 fl. 1807–21. Marines, with a

delicate touch on the rigging.
Exhibited 40 works, 29 at R.A.,
11 at B.I. (*V. & A.*)

POWELL, Sir Francis (1833–1914)
 Born Pendleton, Manchester;
 studied at Manchester School of
 Art; founder and first president
 Scottish Society of Painters in
 Water Colours; assoc. O.W.C.S.
 1867, member 1876; knighted
 1893. Marines and lake views.
 Exhibited 206 works, 190 at
 O.W.C.S. (*V. & A.*)

POWELL, John (b. 1780)
 A successful drawing master.
 Landscapes. Exhibited 80 works,
 75 at R.A., 5 at O.W.C.S.,
 1797–1829.

POWELL, Joseph (fl. 1780–1833)
 Often mistakenly called John;
 possibly taught by B. T. Pouncy,
 and himself a drawing master and
 etcher. Landscapes. Exhibited 80
 works, 50 at O.W.C.S. (*V. & A.,
 B.M., Newport, Newcastle,
 Whitworth*)
 (*Note.* There is some confusion
 between this artist and the Joseph
 Powell who was first president
 N.W.C.S. in 1832 and a portrait-
 painter, exhibiting 29 works at
 N.W.C.S. 1808–34 (he died in
 1834), according to Cundall and
 Graves.)

POWELL, Leonard M.
 (fl. 1882–93)
 Landscapes. Exhibited 15 works,
 5 at N.W.C.S., 5 at R.A., 2 at S.B.A.

POWELL, P. (fl. 1826–54)
 Marines, and landscapes in Kent
 and Sussex, and on the Continent.
 Exhibited 30 works, 5 at N.W.C.S.,
 10 at R.A., 6 at B.I., 9 at S.B.A.

POWER, A. W. (fl. 1789–1830)

Lived at Maidstone. Flowers and Italian landscapes. Exhibited 2 works at R.A. (*V. & A.*)

POWLE, George (fl. 1750–77)
Best known as a portrait-engraver in the style of T. Worlidge, his teacher. Views in Herefordshire, engraved by James Ross.

POYNTER, Ambrose (1796–1886)
Born London; father of Sir E. J.; employed by John Nash 1814–19; travelled in Italy 1819–21; founder member of R.I.B.A. Landscapes in the style of T. Shotter Boys, and still-lifes in the style of De Wint. Exhibited 9 works at R.A. (*V. & A.*)

POYNTER, Sir Edward John, Bart. (1836–1919)
Born Paris; son of Ambrose; visited Madeira 1852; to Rome 1853 working with Lord Leighton; studied at Leigh's Academy and under W. C. T. Dobson, and at R.A. 1855; in Paris 1856–59 a pupil of Gleyre; A.R.A. 1868, R.A. 1876 and president 1896; member R.W.S. 1883. Landscapes and historical subjects. Exhibited 255 works, 35 at O.W.C.S., 70 at R.A., 63 at Grosvenor gallery. (*V. & A.*)

PRENTICE, Kate (1845–1911)
Born Stowmarket, Suffolk; as a child lived near Leeds, and later moved to London; mostly self-taught. Landscapes, and subjects in Kew Gardens, South of England, and Yorkshire. Exhibited 5 works, 2 at N.W.C.S. (*V. & A.*)

PRETTY, Edward (1792–1865)
Born Hollingbourne, Kent; drawing master at Rugby School 1809; first curator of Maidstone Museum; worked for Ackermann; published topographical guide-books. Landscapes. Exhibited 3 works, 2 at B.A. (*B.M., Maidstone*)

PRICE, Mrs Frank Corbin (fl. 1890–93)
Domestic subjects. Exhibited 8 works, 5 at N.W.C.S., 3 at R.A.

PRICE, James (fl. 1842–76)
Worked around Charlton, in Kent. Rustic scenes and landscapes. Exhibited 75 works, 38 at S.B.A., 26 at R.A., 7 at B.I.

PRICE, Robert (fl. 1756–61)
Father of Sir Uvedale, 'the Picturesque' architect; pupil of Malchair. Landscapes, some engraved by James Basire (1730–1802).

PRICE, Sarah Woodward (fl. c. 1820)
Landscapes. (*Nottingham*)

PRICE, William Lake (1810–1890's)
Articled to architect A. C. Pugin; had lessons from De Wint; travelled much on the Continent; assoc. O.W.C.S. 1837–52. Portraits, architectural and historical subjects. Exhibited 63 works, 49 at O.W.C.S., 7 at R.A., 5 at N.W.C.S. (*V. & A., B.M.*)

PRIEST, Alfred (1810–50)
Pupil of H. Ninham, and like him of the Norwich School; a capable etcher. Norfolk coastal scenes, and landscapes in Norfolk, Derbyshire, on the Wye and at Oxford. Exhibited 89 works, 17 at R.A., 23 at B.I., 49 at S.B.A., 1833–47.

PRIOR, William Henry (fl. 1833–57)
Landscapes. Exhibited 21 works, 4 at N.W.C.S., 2 at R.A., 1 at B.I., 14 at S.B.A.

PRITCHETT, Edward T.
(fl. 1828–64)
One of four artists of this name, probably relatives of a noted gunsmith; best known for views of Venice in oils. Architectural watercolours rather in the style of D. Roberts. Exhibited 23 works, 3 at R.A., 17 at B.I., 3 at S.B.A. (*V. & A., Newport, Whitworth, Newcastle*)

PRITCHETT, Robert Taylor
(1828–1907)
Son of the gun-smith referred to above; widely travelled; published many travel books, and was an illustrator. Landscapes, some Indian. Exhibited 18 works, 4 at R.A., 1 at S.B.A., 1851–77. (*V. & A.*)

PROCTOR, Adam Edwin
(1864–1913)
Member R.I. 1909.

PROUT, John Skinner (1806–76)
Born Plymouth; nephew of Samuel; largely self-taught, though probably had lessons from Samuel; friend of W. J. Müller, and worked with him in Bristol; lived in Australia for a time; member N.W.C.S. 1838, forfeited membership, but re-elected assoc. in 1849, member 1862. Landscapes, some continental, and architectural subjects of Old Bristol. Exhibited 281 works, 278 at N.W.C.S. (*V. & A., B.M., Newport*)

PROUT, Mrs Margaret Fisher
(1875–1963)
A.R.W.S. 1938, R.W.S. 1945, daughter of Mark Fisher, the American painter. A.R.A. 1948. Flowers, horses and figure studies.

PROUT, Samuel (1783–1852)

Born Plymouth; first empoyled by John Britton in Cornwall; to London 1811; member O.W.C.S. 1819, after which time he travelled much on the Continent and developed a love for old buildings; painter in watercolours to George IV and Queen Victoria; a competent lithographer of his own drawings. At first English landscapes and coastal scenes, and later continental architecture with much use of his well known 'broken line'. Exhibited 656 works, 560 at O.W.C.S., 28 at R.A., 8 at B.I. (*V. & A., Newport, Whitworth, Exeter, Manchester, Bristol, Birmingham, Derby*)

PROUT, Samuel Gilhespie
(1822–1911)
Born Brixton, near Plymouth; son of Samuel, and much influenced by him; friend of John Ruskin and Wm. Henry Hunt; Spain 1874, Egypt 1884. Landscapes and architectural subjects. (*V. & A.*)

PUGH, Charles J. (fl. 1795–1828)
Landscapes in Surrey, Sussex, Wales and Isle of Wight. Exhibited 19 works at R.A.

PUGH, Edward (fl. 1793–1813)
Exhibited only miniatures, but also painted landscapes; a well-known illustrator. Exhibited 26 miniatures, 25 at R.A., 1 at B.I.

PUGIN, Augustus Charles
(1762–1832)
Born France; to England during the French Revolution; studied at R.A.; worked with John Nash; a leader of the Gothic Revival; assoc. O.W.C.S. 1807, member 1812. Architectural views in London, Oxford and elsewhere. Exhibited 98 works, 77 at O.W.C.S., 18 at R.A., 3 at B.I. (*V. & A.,*

*B.M., Sheffield, Newport,
Whitworth*)

PUGIN, Augustus Welby
Northmore
(1812–52)
Born London; son of A. C., and
trained by him; wrote on Gothic
architecture; became insane 1851.
Architectural subjects. Exhibited 8
works at R.A. (*V. & A., B.M.*)

PURDON, George (fl. 1772–77)
Portraits, animals, and landscapes
in chalk and watercolour.
Exhibited 7 works, 1 at Soc. of
Artists, 6 at Free Soc.

PURSER, William (fl. 1805–34)
For a time in Greece and Middle
East; drew for topographical
publications. Eastern subjects and
architecture. Exhibited 23 works,
22 at R.A. (*V. & A., B.M.,
Newcastle*)

PYE, Charles (b. 1777)
Engraver and illustrator.

PYE, John (1745–84)
Known as 'the Elder'. Landscapes.
Exhibited at R.A.

PYE, William (fl. 1881–90)
Of Hadleigh. Landscapes.
Exhibited 30 works, 4 at N.W.C.S.,
1 at R.A., 13 at S.B.A.

PYNE, Annie C. (fl. 1886–92)
Landscapes. Exhibited 14 works,
8 at N.W.C.S., 6 at S.B.A.

PYNE, Charles (fl. 1861–80)
Landscapes. Exhibited 62 works,
54 at S.B.A., 1 at R.A.

PYNE, Charles Claud (1802–78)
Taught drawing at Guildford
Grammar School. Landscapes,
some in Wales, but mostly
continental. Exhibited 3 works,

2 at R.A., 1 at B.I. 1836–39.
(*V. & A.*)

PYNE, Eva E. (fl. 1886–93)
Landscapes. Exhibited 16 works,
8 at N.W.C.S., 8 at S.B.A.

PYNE, George (1800?–84)
Son of W. H.; assoc. O.W.C.S.
1827–43. Interiors and exteriors of
buildings, notably of Oxford
colleges. Exhibited 41 works, 38
at O.W.C.S., 2 at S.B.A. (*V. & A.,
B.M., Dublin*)

PYNE, James Baker (1800–70)
Born Bristol; articled to a lawyer,
but preferred art; taught W. J.
Müller; to London 1835; travelled
in Italy and elsewhere on the
Continent; member S.B.A. 1841 and
subsequently vice-president.
Landscapes, especially lake and
river scenes, often numbered.
Exhibited 252 works, 206 at S.B.A.,
7 at R.A., 28 at B.I. (*V. & A.,
B.M., Newport, Gateshead,
Newcastle, Whitworth*)

PYNE, Thomas (1843–1935)
Member R.I. 1885 and R.B.A.
Landscapes. Exhibited 232 works,
64 at N.W.C.S., 14 at R.A., 110 at
S.B.A.

PYNE, W. B.
A little-known mid-19th century
watercolourist, probably related
to W. H. Landscapes with animals
and figures.

PYNE, William Henry
(1769–1843)
Born Holborn, London. Father of
George; published illustrated
books on many subjects, and
magazine articles, often under
the pseudonym of Ephraim
Hardcastle; founder member
O.W.C.S. 1804–09. Landscapes.
Exhibited 80 works, 22 at R.A.,

58 at o.w.c.s. (*V. & A., B.M.,*
Bedford, Whitworth)

QUARTLEY, Arthur (fl. 1884–85)
Worked in London. Landscapes.
Exhibited 3 works, 2 at s.b.a.

QUILTER, Harry (fl. 1884–92)
Landscapes. Exhibited 11 works.

QUINTON, Alfred Robert
(fl. 1874–93)
Landscapes. Exhibited 44 works,
9 at n.w.c.s., 7 at r.a., 18 at s.b.a.

RACKETT, Thomas (1757–1841)
Pupil of P. Sandby and of T. T.
Forrest; an amateur antiquarian,
rector of Spettisbury, Dorset.
Landscapes.

RACKHAM, Arthur (1867–1939)
Studied at Lambeth School of Art;
assoc. r.w.s. 1902, member 1908,
vice-president 1910. Illustrator of
fairy stories. (*V. & A.*)

RADCLYFFE (or RADCLIFFE),
Radcliffe W.
(fl. 1875–91)
Of Guildford. Domestic subjects.
Exhibited 102 works, 9 at n.w.c.s.,
27 at r.a., 28 at s.b.a.

RADCLYFFE, Charles Walter
(1817–87)
Son of engraver William, and
brother of engraver Edward and
portrait-painter William Jr;
worked in Birmingham and
London. Landscapes, mostly in
Warwickshire. Exhibited 34
works, 5 at n.w.c.s., 3 at r.a., 5 at
b.i., 3 at s.b.a.

RADCLYFFE, William
(1780–1855)
Born Birmingham; an engraver.
Illustrations for 'Graphic
Illustrations of Warwickshire' and
Roscoe's 'Wanderings in North
and South Wales'.

RADCLYFFE, William, Jr
(d. 1846)
Son and pupil of engraver
William. Portraits. Exhibited 4
works, 2 at r.a., 2 at s.b.a.
1834–43.

RADFORD, Edward (b. 1831)
a.r.w.s. 1875, resigned 1913.
Landscapes.

RADFORD, James (fl. 1841–59)
Landscapes. Exhibited 28 works,
15 at r.a., 5 at b.i., 7 at s.b.a.

RAEBURN, Sir Henry (1756–1823)
Born Stockbridge, Edinburgh;
Scottish portrait-painter and
teacher of many who later became
famous; studied in Rome 1785–87;
a.r.a. 1814, r.a. 1815. Portraits.
Exhibited 53 works at r.a.
1792–1823.

RAGON, Adolphe (fl. 1872–93)
Landscapes. Exhibited 30 works,
9 at n.w.c.s.

RAILTON, F. J. (fl. 1846–66)
Landscapes. Exhibited 51 works,
17 at r.a., 23 at b.i., 11 at s.b.a.

RAIMBACH, Abraham
(1776–1843)
Born London, of Swiss birth;
apprenticed to engraver J. Hall;
studied at r.a. Miniatures.
Exhibited 13 works at r.a.

RAIMBACH, David Wilkie
(1820–95)
Son of Abraham, and a godson of

Wilkie; studied at R.A.; head-
master at Limerick and
Birmingham Schools of Art.
Portraits, landscapes and interiors.
Exhibited 22 works, 16 at R.A.,
6 at S.B.A. 1843–55. (*V. & A.*)

RAINEY, William (1852–1936)
Member R.I. 1891. Landscapes.
Exhibited 40 works, 12 at N.W.C.S.,
13 at R.A., 6 at S.B.A.

RALPH, G. Keith (fl. 1778–1811)
Portrait-painter to the Duke of
Clarence. Exhibited 45 works, 9 at
Soc. of Artists, 35 at R.A., 1 at
S.B.A.

RAMSAY, Allan (1713–84)
Born Edinburgh; eldest son of
poet Allan; studied in Italy;
settled in London 1762; portrait-
painter to George III 1767.
Portraits.

RANDALL, James (fl. 1798–1814)
Worked in London. Aquatinted
architectural subjects. Exhibited
21 works at R.A.

RANKEN, William Bruce Ellis
(1881–1941)
Member R.I. 1915; vice-president
R.O.I. Landscapes.

RASHLEIGH, Peter (1746–1836)
A pupil of Malchair; Fellow of All
Souls, Oxford; rector of New
Romney, Kent 1781; settled in
Southfleet, Kent 1788.

RATHBONE, John (1750–1807)
Born Cheshire; self-taught; friend
of Morland and Ibbetson; member
Liverpool Society of Arts. Land-
scapes, mostly in Cumberland.
Exhibited 50 works, 2 at Soc. of
Artists, 48 at R.A. 1785–1806.
(*B.M., V. & A.*)

RAVEN, Rev. Thomas (1795?–1868)
Little known, but worked at
Budleigh Salterton, Devon 1865.
Landscapes in Wales, Devon and
the Lakes. (*V. & A.*)
(*Note.* His son, John Samuel
(1829–77), is better known as a
landscapist, but in oils, exhibiting
81 works.)

RAVENSCROFT, Ernest (1852–88)
Born London; travelled on the
Continent buying lace; self-taught,
with a studio in Newport,
Monmouth; worked at Frost and
Reed of Bristol; became manager
of the Theatre Royal, Wakefield.
Landscapes. (*Newport*)

RAWLE, John S. (fl. 1870–87)
Of Nottingham. Religious
subjects. Exhibited 24 works,
3 at N.W.C.S., 14 at R.A., 2 at S.B.A.

RAWLE, Samuel (1770?–1860)
An engraver and draughtsman,
but also painted country seats.
Exhibited 2 works at R.A. 1801–06.
(*V. & A.*)

RAWLINGS (or RAWLINS),
Sophia (fl. *c.* 1783)
Landscapes. Exhibited 2 works at
Free Society.

RAWLINSON, Richard (fl. c. 1656)
An early draughtsman of archi-
tectural views, some of them used
as illustrations to Daniel King's
folio of cathedrals.

RAYNER, Louise J. (fl. 1852–1900)
Daughter of Samual A.
Landscapes. Exhibited 91 works,
17 at N.W.C.S., 31 at R.A., 1 at B.I.,
12 at S.B.A. (*V. & A.*)

RAYNER, Nancy (1827–55)
Daughter of Samuel A.; assoc.
O.W.C.S. 1850. Rustic figure

subjects, interiors and portraits.
Exhibited 24 works, 15 at o.w.c.s.,
3 at R.A.

RAYNER, Samuel A.
(fl. 1821–d. 1874)
Assoc o.w.c.s. 1845 but expelled
1851. Topography in sepia wash,
and old buildings and interiors in
the Cattermole style; some
engraved in Britton's 'Cathedral
Antiquities'. Exhibited 93 works,
30 at o.w.c.s., 20 at R.A., 4 at B.I.,
22 at s.B.A. (*B.M.*)

READ, David Charles (1790–1851)
Born Salisbury, and taught
drawing there. Landscapes.
Exhibited 14 works, 1 at R.A., 7 at
B.I., 6 at s.B.A. 1823–40.

READ, Samuel (1816–83)
Born Needham Market, Suffolk;
first worked for an Ipswich lawyer,
then for an architect; to London
1841, and learnt drawing on wood
under J. W. Whymper; worked
for the *London Illustrated News*
1844 onwards; visited Con-
stantinople (Istanbul) 1853 to
make sketches of the Crimean
War; assoc. o.w.c.s. 1857,
member 1880. Chiefly very fine
architectural subjects and topo-
graphy, but also some shipping
scenes. Exhibited 259 works, 212
at o.w.c.s., 18 at R.A., 13 at s.B.A.
(*V. & A., Ipswich*)

READY, William James Durent
(1823–73)
Little known marines, usually
signed 'Durant' or 'W.F.R.'
Exhibited 6 works, 2 at R.A., 3 at
B.I., 1 at s.B.A.

REDGRAVE, Evelyn Leslie
(fl. 1872–88)
Landscapes. Exhibited 39 works,
7 at N.W.C.S., 12 at R.A., 8 at s.B.A.

REDGRAVE, Richard (1804–88)
Born Pimlico; studied at R.A.
1826; joint author of 'A Century of
Painters of the English School';
director at South Kensington
Museum until 1875; compiled a
catalogue of V. & A. collection of
drawings; A.R.A. 1840, R.A. 1851,
H.R.A. 1881. Figure subjects from
literature, domestic and Biblical
subjects, and landscapes in the
Home Counties. Exhibited 188
works, 141 at R.A., 18 at B.I., 18 at
s.B.A. 1825–83. (*V. & A., B.M.*)

REDPATH, Miss Anne (Mrs
Mitchie) (1895–1965)
Born Galashiels, Scotland; Assoc.
R.W.S. 1962. Studied at Edinburgh
College of Art. Daughter of a
tweed merchant. Flowers, interiors
and landscapes.

REED, Joseph Charles (1822–77)
Assoc. N.W.C.S. 1861, member
1866. Landscapes. Exhibited 190
works, 186 at N.W.C.S., 1 at R.A.,
3 at s.B.A.

REEVES, Mary (fl. 1871–87)
Of Cork. Landscapes. Exhibited 7
works, 3 at N.W.C.S., 2 at s.B.A.

REID, Andrew (1831–1902)
Well-known illustrator of
Wornum's 'Life of Holbein'.
Topography. (*V. & A.*)

REID, John Robertson (1851–1926)
Member R.I. 1897. Landscapes.

REINAGLE, George Philip
(1803–35)
Son of R. R.; present at the Battle
of Navario 1827. Marines.
Exhibited 72 works, 37 at R.A.,
30 at B.I., 5 at s.B.A. 1822–35.
(*B.M.*)

REINAGLE, Philip (1749–1833)

Born Scotland, of Hungarian descent, the son of a musician; studied under Allan Ramsay, and at R.A. 1769; A.R.A. 1787, R.A. 1812. Copies of Dutch Masters, animal and hunting subjects, and landscapes mostly after 1794. Exhibited 253 works, 114 at R.A., 138 at B.I., 1 at S.B.A. (*V. & A., B.M.*)

REINAGLE, Ramsay Richard (1775–1862)
Son of Philip; studied under Philip and then in Italy and Holland; assoc. O.W.C.S. 1805, member 1806, and president 1808–12; A.R.A. 1814, R.A. 1823–48. Landscapes. Exhibited 364 works, 67 at O.W.C.S., 244 at R.A., 51 at B.I., 2 at S.B.A. (*V. & A., B.M., Newcastle, Whitworth*)

RENDLE, John Morgan (b. 1889)
Member R.I. 1937.

RENTON, John (fl. 1799–1841)
Figure subjects and landscapes in the styles of J. Varley and J. S. Cotman, mostly in the Lake District and Thames Valley. Exhibited 51 works, 40 at R.A., 10 at B.I., 1 at S.B.A. (*B.M.*)

REPTON, Humphrey (1752–1818)
Born Bury St Edmunds; to Holland 1764, and returned to Norwich; private secretary to Lord Wyndham (secretary to the Lord Lieutenant of Ireland), when he took up landscape-gardening; employed by the Duke of Portland at Welbeck Abbey. Drawings of gardens. Exhibited 15 works at R.A. (*V. & A., B.M., Newcastle*)

REVELEY, Willey (d. 1799)
Pupil of Sir William Chambers; fl. 1781–93; visited Rome 1784 and Athens 1785, always

sketching and learning classical design. Architectural subjects, mostly abroad. Exhibited 12 works at R.A. (*V. & A.*)

REVETT, Nicholas (1721–1804)
Born Brandeston Hall, Suffolk; travelled in Greece and Italy. Illustrated books on Athenian antiquities by 'Athenian Stuart'.

REYNOLDS, Elizabeth
See Walker, Mrs William.

REYNOLDS, Frances (1729–1807)
Born Plympton, Devon; sister of Sir Joshua. Miniatures, and miniature copies of her brother's work.

REYNOLDS, Frederick George (1824?–1921)
Little-known topographer. Exhibited 58 works, 32 at R.A., 8 at S.B.A. 1859–87. (*V. & A., Newcastle*)

REYNOLDS, Sir Joshua (1723–92)
Born Plympton, near Plymouth, the son of a clergyman; to London 1740 to study art; in Rome 1749–52; member Incorp. S.A.; first president R.A. 1768. Portraits. Exhibited 272 works, 25 at Soc. of Artists, 247 at R.A. 1760–90.

REYNOLDS, Samuel William (1773–1835)
Born London; studied under W. Hodges, and at R.A.; visited France 1826; a fine mezzotint engraver after Sir Joshua and other contemporary painters. Landscapes. Exhibited 131 works, 65 at R.A., 56 at B.I., 10 at S.B.A. (*V. & A., B.M.*)

REYNOLDS, Walter (fl. 1859–85)
Landscapes. Exhibited 51 works,

2 at N.W.C.S., 7 at R.A., 41 at S.B.A.
(*V. & A.*)

REYNOLDS-STEPHENS,
William (fl. 1884–93)
Domestic subjects. Exhibited
20 works, 4 at N.W.C.S., 12 at R.A.,
2 at S.B.A.

RHEAM, Henry R. (fl. 1887–93)
Of Birkenhead; member R.I.
Domestic subjects. Exhibited 10
works, 3 at N.W.C.S., 6 at R.A., 1 at
S.B.A.

RHODES, Miss H. (fl. 1811–13)
A Sheffield amateur, but worked
also in Derbyshire and at
Liverpool. Landscapes, some of
which were engraved. Exhibited
5 works at R.A.

RHODES, John Nicholas (1809–42)
Born Leeds; taught by his father
Joseph; to London c. 1832;
returned to Leeds, where he died.
Landscapes, and rustic figure
subjects. Exhibited 8 works, 2 at
R.A., 4 at B.I., 2 at S.B.A., 1839–42.
(*Leeds*)

RHODES, Joseph (fl. 1811–54)
Of Leeds; father of J. N. Land-
scapes. Exhibited 2 works at B.I.
(*Leeds*)

RHODES, Richard (1765–1838)
Line engraver.

RICCI, Marco, (1679–1729)
Born Belluno northern Italy;
studied under his uncle Sebastiano
Ricci; to England 1710. Ruins, and
a few English landscapes with
figures, mostly in gouache.
(*V. & A.*)

RICH, Alfred William (1856–1921)
Born Gravely; to Croydon 1874
and worked as heraldic draughts-

man; studied at the Slade; taught
and practised watercolour
landscape-painting; much
influenced by De Wint; member
New English Art Club and
International Society. (*V. & A.,
B.M., Newcastle, Whitworth*)

RICHARDS, Frank (fl. c. 1887)
Member R.B.A. Figure subjects.
(*Birmingham*)

RICHARDS, John Inigo (d. 1810)
A scene-painter; fl. from 1769;
succeeded Dall at Covent Garden
1777; founder member R.A., and
secretary from 1788. Landscapes.
Exhibited 44 works, 39 at R.A.,
5 at Soc. of Artists (*V. & A.,
Newcastle, B.M., Whitworth*)

RICHARDSON, Charles
(fl. 1855–91)
Son of T. M. Sr; taught drawing at
Newcastle. Landscapes, often with
horses. Exhibited 94 works, 2 at
N.W.C.S., 26 at R.A., 6 at S.B.A.
(*Newcastle, Gateshead*)

RICHARDSON, Edward (d. 1875)
Son of T. M. Sr; fl. c. 1856; assoc.
N.W.C.S. 1859. Landscapes rather in
the John Varley style. Exhibited
189 works, 187 at N.W.C.S., 2 at
R.A. (*V. & A., Newcastle*)

RICHARDSON, Frederick Stuart
(1855–1934)
Member R.S.W.; member R.I. 1897,
R.W.A. Domestic subjects.
Exhibited 53 works, 13 at N.W.C.S.,
20 at R.A., 5 at S.B.A.

RICHARDSON, George (1808–40)
Eldest son of T. M. Sr; taught
drawing at Newcastle; secretary
Newcastle Water Colour Society.
Landscapes. Exhibited 8 works,
2 at N.W.C.S., 6 at B.I. (*V. & A.,
Newcastle*)

RICHARDSON, Henry Burdon
(fl. 1826–62)
Son of T. M. Sr; travelled much on
the Continent. Landscapes.
Exhibited 18 works, 6 at R.A., 7 at
S.B.A. (*Newcastle, Gateshead*)

RICHARDSON, John Isaac
(1836–1913)
Member R.I. 1882–1907.
Landscapes.

RICHARDSON, Thomas Miles, Sr
(1784–1848)
Born Newcastle-upon-Tyne;
apprenticed to an engraver and
later to a cabinet-maker; master of
St Andrew's Grammar School
1808; after 1813 entirely devoted
to art; founder Newcastle Water
Colour Society 1831; assoc.
N.W.C.S. 1840–43. Landscapes,
coastal scenes, and marines.
Exhibited 90 works, 23 at N.W.C.S.,
13 at R.A., 24 at B.I., 19 at S.B.A.,
11 at O.W.C.S. (*V. & A., Newcastle,
Gateshead, Stirling, B.M.,
Birmingham*)

RICHARDSON, Thomas Miles, Jr
(1813–90)
Born Newcastle-upon-Tyne; son of
T. M. Sr, with whom he worked for
a time; made several visits to the
Continent; assoc. O.W.C.S. 1843,
member 1851. Landscapes, many
abroad and some Scottish.
Exhibited 719 works, 702 at
O.W.C.S., 6 at R.A. (*V. & A.,
Newcastle, Gateshead, Warrington,
B.M.*)

RICHARDSON, William
(fl. 1842–77)
Architectural subjects and land-
scapes. Exhibited 43 works, 16 at
R.A., 3 at B.I., 18 at S.B.A.

RICHMOND, George (1809–96)
Born Brompton, London; son of

miniature-painter Thomas;
inspired by W. Blake; studied at
R.A. 1824; with Palmer to Italy
1837–39; A.R.A. 1857, R.A. 1866,
H.R.A. 1887. Portraits, and rare
landscapes. Exhibited 205 works,
106 at R.A., 3 at B.I., 5 at S.B.A.
(*V. & A., Newport*)

RICHMOND, Thomas, Sr,
(1771–1837)
Born Kew. Miniatures. Exhibited
46 works at R.A. 1795–1825.

RICHMOND, Thomas, Jr
(1802–74)
Born London; son of Thomas Sr;
visited Rome, and became a friend
of J. Ruskin and Joseph Severn.
Portraits. Exhibited 51 works,
45 at R.A. 1822–60.

RICHMOND, Sir William Blake
(1842–1921)
Born London; son of George;
studied at R.A.; visited Italy 1859,
and later to learn fresco painting;
Slade professor at Oxford
1878–83; R.A. 1895; knighted
1897. Portraits and designs for
decoration, e.g. for St Paul's
Cathedral. Exhibited 187 works,
37 at R.A., 2 at B.I., 119 at
Grosvenor gallery.

RICHTER, Herbert Davis
(1874–1960)
R.I. 1921, R.O.I., R.S.W., R.B.A.
Pastel Society. Flowers and
interiors. (*V. & A.*)

RICHTER, Henry James
(1772–1857)
Born London; son of a German
engraver; studied under Stothard,
and at R.A. 1790; president
Associated Artists in Water
Colours 1811–12; member O.W.C.S.
1813. Scriptural and historical
subjects, and a few landscapes.

Exhibited 150 works, 88 at
o.w.c.s., 37 at r.a., 4 at b.i., 3 at
s.b.a.

RICKATSON, Octavius
(fl. 1877–93)
Member r.b.a. Landscapes.
Exhibited 87 works, 8 at n.w.c.s.,
25 at r.a., 35 at s.b.a.

RICKETTS, Charles (1866–1931)
r.a. Historical subjects. Exhibited
2 works at n.w.c.s. (*B.M.,*
Newcastle, Nottingham, Carlisle)

RIDDEL, John (fl. c. 1760)
A little-known marine painter,
some of whose drawings were
engraved by A. Walker.

RIDDELL, Robert Andrew
(fl. 1793–99)
Landscapes, probably influenced
by A. Cozens. Exhibited 1 work at
r.a. 1793.

RIDER, Urban (fl. 1883–86)
Of Dover. Landscapes. Exhibited
4 works at n.w.c.s.

RIDLEY, Matthew White
(fl. 1857–80)
Figure subjects. Exhibited 37
works, 19 at r.a., 3 at b.i., 6 at
s.b.a.

RIDLEY, William (1764–1838)
A book illustrator.

RIECK, E. (fl. 1850–60)
Of German birth, but worked in
England as well as on the
Continent. Unusually fine marines,
coastal scenes and Rhineland
landscapes. Exhibited 2 works at
s.b.a.

RIGAUD, Jean (fl. 1700–54)
Painted views of palaces in France,
and went to England to do the

same, e.g. St James's and Hampton
Court. Also some landscapes.

RIGAUD, John Francis
(1742–1810)
Born Turin; to England 1772, r.a.
1774. Illustrated Shakespeare for
Boydell. Scriptural and historical
subjects. Exhibited 176 works,
155 at r.a., 21 at b.i. (*Newport*)

RIGAUD, Stephen Francis
(1777–1861)
Born London; son of J. F.; studied
at r.a., founder member o.w.c.s.
and treasurer 1809-12. Imaginative
and allegorical subjects. Exhibited
127 works, 50 at o.w.c.s., 38 at
r.a., 24 at b.i., 6 at s.b.a.
(*V. & A.*)

RIGBY, Cuthbert A. (fl. 1850–1935)
Assoc. r.w.s. 1877. Landscapes.
Exhibited 243 works, 223 at
o.w.c.s., 7 at r.a. (*V. & A.*)

RIGBY, Elizabeth (1809–93)
Wife of Sir Charles Eastlake and
pupil of J. S. Cotman, who used
her sketches.

RIGNY, Chevalier de (fl. 1795–99)
Landscapes, some around London.
Exhibited 9 works at r.a.

RILEY, John (1646–91)
Born London, the son of the
record-keeper at the Tower;
studied under Soest and Fuller.
Painted several Royal portraits.
(*V. & A.*)

RIMINGTON, Alexander Wallace
(1854?–1918)
Born London; studied at London
and Paris; professor of arts at
Queen's College, London; member
r.s.b.a.c. 1902. Assoc. Royal
Society of Painter-Etchers and
Engravers. Landscapes.

Exhibited 19 works, 14 at R.A.,
2 at N.W.C.S. 1880–93. (*V. & A.*)

RIPPINGILLE, Edward Villiers
(1798–1859)
Born King's Lynn; self-taught; to
Italy 1837, and then to the East;
lectured on art. Genre. Exhibited
72 works, 41 at R.A., 19 at B.I.,
12 at S.B.A., 1813–57. (*V. & A.*)

RIVERS, Leopold (fl. 1873–93)
Landscapes. Exhibited 219 works,
18 at N.W.C.S., 32 at R.A., 151 at
S.B.A.

RIVIERE, Briton (1840–1920)
Born London, of Huguenot
descent, father a drawing
master at Cheltenham College;
settled in London 1870, A.R.A.
1878, R.A. 1881. Figure subjects
and animals. Exhibited 125 works,
82 at R.A., 3 at B.I., 6 at S.B.A., 4 at
Grosvenor gallery. (*V. & A.*)

RIVIERE, Henry Parsons
(1811–88)
Born London, probably brother of
Briton; studied at R.A. 1830,
member N.W.C.S. 1834–50, assoc.
O.W.C.S. 1852; to Rome 1865–84.
Landscapes. Exhibited 432 works,
299 at O.W.C.S., 101 at N.W.C.S.,
6 at R.A., 7 at B.I., 19 at S.B.A.
(*V. & A.*)

RIX, Mary Anne. *See* Mrs. John
Chase
Landscapes. Exhibited 6 works,
4 at N.W.C.S.

RIZAS, W. A. (fl. 1878–89)
Domestic subjects. Exhibited 6
works, 5 at N.W.C.S., 7 at S.B.A.

ROBERTS, David (1796–1864)
Born Edinburgh; apprenticed 7
years to a house-painter; scene-
painter at Carlisle, Glasgow and
Edinburgh; to London 1822 and
employed at Drury Lane; first
vice-president S.B.A. 1824–34;
visited Egypt and Syria 1838,
Italy and Austria 1850's; A.R.A.
1838, R.A. 1841. Brilliantly
coloured topography. Exhibited
179 works, 46 at S.B.A., 101 at R.A.,
32 at B.I. (*B.M.*, *Edinburgh*,
Whitworth, *Newport*)

ROBERTS, Henry (1710–90?)
Humorous subjects, and engraver
of works by T. Smith of Derby.

ROBERTS, Henry Benjamin
(1832–1915)
Member R.I. (1867–84) and
S.B.A. Domestic subjects.
Exhibited 103 works, 64 at
N.W.C.S., 15 at R.A., 10 at B.I., 8 at
S.B.A.

ROBERTS, Thomas Sotelle
(or Sautelle)
(1760?–1826)
Born Waterford, Ireland; studied
at Dublin Society's Schools
1777–79; articled to an architect,
and later practised in London;
returned to Dublin 1799. Pre-
dominantly blue landscapes.
Exhibited 84 works, 59 at R.A.,
14 at B.I., 2 at O.W.C.S., 1789–1818.
(*V. & A.*)

ROBERTS, William (1788–1867)
Born Darton, Yorks.; removed to
Birmingham; a businessman who
became an amateur artist; intimate
friend of D. Cox 1825 onwards,
and painted much in the style of
D. Cox Jr; member Birmingham
Academy of Arts (later R.B.S.A.)
1814. Landscapes. (*Birmingham*)

ROBERTSON, Alexander
(1772–1841)
Born Aberdeen, the son of a
cabinet-maker; brother of Andrew

and Archibald, studied at R.A.,
and under S. Shelley; emigrated to
the United States 1792, and died in
New York. Miniatures.

ROBERTSON, Andrew
(1777–1845)
Born Aberdeen; brother of
Alexander and Archibald; pupil of
Alexander Nasmyth; to London
c. 1801, and studied at R.A.;
member and secretary Associated
Artists in Water Colours.
Miniatures. Exhibited 355 works,
37 at O.W.C.S., 292 at R.A., 4 at B.I.
(*Edinburgh*)

ROBERTSON, Archibald
(1765–1835)
Born Monymusk, Aberdeen;
brother of Andrew and Alexander;
studied at Edinburgh and R.A.; a
pupil of Sir Joshua Reynolds;
emigrated to the United States
1791. Portraits in oils and water-
colour marines. Exhibited 3 works
at R.A.

ROBERTSON, Charles
(1844–1891)
Assoc. O.W.C.S. 1885, member
1891. Landscapes and figure
subjects. Exhibited 147 works, 103
at O.W.C.S., 14 at R.A., 2 at S.B.A.

ROBERTSON, George
(1748?–1788)
Born London, the son of a wine
merchant; studied at Shipley's
School; with William Beckford to
Italy, and back to London c. 1770;
subsequently with Beckford to
Jamaica; vice-president Incorp.
S.A.; a successful drawing master.
Landscapes, with early use of
scratching-out for highlights.
Exhibited 87 works, 84 at Soc. of
Artists, 3 at R.A. (*V. & A.,
Bedford, B.M.*)

ROBERTSON, Henry Robert
(fl. 1861–93)
Of Slough. Domestic subjects.
Exhibited 103 works, 8 at N.W.C.S.,
47 at R.A., 1 at B.I., 17 at S.B.A.

ROBERTSON, James (fl. 1815–36)
Known as 'the drunken drawing
master'. Monochrome landscapes
handled in the Gainsborough
style, but sometimes attributed to
Rowlandson. Exhibited 29 works,
2 at O.W.C.S., 6 at N.W.C.S., 13 at
R.A., 4 at S.B.A. (*B.M.*)

ROBERTSON, William (d. 1856)
Member N.W.C.S. 1836; fl.
1829–35. Marines. Exhibited 120
works, 116 at N.W.C.S., 4 at S.B.A.

ROBINS, Luke (fl. 1768–1801)
Of Bath; son of an artist of the
same name, who died 1769.
Landscapes.

ROBINS, Thomas, Sr 'of Bath'
(fl. 1718–70)
Father of T. Jr; probably
a fan-painter on vellum; also an
engraver; influenced by Delacour.

ROBINS, Thomas, Jr (1743–1806)
Son of T. Sr; a drawing master;
visited Jamaica to study natural
history. Flowers.

ROBINS, Thomas Sewell
(1814–1880)
Member N.W.C.S. 1839–66.
Landscapes and marines. Exhibited
412 works, 317 at N.W.C.S., 7 at
R.A., 39 at B.I., 21 at S.B.A.
(*V. & A., B.M., Newport,
Birmingham*)

ROBINS, William Palmer
(1882–1959)
Assoc. R.W.S. 1948, member 1955,
hon. treasurer 1955–58. Member
Royal Society of Painter-Etchers

and Engravers. Landscapes,
particularly trees.

ROBINSON, Charles F.
(fl. 1874–96)
Assoc. Royal Society of Painters
and Etchers 1890–96. Exhibited
22 works, 1 at N.W.C.S., 4 at R.A.,
12 at S.B.A. (*V. & A.*)

ROBINSON, Edith Brearey
(fl. 1889–93)
Of Scarborough. Landscapes.
Exhibited 9 works, 4 at N.W.C.S.,
2 at R.A., 3 at S.B.A.

ROBINSON, E. Julia (fl. 1869–93)
Of Dorking. Landscapes.
Exhibited 14 works, 10 at N.W.C.S.

ROBINSON, Edward (1824–83)
Topographical subjects, some in
Normandy. (*V. & A.*)

ROBINSON, Edward W.
(fl. 1859–75)
Landscapes. Exhibited 44 works,
27 at S.B.A., 5 at R.A. (*V. & A.*)

ROBINSON, Frederick Caylery
(1862–1927)
Born Brentford; studied at St
John's Wood School, at R.A., and
at Julian's School in Paris
1890–92; member R.B.A. 1888,
A.R.A. 1921; assoc. R.W.S. 1911,
member 1918 and vice-president
1920–23. Murals and imaginative
figure subjects. Exhibited 30
works, 28 at S.B.A. (*Birmingham*)

ROBINSON, William (fl. 1884–89)
Of Manchester. Landscapes.
Exhibited 5 works, 4 at N.W.C.S.
(*Note.* A William R. (1799–1839)
was a pupil of Lawrence, and a
portrait-painter and landscapist in
oils, and W.R.R. (fl. c. 1831) was
an obscure landscape-painter in
watercolour.

ROBSON, George Fennel
(1788–1833)
Born Durham; studied under
Harle, a local drawing master;
early to London; visited the
Scottish Highlands; member
Associated Artists in Water
Colours; member O.W.C.S. 1813
and president 1819; published
'Scenery of the Grampian
Mountains' 1819. Landscapes,
soft and granulated but entirely
pleasing, sometimes with animals
by Robert Hills. Exhibited 700
works, 651 at O.W.C.S., 8 at R.A.
(*V. & A., B.M., Birmingham,
Newcastle, Liverpool*)

ROCHARD, Francois Theodore
(1798–1858)
Born France; studied in Paris;
spent much time in England, dying
in London; member N.W.C.S.
Miniatures. Exhibited 240 works,
70 at N.W.C.S., 148 at R.A., 22 at
S.B.A.

ROCHARD, Simon James
(fl. 1816–45)
Probably son of F. T. Miniatures.
Exhibited 230 works, 5 at N.W.C.S.,
191 at R.A.

RODEN, William T. (1817–92)
Born Birmingham; engraver and
portrait-painter. Scriptural
subjects. Exhibited 12 works, 6 at
R.A., 2 at B.I., 4 at S.B.A. 1856–79.

ROE, Fred (1865–1947)
Member R.I. 1909, member R.B.C.
Domestic subjects. Exhibited 22
works, 7 at R.A. (*V. & A.*)

ROE, J. (fl. 1771–90)
Still living in Warwick 1812.
Landscapes. Exhibited 5 works,
3 at Soc. of Artists, 2 at R.A.
(*V. & A.*)

ROFFE, William John (fl. 1845–89)
Landscapes. Exhibited 42 works,
12 at s.b.a.

ROGERS, George (fl. 1861–93)
An amateur, who settled in the
Isle of Wight. Landscapes.
Exhibited 4 works, 2 at Soc. of
Artists, 2 at r.a. (*V. & A.*)

ROGERS, Philip Hutchins
(fl. 1808–51)
Of Plymouth. Landscapes.
Exhibited 91 works, 3 at n.w.c.s.,
24 at r.a., 47 at b.i., 14 at s.b.a.

ROMNEY, George (1734–1802)
Born Dalton-in-Furness, Lancs.;
the son of a cabinet-maker;
studied painting in Kendal; to
London 1762 as a portrait-painter;
visited France and Italy; returned
to Kendal 1799, where he died.
Portraits and figure subjects.
Exhibited 25 works, 10 at Soc. of
Artists, 15 at Free Soc. 1763–72.

ROOKE, Thomas Matthews
(1842–1942)
Church interiors and exteriors.
Assoc. r.w.s. 1891, member 1903.
Exhibited 108 works, 48 at
o.w.c.s. (*Birmingham*)

ROOKER, Michael 'Angelo'
(1743–1801)
Born London; son and pupil of
Edward Rooker, an engraver;
studied at St Martin's Lane
Academy, at r.a. 1769, and under
P. Sandby; principal scene-painter
at Haymarket Theatre; a.r.a.
1770. Landscapes with lively
figures and animals. Exhibited 99
works, 98 at r.a., 1 at Soc. of
Artists. (*V. & A., B.M.,
National Gallery of Ireland,
Diploma Gallery R.A., Newport,
Whitworth, Newcastle, Nottingham,
Leeds, Oxford*)

ROPE, George Thomas
(1846–1929)
Born East Anglia; the son of a
farmer; pupil of W. Webb.
Landscapes and animals. Exhibited
3 works, 2 at r.a., 1 at s.b.a.

ROSCOE, S. G. W. (fl. 1874–88)
Landscapes. Exhibited 44 works,
10 at n.w.c.s., 3 at r.a., 27 at
s.b.a.

ROSCOE, William (1753–1831)
Of Liverpool. Patron of Ibbetson.
(*Liverpool*)

ROSE, H. Ethel (fl. 1877–90)
Figure subjects. Exhibited 30
works, 5 at n.w.c.s., 5 at r.a., 9 at
s.b.a.

ROSE, H. Randolph (fl. 1880–93)
Figure subjects. Exhibited 45
works, 13 at n.w.c.s., 3 at r.a.,
11 at s.b.a.

ROSE, Richard H. (fl. 1869–89)
Domestic subjects. Exhibited 24
works, 6 at n.w.c.s., 10 at s.b.a.

ROSENBERG, Charles
(fl. 1844–48)
Of Bath; brother of G. F.; author
of r.a. Exhibition guides 1847–48.
Landscapes and domestic subjects.
Exhibited 10 works, 5 at s.b.a.,
3 at r.a., 2 at b.i. (*Bethnal
Green*)

ROSENBERG, Frances (or Fanny)
Elizabeth Louise
See Harris, Mrs John D.

ROSENBERG, George F.
(1825–69)
Born Bath; brother of Charles;
assoc. o.w.c.s. 1847; published a
guide to flower painting 1853.
Flowers, still-life, and landscapes
in Scotland and, later, in Norway.

Exhibited 231 works, 230 at
o.w.c.s., 1 at r.a. (*Bath*)

ROSENBERG, Mary Elizabeth
See Duffield, Mrs William.

ROSS, Miss Christian P. (d. 1906)
Of Edinburgh; fl. 1878–90;
member r.s.w. Figure subjects.
Exhibited 9 works, 5 at n.w.c.s.,
1 at r.a., 3 at s.b.a.

ROSS, F. W. R. (1792–1860)
A naval officer. Subjects of naval
history, but excelled in bird
painting.

ROSS, Robert Thorburn (1816–76)
Born Edinburgh; pupil of Sir W.
Allan; assoc. r.s.a. 1852, member
1869. Portraits and genre.
Exhibited 9 works, 6 at r.a., 2 at
s.b.a., 1871 onwards.

ROSS, Sir William Charles
(1794–1860)
Born London; son of William
Ross, a miniature-painter; studied
at r.a. 1808; assistant to
miniature-painter Andrew
Robertson 1814; a.r.a. 1838, r.a.
1843; knighted 1842. Miniatures
and portraits. Exhibited 309
works, 304 at r.a., 5 at b.i.

ROSSETTI, Gabriel Charles Dante
(1828–82)
Born London; son of Gabriel, an
Italian refugee who was professor
of Italian at King's College;
studied under J. S. Cotman, and at
r.a. 1845; a founder of the Pre-
Raphaelites; worked with Burne-
Jones at Oxford 1857–58; a noted
poet. Romantic and poetical
subjects, portraits. Married Mrs
Elizabeth Siddal 1860; the model
in many of his pictures; she died
tragically two years later.
Exhibited 2 works 1849–50.

(*B.M., V. & A., Birmingham*)

ROSSETTI, Lucy Madox (1843–94)
Daughter of Ford Madox Brown,
wife of G. C. D. Rossetti.

ROSSI, Alexander M. (fl. 1870–93)
Of Preston. Domestic subjects.
Exhibited 127 works, 16 at
n.w.c.s., 49 at r.a., 47 at s.b.a.

ROSSITER, Mary
See Harrison, Mrs George Henry.

ROSSITER, Mrs Charles
(née Frances Fripp Seares)
(fl. 1862–92)
Domestic subjects. Exhibited 48
works, 5 at n.w.c.s., 12 at r.a., 3 at
b.i., 10 at s.b.a.

ROUNDELL, Mary Ann
(fl. 1832–40)
Recorded as having been a pupil of
De Wint.

ROUSE, Robert William Arthur
(fl. 1882–93)
Member r.b.a. Landscapes.
Exhibited 117 works, 8 at
n.w.c.s., 39 at r.a., 56 at s.b.a.

ROUSSEL, Théodore Casimir
(d. 1926)
Born Lorient, Brittany; fl. from
1872; died at St Leonards. Etcher
and painter, influenced by
Whistler; member r.s.b.a.
1887–88, assoc. Royal Society
of Painters, Etchers and
Engravers. Portraits and genre.
Exhibited 9 works, 6 at s.b.a., 1 at
Grosvenor gallery 1886 onwards.

ROUW, Peter (fl. 1787–1840)
A sculptor, but exhibited 28 works
at o.w.c.s.

ROWBOTHAM, Charles
(fl. 1877–88)

Landscapes. Exhibited 8 works,
4 at N.W.C.S., 3 at S.B.A.

ROWBOTHAM, Thomas Lesson, Sr
(1783–1853)
Lived at Bath, Dublin and Bristol;
drawing master at Royal Naval
School, New Cross. Landscapes.
(*V. & A.*)

ROWBOTHAM, Thomas Lesson, Jr
(1823–75)
Born Dublin; son of T. L. Sr, but
unlike his father worked mostly in
watercolour; visited Wales 1847,
and subsequently toured in
Scotland, Germany, Normandy and
Italy; succeeded his father at New
Cross Royal Naval School; assoc.
N.W.C.S. 1848, member 1851.
Landscapes in the style of W.
Callow and Bonington, and Italian
landscapes finally Exhibited 485
works, 464 at N.W.C.S., 4 at R.A.,
16 at S.B.A. (*V. & A., B.M.,
Gateshead, Newcastle*)

ROWE, E. Arthur (fl. 1885–93)
Domestic subjects. Exhibited 58
works, 11 at N.W.C.S., 17 at R.A.,
21 at S.B.A.

ROWE, Edith d'Oyley (fl. 1889–92)
Churches. Exhibited 5 works, 3 at
N.W.C.S., 2 at S.B.A.

ROWE, H. (?) (fl. 1790–96)
A topographical draughtsman,
some of whose works were
engraved in the 'Copper Plate
Magazine' 1796.

ROWE, Trythall Tom (fl. 1882–93)
Landscapes. Exhibited 56 works,
4 at N.W.C.S., 15 at R.A., 24 at
S.B.A.

ROWLAND, W.
(pseudonym of Holmes Edwin
Cornelius Winter)

(1851–1935)
Born Great Yarmouth; son of
Cornelius J. W. Winter, whose
watercolours he seems to have
signed; in St Albans 1884.

ROWLANDSON, Thomas
(1756–1827)
Born Old Jewry, London; brother-
in-law of Samuel Howitt; studied
at R.A. 1771; visited Paris
1772–74. Caricatures, landscapes,
and figure subjects. Exhibited 24
works, 20 at R.A. 1775–1787, 4 at
Soc. of Artists. (*V. & A.,
Aberystwyth, Birmingham, London
Museum*)

ROYER, Pierre (fl. 1774–96)
A Frenchman who spent some
time in England, returning to
France 1778, and thereafter
exhibiting at the Paris Salon until
1796. Landscapes around London,
particularly at Epping, Chelsea and
Hampton Court. Exhibited 17
works, 9 at Soc. of Artists, 8 at
R.A., 1774–78.

ROYLE, Herbert (fl. 1893)
Born Manchester; a pupil of J. W.
Buxton Knight. Landscapes.
Exhibited 1 work. (*Leeds*)

RUDD, Charles (fl. c. 1840)
A painter of Birmingham street
scenes. (*Birmingham*)

RUNCIMAN, Alexander (1736–85)
Born Edinburgh; brother of John;
studied at Foulis Academy,
Glasgow; visited Rome 1766;
master at Trustees' Academy,
Edinburgh, 1771. Landscapes,
figure subjects and genre.
Exhibited 17 works, 10 at R.A.,
7 at Free Soc. (*Edinburgh, B.M.*)

RUNCIMAN, Charles (fl. 1825–67)
Landscapes on the Rhine, on the

Thames, in the Lake District and in Switzerland, and humorous genre. Exhibited 74 works, 3 at N.W.C.S., 16 at R.A., 25 at B.I., 16 at S.B.A.

RUNCIMAN, John (1744–76)
Brother of Alexander; to Rome 1766, and died at Naples. Pen and wash landscapes. (*Edinburgh*)

RUNDLE, Joseph Sperkhall (1815–80)
Born Devon; in the Royal Navy 1829; led storming party at Aden 1839; visited China 1839–40; was at Balaclava. Sketches of army camps, and so on, seen during his campaigns.

RUSHBURY, Sir Henry George (1889–1968)
Born Harborne, Birmingham. A.R.W.S. 1922, R.W.S. 1926, A.R.A. 1924, R.A. 1936. Member Royal Society of Painter-Etchers and Engravers. Graphic landscapes and Etchings. Buildings and street scenes.

RUSKIN, John (1819–1900)
Born London; famous art critic, author, reformer and artist, who illustrated his own books; a champion of the Pre-Raphaelites; Slade professor of art at Oxford, 1869–84; hon. R.W.S. Landscapes, some architectural. Exhibited 22 works, 17 at N.W.C.S. (*B.M., Sheffield, Oxford, Bedford, Newport, Birmingham*)

RUSSELL, Janet Catherine (fl. 1868–93)
Of Surbiton. Domestic subjects. Exhibited 18 works, 5 at S.B.A., 5 at R.A. (*V. & A.*)

RUSSELL, John (1745–1806)
Born Guildford, the son of a bookseller; studied under Francis

Cotes R.A., and at R.A. 1770; A.R.A. 1772, R.A. 1788; portrait-painter to George III and the Prince of Wales. Portraits in crayon and chalk. Exhibited 337 works, 330 at R.A. 1768–1806. (*V. & A., Leeds*)

RUSSELL, Miss T. (?) (fl. 1805–13)
An amateur portrait-painter, but also some landscapes. Exhibited 7 works at R.A.

RUSSELL, Sir Walter Westley (1867–1946)
A.R.W.S. 1921, R.W.S. 1930, R.A. 1926. Keeper of R.A. 1927. Landscapes.

RUTHERFORD, Archibald (1743–70)
Born Jedburgh, Roxburghshire; drawing master at Perth Academy. Scottish views. (*Edinburgh*)

RUTHERSTON, Albert Daniel (1889–1953)
Born Bradford; A.R.W.S. 1934, R.W.S. 1941. Ruskin Master of Drawing, Oxford University.

RYLAND, Henry (1856–1924)
Member R.I. 1898. Figure subjects Exhibited 38 works, 18 at N.W.C.S.

RYLAND, Miss (fl. c. 1841)
An amateur landscapist. Exhibited 1 work. (*V. & A.*)

RYLEY, Charles Rueben (1752–98)
Born London; gold medallist R.A.; a drawing master and book illustrator. Domestic subjects. Exhibited 55 works, 1 at Free Soc., 54 at R.A.

RYND, Edith (fl. 1892–93)
Of Oxford. Churches. Exhibited 3 works at N.W.C.S.

SADDLER, John (1813–92)
A line engraver. Worked with Sir
E. H. Landseer and Sir J. E.
Millais, and on J. M. W. Turner's
'Southern Coast of England'.
Exhibited 44 works, 21 at R.A.,
5 at S.B.A., 1855–83.

SADLER, Kate (fl. 1878–93)
Of Horsham. Flowers. Exhibited
52 works, 26 at N.W.C.S., 10 at R.A.,
6 at S.B.A.

SAILMAKER, Isaac (1633–1721)
Marines.

SAINTON, Charles Prosper
(1861–1914)
Member R.I. 1897.

SALA, George Augustus (1828–96)
Pupil of a miniature-painter, and
assistant to W. R. Beverley;
journalist, critic and illustrator. A
little-known watercolourist.
(*B.M.*)

SALMON, J. (fl. c. 1868)
Marines and shipping. Exhibited
1 work. (*V. & A.*)

SALT, Henry (1780–1827)
A travelling draughtsman, visiting
India, Ceylon, Abyssinia and
Egypt 1815–27. Antiquarian
illustrations. (*B.M.*)

SALTER, William (1804–75)
Born Honiton, Devon; vice-
president S.B.A. Historical and
Shakespearean subjects. Exhibited
135 works, 6 at R.A., 28 at B.I.,
101 at S.B.A., 1822–75.

SALVIN, Anthony (d. 1881)
Worked in London, mostly in
pencil and ink; died Haslemere.

Architectural subjects and ruins.

SAMNOLL, ? (fl. c. 1780)
An obscure painter of Warwick-
shire views in watercolour, some
engraved.

SAMUEL, George (d. 1824?)
Worked throughout England and
Wales from c. 1784. A prolific
landscapist, better known for his
work in oils. Exhibited 148 works,
94 at R.A., 54 at B.I. (*Manchester,
V. & A.*)
(*Note.* Grant mentions many works
exhibited at O.W.C.S., but Graves
lists none.)

SANDBY, Paul (1730–1809)
Born Nottingham; brother of
Thomas, and both at first
employed in Military Drawing
Office at Tower of London;
draughtsman on survey of roads in
Scottish Highlands 1746; to
Windsor with Thomas 1751, and
later to Wales with Sir Joseph
Banks, always sketching; member
Incorp. S.A., and founder
member R.A. 1768; chief drawing
master at Royal Military College,
Woolwich; resigned 1796, and
succeeded by his son, Thomas Jr.
Landscapes. Exhibited 180 works,
39 at Soc. of Artists, 2 at Free
Soc., 125 at R.A., 14 at B.I.
1760–1809. (*V. & A., B.M.,
Nottingham, Birmingham, National
Gallery of Ireland, Derby,
Wolverhampton, and others*)

SANDBY, Thomas (1721–98)
Born Nottingham; brother of Paul;
draughtsman to the Duke of
Cumberland, whom he
accompanied to Flanders and
Scotland 1743–48; deputy ranger
at Windsor Great Park 1746–98;
founder member R.A. 1768, and
its first professor of architecture.

Landscapes and architectural
subjects. Exhibited 11 works, 9 at
R.A. (*Birmingham, B.M.,
Nottingham, Whitworth*)

SANDBY, Thomas, Jr
(fl. 1797–1828)
Son of Paul, whom he succeeded as
drawing master at Royal Military
College, Woolwich.

SANDERS, George L. (1774–1846)
Born Kinghorn, near Kirkcaldy;
an Edinburgh coach-painter; pupil
of Smeaton; to London 1807.
Miniatures.

SANDERS, John (1750–1825)
Born Stourbridge; the son of an
artist in pastel of the same name;
studied at R.A. 1769. Portraits and
scriptural subjects. Exhibited 60
works, 8 at Soc. of Artists, 4 at
Free Soc., 48 at R.A., 1771–1824.

SANDERS, John Arnold (b. 1801)
Born Bath; went to Canada. Pencil
portraits tinted with colour, and
landscapes. Exhibited 20 works,
10 at R.A., 9 at B.I., 1 at S.B.A.

SANDERS, W. (fl. 1826–38)
Still-lifes. Exhibited 32 works,
9 at N.W.C.S.

SANDERSON-WELLS, John
Sanderson (1872–1950?)
Member R.I. 1903. Hunting
scenes and landscapes.

SANDY, Joseph Michael
(1771–1845)
A.R.A.; visited Rome 1794.

SANDYS, Anthony Frederick
Augustus (1832–1904)
Born Norwich; went to London
and copied at National Gallery;
influenced by the Pre-
Raphaelites. Mythological

subjects and portraits. Exhibited
59 works, 47 at R.A., 2 at B.I., 9 at
Grosvenor gallery 1851–66.
(*V. & A., Birmingham*)

SANFORD, S. Ellen (fl. 1887–92)
Domestic subjects. Exhibited 5
works at N.W.C.S.

SARGENT, John Singer
(1856–1925)
Born Florence, the son of an
American doctor; studied at
Florence, and under Duran at
Paris; to Spain 1879; also paid
several visits to United States;
settled in London 1884; A.R.A.
1894, R.A. 1897; assoc. R.W.S.
1904, member 1908. Landscapes
in the Brabazon style and
portraits. Exhibited 32 works, 19
at R.A., 6 at Grosvenor gallery.
(*Oxford, Cambridge, Newcastle,
Whitworth*)

SARJEANT
(or SARGENT or SARJENT)
Francis John (or James)
(fl. 1800–12)
Studied at R.A. 1805; aquatinted
after drawings by J. Sillett for the
'History of Lynn' 1812.
Landscapes. Exhibited 2 works at
R.A., 1802–03. (*V. & A.*)

SASS, Henry (1788–1844)
Born London; a successful drawing
master. Portraits and mytho-
logical subjects. Exhibited 95
works, 84 at R.A., 8 at B.I., 3 at
S.B.A., 1807–39.

SASS (or SASSE), Richard
(1774–1849)
Relative of Henry Sass
(1788–1844) who kept the
Charlotte St Drawing School;
drawing teacher to Princess
Charlotte 1811 and landscape-
painter to the Prince Regent; to

the Continent 1815; settled in
Paris 1825. Landscapes, often with
figures and cattle. Exhibited 131
works, 77 at R.A., 38 at B.I.
(*V. & A., B.M., Newport*)

SAUNDERS, Joseph (fl. 1778–97)
Miniatures and portraits of ladies.
Exhibited 43 works.

SAVAGE, Reginald (fl. 1886–90)
Portraits. Exhibited 12 works, 6 at
N.W.C.S., 1 at R.A., 2 at S.B.A.

SAY, William (1768–1834)
Born near Norwich; went to
London as an engraver; pupil of
James Ward. Figure and animal
subjects of the Ward and Morland
type.

SCAIFE, David (fl. 1790–1820)
A scene-painter at Edinburgh, and
later at Astley's Theatre, London.
Landscapes somewhat in the style
of Girtin sketches.

SCANDRETT, Thomas
(1797–1870)
Born Worcester. Architectural
topography in a style between
S. Prout and D. Roberts. Exhibited
42 works, 13 at R.A., 4 at B.I., 25 at
S.B.A. 1824–70.

SCANES, Agnes (fl. 1880–92)
Portraits. Exhibited 18 works, 4 at
N.W.C.S., 2 at R.A., 5 at S.B.A.

SCHARF, George (1788–1860)
Born Bavaria; father of Sir G.,
studied in Munich; in Paris with
the British Army at the time of
Waterloo; settled in England
1816; member N.W.C.S. 1833–36.
Landscapes and views of London
streets and buildings. Exhibited 46
works, 14 at N.W.C.S., 28 at R.A.
4 at S.B.A. (*V. & A., B.M.*)

SCHARF, Sir George (1802–95)
Son of George; a lecturer and
writer on art, and an illustrator;
F.S.A. Ruins. Exhibited 8 works,
6 at R.A., 2 at B.I.

SCHETKY, John Alexander
(1785–1824)
Born Edinburgh, the son of a
German musician; brother of J. C.;
became an army surgeon and
served in Portugal. Views in
Portugal and naval engagements
in collaboration with his brother.
Exhibited 4 works at O.W.C.S.
1816–17. (*B.M.*)

SCHETKY, John Christian
(1778–1874)
Born Edinburgh; brother of J. A.
and with him in Portugal; pupil of
Alexander Nasmyth; taught
drawing at Royal Military
College, Great Marlow, 1808–11,
and at Royal Naval College,
Portsmouth, 1811–36; member
Associated Artists in Water
Colours; marine painter to George
IV, William IV and Victoria.
Marines. Exhibited 130 works,
7 at O.W.C.S., 66 at R.A., 6 at B.I.,
15 at S.B.A. (*B.M., Greenwich*)

SCHNEBBELIE, Jacob C.
(1760–92)
Born London; father of R. B.;
pupil of P. Sandby; a magazine
illustrator, and draughtsman to the
Society of Antiquaries.
Architectural subjects. Exhibited
7 works at R.A.

SCHNEBBELIE, Robert Blemmel
(1803–49)
Son of J. C. Old buildings and a few
landscapes. Exhibited 9 works at
R.A. (*V. & A., B.M.*)

SCHWABE, Randolph (1885–1948)

Assoc. R.W.S. 1938, member 1942.
Prof. of Drawing, Slade.

SCOTT, Lady Caroline
(fl. c. 1810)
Married Admiral Sir G. Scott
1810. Rural sketches.

SCOTT, David (1806–49)
Born Edinburgh; member R.S.A.
An engraver, and painter of
historical subjects. Exhibited 5
works, 2 at R.A. 1840–48.

SCOTT, Edmund (1746–1810)
Born London; pupil of Bartolozzi.
Engraver of works by Morland.

SCOTT, Henry John (1858–1930)
Member R.I. 1879, member R.O.I.

SCOTT, James V. (fl. 1877–89)
Of Edinburgh, Landscapes.
Exhibited 22 works, 10 at N.W.C.S.,
3 at R.A.

SCOTT, John (1850–1918)
Member R.I., 1855, member R.B.A.

SCOTT, John Henderson (1829–86)
Born Brighton; son of W. H. S.
Landscapes. Exhibited 23 works,
3 at N.W.C.S. (*V. & A.*)
(*Note*. The Brighton family of
artists named Scott was a large
one, and confusion is possible
between its members. The initials
J.H. are also those of a Brighton
architect who exhibited views of
local churches, and a London artist
who exhibited at R.S.B.A.
1849–59).

SCOTT, Katherine (fl. 1872–92)
Of Streatham. Flowers. Exhibited
41 works, 15 at N.W.C.S.

SCOTT, Miss Maria (Mrs
Brookbank) (fl. 1823–40)
Daughter of W.H.S. of Brighton;

exhibited under the name of
Brookbank after 1833; assoc.
R.W.S. 1823, member 1838. Fruit
and flowers. Exhibited 22 works,
21 at O.W.C.S.

SCOTT, Samuel (1702?–72)
Born London; friend of Hogarth;
lived first in London and later in
Bath; taught S. Gilpin and W.
Marlow. Landscapes and marines.
Exhibited 5 works, 3 at Soc. of
Artists, 1 at Free Soc., 1 at R.A.
(*B.M.*, *Whitworth*)

SCOTT, Samuel (1756–1825)
A 'Sussex Water Mill', dated
1817, is in the Whitworth.

SCOTT, William (1783–1850)
Of Brighton; toured a great deal in
Britain, and also in France and
Spain. Assoc. O.W.C.S. 1811,
resigned and re-elected 1820.
Landscapes. Exhibited 244 works,
229 at O.W.C.S.

SCOTT, William Bell (1811–90)
Born Edinburgh; studied under
his father Robert Scott, an
engraver, and his brother David,
R.S.A., and also at Trustees'
Academy, Edinburgh; to London
1837; master at Government
School of Design, Newcastle-upon-
Tyne, to where he returned from
London; hon. member R.S.A. 1887.
Domestic subjects. Exhibited 31
works, 7 at R.A., 9 at B.I., 4 at
S.B.A. (*V. & A.*, *B.M.*, *Newcastle*)

SCOTT, William Henry Stothard
(1783–1850)
Of the Brighton family; assoc.
O.W.C.S. 1810; friend of J. S.
Cotman. Rustic views. (*V. & A.*,
Maidstone, B.M.)

SCOULER (or SCOULAR), James
(1741?–1810?)

Miniatures. Exhibited 40 works,
7 at Soc. of Artists, 1 at Free Soc.,
32 at R.A.

SCRIVEN, Edward (1775–1841)
Born Alcester, Warwicks.; a
painter and engraver. Exhibited
13 works at S.B.A., 1824–28.

SEARES, Frances Fripp
See Rossiter, Mrs Charles.

SEDDING, John Dando (1838–91)
An ecclesliatical architect. Said to
have been one of the most perfect
draughtsmen of leaves and plants
who has ever lived. Exhibited 40
works at R.A., 1875–91.

SEDGWICK, Mrs John
See Oliver, Mrs William.

SERRES, Dominic (1722–93)
Born Gascony; became a sailor;
was captured and taken to England
c. 1758; helped by C. Brooking;
member Incorp. S.A. 1765;
founder member R.A. 1768, and
Librarian 1792; marine painter to
George III. Marines. Exhibited
134 works, 105 at R.A., 8 at Soc. of
Artists, 21 at Free Soc. (*V. & A.,
B.M., Whitworth*)

SERRES, Dominic M.
(fl. 1778–1804)
Younger son of Dominic and
brother of J. T.; a drawing
teacher. Landscapes. Exhibited 9
works at R.A. (*B.M.*)

SERRES, John Thomas
(1759–1825)
Born London; son of Dominic and
brother of D. M.; drawing master
at Chelsea Naval School; visited
France and Italy 1790; marine
painter to the king and draughts-
man to the Admiralty 1793.
Marines. Exhibited 78 works, 67

at R.A., 10 at B.I., 1 at S.B.A.
(*V. & A., B.M., Whitworth*)

SERRES, Olivia (1772–1834)
Wife of J. T. Landscapes.
Exhibited 27 works, 14 at R.A.,
13 at B.I., 1793–1811.

SETCHEL, Sarah (1814–94)
Member N.W.C.S. 1841–86.
Landscapes, genre and portraits.
Exhibited 58 works, 34 at N.W.C.S.,
9 at R.A., 15 at S.B.A.

SETTLE, William Frederick
(fl. 1862–84)
Lived in Hull 1862, and London
1884. Marines. Exhibited 1 work
at R.A. (*V. & A.*)

SEVERN, Arthur (1842–1931)
Son of Joseph. Historical subjects,
portraits, European topography,
landscapes and marines. Exhibited
163 works, 44 at N.W.C.S., 1 at R.A.
(*V. & A., B.M.*)

SEVERN, Joseph (1793–1879)
Studied at R.A. 1815; to Rome
1820, London 1841; back to Rome
1861 as British Consul, and died
there. Figure subjects and
portraits. Exhibited 63 works, 53
at R.A., 8 at B.I., 1 at O.W.C.S.
(*V. & A.*)

SEVERN, Joseph Arthur Palliser
(Arthur Severn) (1848–1931)
Member R.I., 1882, member R.O.I.

SEVERN, Mary
See Newton, Mrs Charles J.

SEVERN, Walter (1830–1904)
Born Rome; son of Joseph and
brother of Arthur; collaborated
with Sir Charles East; president
Dudley Gallery Art Society. R.C.A.
Landscapes and animals.

Exhibited 44 works, 2 at R.A., 1 at S.B.A. (*V. & A.*)

SEYFFARTH, Mrs Woldeman
See Sharpe, Louisa.

SEYMOUR, James (1702–52)
A fine early painter of horses, some of his drawings were engraved.

SHALDERS, George (1826?–1873)
Member N.W.C.S. 1864. Landscapes, notably in Surrey, Hampshire and Ireland. Exhibited 137 works, 77 at N.W.C.S., 15 at R.A., 4 at B.I., 41 at S.B.A.
(*V. & A.*)

SHANNON, Charles Haslewood
(fl. 1885–89)
Figure subjects. Exhibited 16 works, 5 at N.W.C.S., 2 at R.A., 3 at S.B.A.

SHARP, R. H. (fl. c. 1819)
Of York. Drawings of Roman ruins.

SHARPE, Charles Kirkpatrick
(1781–1851)
Born Dumfries. Painted in both oils and watercolour.

SHARPE, Charlotte B. (d. 1849)
Fl. 1838–42. Pencil portraits and landscapes. Exhibited 7 works at R.A.

SHARPE, Eliza (1796–1874)
Born Birmingham. Sister of Louisa, member O.W.C.S. 1829. Portraits. Exhibited 120 works, 87 at O.W.C.S., 33 at R.A.

SHARPE, Louisa (1798–1843)
(Mrs Woldeman Seyffarth)
Born Birmingham. Sister of Eliza; member O.W.C.S. 1829. (fl. 1817–33) died Dresden.

Portraits. Exhibited 43 works, 14 at O.W.C.S., 29 at R.A.

SHARPE, Mrs S.
See Paterson, Caroline.

SHARPLES, James (1825–93)
A blacksmith. Portraits.

SHARPLES, Rolinda (1797–1838)
Of Bristol. Landscapes. (*Bristol*)

SHAW, A. (fl. 1826–39)
Employed by A. W. Pugin. Italian churches. Exhibited 15 works.

SHAW, Arthur Winter (b. 1869)
Member R.I. 1900. Landscapes.

SHAW, Henry (1800–73)
Born London; F.S.A. and wrote books on ornament. Architectural subjects. Exhibited 3 works at R.A. 1821–48.

SHAW, John Byam Lister
(1872–1919)
Member R.I. 1898.

SHAYER, William (1788–1879)
Born Southampton. Worked mostly in oils, but a few watercolour landscapes.

SHEE, Sir Martin Archer
(1769–1850)
Born Dublin; settled in London 1788; R.A. 1800, president R.A. 1830. Portraits and figure subjects. Exhibited 343 works, 324 at R.A., 19 at B.I. 1789–1845.

SHEFFIELD, George (1839–92)
Lived first at Warrington, then moved to Liverpool. Landscapes in the Thirtle style, and chalk drawings of trees. Exhibited 17 works, 6 at R.A. (*B.M., Warrington, Whitworth, Carlisle, Birmingham*)

SHELLEY, Samuel (1750?–1808)
Born Whitechapel; self-taught;
copied after Reynolds; a founder
member and later treasurer of
o.w.c.s. Portraits and poetic
subjects. Exhibited 328 works, 63
at o.w.c.s., 245 at R.A. 15 at B.I.,
(*V. & A.*, *B.M.*)

SHEPARD, Henry Dunkin
(fl. 1885–91)
Domestic subjects. Exhibited 25
works, 16 at N.W.C.S.

SHEPHEARD, George
(1770?–1842)
Studied at R.A. Landscapes in
Surrey, Kent and on the South
Coast, usually with hop-pickers,
gipsies, and so on. Exhibited 96
works, 50 at R.A., 3 at B.I., 25 at
S.B.A., 1 at o.w.c.s.

SHEPHEARD, George Wallwyn
(1804–52)
Son of George; much travelled on
the Continent. Landscapes.
Exhibited 19 works at R.A.

SHEPHERD, George (fl. 1800–30)
A successful topographer, and
illustrated many books. River and
street scenes, many in London, and
landscapes. (*B.M.*, *V. & A.*,
Maidstone, Newport, Whitworth)

SHEPHERD, G. M. (fl. c. 1820)
Probably related to George.
London views. (*V. & A.*)

SHEPHERD, George Sidney
(fl. 1821–60)
Son of George; member N.W.C.S.
1831; drew for topographical
books, much in his father's style
but more artistically. Street
scenes, buildings, landscapes and
still-life. Exhibited 283 works, 223
at N.W.C.S., 17 at R.A., 43 at S.B.A.
(*V. & A.*, *B.M.*, *Newport*)

SHEPHERD, Thomas Hosmer
(fl. 1817–40)
Possibly a brother of G. S. London
views, also some in Scotland and
elsewhere in England. Exhibited
4 works at S.B.A. (*Bath, V. & A.*,
Bethnal Green, Newcastle)

SHEPPARD, Philip (1838–95)
Born Bath; became blind c. 1868.
Landscapes. Exhibited 9 works,
3 at R.A., 3 at S.B.A., 1861–66.

SHEPPERSON, Claude Allin
(1867–1921)
Born Beckenham; first a lawyer,
but later followed art in London
and Paris; A.R.A. 1919, assoc.
R.W.S. 1910. At first mountain and
moorland views, later illustrations,
some for *Punch*. (*V. & A.*)

SHERLOCK, William P.
(1780?–1825?)
Son of William, a miniature-
painter 1759–1806; a notable
etcher; imitated R. Wilson.
Landscapes. Exhibited 9 works at
R.A. (*B.M.*, *V. & A.*)

SHERREFF (or SHERRIFF)
Charles (fl. 1770–1823)
Born Edinburgh, but worked also
in London and Bath; worked
mostly in chalk or crayon. Also
a miniaturist. Exhibited 105
works, 6 at Free Soc., 89 at R.A.,
3 at B.I., 8 at S.B.A.

SHERRIN, John (1819–96)
Apprenticed to a jeweller; member
R.I. 1879. Assoc. N.W.C.S. 1866.
Fruit and flowers. Exhibited 206
works, 151 at N.W.C.S., 41 at R.A.,
7 at S.B.A.

SHERRINGTON, James
(fl. 1820–58)
A Great Yarmouth ironmonger;
collector of pictures by John

Crome; copied Crome and D. Cox.
Landscapes.

SHERWIN, John Keyse (1751–90)
Born Eastdean, Sussex; pupil of
Bartolozzi. Worked mostly in oils,
but also some chalk drawings and
watercolours. Exhibited 9 works,
8 at R.A., 1774–84.

SHIELDS, Frederick J. (fl. 1865–93)
Assoc. R.W.S. Scriptural and figure
subjects. Exhibited 106 works at
N.W.C.S.

SHIELS, William (1785–1857)
Born Berwickshire; member R.S.A.
Domestic genre, landscapes and
animals. Exhibited 37 works, 8 at
R.A., 17 at B.I., 12 at S.B.A.,
1808–52.

SHIPLEY, William (1714–1803)
A founder of the Society of Arts
and of 'Shipley's School'.

SHIPSTER, Robert (fl. 1796–1804)
Pupil of Bartolozzi; taught
drawing at the Royal Military
College, Woolwich. (*B.M.*)

SHIRT, W. (fl. c. 1811)
An obscure landscape-painter.

SHOESMITH, Kenneth Denton
(1890–1939)
Member R.I. 1925. Landscapes.

SHOOSMITH, Thurston Laidlaw
(fl. c. 1893)
Of Northampton. Landscapes.
Exhibited 1 work at N.W.C.S.
(*V. & A., Birmingham*)

SHORT, Sir Frank (1857–1945)
A fine late 19th century water-
colourist. Landscapes and coastal
scenes. (*V. & A., Whitworth,
Newport, Mon., B.M., Whitby*)

SHORT, Obadiah (1802–86)
Of the Norwich School, and best
known as an oil painter in the
Crome style. Landscapes.
(*Norwich*)

SHORT, Richard (fl. 1882–89)
Marines. Exhibited 17 works, 9 at
R.A., 2 at S.B.A.

SHRIMPTON, Ada M.
(fl. 1889–93)
Domestic subjects. Exhibited 15
works, 5 at N.W.C.S., 3 at R.A., 7 at
S.B.A.

SHUBROOK, Minnie J.
(fl. 1885–93)
Flowers. Exhibited 37 works, 3 at
N.W.C.S., 15 at R.A., 14 at S.B.A.

SHURY, G. W. (fl. 1833–38)
Of Ealing. Landscapes. Exhibited 5
works, 4 at N.W.C.S., 1 at S.B.A.

SHUTE, John (d. 1563?)
Born Cullompton, Devon; an
architect. Miniatures.

SIBSON, Thomas (1817–44)
Born Cumberland; died Malta;
etcher and subject painter; also an
illustrator.

SICKERT, Walter (fl. 1883–88)
Domestic subjects. Exhibited 26
works, 1 at N.W.C.S., 1 at R.A.,
21 at S.B.A.

SIEBERECHTS, Jan (1627–1700)
Born Antwerp; in England from
1674. Landscapes.

SILLETT, James (1764–1840)
Born Norwich; a heraldic painter;
studied at R.A. 1787–90; scene-
painter at Drury Lane and Covent
Garden; a drawing master at
King's Lynn; member Norwich
Society from 1810. Fruit and

flowers, game, churches in
monochrome, and architectural
subjects. Exhibited 49 works, 43 at
R.A., 2 at S.B.A. 1796–1837.
(*V. & A.*, *King's Lynn, B.M.,
Norwich*)

SIMMONS, J. Deane (fl. 1882–89)
Of Dorking. Rustic subjects.
Exhibited 49 works, 13 at N.W.C.S.,
7 at R.A., 14 at S.B.A.

SIMMONS, W. Sinclair (or St.
Clair) (fl. 1878–93)
Landscapes. Exhibited 47 works,
11 at N.W.C.S., 7 at R.A., 4 at S.B.A.

SIMONAU, Gustave Adolphe
(1810–70)
Born Bruges; worked in London
for a time; assoc. N.W.C.S. 1858.
Exhibited 21 works at N.W.C.S.

SIMPSON, Henry (fl. 1875–91)
Figure subjects. Exhibited 29
works, 6 at N.W.C.S., 4 at R.A., 10 at
S.B.A.

SIMPSON, William (1823–99)
Born Glasgow; apprenticed to
lithographers 1839; to London
1851, and became a war artist in
the Crimea; travelled extensively;
joined the *Illustrated London News*
1866; member R.I. 1879.
Landscapes and events. Exhibited
44 works, 43 at N.W.C.S. (*V. & A.,
B.M., Glasgow*)

SIMS (or SIMMS,) Charles
(fl. 1840–75)
Landscapes, many in Devon.
Exhibited 63 works, 13 at R.A.,
15 at B.I., 32 at S.B.A.

SIMS, Charles (1873–1928)
Born Islington. A.R.W.S. 1911,
R.W.S. 1914, R.A. 1916, keeper
R.A. 1920–26. Blake-like
drawings.

SIMS, G. (d. 1840)
A relative of Charles, whom he
lived with; fl. c. 1829. Member
R.I. 1835. Landscapes in Home
Counties and in France and
Belgium. Exhibited 118 works,
61 at N.W.C.S., 11 at R.A., 15 at B.I.,
31 at S.B.A.

SIMS, William (fl. 1821–67)
A notable portrait-painter, but also
painted landscapes in Wales,
Devon and the Isle of Wight.
Exhibited 35 works, 25 at R.A., 7 at
B.I., 3 at S.B.A.

SIMSON, George (1791–1862)
Born Dundee; brother of William.
Portraits and genre.

SIMSON, William (1800–47)
Born Dundee; brother of George;
studied at Trustees' Academy,
Edinburgh; member Scottish
Academy 1830; to Italy 1835,
London 1838. Coastal scenes at
first, later domestic and figure
subjects. Exhibited 56 works, 25 at
R.A., 30 at B.I. (*Edinburgh*)

SINGLETON, Henry (1766–1839)
Born London; studied at R.A.
Portraits and book illustrations.
Exhibited 449 works, 285 at R.A.,
157 at B.I., 5 at S.B.A., 1780–1839.
(*V. & A., B.M.*)

SISLEY, Alfred (1840–99)
Born Paris, of English parents;
worked in oils, pastel and
watercolour. Landscapes.

SITWELL, Lady (fl. c. 1820)
Visited Paris; possibly a pupil of
Hearne.

SKELTON, Jonathan
(fl. c. 1754–58)
Very little known, and his work
often confused with that of

Taverner; probably in Croydon 1754, and London and Rochester 1757; to Italy 1758, where he died. Views in Rome. (*V. & A.*)

SKELTON, William (1763–1848)
An engraver after Sir William Beechey. (*B.M.*)

SKILL, Frederick John (1824?–81)
Trained as a steel engraver; member R.I. 1876, lived for some years in Venice. Assoc. member R.I. 1871. Landscapes. Exhibited 250 works, 176 at N.W.C.S., 11 at R.A., 17 at S.B.A. (*V. & A.*, *B.M.*)

SKIPPE, John (1741–1812)
Born Ledbury, Herefordshire; studied at Oxford under Malchair; travelled in Italy and there studied landscape painting under C. J. Vernet; sheriff for Hereford-shire 1801. Landscapes and figure subjects in pen and grey wash. (*V. & A.*, *B.M.*)

SKIPWORTH, Frank Markham (fl. 1882–93)
Figure subjects. Exhibited 97 works, 4 at N.W.C.S., 25 at R.A., 12 at S.B.A., 13 at Grosvenor gallery.

SKIRVING, Archibald (1749–1819)
The son of a farmer; self-taught; also studied in Italy. Crayon portraits and miniatures.

SLATER, Joseph (fl. 1772–87)
Landscapes, decorative painting and miniatures. Exhibited 9 works, 4 at R.A., 5 at Free Soc.

SLEAP, Joseph Axe (1808–95)
Born London; brilliant, but always poverty-stricken. Landscapes and river scenes. Exhibited 6 works.

SLOANE, Mary A. (fl. 1889–93)

Landscapes. Exhibited 11 works, 7 at N.W.C.S., 3 at S.B.A.

SLOCOMBE, Charles Philip (1832–95)
A well-known etcher; taught at the National Art Training Schools (now R.C.A.), South Kensington. Landscapes.

SMALL, William (1843–1928)
Assoc. N.W.C.S. 1870; member R.I. 1874. Hon. R.S.A., F.R.S.A. Landscapes. Exhibited 146 works, 61 at N.W.C.S., 30 at R.A.

SMALLFIELD, Frederick (1865–1911)
Assoc. R.W.S. 1865. Figure subjects. Exhibited 532 works, 425 at O.W.C.S., 39 at R.A., 6 at B.I., 11 at S.B.A.

SMALLWOOD, William Froome (or Frome) (1806–34)
Born London; studied under Cottingham, an architect; visited the Continent and made sketches, some engraved for the 'Penny Magazine'. Architectural subjects and some landscapes. Exhibited 25 works, 17 at R.A., 8 at S.B.A. (*V. & A.*, *B.M.*, *Oldham*)

SMART, John (1838–99)
Born Leith; apprenticed to his father, an engraver; pupil of H. McCulloch; assoc. R.S.A. 1871, member 1877; member R.B.A. and R.S.W. Landscapes. Exhibited 46 works, 4 at N.W.C.S., 24 at R.A.

SMART, John (1741–1811)
Born Norfolk; studied at St Martin's Lane Academy; member and vice-president Incorp. S.A.; spent some years in India. Miniatures and crayon portraits. Exhibited 27 works, 23 at R.A.

SMETHAM, James (1821–89)
A drawing master; friend of the
Pre-Raphaelites. Domestic
subjects. Exhibited 38 works, 18 at
R.A., 2 at B.I., 17 at S.B.A. 1851–76.

SMIRK, Mary (fl. 1809–80)
An amateur. Views on the South
Coast. Exhibited 6 works at R.A.

SMIRKE, Richard (1778–1815)
Brother of Robert; employed by
the Society of Antiquities.

SMIRKE, Robert (1752–1845)
Born Wigton; a book illustrator;
F.S.A., R.A. Humorous and
sentimental subjects. Exhibited 38
works, 7 at Soc. of Artists, 25 at
R.A., 5 at S.B.A. 1775–1834.

SMIRKE, Sydney (1799–1877)
Son of Robert; an architect; fellow
R.I.B.A.; travelled widely and made
many sketches. Exhibited 14
works at R.A. 1820–69.

SMITH, Arthur Reginald
(1871–1934)
Born Skipton, Yorkshire; assoc.
R.W.S. 1917, member 1925.
Member R.S.W. Landscapes.

SMITH, Barbara Leigh
(fl. 1850–74)
Probably the wife of C. D. Smith,
marine painter, fl. c. 1850; later
became Madame Eugene
Bodichon. Landscapes in Wales,
the Lake District, and the Isle of
Wight, and stormy coastal scenes,
especially at Hastings, where she
lived for some time.

SMITH, Carlton Alfred (b. 1853)
Member R.I. 1889–1939.

SMITH, David Murray
(1865–1952)
Born Edinburgh. Assoc. R.W.S.
1916, member 1933.

SMITH, Emma (fl. 1799–1808)
Daughter of engraver J. R.;
member Associated Artists in
Water Colours. Miniatures and
genre. Exhibited 40 works, 35 at
R.A.

SMITH, Frederick Coke (d. 1839)
Travelled in Turkey and Canada.
Landscapes.

SMITH, George (fl. 1847–87)
Domestic subjects. Exhibited 134
works, 5 at N.W.C.S., 78 at R.A.,
26 at B.I., 15 at S.B.A.

SMITH, G. W. (fl. 1814–25)
Of Lichfield, Staffs. Landscapes.
Exhibited 16 works, 11 at O.W.C.S.,
1 at B.I., 2 at S.B.A.

SMITH, Mrs H. Clarendon
(fl. 1858–77)
Domestic subjects. Exhibited
29 works at N.W.C.S.

SMITH, James Burrell (fl. 1824–81)
Lived for a time in Alnwick,
Northumberland. Highly coloured
landscapes, influenced often by
J. S. Cotman. Exhibited 65
works, 53 at S.B.A. (*V. & A.,
Newcastle*)

SMITH, John Irthington
(1749–1831)
Born Cumberland; known as
'Warwick' or 'Italian' Smith,
since he accompanied Lord
Warwick to Italy; pupil of
S. Gilpin at Windsor; member
O.W.C.S. 1806 and president 1814,
17 and 18. Landscapes, especially
Italian. Exhibited 162 works, 159
at O.W.C.S. (*B.M., V. & A.,
Aberystwyth, Douglas, Manchester*)

SMITH, John Raphael (1752–1812)
Born Derby; son of 'Smith of
Derby'; a noted mezzotint

engraver, being appointed to the
Prince of Wales; friend of Morland
and Ibbetson; among his pupils
were the brothers James and
William Ward, De Wint and
Hilton. Crayon portraits.
Exhibited 129 works, 73 at R.A.,
48 at Soc. of Artists. (*V. & A.*)

SMITH, John Rubens (1775–1849)
Born London; perhaps the son of
John Raphael; to Boston 1809, and
three times to Philadelphia, where
he founded an art school. Land-
scapes reminiscent of H. Cave of
York, and portraits. Exhibited 48
works at R.A.

SMITH, John Thomas (1776–1833)
Known as 'Antiquity Smith';
studied at R.A., and under the
engraver K. Sherwin; a drawing
master; keeper of prints at B.M.
from 1816. Topographical
subjects and portraits. Exhibited
2 works at R.A. (*B.M.*)

SMITH, Joseph Clarendon
(1778–1810)
Born London; went to sea as a
boy, but was later placed with an
engraver; member Associated
Artists in Water Colours. Land-
scapes and topographical.
Exhibited 37 works, 9 at R.A.
(*V. & A.*)

SMITH, Marcella Claudia Heber
(1887–1960)
Member R.I. 1944. Flower
paintings.

SMITH, Mary
See Lucan, Lady.

SMITH, Robert (fl. c. 1806)
An amateur, working in India;
could be Robert Parcy, advocate-
general of Bengal.

SMITH, William (fl. c. 1727)
Surveyor to the Royal Africa
Company of England. Views in
Guinea, engraved by Gray and
published 1727.

SMITH, William (fl. 1826–27)
A naval lieutenant. Arctic views,
with figures, in the Ibbetson style.

SMITH, William (fl. 1813–47)
Sporting subjects. Exhibited 48
works, 9 at O.W.C.S., 17 at R.A.,
15 at B.I., 7 at S.B.A.

SMITH, W. A. (fl. c. 1790)
Scottish landscapes. (*Edinburgh*)

SMITH, William Collingwood
(1815–87)
Born Greenwich; mainly self-
taught, but had a few lessons from
J. D. Harding; member O.W.C.S.
1849 and treasurer 1854–79;
travelled to France, Switzerland
and Italy. At first marines and
coastal scenes, and later landscapes
and architectural views. Exhibited
1,132 works, 1,064 at O.W.C.S., 32
at R.A., 15 at B.I., 21 at S.B.A.
(*V. & A., B.M., Newcastle*)

SMITH, W. Harding C.
(fl. 1868–93)
Member R.B.A. Domestic subjects.
Exhibited 63 works, 8 at N.W.C.S.,
7 at R.A., 29 at S.B.A.

SMYTH, Frederick (?) Coke
(fl. 1835–67)
Visited Constantinople 1835–36.
Turkish drawings. (*National
Gallery of Scotland*)

SMYTHE, Edward Robert
(1810–99)
Born Ipswich; studied at R.A.;
in Bury St Edmonds 1848–86.
Pastel landscapes and animals.

SMYTHE, Emma (fl. c. 1850)
Sister of E. R. Still-lifes.

SMYTHE, Lionel Percy
(1839–1918)
Studied at Heatherley's School;
member R.I. 1880–90 and R.W.S.
1894; A.R.A. 1898, R.A. 1911.
Landscapes and rural life.
Exhibited 137 works, 36 at
N.W.C.S., 35 at R.A., 31 at S.B.A.
(*V. & A.*)

SMYTHE, Miss Minnie (d. 1955)
Daughter of L. P. Smythe; assoc.
R.W.S. 1901, R.W.S. 1937. Flowers
and landscapes.

SNELLING, Matthew (fl. 1647–78)
Miniatures.

SOANE, Sir John (1752–1837)
Celebrated architect and writer of
fanciful illustrated books; R.A.
Architectural subjects. Exhibited
168 works at R.A.

SOLOMON, Simeon (1840–1905)
Friend of Rossetti, Burne-Jones
and the Pre-Raphaelites. Scenes
from Dante, the Bible, and so on,
and genre. Exhibited 53 works,
15 at R.A.1858–72. (*Birmingham*)

SOPER, Thomas James
(fl. 1836–90)
Of Edmonton. Landscapes.
Exhibited 243 works, 15 at
N.W.C.S., 47 at R.A., 48 at B.I., 57 at
S.B.A.

SOTHEBY, Maria E. (fl. 1829)
An amateur. Landscapes in the
style of Nattes.

SOUNES, William Henry
(1830–90)
Born London; studied at Govern-
ment School of Design, Somerset
House; modelling master at

Birmingham School of Art
1855–63, and later head master
Sheffield School of Art. Designs for
medals, and architectural interiors.

SOUTHALL, Joseph Edward
(1861–1944)
Born Nottingham; assoc. R.W.S.
1925, member 1931.

SPACKMAN, Isaac (d. 1771)
Birds, and small 'embossed'
pictures of birds.

SPARKES, Mrs J.
(née Catherine Adelaide Edwards)
(fl. 1869–91)
Domestic subjects. Exhibited 35
works, 6 at N.W.C.S., 11 at R.A.

SPEARE, R. (fl. 1799–1812)
Birds and landscapes. Exhibited
17 works at R.A.

SPEECHLEY, William (fl. 1766)
Still-lifes of fruit.

SPENCER, Gervase (or Jarvis)
(fl. 1761–74)
A gentleman's servant, who
became a fashionable miniaturist.
Exhibited 5 works at Soc. of
Artists.

SPENLOVE, Frank Spenlove
(1868–1933)
Member R.I. 1907, R.B.A., R.O.I.
Figure subjects. Exhibited 57
works, 8 at N.W.C.S., 16 at R.A., 23
at S.B.A.

SPICER, Henry (1743?–1804)
Born Reepham, Norfolk enamel;
painter to the Prince of Wales;
F.S.A. Miniatures. Exhibited 59
works, 12 at Soc. of Artists, 47 at
R.A. 1765–1804.

SPIERS, Bessie J. (fl. 1884–93)

Landscapes. Exhibited 17 works,
12 at N.W.C.S., 2 at R.A., 3 at S.B.A.

SPIERS, Benjamin Walter
(fl. 1875–93)
Domestic subjects. Exhibited 75
works, 19 at N.W.C.S., 17 at R.A.,
31 at S.B.A.

SPIERS, Charlotte H. (fl. 1873–93)
Landscapes. Exhibited 28 works,
12 at N.W.C.S., 1 at R.A., 8 at S.B.A.

SPIERS, Richard Phené
(1838–1916)
Studied engineering, architecture
in Paris 1858–61, and at R.A.;
worked with Sir Matthew Digby
Wyatt and William Burgess;
president R.I.B.A. and for 35 years
master of architecture at R.A.
Architectural subjects. Exhibited
201 works, 27 at N.W.C.S., 98 at
R.A., 21 at S.B.A. (*V. & A.*)

SPILSBURY, Francis B.
(fl. 1796–1805)
A surgeon in the Royal Navy;
probably related to John; worked
in Palestine and Africa.
Landscapes.

SPILSBURY, John (1730?–95)
Known as 'Inigo' Spilsbury;
one of a large artistic family,
probably related to F. B.; drawing
master at Harrow School.

SPRY, William (fl. 1832–47)
Flowers and still-lifes. Exhibited
43 works, 6 at N.W.C.S.

SQUIRE, Alice (1840–1936)
Member R.I. 1888. Landscapes.
Exhibited 103 works, 26 at
N.W.C.S., 29 at R.A., 5 at S.B.A.

STANFIELD, Clarkson
(1793–1867)
Born Sunderland; wrongly named

in the past as William; became a
sailor when aged 15, then a clerk
in the navy, and after a fall was
discharged 1818; a scene-painter,
finally at Drury Lane; member
S.B.A. 1824, A.R.A. 1832, R.A. 1835.
Marines and landscapes, somewhat
in the style of Bonington or Lear.
Exhibited 178 works, 135 at R.A.,
22 at B.I., 21 at S.B.A. (*V. & A.*,
*B.M., Newport, Mon., Liverpool,
Newcastle, Whitworth*)

STANFIELD, George Clarkson
(1828–78)
Son of Clarkson; studied under his
father at R.A.; worked much
abroad in Italy, France, Switzer-
land and Venice, and also
throughout Britain. Landscapes,
some with much use of body-
colour. Exhibited 127 works, 73
at R.A., 49 at B.I. (*B.M., V. & A.*)

STANHOPE, John Roddan Spencer
(1829–1908)
Member R.I. 1883.

STANILAND, Charles Joseph
(1838–1916)
Studied at R.A. 1861; member R.I.
Member R.O.I. 1879–1907. Figure
subjects. Exhibited 87 works, 62 at
N.W.C.S., 6 at R.A., 2 at B.I., 7 at
S.B.A.

STANLEY, Archer (fl. 1847–77)
Son of C. R. Stormy mountainous
landscapes. Exhibited 39 works,
16 at R.A., 18 at S.B.A.

STANLEY, Caleb Robert
(1795–1868)
Father of Archer; studied in Italy.
Landscapes, many on the
Continent, rather in the style of
J. D. Harding. Exhibited 159
works, 10 at N.W.C.S., 32 at R.A.,
87 at B.I., 23 at S.B.A. (*V. & A.*,
National Gallery of Ireland)

STANLEY, G. (fl. c. 1816)
Views in and around York, some
engraved in the 'Antiquarian
Repository'. Exhibited 1 work at
R.A.

STANNARD, Alfred (1806–89)
Brother of Joseph. Scarce marines.
Exhibited 15 works, 8 at B.I., 7 at
S.B.A.

STANNARD, Joseph (1797–1830)
Brother of Alfred; of the Norwich
School; studied for 7 years under
Robert Ladbrooke of Norwich.
Marines, river scenes and
portraits. Exhibited 13 works, 9 at
B.I., 4 at S.B.A. (*V. & A.*)

STANNUS, Anthony Carey
(fl. 1862–80)
Architectural and figure subjects.
Exhibited 40 works, 5 at R.A., 5 at
B.I., 13 at S.B.A.

STANTON, Clark (1832–94)
Born Birmingham. Painted in both
oils and watercolour.

STANTON, Rose Emily
(1838–1908)
Born Stroud. Still-lifes. Exhibited
20 works, 4 at N.W.C.S.
(*Note*. Her sister, Emily Rose, also
painted.)

STARK, Arthur James (1831–1902)
Born Chelsea; son and pupil of
James; influenced by E. Bristow of
Windsor; drawing teacher
1859–86. Animals and cattle.
Exhibited 179 works, 3 at N.W.C.S.,
35 at R.A., 33 at B.I., 51 at S.B.A.
(*V. & A.*)

STARK, James (1794–1859)
Born Norwich; pupil of John
Crome 1811–14; member Norwich
Society 1812; to London 1814, and
friend of W. Collins; studied at

R.A. 1817. Landscapes, usually
sketches, since main work was
in oils. Exhibited 274 works, 4 at
N.W.C.S., 66 at R.A., 136 at B.I.,
54 at S.B.A., 10 at O.W.C.S.
(*Norwich, V. & A., B.M.,
Whitworth*)

STEEDMAN, Charles (fl. 1826–58)
Landscapes and coastal scenes,
often with figures in the style of
W. Collins. Exhibited 122 works,
25 at R.A., 44 at B.I., 53 at S.B.A.

STEELE, Jane (fl. 1810–12)
Member Associated Artists in
Water Colours. Views of towns.
Exhibited 15 works, 5 at R.A.

STEELE, Jeremiah (fl. 1801–26)
Lived in Nottingham, then
London. Miniatures. Exhibited 30
works, 27 at R.A., 3 at B.I.

STEEPLE, John (fl. 1852–86)
Of Birmingham; member R.S.B.A.
1862. Local and Welsh views.
Exhibited 60 works, 7 at N.W.C.S.,
31 at S.B.A. (*V. & A., Birmingham*)

STEER, Henry Reynolds
(1858–1938)
Member R.I. 1884. Domestic
subjects. Exhibited 90 works, 54
at N.W.C.S., 3 at R.A., 23 at S.B.A.

STEER, Philip Wilson (1860–1942)
Landscapes, in free, wet washes.
(*Liverpool, Whitworth, Oxford,
Cambridge, Waltham Forest*)

STEERS, Fanny (d. 1861)
Member N.W.C.S. 1846; fl.
1833–42. Landscapes. Exhibited
59 works at N.W.C.S.

STEPHANOFF, Francis Philip
(1788–1860)
Born London, the son of a Russian-
born portrait-painter; brother of

James; studied at R.A. 1801.
Subject pictures and interiors,
domestic subjects, and later
London scenes. Exhibited 124
works, 11 at O.W.C.S., 49 at R.A.,
54 at B.I. (*V. & A.*)

**STEPHANOFF, James
(1787?–1874)**
Born London; brother of F. P.;
studied at R.A. 1801; member
O.W.C.S. 1819; historical painter
to William IV 1830. Biblical and
historical subjects. Exhibited 318
works, 245 at O.W.C.S., 20 at R.A.,
33 at B.I., 5 at S.B.A. (*V. & A.*)

STEPHENSON, James (1828–86)
Born Manchester; pupil of Finden.
A line engraver who painted in
oils and in watercolour. Exhibited
16 works, 15 at R.A., 1856–84.

STERNDALE, H. M. (fl. c. 1816)
Landscapes, some engraved.

STEVENS, Alfred (1818–75)
Born Blandford, the son of an
heraldic painter; Italy 1833–42
copying frescoes, sketching, and
studying at Rome under
Thorwaldsen; professor at
Government School of Design,
Somerset House 1845–47. Italian
architecture and scenery. (*V. & A.*)

STEVENS, Francis (1781–1823)
Sometimes called 'Stevens of
Exeter'; pupil of P. S. Munn;
assoc. O.W.C.S. 1806, member
1809, also of Chalons' Sketching
Society; taught at Sandhurst
Military Academy 1816. Cottages.
Exhibited 92 works, 78 at O.W.C.S.,
12 at R.A. (*V. & A., Exeter*)

STEVENS, George (1810–61)
Animals, game and fruit. Exhibited
343 works, 246 at S.B.A., 22 at R.A.,
75 at B.I.

**STEWART (or STEWARD)
Anthony (1773–1846)**
Born Crieff, Perths.; pupil of
A. Nasmyth. Landscapes and
miniatures of children. Exhibited
12 works at R.A. 1807–20.

STOCK, Henry J. (fl. 1874–93)
Member R.I. Figure subjects.
Exhibited 80 works, 39 at N.W.C.S.,
16 at R.A.

STOCKS, Arthur (1846–89)
Member R.I. 1882. Born London;
son and pupil of engraver Lumb
Stocks; studied at R.A. Genre.
Exhibited 115 works, 16 at
N.W.C.S., 59 at R.A.

**STOCKS, Katherine M.
(fl. 1877–89)**
Flowers. Exhibited 30 works, 10
at N.W.C.S., 6 at R.A.

**STOCKS, Walter Fryer
(fl. 1862–93)**
Landscapes. Exhibited 275 works,
21 at N.W.C.S., 95 at R.A., 6 at B.I.,
33 at S.B.A.

**STOCKDALE, Frederick Wilton
Lichfield (fl. 1808–48)**
Assistant to military secretary
East India Company; an anti-
quarian; probably lived in Kent.
Landscapes and buildings.
(*V. & A.*)

**STOCKDALE, W. Colebrook
(fl. 1860–67)**
(*Bath*)

STOCKER, R. (fl. 1830–50)
Rare landscapes.

**STOKES, Charles Adam Scott
(1854–1935)**
Born at Southport; assoc. R.W.S.
1920, member 1926, vice-president
1932–35; A.R.A. 1910; R.A. 1919.

STOKES, Marianne, wife of above.
(d. 1927)
(née Preindsberger of Graz,
Austria). Assoc. R.W.S. 1923.

STONE, Frank (1800–59)
Born Manchester, the son of a
cotton-spinner; to London 1831;
member O.W.C.S. 1842–46, A.R.A.
1851; a book illustrator. Genre.
Exhibited 102 works, 26 at
O.W.C.S., 42 at R.A., 24 at B.I., 10 at
S.B.A. (*V. & A.*)

STONES, Emily R. (fl. 1882–89)
Flowers. Exhibited 20 works, 6 at
N.W.C.S., 1 at R.A., 12 at S.B.A.

STOPFORD, William Henry
(1842–90)
Born Cork; studied under his
father at Cork School of Art, and at
South Kensington; taught in
London; headmaster Halifax
School of Art 1867–90. Marines
and coastal scenes. Exhibited 3
works, 1 at R.A., 2 at S.B.A.
(*V. & A.*)

STOTHARD, Thomas (1755–1834)
Born London; studied at R.A.
1777; a silk designer and book
illustrator; A.R.A. 1791, R.A. 1794,
librarian R.A. 1813. Book
illustrations and landscapes.
Exhibited 111 works, 90 at R.A.,
8 at B.I., 13 at S.B.A. (*V. & A.,
B.M., Liverpool, Newport,
Nottingham, Manchester,
Birmingham*)

STOTT, William Edward
(1855?–1918)
Born Rochdale; studied art in
Manchester under W. K. Keeling,
and in Paris; returned to England
c. 1884; A.R.A. 1906. Figure
subjects. Exhibited 32 works, 3 at
R.A., 21 at S.B.A., 3 at Grosvenor
gallery. (*V. & A.*)

STOWERS, Thomas
(fl. 1778–1814)
An amateur; probably pupil and
friend of R. Wilson. Landscapes.
Exhibited 49 works, 5 at O.W.C.S.,
38 at R.A., 6 at B.I.

STRANGE, Albert (fl. 1878–91)
Of Liverpool. Landscapes.
Exhibited 20 works, 6 at N.W.C.S.,
9 at R.A.

STRANGE, Sir Robert (1721–92)
Born Orkneys; studied in Paris and
Italy; member Incorp. S.A. 1766;
knighted 1787. Miniatures.
Exhibited 17 works, 17 at Soc. of
Artists.

STREATFIELD, Rev. T.
(fl. c. 1800)
Castles, some engraved in 'Copper
Plate Magazine'.

STRUTT, Alfred W. (fl. 1877–93)
Member R.B.A. Domestic subjects.
Exhibited 102 works, 9 at
N.W.C.S., 35 at R.A., 49 at S.B.A.

STRUTT, Jacob George
(1790–1840?)
Born Colchester; son of a friend of
Constable. Landscapes. Exhibited
47 works, 21 at R.A., 24 at B.I.

STRUTT, William (1826–1915)
Lived for some time in Italy and
visited the Middle East.
Landscapes with strong sepia
penwork, studies of lions.

STUART, James (1713–88)
Born London; known as
'Athenian' Stuart; best known as
an architect; travelled to Rome on
foot; visited Athens for the
Dilettanti Society. Antiquities and
Italian landscapes. Exhibited 121
works at Free Society.

STUART, Sir James (1779–1849)
Born Rome; an amateur. Land-
scapes and battle scenes.
(*Edinburgh*)

STUART, The Hon. Miss Louisa
(d. 1891)
Figure subjects; fl. 1877–82.
Exhibited 18 works, 17 at
Grosvenor gallery.

STUBBS, George (1724–1806)
Born Liverpool; renowned
animal-painter in oils, but a few
watercolours are known; A.R.A.
1780, R.A. 1781. (*B.M.*)

STUMP, S. John (d. 1863)
Studied at R.A.; fl. 1802–49.
Landscapes and miniatures.
Exhibited 367 works, 21 at
O.W.C.S., 236 at R.A., 55 at B.I., 47
at S.B.A.

STURGEON, Kate (fl. 1882–92)
Domestic subjects. Exhibited 20
works, 9 at N.W.C.S., 2 at R.A.

SULLIVAN, Edmund Joseph
(1869–1933)
Assoc. R.W.S. 1913, member 1929.
Fellow Royal Society of Painter-
Etchers. On Staff of Graphic
Master Art Workers Guild 1931.
(*Bradford, Rome, New York, etc.*)

SULLIVAN, Luke (1705?–71)
Born Ireland; studied in London
under Thomas Major; member
and director Incorp. S.A. A noted
engraver, but also many land-
scapes. notably of mansions; little
known but highly praised by
Walpole. Exhibited 14 miniatures
at Soc. of Artists.

SUNDERLAND, Thomas
(1744–1823)
An amateur, who lived in

Lancashire and Cumberland;
perhaps a pupil of A. Cozens,
J. Cozens and Farington; widely
travelled in Europe. Landscapes in
the Lake District and Scotland, in
blue-grey monochrome, and very
rarely in colour. (*Newport,
Newcastle, Leeds, Whitworth*)

SUTCLIFFE, Thomas (1828–71)
Born Yorkshire; studied at R.A.;
assoc. N.W.C.S. 1857. Landscapes.
Exhibited 110 works, 109 at
N.W.C.S. (*V. & A., Leeds*)

SUTHERLAND, Thomas
(b. 1785)
An engraver and aquatinter.
Hunting scenes and landscapes in
watercolour.

SWAINE, Francis (d. 1782)
Possibly a pupil of P. Monamy;
fl. c. 1762; member Free S.A.
1763. Marines. Exhibited 124
works, 48 at Soc. of Artists, 76 at
Free Soc. (*Greenwich, Newcastle*)

SWAINSON, William (1798–1883)
A widely travelled naturalist.
Illustrations.

SWAN, Miss Alice Macallan
(1864–1939)
Assoc. R.W.S. 1903, member 1929.

SWAN, John Macallan (1847–1910)
Born Old Brentford; studied at
Worcester and Lambeth Schools of
Art, at R.A., and in Paris under
Gérome; A.R.A. 1894, R.A. 1905,
assoc. R.W.S. 1896, member 1899.
Animals and figure subjects.
Exhibited 26 works, 13 at R.A.
(*V. & A., Glasgow, Manchester,
Newcastle*)

SWANWICK, Joseph Harold
(1866–1929)
Member R.I. 1897, member R.O.I.

A Dictionary of Watercolour Painters

SWARBRECK, Samuel Dunkinfield
(fl. 1839–62)
Buildings in Chester, Newcastle
and Scotland. Exhibited 56 works,
8 at R.A., 14 at R.I., 4 at S.B.A.
(*Newcastle*)

SWETE, A. J. (fl. 1744–47)
Views around London in Indian
ink. (*V. & A.*)

SWETE, Rev. J. (1752?–1835)
Of Exeter, and of an old
Devonshire family, whose real
name apparently was Tripe.
Landscapes, referred to in
Farington's diary.

SWINBURNE, Lady Emilia
(fl. c. 1799)
Wife of Sir Edward, father of
Edward. Topographical subjects
near Rome.

SWINBURNE, Edward
(1765–1829?)
Son of Lady Emilia; an amateur;
travelled in Italy; in Newcastle-
upon-Tyne 1829. Landscapes.
(*V. & A.*)

SWINSTEAD, George Hillyard
(1860–1926)
Member R.I. 1907.

SYBRECHT (or SIBERECHT), Jan
(1625?–1703)
Born Antwerp; to England with
the Duke of Buckingham 1670.
Country seats in oils, but a
watercolour example in B.M.

SYER, John (1815–85)
Born Atherstone, Warwicks.; went
early to Bristol; influenced by
D. Cox and W. J. Müller;
member S.B.A. 1856–75 and R.I.
1875. Landscapes. Exhibited 190
works, 81 at N.W.C.S., 19 at R.A.,
11 at B.I., 68 at S.B.A. (*V. & A.*,

*Birmingham, Bath, Whitby,
Newport, Whitworth, Bristol*)

SYKES, Godfrey (1825–66)
Born Malton, Yorks.; apprenticed
to an engraver; studied at
Government School of Design,
Sheffield; assisted in decoration of
V. & A. Interiors of mills and
forges, and views around Sheffield.
(*V. & A.*)

SYME, Patrick (1774–1845)
Born Edinburgh; a drawing
master; foundation member
Scottish Academy 1826. Flowers
and fruit. Exhibited 2 works at
R.A. 1817.

TALMAN, John (fl. c. 1710)
Son of William, an architect;
visited Rome with William Kent.
Architectural.

TASSAERT, Phillip Joseph
(1732–1803)
Born Antwerp; president Incorp.
S.A. Landscapes. Exhibited 41
works, 38 at Soc. of Artists, 2 at
R.A., 1769–85.

TASSIE, James (1735–99)
Born Glasgow; settled in London
1766. A skilled draughtsman, and
designer of cameos for
Wedgwood. Exhibited 52 works,
50 at R.A., 1769–85.

TATE, Thomas Moss
(fl. 1771–1804)
Probably son of art patron Richard,
of Liverpool; friend and possibly
pupil of Wright of Derby. Italian
scenes. (*V. & A.*)

TATE, William (d. 1806)
A pupil of Wright of Derby;

fl. 1771–1804; F.S.A. Portraits. Exhibited 24 works, 12 at Soc. of Artists, 12 at R.A.

TATTERSALL, George (d. 1849) Known for his guide book to the Lakes of England; worked under the nom-de-plume of 'Wildrake'; fl. 1840–48. Sporting subjects and landscapes, mostly in sepia. Exhibited 6 works at R.A.

TAUNTON, William (fl. 1840–75) Landscapes in chalk or pencil on tinted paper, slightly tinted, and heightened with body-colour. (*B.M.*)

TAVERNER (or TAVENER), William (1703–72) An amateur, but a great name in the development of early English watercolour. Romantic and classical landscapes, sometimes in body-colour. (*V. & A., B.M., Bedford, Newcastle, Whitworth, Nottingham, Liverpool, Sheffield*)

TAYLER, John Frederick (1802–89) Born Borehamwood, Herts.; studied at Sass's Academy, at R.A., at Paris under Vernet, and at Rome. Shared a Paris studio with Bonington; member O.W.C.S. 1834 and president 1858–71. Landscapes reminiscent of Bonington, historical and sporting subjects, and landscapes with figures, many in Scotland. Exhibited 556 works, 528 at O.W.C.S., 5 at R.A. (*Newcastle, Whitworth, B.M.*)

TAYLER, Norman E. (fl. 1863–1915) Assoc. O.W.C.S. 1878–1915. Flowers and sentimental figure subjects. Exhibited 106 works, 90 at O.W.C.S., 13 at R.A. (*V. & A.*)

TAYLEURE, W. (fl. c. 1800) An obscure landscape-painter; when a travelling musician, he met F. Nicholson at Ripon and became his pupil; drawing master at Beverley, Yorks. Landscapes in the Nicholson style.

TAYLOR, Alfred Henry (d. 1868) Member N.W.C.S. 1839; fl. 1832–67. Portraits and domestic subjects. Exhibited 200 works, 107 at N.W.C.S., 26 at R.A., 38 at B.I.

TAYLOR, Edward R. (1838–1912) Born Hanley, Staffs.; the son of a pottery manufacturer; studied at Burslem School of Art; first headmaster Lincoln School of Art 1863, and Birmingham Municipal School of Art 1876–1903; taught W. Landley; member R.B.S.A. 1879. Landscapes, architectural and figure subjects. Exhibited 80 works, 3 at N.W.C.S., 30 at R.A., 23 at S.B.A. (*Birmingham*)

TAYLOR, George Ledwell (or Leadwell) (1788–1873) An architect, trained at Rawes' Academy, Bromley; surveyor of Buildings to Naval Dept. 1824; laid out many London squares; wrote on antiquities and architecture. Architecture in Rome and Athens. Exhibited 10 works at R.A. (*V. & A.*)

TAYLOR, John (1739–1838) Known as 'Old Taylor'. Pupil of Francis Hayman at St. Martin's Lane Academy.

TAYLOR, John B. (fl. c. 1816) A drawing of 'Sunderland' engraved in 'Antiquarian Repository'.

TAYLOR, Tom (fl. 1792–1809)

Known as 'Taylor of Liverpool';
an amateur, taught by T.
Chubbard. Landscapes. Exhibited
57 works at R.A. (_B.M._)

TAYLOR, W. (1800–61)
Son of a schoolmaster; first
secretary King's Lynn Museum.
(_King's Lynn, Norwich_)

**TAYLOR, William Benjamin
Sarsfield** (1781–1850)
Born Dublin; member N.W.C.S.
1831. Landscapes, battle scenes
and marines. Exhibited 44 works,
5 at N.W.C.S., 22 at R.A., 16 at B.I.

TEDDER, M. (fl. 1885–91)
Of Woking. Landscapes.
Exhibited 3 works at N.W.C.S.

TEESDALE, C. (fl. 1883–86)
Landscapes. Exhibited 4 works at
N.W.C.S.

TELBIN, William (1813–73)
Member N.W.C.S. 1839. Theatrical
scenery and landscapes. Exhibited
23 works, 12 at N.W.C.S., 1 at R.A.,
6 at B.I.

TEMPEST, Pierce
Mid-17th century mezzotint
engraver; pupil and assistant of
Hollar. Did the first prints of
'Cries of London'.

TEMPLETOWN, Lady Elizabeth
(d. 1823)
Daughter of Sir W. S. Boughton,
Bart.; a designer of children,
cupids, and so on, in the style of
Lady D. Beauclerk; some of her
drawings were used by
Wedgwood for designs on his
jasper ware; excelled in cut
paperwork; lived for some time in
Rome; fl. c. 1750. A landscape is
in the V. & A.

TENNANT, John F. (1796–1872)
An outstanding Victorian land-
scape artist, but rare in water-
colour. Exhibited 416 works,
4 at N.W.C.S., 18 at R.A., 54 at B.I.,
340 at S.B.A.

TENNIEL, Sir John (1820–1914)
Born London; mainly self-taught;
drew the principal cartoons for
Punch, and illustrated 'Alice in
Wonderland' and 'Alice through
the Looking Glass'; member
N.W.C.S. 1874; knighted 1893.
Cartoons and historical subjects.
Exhibited 65 works, 27 at N.W.C.S.,
14 at R.A., 16 at S.B.A.

TERRIS, John (1865–1914)
Member R.I. 1912, member R.S.W.

TERROT, Rev. Charles Pratt
(d. 1839)
Pupil of De Wint. Romantic and
historical interiors in the George
Cattermole style. (_Tattershall
Castle_)

TERRY, Henry (fl. 1870–80)
Probably Henry J., who studied in
Switzerland under Calame.
Domestic subjects. Exhibited 64
works, 12 at N.W.C.S., 13 at R.A.,
19 at S.B.A.

THACKERAY, William Makepeace
(1811–63)
Born Calcutta; the famous
novelist, but studied art for some
time on the Continent; contributed
drawings to _Punch._ Book
illustrations. (_V. & A._)

THEOBALD, Henry (d. 1849)
Assoc. N.W.C.S.; fl. 1845. Genre.
Exhibited 25 works, 23 at N.W.C.S.

THEW, Robert (1758–1802)
Born Partington; engraver to the
Prince of Wales. Chalk drawings.

THIRTLE, John (1777–1839)
Born Norwich, the son of a shoe-maker and brother-in-law to
J. S. Cotman; first practised as a miniature-painter before moving to London to learn frame-making; set up business in Norwich, and also taught drawing; member Norwich Society. Landscapes and views of towns. Exhibited 1 work at R.A. 1808. (*Norwich, B.M., V. & A., Newport, Liverpool, Newcastle, Whitworth*)

THOMAS, George Housman
(1824–68)
Born London; apprenticed to a wood engraver; studied under
G. W. Bonner, the engraver, and at Paris; worked on a New York newspaper; later for the
Illustrated London News. Views of ceremonies and figure subjects. Exhibited 29 works, 19 at R.A.
(*V. & A.*)

THOMAS, Sidney (fl. 1867–68)
Landscapes. Exhibited 2 works.
(*V. & A.*)

THOMAS, William Cave
(1820–84?)
Born London; studied at R.A. and Munich; travelled in Germany and Italy; back to London 1843. Figure subjects. Exhibited 51 works, 1 at
N.W.C.S., 20 at R.A., 3 at B.I.
(*V. & A.*)

THOMAS, William Leeson (or Luson) (1830–1900)
A wood engraver; worked in Paris, New York, Rome and London;
Assoc. N.W.C.S. 1864, member R.I. 1875 and Institute of Oil Painters; founder of the *Graphic* and *Daily Graphic*. Domestic subjects. Exhibited 184 works, 173 at
N.W.C.S.

THOMPSON, Elizabeth
(fl. 1867–75)
Member R.I. 1874. Military subjects. Exhibited 27 works, 9 at
N.W.C.S., 3 at R.A.

THOMPSON, James Robert
(1799?–1843)
An architectural draughtsman, who worked for Britton; studied at R.A. 1819. Architectural views, some in Switzerland, and a few scenes of elephant hunting.
(*V. & A., B.M.*)

THOMPSON, Margaret
(fl. 1871–93)
Of Hitchin, Herts. Domestic subjects. Exhibited 8 works, 3 at
N.W.C.S., 3 at S.B.A.

THOMPSON, Wilfred H.
(fl. 1884–93)
Historical subjects. Exhibited 21 works, 10 at N.W.C.S., 3 at R.A., 1 at S.B.A.

THOMSON, Hugh (1860–1920)
An illustrator; member R.I. 1897–1907. Figure subjects.
(*V. & A.*)

THOMSON, John Leslie
(1851–1929)
Born Aberdeen; member R.I. 1893–1909; assoc. R.W.S. 1910, member 1912.

THOMSON, Rev. John
(1778–1840)
Born Dailly, Ayrshire; known as 'Thomson of Duddingston'; a Presbyterian minister; helped by
A. Nasmyth; hon. R.S.A. Land-scapes in the tradition of Claude and Poussin. Exhibited 6 works, 1 at R.A., 2 at B.I., 3 at S.B.A., 1813–31. (*V. & A.*)

THOMSON, Robert (fl. c. 1818)

A little-known landscape artist.
Clear and delicate topography, one
example engraved in Rhodes'
'Peak Scenery' 1818–19.

THOMSON, William John
 (1771–1845)
 Born Savannah, America; worked
 in England from c. 1796; member
 Associated Artists in Water
 Colours and R.S.A. 1830. Domestic
 subjects. Exhibited 104 works,
 5 at O.W.C.S., 68 at R.A., 9 at B.I.

THORBURN, Archibald
 (1860–1935)
 Of Kelso, Roxburghshire.
 Renowned for fine studies of birds
 and animals. Exhibited 17 works,
 16 at R.A., 1 at S.B.A., 1880–93.
 (*Edinburgh, Blackburn*)

THORBURN, Robert (1818–85)
 Born Dumfriesshire; studied at
 Trustees' Academy, Edinburgh,
 under Sir William Allan, and at
 R.A. 1836; A.R.A. 1848.
 Miniatures. Exhibited 266 works,
 265 at R.A.

THORNELEY, Charles
 (fl. 1858–93)
 Marines. Exhibited 201 works,
 8 at N.W.C.S., 49 at R.A., 4 at B.I.,
 50 at S.B.A.

THORNHILL, Sir James
 (1675–1734)
 Born Melcombe Regis, Dorset;
 studied under Thomas Highmore,
 a portrait-painter. Founded and
 ran a drawing school, where
 amongst others, he taught
 Hogarth; became a member of
 parliament 1722; sergeant painter
 to George I. Allegorical works.
 (*V. & A.*)

THORNHILL, John
 Son of Sir James; sergeant painter

to George II. Landscapes and
marines.

THORNYCROFT, Mrs Thomas
 (née Francis)
 (fl. 1840–80)

THORNYCROFT, William Hamo
 (fl. 1872–93)

THORPE, John (fl. 1834–73)
 Coastal scenes. Exhibited 172
 works, 2 at N.W.C.S., 39 at R.A.,
 13 at B.I., 26 at S.B.A.

THORS, Joseph (fl. 1863–84)
 Landscapes. Exhibited 24 works,
 6 at R.A., 2 at B.I., 15 at S.B.A.

THROSBY, John (1740?–1803)
 Parish clerk of St Martin's,
 Leicester; wrote antiquarian
 books. Landscapes. (*V. & A.*)

THURNALL, Harry J. fl. (1875–93)
 Flowers and still-life. Exhibited
 15 works, 4 at R.A., 7 at S.B.A.

THURSTON, John (1774–1822)
 Born Scarborough; an engraver
 and book illustrator, chiefly in
 pencil and Indian ink. Assoc.
 O.W.C.S. 1806. Landscapes.
 Exhibited 21 works, 5 at O.W.C.S.,
 16 at R.A.

TIDDEMAN, Letitia E. H.
 (fl. 1870–90)
 Of Stokenchurch, Bucks. Domestic
 subjects. Exhibited 7 works, 4 at
 N.W.C.S.

TIDEY, Alfred (1809–92)
 Abroad 1857–67. Miniatures and
 domestic subjects. Exhibited 9
 works, 2 at R.A., 1 at N.W.C.S.

TIDEY, Henry F. (1814–72)
 Born Worthing; member N.W.C.S.
 Miniatures, genre, and scriptural

and poetical subjects. Exhibited 181 works, 103 at N.W.C.S., 67 at R.A.

TILLEMANS, Pieter (1684–1734)
Born Antwerp, the son of a diamond polisher; to England 1708. Landscapes and hunting scenes, and Northants topography. (*V. & A., B.M.*)

TOBIN, Rear Admiral George (1768–1838)
An amateur; in the West Indies 1782. Marines.

TODD, Arthur Ralph Middleton (1891–1966)
Born at Helston, Cornwall; assoc. R.W.S. 1929, member 1937, A.R.A. 1939, R.A. 1949. Member Royal Society of Painter-Etchers and Engravers. Portraits of gipsies, beggars, etc. Studied in Italy, France and Holland.

TODD, Ralph (fl. 1880–93)
Landscapes. Exhibited 18 works, 4 at N.W.C.S., 3 at R.A.

TOFT, Peter (fl. 1872–93)
Landscapes. Exhibited 59 works, 6 at R.A., 30 at S.B.A., 4 at N.W.C.S.

TOLDERVY, W. F. (fl. 1842–47)
Small landscapes in Devon, Kent, on the Thames and around London. Exhibited 18 works, 5 at R.A., 7 at B.I., 6 at S.B.A.

TOM, Peter (d. 1777)
Son of the engraver W. H. Tom; drapery painter to Reynolds. Pen and wash topography.

TOMBLESON, W. (fl. c. 1830)
Views on the Thames and the Rhine.

TOMKINS, Charles (1757–1823)

Son of W. Tomkins R.A. Landscapes, and illustration of topographical books after 1779. Exhibited 15 works at R.A. (*B.M.*)

TOMKINS, Charles F. (1798–1844)
A scene-painter; collaborated with Clarkson Stanfield and J. W. Allen; a caricaturist; known, and signed himself as 'Charley'; member S.B.A. 1837. Landscapes. Exhibited 2 works at R.A. (*V. & A., B.M.*)

TOMSON, Arthur (1858–1905)
An early member of the New English Art Club; a writer on art. Flowers and landscapes. Exhibited 35 works, 14 at R.A., 6 at S.B.A. (*V. & A.*)

TONGE, Robert (1823–56)
Pupil of R. Beckie of Liverpool. Portraits and landscapes. Exhibited 2 works, 1 at R.A., 1 at S.B.A. 1840–53.

TONKS, Denison Boswell Myles (b. 1890)
Member R.I. 1938, member Pastel Society. Landscapes.

TOOK, William (fl. 1857–92)
Landscapes. Exhibited 32 works, 21 at O.W.C.S.

TOPHAM, Francis William (1808–77)
Born Leeds; apprenticed to a writing engraver in London 1830, and became a heraldic engraver; took to watercolour painting, and became member N.W.C.S. 1843; with A. D. Fripp to Ireland 1844; visited Spain 1852–53, and Ireland 1860, returned Spain 1864, and died at Cordoba. Assoc. O.W.C.S. 1848, member 1848. Figure subjects in Spain and

Ireland. Exhibited 170 works, 119 at o.w.c.s., 38 at n.w.c.s., 7 at r.a.

TOPHAM, Frank William Warwick
(1838–1924)
Member r.i. 1879, member r.o.i.
Figure subjects. Exhibited 162 works, 20 at n.w.c.s., 60 at r.a.

TORRY, John T.
Landscapes. Exhibited 4 works, 2 at s.b.a., 2 at n.w.c.s. 1886.

TOUSSAINT, Augustus
(fl. 1775–88)
Apprenticed to James Nixon.
Miniatures. Exhibited 26 works at r.a.

TOWNE, Charles (1763–1840)
Born Wigan; worked in Liverpool; member Liverpool Academy 1810 and vice-president 1813; to Leeds 1775, and after stays in Manchester and Warrington finally back to Liverpool. Sporting subjects and landscapes. Exhibited 17 works, 12 at r.a., 4 at b.i.

TOWNE, Francis (1740–1816)
Studied at Shipley's Drawing School; visited Italy 1780, returning 1781 with 'Warwick' Smith via Switzerland; to Lake District 1786; friend of William Pars, Cosway and Humphry; taught J. W. Abbot and W. MacKinnon; worked much at Exeter, where he was a drawing master. Landscapes. Exhibited 56 works, 16 at Soc. of Artists, 3 at Free Soc., 27 at r.a., 10 at b.i. (*B.M.*, *Leeds*, *V. & A.*, *Birmingham*, *Exeter*, *Newcastle*, *Bedford*, *Whitworth*)

TOWNLEY, Charles (1746–1800)
Born London; an engraver.
Portraits, many in pastel.
Exhibited 39 works, 2 at Soc. of

Artists, 21 at Free Soc., 16 at r.a. 1778–95.

TOWNROE, Reuben (1835–1911)
Sculptor and designer. Landscapes and architectural designs, mostly in Italy. (*V. & A.*)

TOWNSEND, Henry James
(1810–90)
Born Taunton; trained as a surgeon, but turned to art; a wood engraver and etcher, who illustrated 'The Deserted Village' 1841 and Gray's 'Elegy' 1847; master at Government School of Design, Somerset House. Some landscapes in Devon, and figure subjects, some historical.
Exhibited 21 works, 17 at r.a. 1838–66. (*V. & A.*)

TOWNSEND, Pattie (fl. 1877–92)
Of Nuneaton. Landscapes.
Exhibited 40 works, 17 at n.w.c.s., 3 at r.a.

TOWNSEND, W. H. (1803–49)
Worked in Edinburgh. Landscapes and figure subjects. (*Edinburgh*)

TRESHAM, Henry (1750?–1814)
Born Dublin; studied at Dublin Society's schools; to London 1775 as a portrait-painter; 14 years in Italy; a.r.a. 1791, r.a. 1799; professor of painting at r.a. 1807–09. Portraits, landscapes, genre and mythological subjects.
Exhibited 33 works at r.a. (*V. & A.*)

TREVELYAN, Lady Paulina,
(née Jermyn)
(1816–66)
Italian landscapes.

TRIPE
See Swete, Rev. J.

TROTMAN, Lilian (fl. 1881–93)
Domestic subjects. Exhibited 14
works, 3 at N.W.C.S., 2 at R.A., 9 at
S.B.A.

TROUGHTON, Thomas (d. 1797)
Shipwrecked 1747, and a slave in
Morocco for 33 years; published a
book of his adventures. Little-
known landscapes.

TUCK, Albert (fl. 1870–90)
Domestic subjects. Exhibited 11
works, 5 at N.W.C.S.

TUCK, Harry (fl. 1870–93)
Domestic subjects. Exhibited 60
works, 15 at N.W.C.S., 2 at R.A.

TUCKER, Arthur (fl. 1833–92)
Of Windermere. Landscapes.
Exhibited 14 works, 9 at N.W.C.S.,
3 at R.A.

TUCKER, Edward (fl. 1849–73)
Lived at Woolwich. Coastal
scenes. Exhibited 17 works, 13 at
S.B.A., 2 at R.A. (*V. & A.*)

TUDOR, J. O. (fl. 1809–22)
A Welshman, working almost
entirely in Wales. Landscapes.
Exhibited 24 works, 17 at R.A., 7 at
S.B.A.

TUITE, J. Thomas (fl. c. 1834)
Painted portraits at Bologne, and
marines in the style of C. Bentley.
Exhibited 5 works, 3 at R.A., 2 at
B.I.

TUKE, Henry Scott (1858–1929)
Born York; assoc. R.W.S. 1904,
member 1911, A.R.A. 1900, R.A.
1914. Painter of the Sea and
Sea folk. Nudes, usually boys in
sunlight (*Tate*)

TURNBULL, Mrs Valentine
(née Anne Charlotte Fayermann)
(1800–62)
Born Loddon, Norfolk; married
V. Turnbull 1827, and V.
Bartholomew 1840. Fruit, flowers
and miniatures. Exhibited 22
works, 21 at R.A., 1829–44.

TURNBULL, W. (or perhaps T.)
(fl. c. 1827)
Landscapes and architectural
subjects. (*V. & A.*)

TURNER, C. (fl. c. 1810)
An obscure landscape artist.

TURNER, Francis (fl. 1838–71)
Landscapes, mostly in Devon and
Wales, but also in Kent, Yorkshire,
the Lakes and Scotland. Exhibited
97 works, 35 at R.A., 38 at B.I.,
24 at S.B.A.

TURNER, George (fl. 1782–1820)
Historical subjects and rustic
scenes. Exhibited 47 works, 30 at
R.A., 17 at B.I. (*V. & A.*)

TURNER, Joseph Mallord William
(1775–1851)
Born Covent Garden, the son of a
barber; pupil of Thomas Malton Jr
and Thomas Hardwick; close
friend of Thomas Girtin;
patronised by Dr Monro; studied
at R.A. 1789; A.R.A. 1799; R.A.
1802, and professor of perspective
1807–37. Toured much on the
Continent 1802–40. Landscapes.
Exhibited 283 works, 259 at R.A.,
17 at B.I., 7 at S.B.A., 1790–1850.
(*V. & A., B.M., Manchester,
Whitworth, Birmingham,
Birmingham, Edinburgh, and all
major collections*)

TURNER, William (1789–1862)
Born Black Bourton, Oxon.; known
as 'Turner of Oxford'; pupil of
John Varley in London; member
O.W.C.S. 1808; settled at Oxford as

a drawing teacher 1811, and so failed to live up to early promise. Landscapes. Exhibited 502 works, 464 at o.w.c.s., 17 at R.A., 18 at B.I., 3 at S.B.A. (*V. & A., Newcastle, Leeds, Whitworth, B.M., Birmingham*)

TYLER, William Henry
(fl. 1878–93)
A sculptor. Exhibited 53 works, 3 at N.W.C.S., 25 at R.A.

TYNDALE, Walter Frederick Roope (1856–1943)
Of Bath; member R.I. 1911, R.B.C. Domestic and architectural subjects. Exhibited 28 works, 5 at N.W.C.S., 9 at R.A., 5 at S.B.A. (*V. & A.*)

TYNTE, Anne Kerneys
(fl. 1822–46)
Lived in the West Country. Landscapes in England, Germany and Switzerland. Did not exhibit.

TYTLER, George (1797–1859)
Draughtsman to the Duke of Gloucester. Portraits, and little-known landscapes in Italy which were lithographed. Exhibited 4 works, 3 at R.A., 1 at o.w.c.s., 1819–25.

ULCOQ, Andrew (fl. 1889–93)
Landscapes. Exhibited 3 works, 1 at R.A., 1 at N.W.C.S.

UNDERWOOD, Richard Thomas
(1772–1835)
Studied at Dr Monro's; draughtsman to Society of Antiquaries; to Paris 1802; a civil prisoner in France on his way home from visiting Italy in 1803; friend of Girtin and Francia.

Topographical landscapes in the Rooker style. Exhibited 23 works, at R.A., 1789–1801. (*V. & A.*)

UNDERWOOD, Thomas
(1809–82)
An antiquarian, who drew buildings in Birmingham.

UPHAM, John William
(1772–1828)
Born near Honiton; worked in Devon, Dorset, North Wales and Switzerland. Landscapes. Exhibited 13 works, 12 at R.A. (*V. & A., B.M.*)

UREN, John C. (fl. 1885–90)
Marines and coastal scenes, mostly in Cornwall. Exhibited 4 works, 1 at R.A., 3 at N.W.C.S.

URWICK, Walter (fl. 1887–93)
Domestic subjects. Exhibited 3 works, 8 at R.A., 1 at N.W.C.S.

USSHER, Arland A. (fl. 1885–93)
Born Dublin, Marines. Exhibited 11 works, 1 at R.A., 3 at N.W.C.S.

UTTERSON, Edward Vernon
(1776–1856)
A barrister. Landscapes in the John Varley style.

UWINS, Thomas (1782–1857)
Born Pentonville; trained as an engraver; studied at R.A. 1798; member o.w.c.s. 1810, secretary 1813; to France 1814; also spent several years in Italy; A.R.A. 1833, R.A. 1838 and librarian 1844–55; surveyor of the Royal Pictures 1845–55; keeper National Gallery 1847–55. Figure subjects and landscapes. Exhibited 247 works, 91 at o.w.c.s., 103 at R.A., 37 at B.I., 13 at S.B.A. (*V. & A., B.M., Newcastle*)

VACHER, Charles (1818–83)
Born Westminster; visited Italy
1839 and studied for some years in
Rome; also visited Sicily, Algeria
and Egypt; member N.W.C.S. 1850.
European landscapes. Exhibited
350 works, 324 at N.W.C.S., 20 at
R.A. (*B.M.*, *V. & A.*)

VACHER, Thomas Brittain
(1805–80)
Brother of Charles; an amateur.
Landscapes, many on Continent.
(*V. & A.*)

VALLANCE, William Fleming
(1827–1904)
Of Edinburgh. Marines. Exhibited
5 works at R.A. (*Royal Scottish
Academy*)

VANDER-WEYDE, Harry F.
(fl. 1885–92)
Landscapes. Exhibited 14 works,
6 at S.B.A., 2 at N.W.C.S.

VAN DE VELDE (family)
Cornelius (fl. c. 1720), William
'the Elder' (1611?–93), and his son
William 'the Younger'
(1633–1707). Many marines in
watercolour represented in the
national collections, e.g. over
8,000 by William 'the Younger'.

VAN DYCK (or **VANDYKE**),
Sir Anthony (1599–1641)
Born Antwerp; assistant to
Rubens; to England 1620; in Italy
1621–25; returned to Antwerp
1626–32; settled in London 1632,
when knighted. Renowned
portrait-painter in oils, but also
some beautiful watercolour
landscapes. (*B.M.*, *Chatsworth*)

VAN WORRELL, A. B.

(fl. 1819–49)
Cattle. Exhibited 62 works, 5 at
O.W.C.S., 8 at R.A., 21 at B.I., 28 at
S.B.A.

VARDY, John (fl. 1761–1818)
An architect. Drawings of notable
houses. Exhibited 17 works, 15 at
Soc. of Artists, 2 at R.A.

VARLEY, Albert Fleetwood
(1802–76)
Eldest son of John; a drawing
master. Landscapes. Exhibited 1
work at R.A., 1838. (*V. & A.*)

VARLEY, Charles Smith (1811–88)
Son of John; worked much in
Devonshire, and also in Suffolk and
Sussex. Exhibited 54 works, 38 at
R.A., 4 at B.I., 12 at S.B.A.

VARLEY, Cornelius (1781–1873)
Born Hackney; brother of John and
W. F.; patronised by Dr Monro,
and studied at R.A. 1807;
founder member O.W.C.S. 1804,
visited Wales; became a drawing
master in London; a considerable
inventor of optical instruments.
Landscapes. Exhibited 129 works,
59 at O.W.C.S., 29 at R.A., 4 at B.I.,
29 at S.B.A. (*V. & A.*, *B.M.*,
Whitworth, *Birmingham*)

VARLEY, Edgar John (d. 1888)
Son of C. S. and grandson of John;
curator Architectural Museum,
Westminster; fl. 1861–87.
Landscapes. Exhibited 78 works,
7 at N.W.C.S., 8 at R.A., 59 at S.B.A.
(*V. & A.*)

VARLEY, Elizabeth
See Mulready, Mrs

VARLEY, John (1778–1842)
Born Hackney; brother of
Cornelius and W. F.; apprenticed
to a silversmith; pupil of J. C.

Barrow c. 1794; patronised by Dr Monro; visited Peterborough with Barrow, and also Wales; founder member o.w.c.s. 1804; friend of J. S. Cotman; a successful drawing master, among his pupils being F. O. Finch, W. Henry Hunt, Samuel Palmer, Copley Fielding, Turner of Oxford, David Cox, and John Linnell. Landscapes. Exhibited 786 works, 739 at o.w.c.s., 41 at r.a., 2 at b.i., 4 at s.b.a. (*V. & A. and all major collections*)

VARLEY, John, Jr (fl. c. 1870)
Son of A. F. Oriental subjects and landscapes. Exhibited 70 works, 15 at r.a., 11 at s.b.a., 16 at n.w.c.s., 1870–92. (*V. & A., Whitworth*)

VARLEY, Mrs John (fl. 1883–86)
Probably wife of John Jr. Domestic subjects. Exhibited 4 works, 1 at n.w.c.s., 3 at s.b.a.

VARLEY, Lucy (fl. 1886–90)
Flowers. Exhibited 9 works, 5 at n.w.c.s., 2 at r.a.

VARLEY, William Fleetwood (1785–1856)
Brother of Cornelius and John, who taught him; a drawing master in Cornwall 1810, and later in Bath and Oxford, where he was nearly burnt to death; he never fully recovered. Landscapes. Exhibited 21 works at r.a., 1804–18. (*V. & A., B.M.*)

VARRALL, J. C. (fl. 1816–27)
An engraver. Views in London, some engraved by himself in e.g. the 'Antiquarian Repository' 1816. Exhibited 5 works at s.b.a.

VAUGHAN, Thomas

(fl. 1790–1820)
Landscapes.

VAVASHUR, Ellen
See Carter, Ellen.

VAWSER, George Richard, Sr (fl. 1818–47)
Father of G. R. Jr; worked in Yorkshire and London. Derby topography. Exhibited 24 works, 19 at r.a., 5 at s.b.a. (*Derby*)

VAWSER, George Richard, Jr (fl. 1836–75)
Son of G. R. Sr. Topography. Exhibited 46 works, 39 at r.a., 4 at b.i., 3 at s.b.a. (*Derby*)

VERELST, Simon (1644–1721)
Born Antwerp; to London 1669. Flowers and portraits.

VEREY, Arthur (fl. 1873–93)
Rustic scenes. Exhibited 90 works, 10 at r.a., 63 at s.b.a., 2 at n.w.c.s.

VERNER, Fred Arthur (fl. 1881–93)
Born Ottawa. Animals.

VERNON, R. Warren (fl. 1886–93)
Landscapes. Exhibited 10 works, 1 at r.a., 9 at s.b.a.

VERTUE, George (1684–1756)
Born London; antiquary and engraver. Antiquities, portraits and topographical views.

VIALLS, Frederick Joseph (fl. 1884–85)
Landscapes. Exhibited 2 works, at n.w.c.s.

VICKERS, Alfred (1786–1868)
Born Newington; father of A. G.; self-taught, and studied the Dutch masters. Landscapes. Exhibited

267 works, 61 at R.A., 125 at B.I., 81 at S.B.A. (*V. & A.*)

VICKERS, Alfred Gomersol (1810–37)
Born Lambeth; son of Alfred; commissioned by Charles Heath to make drawings in Russia for the 'Annuals' 1833; worked in Poland; married the sister of H. Liverseege. Topographical scenes and marines. Exhibited 104 works, 16 at N.W.C.S., 16 at R.A., 42 at B.I., 30 at S.B.A. (*V. & A., B.M., Newport, Whitworth*)

VIDAL, Emeric Essex (1791–1861)
Born Bedford; Portugal 1817, and spent much of his life in South America.

VIGERS, A. F. (fl. c. 1880)
Architectural subjects. (*V. & A.*)

VILLIERS, Jean François Marie Huet (1772–1813)
Born Paris; a miniaturist who fled to England at the time of the Revolution c. 1789. Miniatures, animals, landscapes and architectural subjects. Exhibited 130 works, 5 at N.W.C.S., 28 at R.A., 9 at B.I.

VINCENT, George (1796–1831?)
Born Norwich, the son of a weaver; pupil of John Crome; of the Norwich School. Landscapes and marines. Exhibited 67 works, 5 at O.W.C.S., 9 at R.A., 41 at B.I., 12 at S.B.A. (*B.M., Norwich*)

VIOLET, Pierre (1748–1819)
Born France; miniature-painter to Louis XVI and Marie Antoinette; to England as a drawing teacher. Miniatures. Exhibited 117 works, 114 at R.A.

VITALBA, Giovanni (1740?–1792?)

Born Italy; an engraver who worked in England for Boydell. Landscapes. Exhibited 10 works at R.A.

VIVARES, François (1709–80)
Born Montpellier, Southern France; apprenticed to a tailor; to London c. 1727 and studied under Chatelain; an engraver. Member Incorp. S.A. Landscapes in pen and wash or in chalk. (*V. & A.*)

VIVARES, Thomas (1735–1790)
Son of François and one of 31 children; an engraver; employed by Robert Adam. Landscapes and architectural subjects. Exhibited 10 works.

VOS, Hubert (fl. 1888–92)
Member R.B.A. Domestic subjects. Exhibited 52 works.

VOSPER, Sidney Curnow (1866–1942)
Assoc. R.W.S. 1906, member 1914.

VYVYAN, M. Caroline (fl. 1868–91)
Landscapes. Exhibited 13 works, 2 at N.W.C.S.

WADE, George E. (fl. 1887–93)
A sculptor.

WAGEMAN, Thomas Charles (1787?–1863)
Portrait-painter to king of Holland; member N.W.C.S. 1831–32. Portraits of actors and rustic genre. Exhibited 82 works, 9 at N.W.C.S., 56 at R.A., 1 at B.I., 16 at S.B.A. (*V. & A., B.M.*)

WAGHORNE, Frederick (fl. 1880–88)

Architectural scenes. Exhibited
7 works, 3 at R.A., 1 at S.B.A., 3 at
N.W.C.S.

WAINEWRIGHT, Thomas Francis
(fl. 1831–83)
Landscapes, with cattle and sheep,
often in collaboration with
C. Pearson, and bearing both
signatures. Exhibited 258 works,
222 at S.B.A., 26 at R.A., 3 at B.I.
(*V. & A.*)

WAINWRIGHT, William John
(1855–1931)
Of Birmingham; assoc. R.W.S.
1883, member 1905. Domestic
subjects. Exhibited 17 works, 14 at
O.W.C.S., 1 at R.A. (*Birmingham*)

WAITE, James Clark (fl. 1863–85)
Domestic subjects. Exhibited 156
works, 3 at N.W.C.S., 26 at R.A.,
4 at B.I., 117 at S.B.A.

WAITE, Robert Thorne
(1842–1935)
Born Cheltenham. Member R.W.S.
1884. Domestic subjects and
landscapes. Exhibited 381 works,
315 at O.W.C.S., 15 at R.A., 5 at
S.B.A. (*V. & A.*)

WAITE, William A. (fl. 1884–87)
Of Birmingham. Landscapes.
Exhibited 7 works, 6 at N.W.C.S.

WALDEGROVE, Anne, Countess of
(née King) (fl. 1810–52)
Landscapes.

WALE, Samuel (d. 1786)
Pupil of F. Hayman; fl. from 1720.
Founder member R.A.; an
illustrator, e.g. of Wright's folio
Bible 1781 and Walton's 'The
Compleat Angler'. Illustrations
and topography. Exhibited 28
works, 14 at Soc. of Artists, 14 at
R.A. (*B.M., Nottingham*)

WALES, James (1747?–1796?)
Born Peterhead, Aberdeenshire;
to India 1791 where he painted
portraits of princes; met Thomas
and William Daniell, with whom
he painted Indian scenery and
antiquities. Exhibited 6 works,
3 at Soc. of Artists, 3 at R.A.

WALKER, Amy (fl. 1885–93)
Landscapes. Exhibited 14 works,
6 at N.W.C.S., 5 at S.B.A.

WALKER, Edmund (d. 1882)
Probably a flower painter, who
exhibited 1836–49, 9 at R.A.
(*V. & A.*)

WALKER, Frederick (1840–75)
Born Marylebone, the son of a
jewellery designer; at first
intended to be an architect; then
studied antique art at B.M. and art
at Leigh's Life School; studied at
R.A. 1855; subsequently employed
by J. W. Whymper; member
O.W.C.S. 1866, A.R.A. 1871.
Sentimental genre. Exhibited 50
works, 38 at O.W.C.S., 8 at R.A., 38
at O.W.C.S. (*V. & A., Whitworth*)

WALKER, George (fl. 1792–95)
Landscapes, engraved by William
Byrne. Exhibited 4 works at R.A.
(*V. & A.*)

WALKER, Horatio (1858–1938)
Member R.I. 1901–30. Landscapes.

WALKER, James William
(1831–98)
Born Norwich; apprenticed to a
house-painter; studied at Norwich
School of Design; taught first in
London, then Bolton, where he was
master of the School of Art, and
Southport. Landscapes in Wales,
France and Italy, and domestic
subjects. Exhibited 66 works, 8 at

N.W.C.S., 16 at R.A., 3 at S.B.A.
(*V. & A.*)

WALKER, William (1780–1863)
Born Hackney; studied under
Robert Smirke and at R.A. 1797;
visited Greece 1803; member
Associated Artists in Water
Colours 1807 and assoc. O.W.C.S.
1820. Mediterranean and
Eastern landscapes. Exhibited 73
works, 67 at O.W.C.S., 6 at R.A.
(*V. & A.*)

WALKER, Mrs William
(née Elizabeth Reynolds)
(1800–76)
Born London; married William
Walker, an engraver, 1829.
Miniatures. Exhibited 7 works at
R.A.

WALKER, William Eyre
(1847–1930)
Born Manchester. Of West
Holme, Dorset; assoc. R.W.S. 1880,
member 1896. Landscapes.
Exhibited 214 works, 197 at
O.W.C.S., 3 at R.A., 1 at S.B.A.

WALLACE, John (d. 1903)
Studied at Royal Scottish
Academy; a book illustrator.
Landscapes. Exhibited 1 at R.A.
before 1892 and 6 at S.B.A. from
1874.

WALLER, A. Honeywood
(fl. 1884–91)
Of Godalming. Landscapes.
Exhibited 14 works, 6 at N.W.C.S.,
3 at R.A., 5 at S.B.A.

WALLER, C. (fl. 1785–88)
Probably an amateur. Landscapes.
Exhibited 2 works at R.A. 1788.
(*Newcastle*)

WALLIS, George (1811–91)
Born Wolverhampton; taught at
the Government School of Design,
Somerset House, 1841; head-
master Spitalfields School,
Manchester, 1843; headmaster
Birmingham School of Design
1851–52; keeper of South
Kensington Art Collections 1863.
Landscapes. Exhibited 2 works,
1 at R.A. (*Birmingham*)

WALLIS, Henry (1830–1916)
Born London; studied at Carey's
Academy, London, at R.A., and in
Paris, Rome and Venice; assoc.
O.W.C.S. 1878, member 1880;
wrote about ceramics. Historical
and figure subjects. Exhibited 132
works, 81 at O.W.C.S., 35 at R.A.,
1 at B.I., 5 at S.B.A. (*Birmingham*)

WALLIS, Joshua (1789–1862)
Cousin of Benjamin West.
Landscapes and snow scenes
praised by Ruskin, many
varnished. Exhibited 7 works at
R.A. (*V. & A., Birmingham*)

WALLIS, Robert (1794–1878)
Born London; worked for *Art
Journal*. Engravings after
J. M. W. Turner. Exhibited 6
works, 1 at R.A., 5 at S.B.A.
1824–59.

WALLIS, Rosa (fl. 1878–93)
Flowers. Exhibited 52 works,
18 at N.W.C.S., 5 at R.A., 19 at
S.B.A., 18 at N.W.C.S.

WALLIS, W. (fl. c. 1816)
An obscure landscape-painter,
working in Essex. Some works
engraved in the 'Antiquarian
Repository'.

WALLS, William (1860–1912?)
Of Dunfermline; studied at
Edinburgh. Animals. Exhibited 4
works at R.A. (*V. & A.*)

**WALMSLEY, Thomas
(1763–1805?)**
Born Dublin; to London, where a
scene-painter at King's and Covent
Garden theatres; later returned to
Dublin, to paint scenery at the
Crow Street Theatre 1788; to
England again 1790. Brooding
landscapes in body-colour.
Exhibited 19 works, 1 at Soc. of
Artists, 18 at R.A. 1790–96.
(*V. & A., B.M., Whitworth*)

WALROND, Sir John W., Bart.
(fl. 1879–88)
Landscapes. Exhibited 5 works,
4 at N.W.C.S.

WALTER, Emma (fl. 1855–91)
Flowers. Exhibited 110 works,
7 at N.W.C.S., 7 at R.A., 65 at S.B.A.

WALTER, Henry (1790?–1849)
Friend of Blake and Linnell. Rural
genre, animals and landscapes.
Exhibited 17 works, 3 at N.W.C.S.,
6 at R.A., 6 at B.I. (*National
Gallery of Scotland*)

WALTERS, George Stanfield
(fl. 1860–93)
Of Liverpool. Marines. Exhibited
474 works, 29 at N.W.C.S., 31 at
R.A., 5 at B.I., 340 at S.B.A.
(*V. & A.*)

WALTON, Miss D. S. (fl. 1890–92)
Of Dorking. Flowers. Exhibited
6 works at N.W.C.S.

WALTON, Elijah (1832–80)
Born Manchester or Birmingham
(both are recorded as his birth-
place); studied at Birmingham
School of Design and at R.A. 1855;
travelled in the East and on the
Continent. Illustrator of his own
travel books. Landscapes,
especially in the Alps. Exhibited
35 works, 8 at R.A., 10 at B.I., 4 at

S.B.A. (*Birmingham, B.M.,
V. & A., Newcastle*)

WALTON, Frank (1840–1928)
Born London, the son of a
publisher; member R.I. 1882–1923,
president Royal Institute of Oil
Painters. Landscapes. Exhibited
371 works, 82 at N.W.C.S., 75 at
R.A.

WALTON, Henry (1746–1813)
Of East Anglia; a connoisseur;
member R.I. Rare portraits and
genre. Exhibited 13 works, 9 at
Soc. of Artists, 4 at R.A.

WALTON, William (fl. 1841–66)
Known as 'Walton of Bath'.
Landscapes. Exhibited 6 works,
1 at R.A., 3 at S.B.A. (*V. & A.*)

WARD, Charles (fl. 1826–69)
Latterly retired to Cambridge;
visited Italy. Landscapes, notably
in Wales, around Cambridge, and
around Venice and the Bay of
Naples. Exhibited 106 works,
15 at N.W.C.S.; 58 at R.A., 23 at
S.B.A.

**WARD, Edward Matthew
(1816–79)**
Born Pimlico; son of James;
studied at R.A. 1835; in Rome 1836
and later in Munich; A.R.A., 1847,
R.A. 1855; hon. member R.I. 1876.
Historical subjects. Exhibited 121
works, 4 at N.W.C.S., 86 at R.A.,
16 at B.I., 11 at S.B.A.

WARD, James (1769–1859)
Born London; father of Edward;
studied engraving under John
Raphael Smith; apprenticed to his
brother William, 1783; painter
and mezzotint engraver to the
Prince of Wales 1794; married
Morland's sister; A.R.A. 1807,

R.A. 1811. Animals above all, but also landscapes and figure subjects. Exhibited 400 works, 298 at R.A., 2 at Soc. of Artists, 91 at B.I., 9 at S.B.A. (*V. & A., B.M., Newcastle, Birmingham, Bedford, Nottingham, Whitworth*)

WARD, John (fl. 1803–47)
Marines. Exhibited 182 works, 6 at N.W.C.S., 50 at R.A., 95 at B.I., 31 at S.B.A.

WARD, Sir Leslie (1851–1922)
Born London; known as 'Spy'; son of E. M.; studied architecture under Sydney Smirke, and at R.A.; a caricaturist, and drew for the *Graphic*. Portraits. Exhibited 35 works, 11 at R.A. (*V. & A.*)

WARD, William (d. 1802)
An obscure marine painter of Hull. Trinity Brethren Gallery. (*Hull*)

WARDLE, Arthur (fl. 1880–93) (b. 1864)
Member R.I. 1922, member R.B.C. Cattle. Exhibited 97 works, 20 at N.W.C.S., 21 at R.A., 29 at S.B.A.

WARE, Isaac (d. 1766)
Pencil drawings of London.

WARING, John Burley (1823–75)
Born Lyme Regis; apprenticed to an architect; studied at R.A.; spent two years in Italy. Flowers, landscapes and architectural subjects. Exhibited 5 works at R.A.

WARREN, Edmund George (1834–1909)
Member N.W.C.S. 1856; assoc. N.W.C.S. 1852, member R.O.I. Landscapes. Exhibited 219 works, 197 at N.W.C.S., 1 at R.A. (*V. & A.*)

WARREN, Henry (1794–1879)
Born London; studied sculpture under Nollekens, and painting at R.A. 1818; member N.W.C.S. 1835 and president 1839–73. Eastern scenes, though he never visited the East. Exhibited 263 works, 244 at N.W.C.S., 7 at R.A. (*V. & A.*)

WARREN, Sophy (fl. 1865–78)
Of Basingstoke. Landscapes. Exhibited 50 works, 6 at R.A., 38 at S.B.A. (*V. & A.*)

WARREN, William White (d. 1912?)
Worked in London and Bath; fl. 1865–88. Landscapes. Exhibited 10 works, 3 at N.W.C.S., 7 at B.I.

WARWICK, Lord (Henry Richard Greville, 2nd Earl) (1746–1816)
Travelled in Italy with J. I. Smith. Landscapes in sepia wash. (*B.M.*)

WATERFORD, Louisa, Marchioness of (1818–91)
Daughter of Lord Stuart of Rothesay, ambassador at Paris, where she spent her youth; married and lived in Ireland; friend of Ruskin, G. F. Watts and Burne-Jones. Copies of the Old Masters and figure subjects. Exhibited 18 works, 17 at Grosvenor galleries (*V. & A., B.M.*)

WATERHOUSE, John William (1849–1917)
Member R.I. 1882, R.A.

WATERHOUSE, Mrs J. W. (fl. 1884–90)
Flowers. Exhibited 13 works, 6 at N.W.C.S., 6 at R.A.

WATERLOW, Sir Ernest Albert (1850–1919)

Born London, the son of a litho-
grapher; studied at Carey's Art
School, and at R.A. 1872; member
O.W.C.S. 1894 and president 1897;
A.R.A. 1890, R.A. 1903; knighted
1902. Landscapes with figures.
Exhibited 255 works, 99 at
O.W.C.S., 45 at R.A., 11 at S.B.A.
(*V. & A., Newcastle, Birmingham*)

WATERS, Ralph, Jr (1759–84?)
Born Newcastle-upon-Tyne, the
son of a painter. Landscapes.
Exhibited 8 works at R.A.
(*Newcastle*)

WATHEN, James (1752–1828)
Born Hereford; an amateur artist,
collector, antiquarian and
traveller; somewhat of an
eccentric; friend of Britton;
travelled in the Far East.
Landscapes.

WATKINS, John (fl. 1876–93)
Figure subjects. Exhibited 39
works, 11 at N.W.C.S., 5 at R.A.,
16 at S.B.A.

**WATSON, Charles John
(1846–1927)**
An engraver. Fellow of the Royal
Society Painter-Etchers and
Engravers. Landscapes, perhaps
influenced by J. Thirtle. Exhibited
126 works, 13 at N.W.C.S. (*V. & A.,
B.M., Norwich*)

WATSON, Edward (1814–87)
Born Birmingham; apprenticed to
J. V. Barber; a drawing teacher;
visited Norway and Switzerland;
member Birmingham Society of
Artists 1842–57. Landscapes.
(*Birmingham*)

WATSON, Harry (1871–1936)
Born Scarborough; assoc. R.W.S.
1915, member 1920. Landscapes.

WATSON, John Burgess (d. 1847)
An architect; fl. 1819–38.
Architectural subjects. Exhibited
12 works at R.A.

WATSON, John Dawson (1832–92)
Born Sedburgh, Yorkshire; studied
at Manchester School of Design
1847, at R.A. 1851, and also under
A. D. Cooper; member O.W.C.S.
1870, S.B.A., and Manchester
Academy of Fine Arts 1868; an
illustrator. Domestic and figure
subjects. Exhibited 372 works, 267
at O.W.C.S., 41 at R.A., 2 at B.I.,
26 at S.B.A. (*V. & A., Norwich,
Newcastle, Manchester*)

**WATSON, Musgrave Lewthwaite
(1804–47)**
Born Carlisle; studied at R.A. Bold
cartoons in charcoal, and many
watercolours.

WATSON, Rosalie M. (fl. 1877–87)
Domestic subjects. Exhibited 43
works, 6 at N.W.C.S., 8 at R.A., 4 at
S.B.A.

**WATSON, Thomas J.
(fl. 1847–1912)**
Born Sedburgh, Yorkshire.
Assoc. O.W.C.S. 1880,
resigned R.W.S. 1912. Landscapes.
Exhibited 202 works, 122 at
O.W.C.S., 21 at R.A., 23 at S.B.A.

**WATTS, Frederick William
(1800–62)**
Landscapes, usually small.
Exhibited 258 works, 8 at N.W.C.S.,
76 at R.A., 108 at B.I., 65 at S.B.A.

**WATTS, George Frederick
(1817–1904)**
Born London; studied at R.A.
1835; in Florence 1843 for 4 years;
visited Constantinople 1856;
married, briefly to Ellen Terry,
1864; R.A. 1867, H.R.A. 1896.

Portraits, landscapes, and allegorical and mythological subjects. Exhibited 268 works, 126 at R.A., 6 at B.I., 3 at S.B.A., 84 at Grosvenor gallery. (*V. & A., B.M.*)

WATTS, James T. (fl. 1873–93)
Of Birmingham. Landscapes. Exhibited 53 works, 17 at N.W.C.S., 25 at R.A., 4 at S.B.A.

WATTS, Mrs J. T.
(née Louisa M. Hughes)
(fl. 1884–92)
Landscapes. Exhibited 19 works, 11 at N.W.C.S., 5 at R.A.

WATTS, Walter Henry
(fl. 1803–30)
Member Associated Artists in Water Colours. Miniatures. Exhibited 93 works, 6 at O.W.C.S., 67 at R.A., 9 at B.I.

WATTS, William (1752–1851)
Engraver and publisher; probably a pupil of Paul Sandby and Rooker; travelled in France and Italy; lived in Bath 1791–93; visited Turkey 1800. A pioneer topographer, and also painted figure subjects. Exhibited 6 works, 3 at R.A., 3 at B.I. (*Bath*)

WAY, Thomas R. (fl. 1883–93)
Landscapes. Exhibited 39 works, 13 at N.W.C.S., 6 at R.A., 8 at S.B.A.

WAY, William Cosens
(1832–1905)
Born Torquay; studied at South Kensington; taught at Newcastle School of Art 1862, and at Sunderland School of Art for 25 years. Landscapes. Exhibited 26 works, 5 at N.W.C.S., 5 at R.A., 9 at S.B.A. (*V. & A., B.M.*)

WEATHERHEAD, William Harris

(b. 1843)
Fl. from 1862; member R.I. 1885–1903. Landscapes and domestic subjects. Exhibited 260 works, 52 at N.W.C.S., 21 at R.A., 18 at B.I., 154 at S.B.A.

WEATHERHILL, George
(fl. 1868–73)
Born Whitby. Local topography and marines. Exhibited 6 works, 3 at S.B.A. (*B.M., Whitby*)

WEBB, Archibald (fl. 1886–92)
Landscape. Exhibited 45 works, 8 at N.W.C.S., 6 at R.A., 26 at S.B.A.

WEBB, Edward (1805?–54)
Topography. (*V. & A.*)
(*Note*. An E. Webb exhibited architectural topography in pencil and wash, represented in the B.M.)

WEBB, James (1825?–95)
Landscapes and marines. Exhibited 129 works, 6 at N.W.C.S., 29 at R.A., 37 at B.I., 38 at S.B.A. (*Gateshead*)

WEBBER, John (1752–93)
Born London; the son of a Swiss sculptor; studied in Berne, Paris and at R.A. 1775; draughtsman to Capt. Cook on his last and fatal voyage 1776; toured the Continent 1787; A.R.A. 1785, R.A. 1791. Landscapes, particularly of the South Seas. Exhibited 49 works at R.A. (*V. & A., B.M., Derby*)

WEBER, Otto (1832–88)
Born Berlin; to London 1872; assoc. O.W.C.S. 1876, hon. R.H.A.; painted for Queen Victoria. Landscapes with cattle. Exhibited 130 works, 82 at O.W.C.S., 27 at R.A. (*V. & A.*)

WEBSTER, George (fl. 1797–1832)

Toured Wales with J. Varley
1802. Landscapes, some in Tripoli
and on the west coast of Africa.
Exhibited 29 works, 14 at R.A.,
11 at B.I., 4 at S.B.A. (*V. & A.,
B.M.*)

WEBSTER, Moses (1792–1870)
Born Derby; apprenticed at Derby
Porcelain Works and became an
outstanding painter of flowers on
porcelain; at Worcester for 4
years, then to London to work in a
china-decorating studio; eventually
back to Derby. Flowers, and some
topography. Exhibited 3 works at
O.W.C.S. (*V. & A., B.M., Derby*)

WEBSTER, Simon (d. 1820)
Fl. from c. 1872. Miniatures and
landscapes, an example etched by
F. Stevens for Ackerman's
'Cottages and Farm Houses' 1815.
Exhibited 17 works, 16 at Soc. of
Artists, 1 at Free Soc.

WEBSTER, Thomas (1800–86)
R.A. Fine rustic and indoor genre.
Exhibited 131 works, 83 at R.A.,
39 at B.I., 9 at S.B.A., 1823–79.

WEBSTER, Thomas (1772–1844)
A geologist, who toured Britain
and France. Architectural subjects.

WEEDON, Augustus Walford
(1838–1908)
Member R.I. 1887 and R.B.A.
Landscapes in the style of Collier,
Wimperis and Whittaker.
Exhibited 269 works, 57 at
N.W.C.S., 23 at R.A., 109 at S.B.A.

WEEKES, Frederick (fl. 1854–93)
Battle scenes. Exhibited 114
works, 5 at N.W.C.S., 15 at R.A.,
21 at B.I., 34 at S.B.A.

WEGUELIN, John Reinhard
(1849–1927)

Born South Stokes; assoc. R.W.S.
1894, member 1897.

WEHNERT, Edward Henry
(1813–68)
Born London, the son of a German
tailor; studied in Göttingen, and
returned to England c. 1833;
worked in Paris and Jersey, then
back to London again 1837;
visited Italy 1858; member
N.W.C.S. 1837. Historical genre,
German in character. Exhibited
157 works, 147 at N.W.C.S., 3 at
R.A. (*V. & A.*)

WEIGALL, Charles Harvey
(1794–1877)
Member N.W.C.S. 1834. Land-
scapes, genre, and animals.
Exhibited 441 works, 419 at
N.W.C.S., 20 at R.A. (*V. & A.,
Dublin*)

WEIR, Harrison William
(1824–1906)
Born Lewes; studied colour
printing under Baxter; drew for
periodicals; member N.W.C.S.
1851–70; friend of Darwin. Birds
and animals. Exhibited 116 works,
100 at N.W.C.S., 6 at R.A. (*V. & A.*)

WEIR, Walter (d. 1816)
Of Edinburgh; studied in Italy;
fl. c. 1809. Scottish genre in the
style of D. Allan. Exhibited 2
works at R.A. (*Edinburgh*)

WELBY, Rose Ellen (fl. 1879–93)
Flowers. Exhibited 30 works,
6 at N.W.C.S., 3 at R.A., 6 at S.B.A.

WELLS, Josiah Robert (?) **Joseph**
(fl. 1872–93)
Of Bromley. Marines. Exhibited
51 works, 14 at N.W.C.S., 5 at R.A.,
10 at S.B.A.

WELLS, William Frederick

(1762–1836)
Born London; taught by Barralet;
travelled in Norway and Sweden;
a founder member o.w.c.s. 1804
and president 1806–07; professor
of drawing Addiscombe Military
College; friend of J. M. W.
Turner. Landscapes. Exhibited
128 works, 90 at o.w.c.s., 38 at
r.a. (*V. & A., B.M.*)

WERNER, Carl Friedrich Heinrich
(1808–94)
Born Weimar; known as Carl
Werner; studied in Leipzig and
Munich; travelled in England and
extensively elsewhere; member
n.w.c.s. 1860–83. Topography and
figure subjects. Exhibited 140
works, 139 at n.w.c.s., 1 at r.a.
(*V. & A.*)

WERNER, Rinaldo (1842–1920?)
Born Rome, son of K. F. H., and
his pupil; studied also at Vienna
Academy; settled in London.
Architectural subjects and studies
of fountains. Exhibited 12 works,
8 at n.w.c.s. (*V. & A.*)

WEST, Benjamin P. (1738–1820)
Born Springfield, Pa., USA; in
Italy 1760–63; to London c. 1764;
member Incorp. s.a. 1765;
founder member r.a. 1768 and
president 1792; historical painter
to George III 1772, and surveyor
of the Royal Pictures 1790.
Portraits, landscapes, and historical
and religious subjects. Exhibited
311 works, 258 at r.a., 21 at Soc.
of Artists, 32 at b.i. (*V. & A.,
B.M., Liverpool*)

WEST, Joseph (b. 1790)
Worked at Bath, probably taught
by one of the Barkers; fl. c. 1834.
Landscapes. (*Wolverhampton*)

WEST, Joseph Walter (1860–1933)

Born at Hull; assoc. r.w.s. 1901,
member 1904, vice-president
1916–19 (*Tate*)

WEST, William (1801–61)
Born Bristol; known as 'Waterfall
West'; member s.b.a. 1851.
Landscapes, many in Devonshire
and Norway, usually with cascades
or waterfalls. Exhibited 130
works, 13 at r.a., 14 at b.i., 103 at
s.b.a. (*V. & A.*)

WESTALL, Richard (1765–1836)
Brother of William; studied at r.a.
1785; an illustrator; a.r.a. 1792,
r.a. 1794; gave lessons to Queen
Victoria. Landscapes and figure
subjects. Exhibited 384 works,
313 at r.a., 70 at b.i., 1 at s.b.a.
(*B.M., V. & A., Newcastle,
Nottingham*)

WESTALL, William (1781–1850)
Born Hertford; brother of Richard,
under whom he studied; draughts-
man to Capt. Flinders' expedition
to Australia; was wrecked,
rescued, and taken to China; also
visited India, Madeira and the
West Indies; back in England
1805; member o.w.c.s. and a.r.a.
1811. Topography. Exhibited 145
works, 13 at o.w.c.s., 70 at r.a.,
30 at b.i., 7 at s.b.a. (*B.M.,
V. & A., Newcastle, Nottingham,
Birmingham*)

WETHERBEE, George Faulkner
(b. 1851)
Member r.i. 1883–1909.
Landscapes and figures.

WHAITE, Henry Clarence
(1828–1912)
Born Manchester; member r.w.s.
1882; founder and first president
r.c.a.; president Manchester
Academy of Fine Arts. Landscapes.
Exhibited 191 works, 148 at

A Dictionary of Watercolour Painters

o.w.c.s., 23 at R.A., 7 at B.I., 6 at s.b.a. (*Liverpool*)

WHAITE, James (fl. 1867–81)
Of Manchester. Landscapes.
Exhibited 11 works, 3 at R.A.
(*V. & A.*)

WHATELEY, Henry (1842–1901)
Probably a pupil of De Wint;
worked at Bristol. Landscapes and
figure subjects. Exhibited 4 works
at N.W.C.S.

WHEATLEY, Francis (1747–1801)
Born Covent Garden, the son of a
master tailor; studied at Shipley's
School, and at R.A. 1769; to
Dublin as a portrait-painter, and
then back to London; fellow Incorp.
S.A., A.R.A. 1790, R.A. 1791.
Landscapes with figures, and
genre. Exhibited 133 works, 45 at
Soc. of Artists, 1 at Free Soc., 87 at
R.A. (*B.M., V. & A., Newport,
Mon., Liverpool, Newcastle,
Whitworth*)

WHEATLEY, Mrs Francis
See Leigh, Clara Moira.

WHEATLEY, Mrs Grace
(1884–1970)
Assoc. R.W.S. 1945, member 1952.
From 1925–37 Lecturer in Fine
Art, Capetown University,
member R.P. Figures, birds and
flowers (*B.M., Tate*)

WHEATLEY, John (d. 1955)
Assoc. R.W.S. 1943, member 1947,
A.R.A.

WHICHELO, C. John M.
(1784–1865)
Marine and landscape-painter to
the Prince of Wales c. 1818;
assoc. o.w.c.s. 1823. Exhibited
238 works, 210 at o.w.c.s., 15 at
R.A., 13 at B.I. (*V. & A., Newport*)

WHICHELO, H. M. (fl. 1844–49)
Nephew of C. J. M.; a drawing
master at schools of art in Stepney,
Stockwell and Clapham.
Buildings.

WHIPPLE, John (fl. 1873–93)
Landscapes. Exhibited 146 works,
14 at N.W.C.S., 20 at R.A., 60 at
S.B.A.

WHISTLER, James Abbott McNeill
(1834–1903)
Born Lowell, Mass., USA; studied
at West Point Military Academy,
but was dismissed; was draughts-
man to the Coast Survey Dept.,
Washington, for a year; to Europe
1855; settled in London 1859;
member S.B.A. 1884 and president
1886–88. Portraits, views of
towns, and landscapes. Exhibited
155 works, 33 at R.A., 52 at S.B.A.,
40 at Grosvenor gallery.
(*Hunterian Museum, Glasgow*)

WHITAKER, George (1834–74)
Born Exeter; pupil of Charles
Williams. Landscapes in Devon,
Wales and Switzerland, and
marines. Exhibited 26 works, 15 at
S.B.A. (*V. & A.*)

WHITE, John (fl. 1558–93)
To America with Sir Richard
Grenville 1585; lived latterly in
Ireland. Ethnological subjects.
(*B.M.*)

WHITE, John (1851–1933)
Member R.I. 1882–1931

WHITELEY, John William
(fl. 1882–86)
Of Leeds. Landscapes. Exhibited
8 works, 5 at N.W.C.S., 3 at R.A.

WHITFIELD, Helen (fl. 1890–93)
Of Wimbledon. Landscapes.

Exhibited 5 works, 4 at N.W.C.S.,
1 at R.A.

WHITLEY, Kate Mary
(fl. 1884–93)
Of Leicester; member R.I. 1889.
Still-lifes. Exhibited 31 works, 26
at N.W.C.S., 5 at R.A.

WHITMORE, Bryan (fl. 1871–92)
Landscapes. Exhibited 45 works,
7 at N.W.C.S., 10 at R.A., 26 at
S.B.A.

WHITTAKER, James William
(1828–1876)
Born Manchester (a friend of
F. W. Topham); apprenticed to a
calico-printer's engraver; assoc.
O.W.C.S. 1862, member 1864.
Lived at Llanrwst, near Betts-y-
Coed, where he was drowned.
Welsh landscapes in the style of
Wimperis and Collier. Exhibited
166 works, 162 at O.W.C.S., 3 at
R.A. (*V. & A.*)

WHITTOCK, Nathaniel
A late 19th century Oxford
drawing master.

WHYMPER, Josiah Wood
(1813–1903)
Born Ipswich; to London 1829 and
worked as a self-taught wood-
engraver; learned watercolour
painting from Collingwood Smith;
assoc. member N.W.C.S. 1854,
member 1857. Landscapes.
Exhibited 445 works, 414 at
N.W.C.S. (*V. & A.*)

WIDGERY, William (d. 1822)
Born Uppercot; a prolific
landscape-painter, mostly in Devon
and Cornwall. Exhibited 1 work at
R.I. 1866.

WIGSTEAD, Henry (d. 1800)
Friend of Rowlandson, and drew

very much in his style;
fl. 1784–88. Caricatures, genre,
and views in Wales, the New
Forest and the Isle of Wight.
Exhibited 11 works at R.A.

WILD, Charles (1781–1835)
Born London; articled to Thomas
Malton Jr; practiced as an
architectural draughtsman;
member O.W.C.S. 1812, later
secretary and treasurer 1823–31.
Gothic architecture at home and
abroad. Exhibited 178 works, 164
at O.W.C.S., 9 at R.A. (*V. & A.*,
B.M., *Whitworth*)

WILKIE, Sir David (1785–1841)
Born Cults, Aberdeenshire;
studied at Trustee's Academy,
Edinburgh, 1799; to London, and
studied at R.A. 1805; A.R.A. 1809,
R.A. 1811; visited Paris 1814, and
Scotland 1817 and 1822; travelled
abroad after 1825; serjeant
painter to the king 1830; knighted
1836; toured the East 1840, and
died at sea. Portraits and genre.
Exhibited 112 works, 100 at R.A.,
12 at S.B.A. (*Edinburgh, V. & A.*,
B.M., *Aberdeen*)

WILKINSON, Norman
(1878–1970)
R.I. 1906, president R.I. 1937, hon.
R.W.S. R.O.I. Marine paintings.

WILKINSON, Rev. Joseph
(fl. c. 1810)
Published a large folio of views in
the Lake District. Landscapes also
in Lancashire and Norfolk.
(*V. & A., B.M.*)

WILLIAMS, A. Florence
(fl. 1877–91)
Landscapes. Exhibited 17 works,
4 at N.W.C.S., 3 at R.A.

WILLIAMS, Alfred (1832–1905)

Taught by William Bennett;
visited northern Italy and
Switzerland 1854. Alpine scenery.
Exhibited 6 works, 4 at R.A., 1 at
S.B.A. (*V. & A.*)

WILLIAMS, Benjamin
(1868–1920)
Adopted the name Leader; born
Langley Green, Worcs.; to
Birmingham c. 1877; studied at
Birmingham Municipal School of
Art; became a drawing master.
Landscapes, mostly in the
Midlands. Exhibited 12 works,
4 at R.A., 4 at B.I. (*V. & A.*)

WILLIAMS, C. (fl. 1825–26)
Miniature-painter, but also some
landscapes.

WILLIAMS, Henry (fl. 1832–39)
Landscapes. Exhibited 27 works,
6 at N.W.C.S., 8 at R.A., 13 at S.B.A.

WILLIAMS, Hugh William
(1773–1829)
Known as 'Grecian Williams';
settled in Edinburgh, and possibly
a pupil of D. Allan; travelled in
Italy and Greece before 1818, and
published books about his travels.
Landscapes. Exhibited 26 works at
lesser galleries (*V. & A.*,
*Edinburgh, B.M., Newcastle,
Whitworth*)

WILLIAMS, J. W.
See Payne, William (*Note*).

WILLIAMS, Penry (1798–1885)
Born Merthyr Tydfil; studied at
R.A.; settled in Rome 1827; assoc.
O.W.C.S. 1828. Figure subjects.
Exhibited 56 works, 11 at N.W.C.S.,
34 at R.A., 9 at B.I. (*V. & A.*,
*Cyfrartha Castle Museum, Merthyr
Tydvil*)

WILLIAMS, Terrick (1860–1936)

R.I. 1904, P.R.I. 1934, R.A., R.O.I.
Landscapes, boats, etc.

WILLIAMS, T. H. (fl. 1801–30)
Worked at Plymouth. Landscapes
and marines. Exhibited 23 works,
7 at R.A., 15 at B.I., 1 at S.B.A.

WILLIAMS, William (fl. 1841–76)
Lived in turn at Bath, Torquay and
near Exeter. Landscapes in Devon
and Cornwall. Exhibited 129
works, 55 at S.B.A., 34 at R.A., 40 at
B.I.
(*Note.* Another William Williams
of Norwich; fl. c. 1795, painted
landscapes, and is represented at
the V. & A. and at Norwich.)

WILLIAMSON, Daniel
(1783–1843)
Born Liverpool; an art teacher;
member Liverpool Academy.

WILLIAMSON, Daniel Alexander
(1823–1903)
Born Liverpool; son of Daniel.
Landscapes and genre. (*Liverpool*)

WILLIAMSON, J. B.
(fl. 1868–71)
Master at Taunton School of Art,
and later at the Gower Street
School of Art, London. Marines.
Exhibited 4 works, 1 at R.A.
(*V. & A.*)

WILLIAMSON, Samuel
(1792–1840)
Son of J., a portrait-painter;
founder member Liverpool
Academy. Landscapes in the Lakes,
Wales, Yorkshire, Normandy, and
elsewhere. (*Liverpool*)

WILLIAMSON, W. M.
(fl. 1868–73)
Landscapes. Exhibited 17 works,
6 at R.A., 3 at S.B.A. (*V. & A.*)

WILLIS, Henry Brittan (1810–84)
Born Bristol, the son and pupil of a painter; visited United States 1842; to London 1843; member o.w.c.s. 1863. Landscapes, usually with cattle. Exhibited 495 works, 366 at o.w.c.s., 27 at R.A., 18 at B.I., 14 at S.B.A. (*V. & A.*)

WILLS, A. (fl. c. 1780)
A copyist of Angelica Kauffmann.

WILLS, John (b. 1800)
A naval captain. Views in the Canaries.

WILLSON, Harry (fl. 1813–52)
Landscapes. Exhibited 91 works, 11 at N.W.C.S., 25 at R.A., 25 at B.I., 30 at S.B.A.

WILLYAMS, Rev. Cooper (1762–1816)
An amateur, much travelled. Landscapes at Gibraltar and Syracuse 1798.

WILSON, Andrew (1780–1848)
Born Edinburgh; pupil of A. Nasmyth; studied at R.A., and in Rome and Naples; to England 1803, and then to Genoa; back to England 1806; joined Associated Artists in Water Colours in 1808; became a drawing master at Sandhurst Military Academy; resigned 1818, and became master at the Trustees' Academy, Edinburgh; lived in Italy 1826–47. Landscapes. Exhibited 64 works, 14 at B.I. (*V. & A., Whitworth, Edinburgh*)

WILSON, Charles E. (fl. 1891–93)
Of Sheffield. Domestic subjects and genre. Exhibited 18 works, 13 at N.W.C.S., 5 at R.A.

WILSON, John H. (fl. 1807–56)
Member R.S.A. Marines. Exhibited 529 works, 5 at o.w.c.s., 74 at R.A., 149 at B.I., 301 at S.B.A.

WILSON, Richard (1714–82)
Born Penegoes, Montgomeryshire; to London 1729 to study under Thomas Wright, a portrait-painter; to Italy for 6 years until 1755; founder member R.A. 1768, and librarian 1776. Landscapes, mostly in black chalk. Exhibited 63 works, 33 at Soc. of Artists, 30 at R.A. (*B.M., Whitworth, V. & A.*)

WILSON, Thomas Walter (1851–1912)
Assoc. N.W.C.S. 1877, member 1879; member R.O.I.; member R.I. Landscapes. Exhibited 103 works, 58 at N.W.C.S., 4 at R.A.

WIMPERIS, Edmund Morison (1835–1900)
Born Chester; apprenticed to a London wood-engraver 1851; illustrator for periodicals; member S.B.A.; R.I. 1875, treasurer 1888 and vice-president 1895; member R.O.I. and R.B.A. Landscapes in the style of Collier and Whittaker, and often reminiscent of David Cox. Exhibited 287 works. 1 at R.A., 49 at S.B.A., 172 at N.W.C.S. (*B.M., V. & A., Birmingham, Newport, Gateshead, Newcastle*)

WINDHAM, Joseph (1739–1810)
An amateur antiquary and traveller. Collaborated with James 'Athenian' Stuart.

WINKFIELD, Frederick A. (fl. 1873–93)
Marines. Exhibited 72 works, 6 at N.W.C.S., 17 at R.A., 27 at S.B.A., 6 at N.W.C.S.

WINKLES, Henry (fl. 1819–33)

Published a book of cathedrals.
Old buildings and landscapes.
Exhibited 9 works, 8 at R.A., 1 at
S.B.A.

WINTER, Cornelius Jason Walter
(1820–91)
Of Great Yarmouth; father of
H. E. C. Topography and old
buildings. (*Norwich*)

WINTER, Holmes Edwin Cornelius
See Rowland, W.

WINTON, John Blake
(fl. 1787–1800)
Birds in a somewhat Chinese style.

WINTOUR, John Crawford
(1825–92)
Assoc. R.S.A. 1859. Landscapes.

WIRGMAN, Theodore Blake
(fl. 1867–93)
Portraits. Exhibited 139 works,
6 at N.W.C.S., 67 at R.A.

WITHERINGTON, William
Frederick (1785–1865)
Born London; studied at R.A. 1805;
A.R.A. 1830, R.A. 1840, H.R.A.
1863. Landscapes and genre.
Exhibited 201 works, 138 at R.A.,
62 at B.I., 1 at S.B.A. (*V. & A.,
Newport*)

WITHERS, Mrs Augusta Innes
(fl. 1829–65)
Flowers. Exhibited 120 works,
6 at N.W.C.S., 8 at R.A., 68 at S.B.A.

WOLF, Joseph (1820–99)
Born near Coblenz; studied at
Coblenz and Antwerp, and London
1848, being employed at the B.M.;
member R.I. 1874. Natural history,
particularly birds. Exhibited 49
works, 20 at N.W.C.S., 14 at R.A.,
7 at B.I. (*V. & A.*)

WOLFE, George (fl. 1855–73)
Lived at Clifton. Marines.
Exhibited 107 works, 8 at R.A.,
8 at B.I., 74 at S.B.A. (*V. & A.*)

WOLFENSBERGER, Johann Jakob
(1797–1850)
A Swiss, but visited and exhibited
in London. Landscapes in the style
of W. L. Leitch. Exhibited 3 works
at R.A.

WOLLEN, William Barne
(1857–1936)
Member R.I. 1888. Domestic
subjects. Exhibited 37 works, 14 at
N.W.C.S., 8 at R.A.

WOOD, Mrs Eleanor C.
(fl. 1832–56)
Animals. Exhibited 25 works,
11 at N.W.C.S., 1 at R.A., 13 at
S.B.A.

WOOD, Emmie Stewart
(fl. 1886–93)
Landscapes. Exhibited 30 works,
9 at N.W.C.S., 6 at R.A., 3 at S.B.A.

WOOD, Lewis John (1813–1901)
Assoc. N.W.C.S. 1866, member
1871; member R.I. Landscapes and
churches. Exhibited 496 works,
205 at N.W.C.S., 40 at R.A., 52 at
B.I., 101 at S.B.A.

WOOD, Lewis Pinhorn
(fl. 1870–91)
Landscapes. Exhibited 54 works,
5 at N.W.C.S., 4 at R.A., 43 at S.B.A.

WOOD, Thomas (1800–78)
Born London; self-taught, member
N.W.C.S. 1833; drawing master at
Harrow school 1835–71. Land-
scapes and technically accurate
shipping subjects. Exhibited 38
works, 20 at N.W.C.S., 18 at R.A.
(*V. & A., B.M.*)

WOOD, Thomas Peploe (1817–45)
Born near Stafford; self-taught
from studying engravings; made
many visits to London. Landscapes
with figures and cattle. Exhibited
21 works, 1 at R.A., 1 at B.I., 19 at
S.B.A. (*V. & A.*)

WOOD, Thomas William
(fl. 1855–81)
Lived at Rochester. Birds and
animals. Exhibited 10 works, 5 at
R.A., 3 at S.B.A.

WOOD, William Thomas
(1877–1958)
Born at Ipswich; assoc. R.W.S.
1913, member 1918, vice-president
1923–26. Landscapes and flowers.
Official war artist in Balkans
1914–18. (*Imp. War Museum,
V. & A., Manchester, Leeds, Hull,
Bath, Australia, etc.*)

WOODFORDE, Samuel
(1763–1817)
Born near Castle Cary, Somerset;
studied at R.A. 1782; travelled to
Italy, and returned to England
1791; back to Italy 1815, and died
at Bologna; A.R.A. 1800, R.A. 1807.
Rare classical subjects. Exhibited
172 works, 133 at R.A., 39 at B.I.
(*V. & A.*)

WOODMAN, Charles Henry
(or Horwell?) (1823–88)
Landscapes. Exhibited 29 works,
2 at N.W.C.S., 1 at R.A., 6 at B.I.,
5 at S.B.A. (*V. & A., B.M.*)

WOODROFFE, Robert (1805–69)
A drawing master at Bath.
Landscapes and topography.
(*V. & A., Bath*)

WOODVILLE, Richard Catow
(1856–1927)
Member R.I. 1882.

WOODWARD, George Moutard
(1760?–1809)
Born Derbyshire; had no training,
but worked as a professional, in
imitation of Rowlandson. (*B.M.*)

WOODWARD, Thomas (1801–52)
Born Pershore, Worcs.; pupil of
Abraham Cooper. Sporting
subjects and animals. Exhibited
160 works, 85 at R.A., 60 at B.I.,
15 at S.B.A., 1821–52.

WOOLNOTH, Charles N.
(fl. 1833–75)
Of the Scottish School; member
R.S.W. Landscapes. Exhibited 18
works, 3 at N.W.C.S. (*V. & A.*)

WOOLNOTH, W. (fl. c. 1810)
Continental drawings for
Stockdale's 'Antiquities of Kent'.

WOOTTON, John (1686–1765)
Born London; pupil of Jan Wyck.
Sporting subjects.

WORLIDGE, Thomas (d. 1766)
An engraver, etcher, and
miniature-painter; fl. c. 1761;
worked at Bath and London.
Exhibited 11 works, 4 at Soc. of
Artists, 7 at Free Soc.

WORSEY, Thomas (1829–75)
Of Birmingham. Flowers, at first
on papier-mâché. Exhibited 99
works, 17 at R.A., 19 at B.I., 51 at
S.B.A. 1856–74.

WORSLEY, Henry (fl. 1828–43)
Worked at Bath; secretary Bath
Society of Artists 1838. Land-
scapes. Exhibited 24 works, 3 at
R.A., 14 at B.I., 7 at S.B.A. (*Bath*)

WRIGHT, John Masey
(1773–1866)
Born Pentonville; influenced by
Stothard at the age of 16; scene-

painter at His Majesty's Theatre;
began to work in watercolour
c. 1820; member o.w.c.s. 1824.
Book illustrations in the Stothard
style. Exhibited 180 works, 134 at
o.w.c.s., 9 at R.A., 8 at B.I., 29 at
s.b.a. (*V. & A., Newport,
Newcastle, Whitworth*)

WRIGHT, John William (1802–48)
An engraver; son of a miniature-
painter; pupil of T. Phillips R.A.;
assoc. o.w.c.s. 1831, member 1841
and secretary 1844–47. Portraits
and scenes from Shakespeare, and
so on. Exhibited 117 works, 82 at
o.w.c.s.

WRIGHT, Joseph (1734–97)
Known as 'Wright of Derby'; best
known for 'candlelight' oils, but
also painted watercolour land-
scapes. Exhibited 85 works, 43 at
Soc. of Artists, 2 at Free Soc., 40 at
R.A.

WRIGHT, Richard Henry
(fl. 1885–89)
Landscapes and buildings.
Exhibited 6 works, 2 at N.W.C.S.,
1 at R.A. (*V. & A.*)

WRIGHT, Thomas
(fl. c. 1790–1842)
Known as 'Wright of Newark'.
Monochrome landscapes in the
style of J. Robertson and Vandyke
Brown, and a few in colours.
Exhibited 34 works, 31 at R.A.,
3 at B.I.

WRIGHTSON, J. (fl. c. 1840)
Employed by publishers of
topographical books, e.g. Roscoe's
two volumes of towns in Wales.
Landscapes in the style of David
Cox.

WYATT, A. C. (fl. 1883–92)
Landscapes. Exhibited 27 works,

6 at N.W.C.S., 5 at R.A., 13 at S.B.A.

WYATT, Henry (1794–1840)
Born near Lichfield, Staffs.;
studied at R.A. 1811 and under
Lawrence; painted portraits in
Birmingham, Liverpool and
Manchester; lived in London
1825–34, moved to Leamington
1834, and later Manchester.
Landscapes and domestic subjects.
Exhibited 80 works, 35 at R.A.,
28 at B.I., 17 at S.B.A. (*V. & A.*)

WYATT, Sir Matthew Digby
(1820–77)
Born near Devizes; an architect;
travelled on the Continent from
1845; committee member of the
Great Exhibition 1851; Slade
professor of art at Cambridge and
knighted 1869. Architectural
subjects. Exhibited 40 works at
R.A. (*V. & A.*)

WYATVILLE, Sir Jeffry
(born WYATT) (1766–1840)
Born Burton-on-Trent; studied
Gothic architecture; made
additions to Chatsworth and
Windsor Castle; A.R.A. 1822, R.A.
1824, when he also changed his
name; knighted 1828.
Architectural subjects. Exhibited
13 works at R.A. (*V. & A.*)

WYBURN, Leonard (fl. 1879–93)
Domestic subjects. Exhibited 25
works, 9 at N.W.C.S., 5 at R.A., 8 at
S.B.A.

WYCK (or WIJK), Jan
(1640–1702)
Born Haarlem; son of Thomas;
accompanied his father to England
in the reign of Charles II, and
remained. Landscapes.
(*Nottingham*)

WYCK, Thomas (1616–77 or 82)

Of Haarlem; father of Jan.
Topography. (*B.M.*)

WYLD, William (1806–89)
Born London; studied at Calais
under Francia when secretary to
the British Consulate; travelled in
Italy, Spain and Algeria with
Vernet, and was a friend of
Bonington. Lived mostly in Paris,
and had great influence on the
development of French water-
colour art. Member N.W.C.S.
1849–83. Views of towns.
Exhibited 214 works, 206 at
N.W.C.S., 3 at R.A., 5 at B.I. (*B.M.,
V. & A., Newport, Newcastle,
Whitworth*)

WYLLIE, Charles William
(fl. 1871–93)
Member R.B.A. Marines.
Exhibited 141 works, 5 at
N.W.C.S., 32 at R.A., 68 at S.B.A.

WYLLIE, William Frederick
(1835–1918)
To Italy 1842; studied drawing
in Dresden c. 1854, and in London
under J. S. Westmacott and
George Scharf; A.R.A. 1867, R.A.
1878, librarian at R.A. Figure
subjects. (*V. & A.*)

WYLLIE, William Lionel
(1851–1931)
Studied at R.A.; member R.I.
1882–94; re-elected 1917.
Marines. Exhibited 210 works,
35 at N.W.C.S., 54 at R.A., 71 at
S.B.A. (*Gateshead, Bristol*)

YATES, Gideon (fl. 1790–1837)
Views of London bridges. (*B.M.*)

YATES, Major G. (fl. c. 1826–38)
Drawings of the Thames around

London Bridge, somewhat after
the style of Canaletto.

YATES, Thomas (fl. 1750–96)
A naval lieutenant, and amateur
artist. Naval battles. Exhibited 9
works at R.A. (*Whitworth, B.M.*)

YELLOWLEES, William
(1796–1856)
Born Mellerstain; known as 'the
little Raeburn'. Pupil of William
Shiels, the animal painter.
Portraits. Exhibited 20 works at
R.A. 1829–45.

YEOMAN, Anabelle (fl. c. 1798)
Topography.

YORKE, Eliot Thomas (1805–85)
M.P.; pupil of De Wint, and
painted landscapes in his style.

YORKE, Admiral Sir Joseph Sydney
(1763–1831)
Related to E. T. Marines.

YOUNG, Godfrey (fl. 1872–85)
Marines. Exhibited 2 works, 1 at
R.A., 1 at N.W.C.S.

YOUNG, J. T. (fl. 1811–22)
An amateur, of Southampton;
perhaps related to Tobias.
Landscapes in the New Forest
and around Southampton.
Exhibited 3 works at R.A.
(*V. & A.*)

YOUNG, Lilian (fl. 1889–90)
Domestic subjects. Exhibited 12
works, 5 at R.A., 4 at S.B.A., 3 at
N.W.C.S.

YOUNG, Tobias (fl. 1815–21)
(d. 1824)
Of Southampton; is often confused
with J. T.; said to have painted
scenery for Lord Barrymore's
private theatre. Landscapes.

Exhibited 2 works at s.b.a.
(*V. & A.*)

YOUNGMAN, Annie Mary
(1859–1919)
Member r.i. 1887. Landscapes.
Exhibited 57 works, 35 at n.w.c.s.,
6 at r.a., 8 at s.b.a.

YOUNGMAN, John Mallows
(1817–99)
An etcher; studied at Sass's
Academy 1836; assoc. n.w.c.s.
1841. Landscapes. Exhibited 138
works, 110 at n.w.c.s., 24 at r.a.,
1 at s.b.a.

ZEZZOS, A. (fl. 1889–90)
Worked in Edinburgh. Figure
subjects. Exhibited 3 works, 1 at
r.a., 2 at n.w.c.s.

ZIEGLER, Henry Bryan
(1784–1874)
Early to England from Germany,
or may have been born in England;
pupil of J. Varley. Domestic
subjects, and landscapes in
England, Wales, Normandy,
Norway and on the Rhine.
Exhibited 225 works, 26 at
o.w.c.s., 69 at r.a., 70 at b.i., 60 at
s.b.a.

ZINCKE, Christian Frederick
(1684–1767)
Born Dresden; to England c. 1706;
studied under Boit, and patronised
by George II. Miniatures.

ZINC, ZINK (or ZINCKE)
George Frederick (fl. 1882–93)
Of Kilburn. Miniatures. Exhibited
34 works, 6 at n.w.c.s., 23 at r.a.

ZOBELL, J. G. (1791–1879)
Of Norwich. Local topography.
(*Norwich*)

ZORN, Andrew Leon (fl. 1883–93)
Domestic subjects. Exhibited 20
works, 7 at n.w.c.s., 12 at r.a.

ZUCCARELLI, Francesco
(1702–78)
Born Pitigliano, near Florence;
an engraver; studied in Florence
and Rome, and travelled on the
Continent before going to London;
scene-painter at the Opera House;
visited Venice, and back in London
1752; member Incorp. s.a., and a
founder member r.a. 1768;
returned to Florence 1773.
Landscapes. Exhibited 16 works,
3 at Soc. of Artists, 4 at Free Soc.,
9 at r.a. (*V. & A., B.M.,
Newcastle*)

APPENDIX

BIBLIOGRAPHY

The books listed here have been selected from among the many consulted in the preparation of this dictionary as being most useful to the collector. Though many are out of print, they are still useful and for the most part reliable, and second-hand copies are often obtainable. Moreover, some have recently been reprinted. Readers wishing to extend their researches should consult the excellent bibliographies in Martin Hardie's 'Watercolour Painting in Britain', Vol. III, 1968, and in Derek Clifford's 'Collecting English Watercolours', 1970.

BALDRY, A. L.
 British Marine Painting (1919)

BINYON, L.
 English Watercolours (1946)

BRYAN, M.
 Dictionary of Painters and Engravers (1903)

BUNT, C. G. E.
 Little Masters of English Landscape (1949)

CLIFFORD, D.
 Watercolours of the Norwich School (1965)

CLIFFORD, D.
 Collecting English Watercolours (1970)

CUNDALL, H. M.
 Masters of the Watercolour Painting (1922)

CUNDALL, H. M.
 A History of British Watercolour Painting (1908)

CUNDALL, H. M.
 The Norwich School (1920)

CUNNINGHAM, A.
 The Lives of the Most Eminent

Painters (6 volumes, published between 1929–32)

DAVIES, R.
Chats on Old English Drawing (1923)

DICKES, W. F.
The Norwich School of Painting (1905)

FINBERG, A. J.
The English Watercolour Painters (1905)

FINBERG, A. J.
The Development of British Landscape Painting in Watercolours (Studio Special Number, 1917–18)

FISHER, S. W.
English Watercolours (1970)

GRANT, M. H.
Dictionary of British Landscape Painters (1952)

GRAVES, A.
A Dictionery of Artists, 1760–1893 (3rd edition 1901—Reprinted 1969)

HARDIE, M.
Watercolour Painting in Britain (1968)

HOLME, C.
The Royal Institute of Painters in Watercolour (1906)

HUGHES, C. E.
Early English Watercolour (1913, second edition 1929, third edition 1950)

HUISH, M. B.
British Watercolour Art (1904)

MAAS, J.
Victorian Painters (1968)

MONKHOUSE, C.
The Earlier English Watercolour Painters (1890)

REDGRAVE, G. R.
A History of Watercolour Painting in England (1892)

REDGRAVE, R. and S.
A Century of British Painters— 1866–1947

REYNOLDS, G.
Victorian Painting (1966)

ROGET, J. L.
A History of the Old Watercolour Society (1891)

SANDBY, W.
The History of the Royal Academy of Arts (1862)

WEDMORE, Sir F.
English Watercolour (1902)

WHITLEY, W. T.
Art in England (1928)

WHITLEY, W. T.
Artists and Their Friends in England (1928)

WILENSKI, R. H.
English Painting (1964)

WILLIAMS, I.
Early English Watercolours (1952, 1970)

CATALOGUES

A wealth of information is contained in museum and art-gallery catalogues, and in the published proceedings of Societies. The following are particularly valuable.

Annual Volumes of the Old Water-colour Society's Club

Annual Volumes of the Walpole Society

Catalogue of Pictures and Drawings at Harwell House, 1936

Catalogue of the Sale Bequest of Watercolours, Victoria Institute, Worcester

Catalogue of Watercolours at the Laing Art Gallery, Newcastle-upon-Tyne, 1939

Catalogue of Paintings, etc., City of Birmingham Art Gallery

Catalogue of the Permanent Collection, Walker Art Gallery, Liverpool, 1927

Catalogue of the Watercolours and Drawings, Cecil Higgins Collection, Cecil Higgins

useum, Bedford, 1959

Catalogue of English Drawings, Ashmolean Museum, Oxford

Catalogue of the Permanent Collection of Paintings and Drawings, Leeds City Art Gallery

Catalogue of the Permanent Collection of Watercolour Drawings, Museum and Art Gallery, Newport, Mon., 1951

Catalogue of the Colman Collection of Norwich School Pictures, The Castle Museum, Norwich, 1951

Catalogue of Watercolours and Drawings, National Gallery, Edinburgh, 1957

Catalogue of Watercolour Painting by British Artists, Victoria and Albert Museum, 1908, 1927, Supplement 1951

Catalogue of Early English Water-
colours, City Art Gallery,
Sheffield, 1966

English Drawings and Water-
colours from the Collection of Mr
and Mrs Paul Mellon, 1964–65,
Colnaghi

Illustrations of One Hundred Water-
colours, City of Birmingham Art
Gallery, 1953

Masters of British Watercolours,
17th–19th Century, Royal
Academy, 1949

The British Watercolour School,
National Museum of Wales,
Cardiff, 1939

Watercolours from the Gilbert
Davies Collection, Arts Council,
1949, 1955

PERIODICALS

Many periodicals carry occasional articles on watercolour painting, and back numbers are often available from the publishers or second-hand. The *Studio* in particular has for many years published special numbers dealing with the work of painters in watercolour.

Antique Dealer and Collector's Guide (Monthly)

Antique Collector (Bi-monthly)

Apollo (Monthly)

The Burlington Magazine (Monthly)

The Connoisseur (Monthly)

Country Life (Weekly)

Art and Antiques Weekly

Art and Artists (Monthly)

Art Prices Current (Annually)

Arts Review (Fortnightly)

International Auction Records (Annually)

Studio International (Monthly)